THE PRACTICAL ENCYCLOPEDIA OF
CARTOONING

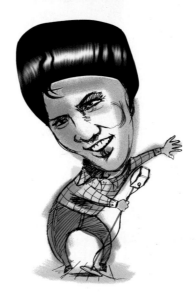

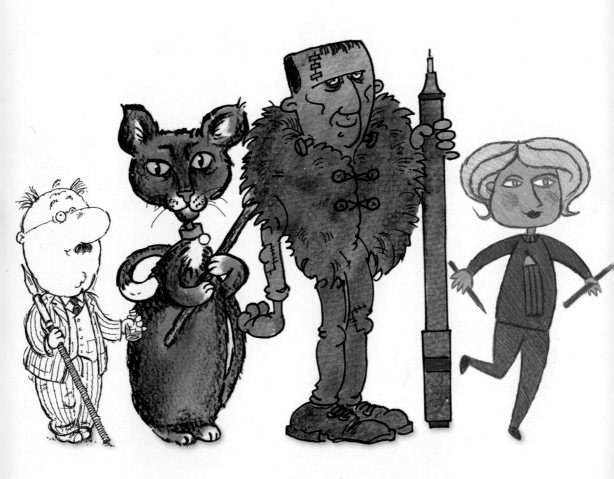

THE PRACTICAL ENCYCLOPEDIA OF
CARTOONING

LEARN TO DRAW CARTOONS STEP BY STEP WITH OVER 1500 ILLUSTRATIONS

IVAN HISSEY
AND CURTIS TAPPENDEN

southwater

This edition is published by Southwater,
an imprint of Anness Publishing Ltd, 108 Great Russell Street,
London WC1B 3NA; info@anness.com

www.southwaterbooks.com; www.annesspublishing.com

If you like the images in this book and would like to investigate
using them for publishing, promotions or advertising, please visit
our website www.practicalpictures.com for more information.

Designed and produced for Anness Publishing by
THE BRIDGEWATER BOOK COMPANY LIMITED

Publisher: Joanna Lorenz
Editorial Director: Helen Sudell
Project Editor: Polita Caaveiro
Designers: Jan Lanaway, Kevin Knight, Steve Knowlden
Art Director: Lisa McCormick
Production Manager: Mai-Ling Collyer

PUBLISHER'S NOTE
Although the advice and information in this book are believed
to be accurate and true at the time of going to press, neither the
authors nor the publisher can accept any legal responsibility or
liability for any errors or omissions that may have been made nor
for any inaccuracies nor for any loss, harm or injury that comes
about from following instructions or advice in this book.

Contents

Introduction

Cartooning is a broad yet unique art form. Using a selected number of drawn strokes, it can not only communicate to the masses through simple drawing but can also encapsulate complex information on an infinite range of topics. More peculiar still, cartoons often carry information with humour, appealing to an innate comic faculty found in each and every one of us, irrespective of language, creed or social standing. Cartoon subjects, as they are known, appear in diverse formats: as a single 'gag' that occupies a small space of a newspaper or magazine page; as a story linking a number of consecutive pictures (frames) in a strip; on packaging or billboard advertisements; on greetings cards; and as animations on television, film or the Internet. In fact, cartoons have become a powerful communication tool, allowing billions of people around the world to be entertained, informed or prompted to think visually.

Cartooning through the ages

The cartoon has its origins in the 14th and 15th centuries, when Renaissance artists prepared full-size drawn studies for fresco wall paintings or mosaics. The actual word, *cartone*, defines the board used for these drawings. Yet it was only around 270 years ago – thanks to the rapid expansion of the printing trades and their mass production of pamphlets and journals – that humorous and sardonic drawings become known as cartoons. This influx of written material fuelled a passion for narratives in artists – and thus began the strip cartoon.

From the 18th century, satirical social cartoons of William Hogarth or the small political gags in *Punch* magazine from the 1840s, which wittily commented on relevant stories of the day, to the masterful vignettes of American life in Charles Schultz's *Peanuts* or Matt Groening's dysfunctional, left-field family, *The Simpsons*, cartoons play an essential role as a running social commentary. Throughout, artists have also turned their

hand to the uncertainty of the future, thoroughly explored in printed comics. From Frank Hampson's space hero, Dan Dare, in the 1950s' comic, *Eagle*, through the dynasties of Marvel and DC Comics superheroes – Batman, Superman, Spiderman, the Incredible Hulk – generations have enjoyed the struggle of good over evil – a parody that often drew parallels between superpowers or international conflicts.

Today, cartoons still occupy many of the traditional formats mentioned above but technology has made them 'larger than life' with sophisticated, digital animation. The increasingly popular art form, Japanese manga,

Above left ▲
Betty Boop, based on the singer Helen Kane, was a popular cartoon, first animated in the 1930s.

Above right ▲
Superheroes, on their endless battle against various forces of evil, remain a staple of printed comics.

Left ◄
Deceptively simple, the *Peanuts* comic strip by Charles Schultz revealed a masterful view of American life.

is an excellent case in point, or take the pioneering work of the Dreamworks and Pixar studios, which have harnessed and developed cutting-edge methods that have considerably extended the work set in motion by animator Walt Disney back in the early 20th century.

Unlike fine art, where the viewing public come to a painting or sculpture to consider their own conclusions, cartooning is specifically intentioned and often commissioned by editors for a set purpose – to get the message across in the simplest and clearest of terms, to reveal the 'truth' within a complex, often political issue, or simply to add humour. Historically, the pen and the brush were the tools of the cartoonist, who would employ a range of line and cross-hatching techniques and, where necessary, add some flat colour.

Above ▲
The Simpsons TV show contains some of the world's most recognized characters.

Using this book

This cartooning encyclopedia aims to provide a comprehensive resource for the aspiring cartoonist, or those who wish to further develop their skills, both manual and digital, beyond the simple and traditional techniques. The book divides into two sections: the first half focuses on the development of your skills and knowledge, and the second half puts into practice what you will have learned. To get you started, there is an introduction to the tools and materials used, followed by a guide to principle drawing techniques. Subsequently, you will be shown the methodologies for creating successful characters, placing them into appropriate settings, and designing the comic page with a layout application. A wide variety of exercises are dotted throughout to help you to perfect your newly found skills.

The book's second half is packed with useful projects for you to practise your newly acquired skills, and these increase in complexity as the book progresses. The manual projects are designed to work across genres, including caricature, fantasy, using words, developing strips, adopting viewpoints, scale and using mixed media. A large part of the second half is devoted to the development of digital, computer-based cartooning using vector-based and bitmap programs.

These will take you through the creation of digital cartoons using a step-by-step approach, with illustrative screengrabs. Having practised a plethora of essential and useful techniques for the creation of still images, the book ends with an introduction to simple animation.

Finally, to get the most out of this book, work consistently through the spreads, take your time and try out the exercises and projects at a pace that suits you. If you need to spend longer or go back and repeat any sections, do

so to gain fuller understanding and greater mastery. This will prove to be most beneficial in the long run. Enjoy the challenge.

Below left ▼
Popeye first appeared in a black-and-white comic strip in 1929, and still delights fans across the globe.

Below right ▼
Dumbo was one of the first cartoons to appear in a feature length film.

1

Materials
and methods

A cartoon is essentially like any other drawing: it needs a
theme, a style and, most important of all, materials that can
deliver marks through a variety of techniques. Your choices
of surface to draw on and materials to draw with are vital.
In this chapter try out pencil, pen, inks and watercolours,
to explore tone and colour and their combinations.

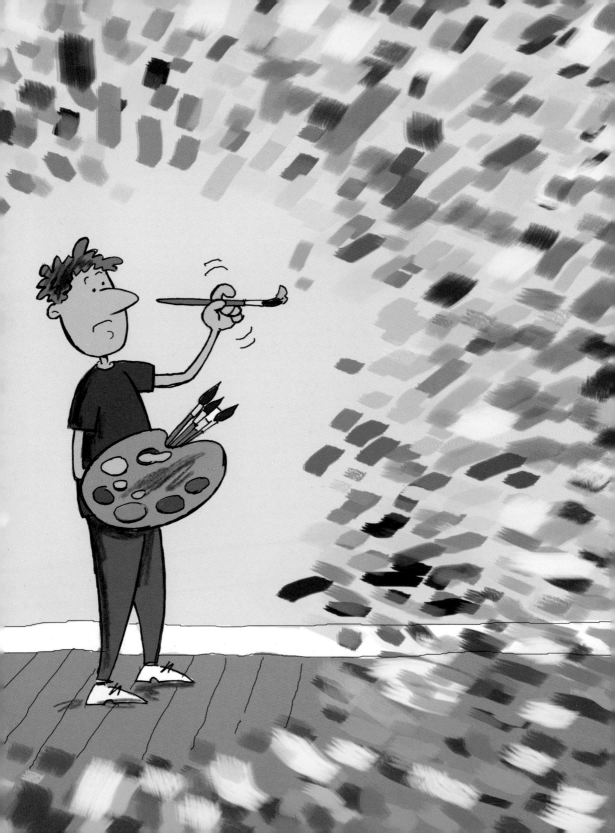

Types of paper and card

Cartooning is rapid-fire visual communication and shouldn't require anything other than a basic surface upon which to burst into life. Like all art forms, though, there are levels of accomplishment and the presentation necessary for one image may not necessarily match that of another. For this reason it is a good idea to become acquainted with a variety of papers and boards to discover their versatility by trying them out using different media.

Of course, your choice of materials and media will be largely dictated by personal preference and individual drawing style. However, the following provides a useful guide for the beginner: a good-quality cartridge paper that allows for pencil under-drawing and takes an ink wash, a heavier type of paper for brush drawing and watercolour paper for pen drawings and

watercolour washes. Watercolour papers are available in rough, smooth (hot-pressed) and 'Not' (not hot-pressed) surfaces. Any of these is suitable; your main consideration is that the pen nib won't get snagged in the surface fibres.

A firm, resilient surface, such as watercolour or heavy cartridge paper, allows you the freedom to make corrections with an eraser, whiting-out ink or paint and to collage separate elements, and can be wetted in preparation for a colour wash. Smooth boards have added chalk, which gives extra fluidity. Be aware that a tip (known as the nib) on a smooth board might break the shiny surface, causing the ink to bleed into the absorbent fibres beneath. A colour cartoon may need to be scanned, so try to make sure that you work to the maximum size of the flatbed, desktop scanner you will be using.

Testing surfaces

The only way to know which type of surface is best for you is to try out as many different variations as possible. Many artists find a particular paper that works well for them and tend to stay with it. Below, the first skater sketch uses a 0.3mm fineliner drawing pen on standard cartridge paper. The result is a crisp black outline. The same cartoon on rough watercolour paper has a textured look.

The black ink outline is drawn directly with a medium-sized, round brush. Dryish layers of drawing ink give shading and light charcoal strokes in selected areas emphasize texture. The contrast between a textured surface and smooth Bristol board is distinct. Here, the outline is made with a fineliner pen and colour fills are in translucent ink washes. The brushed-on black strokes add extra definition.

Types of support ▼
Your choice of support will have a real bearing on the visual appearance of your drawings. A rough, textured paper will cause your lines to break up slightly, whereas a smooth one will deliver a continuous line. For much work a medium-grain paper is best – something that accepts a reasonably crisp line and to which a wash or two can be added.

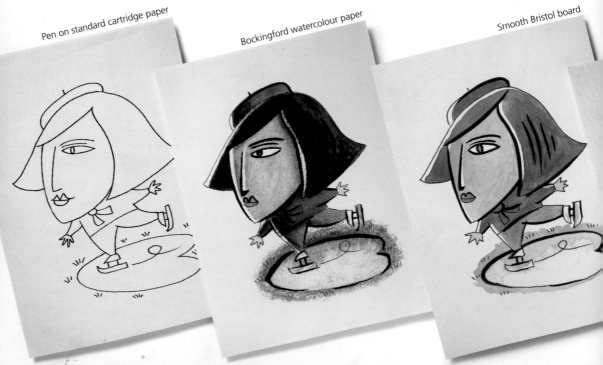

Pen on standard cartridge paper

Bockingford watercolour paper

Smooth Bristol board

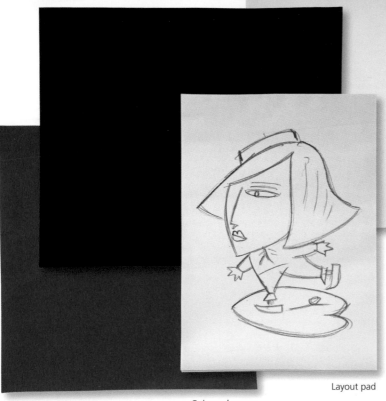

Other useful materials ▲
Light, tinted papers offer a softer
background; darker ones provide
a background that suits the setting,
for example dark blue or black for a
night scene. Boards are thicker and
take wet washes without cockling
(buckling). Pastel papers, such as
Ingres, are grainy. A layout pad can
be used for tracing; sketchbooks
for recording and learning.

Layout pad

Coloured paper

Soft texture weave

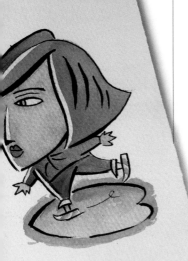

Tip: Get into the habit of keeping
sketchbooks, and record all manner
of things in them. How you maintain
an ongoing record is entirely up to
you; after all, it does need to be
personal and, most importantly, of
use to you as a practising artist.
Date all work and number your
books as it won't be long before
a library begins to emerge.

The pencil

One of the most versatile drawing tools is the humble pencil. It is available in the H (hard) grades, which are used most commonly by designers and architects, and the softer B (black) grades preferred by artists. The 'lead' is actually graphite or a graphite and clay mix. You can choose between the classic wooden-cased style or the non-sharpening, mechanical type, which are classified by width, such as 0.5mm.

It is worth testing all the grades to find the one that you feel most comfortable using. The inexperienced artist may prefer the slighter mark of an H pencil, though note that it has a tendency to score the paper if too much pressure is used. The more confident drawer is likely to enjoy using the blacker B-grade pencils. They are ideal if a clean yet soft outline is wanted. As its name suggests, the HB pencil is a balance of hard and black:

the perfect all-round choice. The basic pencil is the ideal tool for everyday sketching and making those all-important first outlines, and it is also invaluable for shading.

Water-soluble drawing pencils have the same properties as ordinary graphite when used dry, but with added water they take on the qualities of watercolour. Dipping them in water produces a tonal range from the palest grey to the deepest black. The same effect can be achieved by washing over the pencil shading with a wet paintbrush. These pencils have a rapidity of use and are fully portable, making them ideal for quick note-taking or in the studio as a valid medium of colour and tone.

Charcoal is a highly expressive medium. Water soluble, it can be manipulated with a brush and water to create wash effects or blended directly using fingers, a soft cloth or an eraser.

Pencil choices

By trying out the various kinds of product available, you will discover which pencil types suit you best and for what purposes. For example, a drawing made with vigour and bold expression is likely to employ a drawing pencil with soft, dark grey or black lead, bearing the coding of at least a 3B. In direct

contrast, the fine layout drawing or tracing, requiring greater accuracy, would be better executed with a 0.5mm or 0.7mm mechanical 'clutch' pencil, which features a narrow bar of graphite that is extended from the pencil barrel out to the tip by clicking through a special spring mechanism.

A pencil plethora ▼
An art store trip is a great way to learn how to identify pencils and their uses: graphite drawing pencils (HB–6B) for general sketching; water-soluble pencils in a wide range of colours; mechanical pencils; and chisel-edged carpenter types, which deliver a wide, blocky stroke.

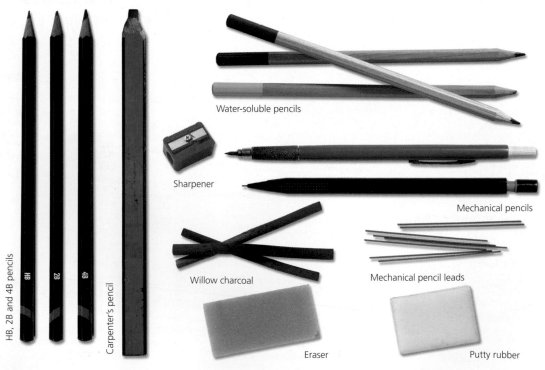

HB, 2B and 4B pencils

HB

2B

4B

Carpenter's pencil

Water-soluble pencils

Sharpener

Mechanical pencils

Willow charcoal

Mechanical pencil leads

Eraser

Putty rubber

Matching pencils to white papers

Your choice of drawing tool and surface will always determine the outcome and should be considered carefully. It is not difficult to gauge the effects of the various grades of pencil on different textures and weights of paper. The simple swatches on this page clearly show all the necessary information: an exercise well worth doing for yourself. Try to obtain paper samples from stockists for testing purposes so that you do not purchase the wrong types.

The swatch library ▼
As you complete simple swatches, classify them by pencil and paper type and then glue into a sketchbook. Don't be afraid to experiment with different shading techniques.

6B carpenter's pencil on rough watercolour paper

6B carpenter's pencil on artificial weave paper

6B carpenter's pencil on very smooth paper

6B carpenter's pencil on medium cartridge paper

4B pencil – light shading on rough watercolour paper

4B pencil – light shading on artificial weave paper

4B pencil – light shading on very smooth paper

4B pencil – light shading on medium cartridge paper

2B pencil – tonal strokes on rough watercolour paper

2B pencil – tonal strokes on artificial weave paper

2B pencil – tonal strokes on very smooth paper

2B pencil – tonal strokes on medium cartridge paper

HB pencil – tonal strokes on rough watercolour paper

HB pencil – tonal strokes on artificial weave paper

HB pencil – tonal strokes on very smooth paper

HB pencil – tonal strokes on medium cartridge paper

All pencils – constant zigzag lines on rough watercolour paper

All pencils – constant zigzag lines on artificial weave paper

All pencils – constant zigzag lines on very smooth paper

All pencils – constant zigzag lines on medium cartridge paper

Pencil variations on coloured papers

Pencil marks against coloured paper instead of white can appear startlingly different. Tonal papers ease the brightness on the eye and are useful in setting the mood too. Test a range of smooth and rough textured papers. A pastel paper, such as Ingres, has a consistent linear weave running through it, which gives a slightly crumbling graphite line.

Coloured-paper moods ▼
Try out a range of strokes and marks using a variety of pencils on different colour tones of paper and compare the results to find the most appropriate.

6B, 4B, 2B, B pencil zigzags on smooth blue paper

6B, 4B, 2B, B pencil zigzags on brown Ingres paper

6B, 4B, 2B, B pencil zigzags on buff smooth paper

6B, 4B, 2B, B pencil zigzags on yellow Ingres paper

Pencil shading

Much of cartooning involves creating detailed 3-D figures and settings. Shading – a crucial technique to learn – is used to make shapes appear solid. The distinction between the different planes of a solid structure, such as a cube, is made using light, medium and dark shading. The first uses a gradual build-up of cross-hatch tone; the second, gentle shading, and the third stronger shading. The cubes below all use a different type of pencil shading. How you shade can have a radical impact on the style of the drawing, which affects the mood of the cartoon: the heavier your shading, the heavier the mood.

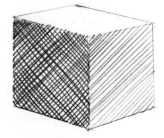

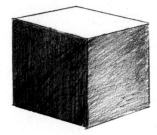

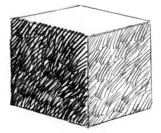

Cross-hatch ▲
Draw lines at a 45-degree angle across a paper surface to cover the blank, white paper. On the surface you wish to be in darker shadow, so sketch diagonal lines in the opposite direction. To darken further, add vertical lines at 90 degrees.

Smooth tone ▲
Sketch with control across the sides of the cube. Move the pencil along extended directional strokes – vertical, horizontal or diagonal – and try to exert even pressure throughout. Add consecutive layers to deepen the tone.

Hatching ▲
A more haphazard approach to shading can be practised using short covering strokes known as hatching. They have a rough-textured appearance, but when viewed from a distance they become unified with an even tonal balance.

Tonal scale ◄
It is important to practise rendering tonal scales as often as you can. Work a line of shaded blocks from the very darkest to the very lightest, and test your response to a range of mark-makers. It is best to begin with pencil as it is the easiest to control. Move consistently along a scale, altering the pressure as you go. The principle is simple: the greater the pressure, the heavier the mark.

Pencil effects

Ideas need to be adjusted frequently during the drawing process. Elements are changed, moved or removed, and a pencil is the perfect tool for versatility.

Most cartoons are inked over the top of an original, lighter first drawing. The pencil lines need to be light and crisp so that they can be rubbed out. Where ink is not used, water-soluble pencils can give greater weighting (density) to a drawing, while charcoal softened with water will add extra depth.

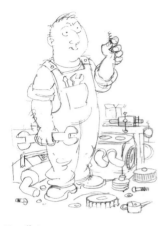

Pencil ▲
Keep the pencil tip sharpened for a detailed subject, such as this garage mechanic. Use an HB pencil and alter the pressure to give life to the line.

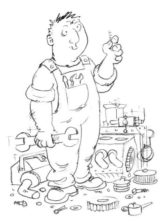

Water-soluble pencil ▲
The same sketch made here using water-soluble pencil is heavier and more apt as the line for the final artwork. The tip is dipped in water to darken the line.

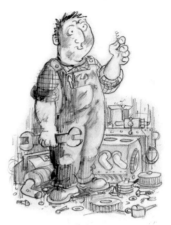

Water-soluble pencil and charcoal ▲
This final composition is outlined using water-soluble pencil. The line and additional charcoal shading is gently softened with a damp brush.

Pencil and paper combinations

The choice of pencil and paper has a strong bearing on the end result: the way that you handle materials always affects the resultant drawing.

Mechanical pencil drawing ▲
As this sketch shows, mechanical pencils are able to deliver a broad range of creative marks, building lines and tones in much the same way as any other pencil.

Pencil on coloured paper ▲
This simple line drawing is assisted by the soft shade of paper it has been created on. Coloured papers can save you laying a basic tonal wash at the start of a job.

Pencil alien ▲
On smooth, cream paper, lightly draw the alien composition with a 2B pencil. Hatch loosely over the alien and planet surface, making the shadow areas deeper in tone.

Pen and brush

Ask any cartoonist to name the traditional tool of the trade and most will tell you it is the dip pen. Dipping the nib into a bottle of Indian ink demands confidence. There is no going back once the nib touches the paper and the pen reservoir releases its fluid line. It takes practice to use the nib proficiently, but it is worth it: no other ink drawing tool offers such a wide range of pressure-led lines. Ensure the pen holder is comfortable to grip and buy a range of nibs. A good nib is flexible and consistent in flow.

The neater fountain pen is a worthy alternative. It requires none of the constant refilling, but its drawback is that it can become clogged with waterproof ink, making it useless for crisp line and wash work. Technical pens, including fineliners, range in nib size from 0.1mm up to 2mm and are designed to deliver a perfect mechanical line. They are excellent for dot stippling (dabbing the tip of the pen on to the paper to create a dotted effect) and regular cross-hatching, but the even flow makes them unsuitable for more expressive drawing styles.

Brushes are a bold alternative to pens, though they take more practice to control. Ranging in size from the ultra-fine 000 to the thick 12, brushes must be thoroughly cleaned with soapy water after use, since ink rots the hairs. Round brushes are the most common and available in synthetic nylon, nylon mixed fibres or, the most natural but expensive, sable. A good brush should be springy, with hairs that easily reform, tapering to a fine point. Round brushes are commonly used for drawing and adding tone; flat brushes offer slabby strokes.

Pen and brush choices

Pens and brushes are essential to all artists, especially the cartoonist. The fountain pen delivers a flowing ink line with consistency, its beauty being that line weights alter according to pressure applied to the nib. A dip pen has a small reservoir at the tip to collect ink as it is dipped into an ink pot. The lines produced can range from blobby or scratchy, to thick or thin. Nibs are available in a range of sizes and shapes, for example the italic nib offering a definite, flat broad line. Technical pens are highly specialized for detailed drawing and are filled with cartridges. Their lines are crisp and definite, so are best on smooth papers. The beauty of fineliner pens is that they are disposable and don't need refilling.

Pens and brushes ▼
Here is a sample taster of what is on offer in most art stores and selected stationers. When choosing pens and brushes, you can only determine what is best for you through trial and error. Try as many varieties as you can and keep swatches of the effects in a scrap or note book as a reminder of their performance.

Tip: Any mistakes that may occur can be corrected by a number of means. You can scratch a small spill of ink or watercolour from the paper surface with a sharp craft knife. Use process white, white gouache or the heavier, spirit-based correction fluids to hide other unwanted drawn marks. Try them out first on scrap paper.

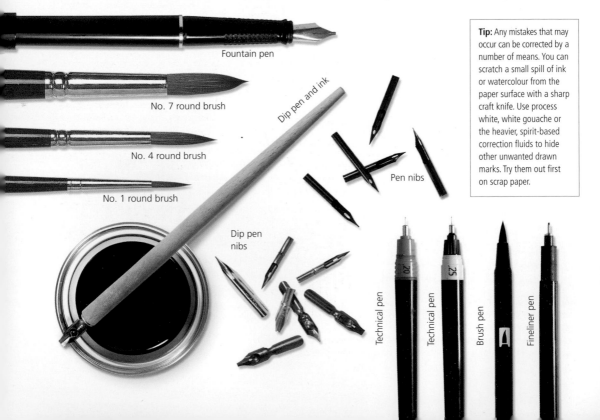

Fountain pen

No. 7 round brush

No. 4 round brush

No. 1 round brush

Dip pen and ink

Pen nibs

Dip pen nibs

Technical pen

Technical pen

Brush pen

Fineliner pen

hatched boxes ▼
...s here are subtle. It is a
...arn when to use one
...e rather than another.
...drawing alive and
...ness of tone.

...r that practice makes
...e simplest lines can be
...dedication. The more
...handle a pen or brush,
...ent your line work will
...artoonists with a very
...en line have developed
...I language of strokes
...xperience.

Pen and brush line swatches
The swatches below have been c...
using a range of pens and brushes...
smooth- and rough-surfaced paper. S...
your own pen and brush swatch libra...
with as many variations as you can. Keep
adding to it so that it builds up into a
valuable resource over time. Make sure
that you note the variety and nib size too.

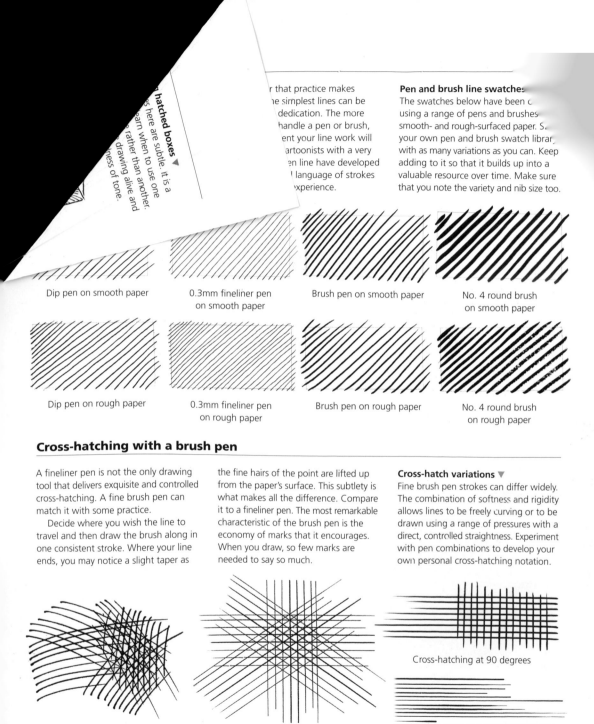

Dip pen on smooth paper

0.3mm fineliner pen
on smooth paper

Brush pen on smooth paper

No. 4 round brush
on smooth paper

Dip pen on rough paper

0.3mm fineliner pen
on rough paper

Brush pen on rough paper

No. 4 round brush
on rough paper

Cross-hatching with a brush pen

A fineliner pen is not the only drawing tool that delivers exquisite and controlled cross-hatching. A fine brush pen can match it with some practice.

Decide where you wish the line to travel and then draw the brush along in one consistent stroke. Where your line ends, you may notice a slight taper as

the fine hairs of the point are lifted up from the paper's surface. This subtlety is what makes all the difference. Compare it to a fineliner pen. The most remarkable characteristic of the brush pen is the economy of marks that it encourages. When you draw, so few marks are needed to say so much.

Cross-hatch variations ▼
Fine brush pen strokes can differ widely. The combination of softness and rigidity allows lines to be freely curving or to be drawn using a range of pressures with a direct, controlled straightness. Experiment with pen combinations to develop your own personal cross-hatching notation.

Curved hatching in multiple directions

Cross-directional hatching
at 45 and 90 degrees

Cross-hatching at 90 degrees

Varied pressure-led lines

...hing to create a solid

...the perfect shape on which to ...using cross-hatched tone to create ...illusion. Hatch two of the surfaces, ...ng more crossed strokes on one. It is ...asy to see that the closer the cross-hatching, the deeper the tone becomes.

Compare the results of a fineliner pen with those of a dip pen. Alter the length of the hatched strokes and see how tone can be given texture. Do not worry about getting your lines absolutely straight. The overall effect is what is most important.

Comparin...
The differenc... good lesson to... hatching techniqu... A blend can keep th... prevent an overall dea...

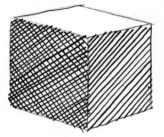

Cross-hatching on one surface with 0.3mm fineliner pen

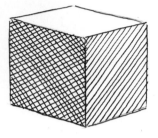

Cross-hatching on one surface with a dip pen

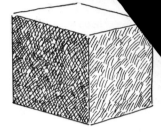

Hatching with 0.3mm fineliner pen

Further pen techniques

The more extensive your repertoire of pen marks, the more interesting your cartoons will become. Don't be afraid to part with tradition and bring less conventional techniques into the mix.

Experimentation will keep your work fresh. In your explorations, practise the tonal scale from black to white so that you are able to gauge the response of the technique with your mark-makers.

Further tonal swatches ▼
Only when you put pen techniques up against one another can you really get the measure of their potential for major tonal description or background.

Directional hatching ▲
This kind of shading offers powerful movement and a rhythm that carries the eye across a drawing.

Curly line ▲
This is a softer, less forceful technique and is very useful for creating airy, nondescript backgrounds.

Small hatching ▲
An approach that offers straightforward tonal backgrounds with a good deal of freedom, yet is also controlled.

Ruled hatching ▲
This form of hatching offers a regular, mechanical alternative, which sets up a rigid, even tonal scale to use.

Stipple ▲
In this technique, each spot of ink represents a tiny area of tone, so it achieves the smoothest tonal transition.

Smudge ▲
This delivers true halftone qualities. You must be in full control and be careful not to use it too heavily.

Practise doodling

A good cartoonist is not only curious, but also able to keep an audience's interest. Practise fun exercises between finished pieces to see how different pens perform. Indulge in simple doodling on a daily basis. Everything you learn can be used whenever the right time arises.

Variety of media styles ▶
Comparing different strokes delivered from a variety of media and placing them side by side is the best way to choose the most suitable. The hairy body of the troll enables you to explore texture with a range of thick and thin strokes.

0.3mm fineliner pen

Dip pen

Dip pen and brush

Handwriting
felt-tip pen

No. 4 round brush

Texture and personality

Using different textures can alter the personality of a cartoon character. Here, three alternative hatching styles have been used to create the cat's fur. The slightly spiky directional hatching implies a suspicious nature, while the curly lines offer greater tonal range, suggesting softness and warmth. The use of the smudging technique is more ad hoc and suggests an unkempt alley cat.

Character-building strategies ▼
Understanding and being capable of accessing these various techniques are essential if you want to be able to display a range of personalities.

Directional hatching

Curly line

Smudging

Further pen and brush effects

The drawings on these pages exploit the range of marks that can be made with pens and brushes. Copy these examples or create your own, but don't expect perfection. Have patience from the outset and relax into your drawings. Be prepared for every stroke to bring new possibilities, as well as the unpredictable, especially if you encounter a moppy brush or scratchy nib.

The key to effective pen and brush work is to retain liveliness in the line. Adjust the pressure that you apply to your tools to vary the line weights at every twist and turn. This contrast in weighting will provoke an animated response in the drawing.

Direct line with brush fills ◄
The flow of the musical notes is matched by that of the pen nib and fluid brushstrokes. Dense, black patches intersperse the flowing rhythms and dry-brush greys soften the contrast.

Bold line ▶
Textured Ingres pastel paper is perfect for both dip pen and brush. The stark whiteness of the background is eliminated without effort. .

Dip-pen hatching ▲
A medium-weight sheet of cartridge paper and a dip pen create this lively warthog sketch. Loose cross-hatching follows the curvy directions of the beast's rotund body, becoming denser beneath the belly. A 0.3mm fineliner pen gives a delicate contrast in the sunglasses reflection.

Small hatching ▶
The candle flame exudes a flickering, soft aura of light around its centre and the rising smoke above. Small hatching is perfect for this since it has movement, yet at the same time subtlety, and delivers a fluctuating overall background with good tonal range. It is most important that you initially leave the white areas with no lines. Extraneous marks can ruin the lighting effect.

Dip pen and gouache ▶
To capture the bright *joie de vivre* of the Parisian café, use a dip pen sensitively and confidently, keeping your pen lines as crisp and direct as possible. Only put necessary detail into the picture to maintain focus. Ink the hat and waistcoat as solid elements, shade the background with stippling and add bands of blue and red gouache for the French tricolour flag. Allow your eye to gaze over the whole composition when you've finished to check that the lines all have enough weight. If any seem overshadowed, reinforce them carefully.

Fake engraving ▲
This simulated engraving or woodcut effect uses a combination of pen line weights. The key is to give equal weight to whites, hatched 'greys' and solid blacks. Spot colour is added to the banana skin to highlight its danger. Try various widths of grain-heavier line weights, or light lines placed close together. Find other wood engraving examples in books and catalogues and study the reproduced line carefully before emulating the style.

Heavier blended marks ▼
Filling larger areas of tone can be undertaken with a blend of heavier techniques. Smudging charcoal initially removes the whiteness of the paper, then a rag with drying ink can be rubbed over the dark, background areas. Brush and ink redefine the main detailed areas.

Scratching and blobbing ▶
Using a dip pen, scratching an outline directly determines the way forward. The spin of the hair is delivered with a fully loaded pen and a continual upward spiralling of hand. The eye blobs are added with a brush and larger blobs dropped in the spaces around, blown from the centre outwards through a straw.

Tip: Experimentation can significantly aid your progress and help you to establish a valuable repertoire of drawing marks with a variety of wet and dry media. Once you have explored a handful of different techniques, set yourself a simple cartoon challenge in order to exploit these newly developed skills.

Tonal control

The most forthright cartoons are those in which the contrast between black and white is stark, lending them enormous power and dynamism. Strong contrast and the variation of composition using black, white and some halftone (usually line-based) is essential in cartoon strips and graphic novels.

Lighting plays a key part in the process of balancing a black-and-white composition. A basic knowledge of how to display directional lighting in drawing is therefore a very useful skill to acquire at an early stage.

Start by looking around you. Observe the direction of light falling on objects and the shadows they cast. A strongly lit day will produce near-black, solid shadows, while a hazy, muted light will cause them to extend softly. The complex surface and

form of an object, or a character, can be simplified by using the fall of light and the resulting shadows to describe it. If you want to create a darkly humorous atmosphere or a heightened mood, you can do no worse than to borrow a technique from the great master artists of the Renaissance. Technically known as *chiaroscuro*, this manipulation of light and dark areas adds depth and can totally transform the mood of an image. If it worked for Caravaggio, then it can work for you!

The only way to learn how to use black and white in an effective way is to practise with simple compositions and move on to more complex themes as your understanding and skills develop. Time taken to master tonal scales all depends on practice: remember that cartoonists draw every day.

Lighting spheres

The same sphere, with lighting falling on it from the right-hand side of the composition, can look very different depending on the treatment of the background and fall of the shadow. Because the horizon line is placed directly behind the spheres, each one appears to be resting. Where a grey tint

forms the complete background, the sphere becomes the major focus and gains natural prominence. This is then exaggerated with the inclusion of a base shadow. The partial blacking out of the background succeeds in balancing the composition, allowing the eye to 'read' the drawing more evenly.

Spherical swatches ▼
Use cross-hatch, stipple and opaque white hatched highlights to experiment with the compositional balance of black and white. Note the effectiveness of the halo around the rim in the bottom row of spheres, caused by light reflecting upwards from the white base.

Cross-hatch on grey

Cross-hatch on
black and white

Cross-hatch on
white and black

Cross-hatch on white

Cross-hatch highlights
in white on grey

Cross-hatch highlights in
white with black and white

Cross-hatch highlights in
white with white and black

Cross-hatch highlights
in white on white

Stipple on grey

Stipple on black and white

Stipple on white and black

Stipple on white

Simple drama

The cartoon spider's strong silhouette form is perfect for demonstrating lighting and shadows. The four identical black spiders reveal how a light source shining from a different direction can alter the mood of the scene and create a dramatic effect. Darkness entering from above creates oppression, while from beneath it underlines the importance of the spider as the main character. From the side there is the anticipation that something may be about to occur from the unknown dark spaces to the right, encouraging the imagination to conjure a dramatic mood.

Overall lighting ▲
The spider hangs from its thread. The overall lighting has no prominent direction and sets a stark contrast as a flat, graphic image.

Lit from above ▲
The light source is at a level with the top of the spider. The stippled fade offers the picture a top and the base is provided by the shadow.

Lit from below ▲
Just below the spider and tilted upwards and back, the light produces a shadow that melts into the stipple, providing a stagey entrance for the spider.

Lit from the left ▲
This composition carries a sense of discovery, as if a torch has just encountered the eight-legged fiend. Even tonal stippling sets a mood.

Practice exercise: Opposing black and white

This uncomplicated scene exemplifies what you have discovered about using black and white in a composition. The torch is a common device because its beam leads the reader's eye into the next frame and a new focus in the narrative.

Once you have planned where your blacks and whites will go, define them clearly using solid, even fineliner pen lines and shapes. If you are unsure, mark them out first in pencil, but try not to become too reliant on the security of a pre-pencil mark.

Materials
- *cartridge paper*
- *pencil*
- *1mm fineliner pen*
- *black Indian ink*
- *No. 3 round brush*

1 Sketch the basic outlines of character and setting in pencil. Use a fineliner pen to go over for crisp, unfaltering lines.

2 Steadily define clear outline shapes that you will paint in black using Indian ink and a brush.

3 Paint the outline shapes. Lessen the pressure on the brush where the lines disperse the light into jaggedness.

Colour overlays

Colour can be applied to cartoons using a variety of methods and media. Here are some of the most popular choices on offer.

Watercolour paints are available in a vast array of colours either as moist cakes (pans) or in tubes. They are water-soluble and contain a gummy binder, which gives them body. A box of 12 artist-quality watercolours that includes the primary colours (red, yellow and blue) is a good choice.

Dyes and inks are fine, translucent liquid colours that stain the paper. Inks are waterproof and cannot be removed once dry. They are available in strong colours, making them ideal for printing, but exposure to strong natural light will fade them. Dyes are a concentrated strain of ink, extracted from plants or minerals or chemically created. Their brightness of colour means

that they are not particularly lightfast and should be avoided for any work where there is an expectation of permanence.

Gouache and poster paints contain chalk, which makes them very opaque, although they can be thinned in water to produce watercolour effects. They are excellent for laying down areas of flat colour, which dry without streakiness.

Acrylic paints deliver a highly versatile catalogue of marks, from thick to thin. These plastic-based paints can be thinned in water and are particularly useful for creating highlights.

Pastels offer smooth blending or solid colour used dry. They mix well with other media, wet and dry, and add texture.

Marker and felt-tip pens are available in two different types: water- or spirit-based (permanent) and in a variety of nib sizes.

Your colour kit

Initially, it is not advisable to go out and buy every colour medium you have ever heard of. Much is of a highly specialized nature and within a genre of materials there is often a large range on offer, from student quality to artist quality. If you know what sort of effect you are aiming to produce and have followed

advice from this or another text, then you should begin researching. Test products in the shop where possible, and only buy what you need and can afford. As a general guide, the most expensive is the best, but if you are simply tinting a small area of a cartoon, the middle range will be fine.

Basic colour materials ▼
For the basic kit: buy some watercolour paints either as pans or in tubes, fluid inks in primary colours, small tubes of acrylic paint, including blue, red, yellow and green, gouache tubes in similar colours, plus white as a mixer, and a mixing palette for creating the right hues.

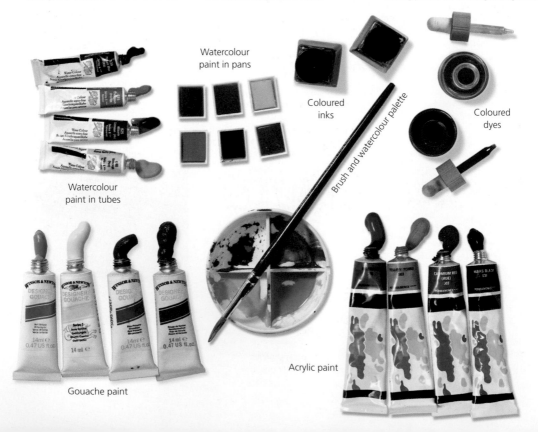

Watercolour paint in pans

Coloured inks

Brush and watercolour palette

Coloured dyes

Watercolour paint in tubes

Gouache paint

Acrylic paint

Practising the pen line

To begin with, try out as many different brushes and pens as you can on a variety of papers. This will help you to understand the properties of the various drawing tools in relation to the surfaces and enable you to select those that you feel most comfortable handling. For example, when using a dip pen, the choice of paper or board is critical.

Remember that practice makes perfect and the simplest lines can be improved with dedication. The more frequently you handle a pen or brush, the more confident your line work will become. Those cartoonists with a very definite style of pen line have developed their own personal language of strokes through extensive experience.

Pen and brush line swatches ▼
The swatches below have been created using a range of pens and brushes on smooth- and rough-surfaced paper. Start your own pen and brush swatch library with as many variations as you can. Keep adding to it so that it builds up into a valuable resource over time. Make sure that you note the variety and nib size too.

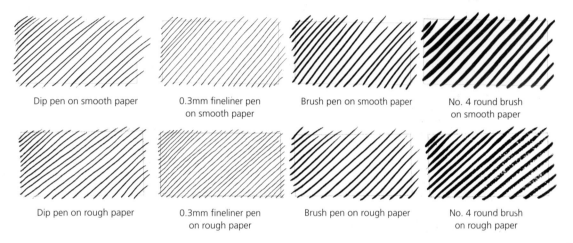

| Dip pen on smooth paper | 0.3mm fineliner pen on smooth paper | Brush pen on smooth paper | No. 4 round brush on smooth paper |

| Dip pen on rough paper | 0.3mm fineliner pen on rough paper | Brush pen on rough paper | No. 4 round brush on rough paper |

Cross-hatching with a brush pen

A fineliner pen is not the only drawing tool that delivers exquisite and controlled cross-hatching. A fine brush pen can match it with some practice.

Decide where you wish the line to travel and then draw the brush along in one consistent stroke. Where your line ends, you may notice a slight taper as

the fine hairs of the point are lifted up from the paper's surface. This subtlety is what makes all the difference. Compare it to a fineliner pen. The most remarkable characteristic of the brush pen is the economy of marks that it encourages. When you draw, so few marks are needed to say so much.

Cross-hatch variations ▼
Fine brush pen strokes can differ widely. The combination of softness and rigidity allows lines to be freely curving or to be drawn using a range of pressures with a direct, controlled straightness. Experiment with pen combinations to develop your own personal cross-hatching notation.

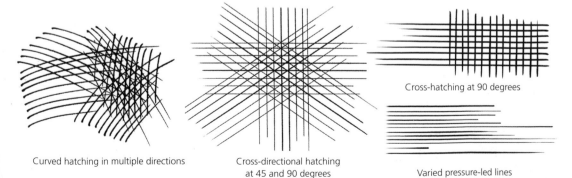

Curved hatching in multiple directions

Cross-directional hatching at 45 and 90 degrees

Cross-hatching at 90 degrees

Varied pressure-led lines

Pen hatching to create a solid

A cube is the perfect shape on which to practise using cross-hatched tone to create a 3-D illusion. Hatch two of the surfaces, using more crossed strokes on one. It is easy to see that the closer the cross-hatching, the deeper the tone becomes.

Compare the results of a fineliner pen with those of a dip pen. Alter the length of the hatched strokes and see how tone can be given texture. Do not worry about getting your lines absolutely straight. The overall effect is what is most important.

Comparing hatched boxes ▼
The differences here are subtle. It is a good lesson to learn when to use one hatching technique rather than another. A blend can keep the drawing alive and prevent an overall deadness of tone.

Cross-hatching on one surface with 0.3mm fineliner pen

Cross-hatching on one surface with a dip pen

Hatching with 0.3mm fineliner pen

Further pen techniques

The more extensive your repertoire of pen marks, the more interesting your cartoons will become. Don't be afraid to part with tradition and bring less conventional techniques into the mix.

Experimentation will keep your work fresh. In your explorations, practise the tonal scale from black to white so that you are able to gauge the response of the technique with your mark-makers.

Further tonal swatches ▼
Only when you put pen techniques up against one another can you really get the measure of their potential for major tonal description or background.

Directional hatching ▲
This kind of shading offers powerful movement and a rhythm that carries the eye across a drawing.

Curly line ▲
This is a softer, less forceful technique and is very useful for creating airy, nondescript backgrounds.

Small hatching ▲
An approach that offers straightforward tonal backgrounds with a good deal of freedom, yet is also controlled.

Ruled hatching ▲
This form of hatching offers a regular, mechanical alternative, which sets up a rigid, even tonal scale to use.

Stipple ▲
In this technique, each spot of ink represents a tiny area of tone, so it achieves the smoothest tonal transition.

Smudge ▲
This delivers true halftone qualities. You must be in full control and be careful not to use it too heavily.

Practise doodling

A good cartoonist is not only curious, but also able to keep an audience's interest. Practise fun exercises between finished pieces to see how different pens perform. Indulge in simple doodling on a daily basis. Everything you learn can be used whenever the right time arises.

Variety of media styles ▶
Comparing different strokes delivered from a variety of media and placing them side by side is the best way to choose the most suitable. The hairy body of the troll enables you to explore texture with a range of thick and thin strokes.

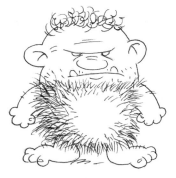

0.3mm fineliner pen

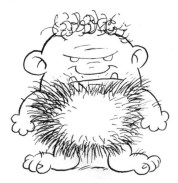

Dip pen

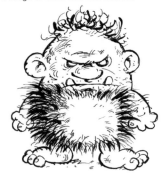

Dip pen and brush

Handwriting
felt-tip pen

No. 4 round brush

Texture and personality

Using different textures can alter the personality of a cartoon character. Here, three alternative hatching styles have been used to create the cat's fur. The slightly spiky directional hatching implies a suspicious nature, while the curly lines offer greater tonal range, suggesting softness and warmth. The use of the smudging technique is more ad hoc and suggests an unkempt alley cat.

Character-building strategies ▼
Understanding and being capable of accessing these various techniques are essential if you want to be able to display a range of personalities.

Directional hatching

Curly line

Smudging

Further pen and brush effects

The drawings on these pages exploit the range of marks that can be made with pens and brushes. Copy these examples or create your own, but don't expect perfection. Have patience from the outset and relax into your drawings. Be prepared for every stroke to bring new possibilities, as well as the unpredictable, especially if you encounter a moppy brush or scratchy nib.

 The key to effective pen and brush work is to retain liveliness in the line. Adjust the pressure that you apply to your tools to vary the line weights at every twist and turn. This contrast in weighting will provoke an animated response in the drawing.

Direct line with brush fills ◀
The flow of the musical notes is matched by that of the pen nib and fluid brushstrokes. Dense, black patches intersperse the flowing rhythms and dry-brush greys soften the contrast.

Bold line ▶
Textured Ingres pastel paper is perfect for both dip pen and brush. The stark whiteness of the background is eliminated without effort.

Dip-pen hatching ▲
A medium-weight sheet of cartridge paper and a dip pen create this lively warthog sketch. Loose cross-hatching follows the curvy directions of the beast's rotund body, becoming denser beneath the belly. A 0.3mm fineliner pen gives a delicate contrast in the sunglasses reflection.

Small hatching ▶
The candle flame exudes a flickering, soft aura of light around its centre and the rising smoke above. Small hatching is perfect for this since it has movement, yet at the same time subtlety, and delivers a fluctuating overall background with good tonal range. It is most important that you initially leave the white areas with no lines. Extraneous marks can ruin the lighting effect.

Dip pen and gouache ▶

To capture the bright *joie de vivre* of the Parisian café, use a dip pen sensitively and confidently, keeping your pen lines as crisp and direct as possible. Only put necessary detail into the picture to maintain focus. Ink the hat and waistcoat as solid elements, shade the background with stippling and add bands of blue and red gouache for the French tricolour flag. Allow your eye to gaze over the whole composition when you've finished to check that the lines all have enough weight. If any seem overshadowed, reinforce them carefully.

Fake engraving ▲

This simulated engraving or woodcut effect uses a combination of pen line weights. The key is to give equal weight to whites, hatched 'greys' and solid blacks. Spot colour is added to the banana skin to highlight its danger. Try various widths of grain-heavier line weights, or light lines placed close together. Find other wood engraving examples in books and catalogues and study the reproduced line carefully before emulating the style.

Heavier blended marks ▼

Filling larger areas of tone can be undertaken with a blend of heavier techniques. Smudging charcoal initially removes the whiteness of the paper, then a rag with drying ink can be rubbed over the dark, background areas. Brush and ink redefine the main detailed areas.

Scratching and blobbing ▶

Using a dip pen, scratching an outline directly determines the way forward. The spin of the hair is delivered with a fully loaded pen and a continual upward spiralling of hand. The eye blobs are added with a brush and larger blobs dropped in the spaces around, blown from the centre outwards through a straw.

Tip: Experimentation can significantly aid your progress and help you to establish a valuable repertoire of drawing marks with a variety of wet and dry media. Once you have explored a handful of different techniques, set yourself a simple cartoon challenge in order to exploit these newly developed skills.

Tonal control

The most forthright cartoons are those in which the contrast between black and white is stark, lending them enormous power and dynamism. Strong contrast and the variation of composition using black, white and some halftone (usually line-based) is essential in cartoon strips and graphic novels.

Lighting plays a key part in the process of balancing a black-and-white composition. A basic knowledge of how to display directional lighting in drawing is therefore a very useful skill to acquire at an early stage.

Start by looking around you. Observe the direction of light falling on objects and the shadows they cast. A strongly lit day will produce near-black, solid shadows, while a hazy, muted light will cause them to extend softly. The complex surface and

form of an object, or a character, can be simplified by using the fall of light and the resulting shadows to describe it. If you want to create a darkly humorous atmosphere or a heightened mood, you can do no worse than to borrow a technique from the great master artists of the Renaissance. Technically known as *chiaroscuro*, this manipulation of light and dark areas adds depth and can totally transform the mood of an image. If it worked for Caravaggio, then it can work for you!

The only way to learn how to use black and white in an effective way is to practise with simple compositions and move on to more complex themes as your understanding and skills develop. Time taken to master tonal scales all depends on practice: remember that cartoonists draw every day.

Lighting spheres

The same sphere, with lighting falling on it from the right-hand side of the composition, can look very different depending on the treatment of the background and fall of the shadow. Because the horizon line is placed directly behind the spheres, each one appears to be resting. Where a grey tint

forms the complete background, the sphere becomes the major focus and gains natural prominence. This is then exaggerated with the inclusion of a base shadow. The partial blacking out of the background succeeds in balancing the composition, allowing the eye to 'read' the drawing more evenly.

Spherical swatches ▼
Use cross-hatch, stipple and opaque white hatched highlights to experiment with the compositional balance of black and white. Note the effectiveness of the halo around the rim in the bottom row of spheres, caused by light reflecting upwards from the white base.

Cross-hatch on grey

Cross-hatch on black and white

Cross-hatch on white and black

Cross-hatch on white

Cross-hatch highlights in white on grey

Cross-hatch highlights in white with black and white

Cross-hatch highlights in white with white and black

Cross-hatch highlights in white on white

Stipple on grey

Stipple on black and white

Stipple on white and black

Stipple on white

Simple drama

The cartoon spider's strong silhouette form is perfect for demonstrating lighting and shadows. The four identical black spiders reveal how a light source shining from a different direction can alter the mood of the scene and create a dramatic effect. Darkness entering from above creates oppression, while from beneath it underlines the importance of the spider as the main character. From the side there is the anticipation that something may be about to occur from the unknown dark spaces to the right, encouraging the imagination to conjur a dramatic mood.

Overall lighting ▲
The spider hangs from its thread. The overall lighting has no prominent direction and sets a stark contrast as a flat, graphic image.

Lit from above ▲
The light source is at a level with the top of the spider. The stippled fade offers the picture a top and the base is provided by the shadow.

Lit from below ▲
Just below the spider and tilted upwards and back, the light produces a shadow that melts into the stipple, providing a stagey entrance for the spider.

Lit from the left ▲
This composition carries a sense of discovery, as if a torch has just encountered the eight-legged fiend. Even tonal stippling sets a mood.

Practice exercise: Opposing black and white

This uncomplicated scene exemplifies what you have discovered about using black and white in a composition. The torch is a common device because its beam leads the reader's eye into the next frame and a new focus in the narrative.

Once you have planned where your blacks and whites will go, define them clearly using solid, even fineliner pen lines and shapes. If you are unsure, mark them out first in pencil, but try not to become too reliant on the security of a pre-pencil mark.

Materials
- *cartridge paper*
- *pencil*
- *1mm fineliner pen*
- *black Indian ink*
- *No. 3 round brush*

1 Sketch the basic outlines of character and setting in pencil. Use a fineliner pen to go over for crisp, unfaltering lines.

2 Steadily define clear outline shapes that you will paint in black using Indian ink and a brush.

3 Paint the outline shapes. Lessen the pressure on the brush where the lines disperse the light into jaggedness.

Colour overlays

Colour can be applied to cartoons using a variety of methods and media. Here are some of the most popular choices on offer.

Watercolour paints are available in a vast array of colours either as moist cakes (pans) or in tubes. They are water-soluble and contain a gummy binder, which gives them body. A box of 12 artist-quality watercolours that includes the primary colours (red, yellow and blue) is a good choice.

Dyes and inks are fine, translucent liquid colours that stain the paper. Inks are waterproof and cannot be removed once dry. They are available in strong colours, making them ideal for printing, but exposure to strong natural light will fade them. Dyes are a concentrated strain of ink, extracted from plants or minerals or chemically created. Their brightness of colour means that they are not particularly lightfast and should be avoided for any work where there is an expectation of permanence.

Gouache and poster paints contain chalk, which makes them very opaque, although they can be thinned in water to produce watercolour effects. They are excellent for laying down areas of flat colour, which dry without streakiness.

Acrylic paints deliver a highly versatile catalogue of marks, from thick to thin. These plastic-based paints can be thinned in water and are particularly useful for creating highlights.

Pastels offer smooth blending or solid colour used dry. They mix well with other media, wet and dry, and add texture.

Marker and felt-tip pens are available in two different types: water- or spirit-based (permanent) and in a variety of nib sizes.

Your colour kit

Initially, it is not advisable to go out and buy every colour medium you have ever heard of. Much is of a highly specialized nature and within a genre of materials there is often a large range on offer, from student quality to artist quality. If you know what sort of effect you are aiming to produce and have followed advice from this or another text, then you should begin researching. Test products in the shop where possible, and only buy what you need and can afford. As a general guide, the most expensive is the best, but if you are simply tinting a small area of a cartoon, the middle range will be fine.

Basic colour materials ▼
For the basic kit: buy some watercolour paints either as pans or in tubes, fluid inks in primary colours, small tubes of acrylic paint, including blue, red, yellow and green, gouache tubes in similar colours, plus white as a mixer, and a mixing palette for creating the right hues.

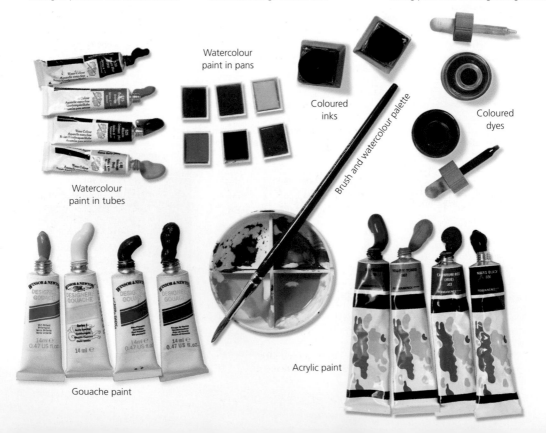

Watercolour paint in pans

Coloured inks

Coloured dyes

Brush and watercolour palette

Watercolour paint in tubes

Gouache paint

Acrylic paint

Dry painting media ▶
Pastels can be made of chalk or oil, and they are available in colours as well as in black and white. There is a huge range of felt-tip pens on the market; the densities and colours of their pigments often vary greatly, but they are certainly convenient.

Oil pastels

Chalk pastels

Water-based felt-tip pens

Spirit-based felt-tip pens

Overlaying watercolour

A strong line cartoon often requires overlaying with a simple wash of colour. If you are using more than one colour in this way, always allow the first colour to overlap the next so that they blend, and make sure that this is done before the colour washes have dried.

Tip: If you lay a wet colour on top of another wet colour, they will merge. Allowing the first colour to dry before applying the second will produce a new combination of the two hues.

Watercolour swatches ▼
Explore colour blends by making experimental swatches. Be sure to test watercolour markers as well as paints and inks, using pressure to control the colour flow; certain pigments will not cover the paper as easily or as smoothly.

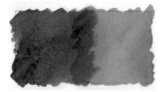

Watercolour, wet into wet blend

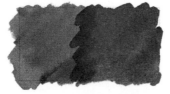

Watercolour, wet on damp; soft edge

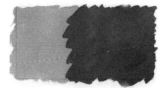

Watercolour, dry on dry; hard edge

Dyes, vivid, permanent colours

Dyes, strong, hard-edged overlaps

Dyes, dry on dry; hard edge

Watercolour markers, controlled, softer blends

Watercolour markers, blended after drying

Watercolour markers, blending strong colours

Practice exercise: Wet-into-wet blending

Take time to explore the effectiveness of wet-into-wet watercolour techniques on a drawing and compare the effects of the different media. Use a round brush to lay fluid trails of colour on each drawing and, while the colour is still wet, move the colour to the edges of the paper with the brush.

All three peacocks are drawn on to smooth cartridge paper with a black dip pen. The watercolour bleeds well, unlike the markers, which have greater vibrancy. The dyes are the most vivid of all and react well to the technique.

Materials
- cartridge paper
- dip pen
- waterproof Indian ink
- No. 6 round brush
- watercolour paints
- watercolour dyes
- watercolour felt-tip pens

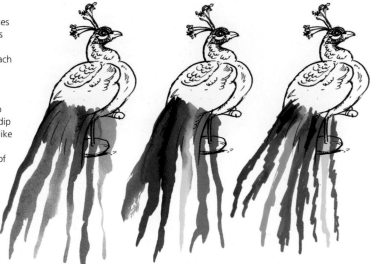

Watercolour paints Watercolour dyes Watercolour felt-tip pens

Smooth and rough surface effects

Different surfaces produce a variety of results, affecting the appearance of your drawings. A rough watercolour paper allows only some paint to rest in its surface hollows, which can cause a mottled effect. In contrast, a smooth paper will give greater fluidity and transparency of colour. Concentrated dyes produce brilliant hues on paper, but cannot be blended once dry.

Rough versus smooth surfaces ▼
The watercolour paper allows the same soft blending for the various media. On smooth paper, there is a stained-glass effect where the hard edges overlap.

Watercolours on rough
watercolour paper

Dyes on rough watercolour paper

Watercolour markers on
rough watercolour paper

Watercolours on smooth paper

Dyes on smooth paper

Watercolour markers on smooth paper

Overlaying gouache and acrylic

The best method of understanding the properties of gouache and acrylic paints is to create colour swatches. Place colours beside and on top of each other. This way you can discover how the paint handles and see how the colours combine. The primary colours make the strongest combinations, while the secondary colours are less reactionary when placed alongside each other.

Colour combining ▼
Add the spot colour when the main colour patch has dried. Note that the lower row of swatches features both liquid and tube acrylic paint.

Red and yellow gouache

Brilliant and viridian green gouache

Ultramarine and cadmium orange gouache

Cadmium red and phthalo blue liquid acrylic

Ultramarine blue and cadmium red liquid acrylic

Cadmium orange and cadmium yellow tube acrylic

Practice exercise: Layering gouache

Building a gouache drawing in layers allows plenty of room to manoeuvre. You can choose to paint from dark to light if you wish, whereas with transparent watercolour the lighest tone must be established first. Here, as each new layer is added, the picture becomes darker and more opaque, giving it a strong sense of structure and solidity.

Materials
- *cartridge paper*
- *fineliner pen*
- *No. 2 and No. 4 round brushes*
- *watercolour paints*
- *gouache paints*

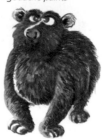

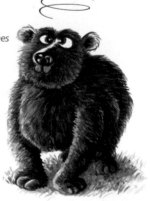

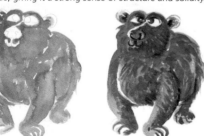

1 Paint a light, fluid bear with yellow ochre watercolour. Don't worry about the patchy look of this layer.

2 Use the same brush to paint on brown directional strokes in gouache. Add the facial features in a sepia tint.

3 Add another layer of individual fur strokes using a smaller brush and a deeper burnt umber colour.

4 Define the facial details and add fine highlights in yellow ochre gouache to the coat. Use the same layering techniques to create the grass base and sketch the wasp using a fineliner pen.

Overlaying colour with line

It is important to be able to gauge how a colour overlay will affect the visibility of drawn lines. The examples here show a range of colour depths over various weights of fineliner pen lines. You can easily see how darker tints can obscure the lines beneath. For your future reference, it is worth creating your own swatch library of pen and brush line overlaid by colour. A small brush 'dip' of water should dilute your colour by ten per cent each time.

Line and colour overlays ▼
These pen lines were drawn using 0.25mm, 0.5mm, 0.75mm, 1mm, 1.5mm and 2mm pens. The colour overlay is ultramarine blue gouache in percentage tints of 10–100 per cent.

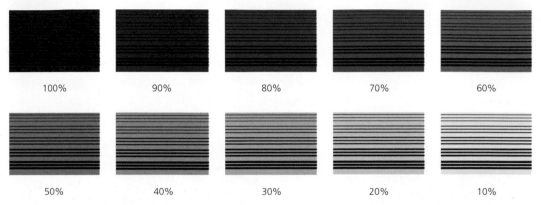

| 100% | 90% | 80% | 70% | 60% |

| 50% | 40% | 30% | 20% | 10% |

Practice exercise: Using a simple palette

This cartoon demonstrates colour harmony over a single line. It uses just two hues – blue and red. Reducing the required palette allows you to focus more closely on the relationship between structural line work and simple tonal variations of colour wash. Using too many colours or those that are over-heavy will suppress the line.

Materials
• *cartridge paper*
• *pencil*
• *0.1mm waterproof fineliner pen*
• *No. 4 round brush*
• *coloured inks*

1 Use a soft pencil to plan your composition, sketching the basic outlines of character and setting.

2 Take your time to draw over your initial pencil sketch with a waterproof ink fineliner pen, using strong, even lines.

3 Lay a pale, diluted wash of blue over the background sky. Colour the hat, chaps and landscape in pale red. Next, add a stronger wash of blue to the horse, waistcoat, sideburns and cuffs. Use a little yellow ochre and red mixed for the face. Finally, add some opaque white highlights to the horse and rider, as well as cloud details to the sky.

Collage backgrounds

All kinds of coloured and textured paper and card can be used for ready-made backgrounds. Gather together samples or offcuts and look for harmonious or contrasting combinations. Try to be imaginative in your choice of materials and consider surface pattern as well as colour and texture. An unusual backdrop is capable of adding a new, surprising dimension to your artwork.

Gathering papers ▼
Collect paper samples that might be handy as backgrounds or textures for your drawings. Label your finds for future reference.

Handmade textured papers

Sugar paper and brown parcel paper

Matt-surfaced papers

Foils and black handmade paper

Wide and narrow corrugated card

Ruled papers: old office document and filing card

Opaque media

The light, delicate touch does not work for every cartoon subject. Political subjects or images designed to pack a punch require media with just as much impact. The opaque colours of gouache or acrylic paints, dense inks, cut paper or a combination of these is ideal. Their ability to produce flat, uniform colour over large areas makes them perfect for backgrounds and for producing works of graphic simplicity.

Graffiti wall ▼
The brick wall is painted in liquid acrylic and the graffiti lettering overpainted using tube acrylic. The ink line drawing of the aerosol is tinted in a red watercolour wash, and then made more opaque with a combination of red and yellow ink washes. The sky is a torn piece of blue sugar paper defined with a white gouache cloud.

Collage ▶
This War Of The Worlds artwork practises collage elements. The alien is drawn with a dip pen and coloured papers provide the gun's ray and background. The frayed edge of paper contrasts against the cut edge of the ray. With a layer of gouache on top, the drawing develops a simple, yet effective finish.

Colour washes

Achieving a perfect colour wash takes practice. You can lay one-, two- and three-colour washes on smooth- or hard-pressed papers, or on rougher watercolour paper textures. Washes are an essential skill for the cartoonist to learn because they can provide a wide, blanket background on which the characters and settings can be placed. It is a great device for simple cartoons too.

Comparing wash swatches ▼
Note how banding occurs on the harder, hot-pressed smooth papers, and granulation (the grittiness of pigment resting) on the rough watercolour sheets.

Orange and yellow mix on smooth

Red and yellow mix on smooth

Red and blue mix on smooth

Orange and yellow mix on rough

Red and yellow mix on rough

Red and blue mix on rough

Practice exercise: Colour harmonies

Colour combinations are crucial in visual storytelling. Warm colours can denote danger or importance. Cool colours can slow the pace or support the focal characters. Spot colour is the use of a specific colour to focus attention. A spot colour in the same colour range as the background blends harmoniously. Spot colour works best when there are only a couple of contrasting colours used.

Materials
- *'Not' watercolour paper and pencil*
- *dip pen and black Indian waterproof ink*
- *watercolour paints or dyes*
- *No. 12 broad brush*

1 Outline your sketch in pencil and draw over it using the dip pen and black waterproof ink.

2 Turn the drawing upside down and paint a yellow watercolour or dye wash from top to bottom.

3 When dry, select harmonious colours for the details: dark yellow bananas and reddish-brown monkey.

Contrasting spot colour

Where you need focus on a main part of an activity within a cartoon, colour can be successfully used to direct the viewer's attention. The most effective approach is to use limited colour in most of the frame, ideally monochrome tones. Then take a contrasting colour – for example red is in powerful opposition to blue – and paint your significant subject with just a little of the contrasting hue. The result will be to strongly shift the emphasis to this distinctive area of 'spot' colour.

Cool against warm colours ▼
In this three-part animated explosion sequence, cool blue and warm red and yellow colours are used in a limited way to express the drama. The contrast between tints produces intensity.

Overlaying ink washes

Inks create new hues where colours overlap. Outline a frog using a pen nib and Indian ink, colour it in yellow ink, leaving the eyes white. Leave to dry and overlay with a red ink wash; the frog will change to warm red. Repeat the exercise, overlaying green and blue on yellow. Now start with a red frog and add yellow, then green and finally blue.

The frog will change from red to brown to deep purple. Note that the ink allows the black line to show through. When using ink as with watercolour, you can only lay a maximum of three washes on top of each other before the reflected light dulls and the colours turn muddy. Consider which hues you intend to use and make a rough paper tester swatch.

Extra drama

Two pale watercolour washes are dropped on to the loose pencil drawing, preserving the graphite tones. White gouache highlights enhance this dramatic, streetlamp-lit scene.

Yellow frog

Yellow frog with
red overlay

Yellow frog with
green overlay

Yellow frog with
blue overlay

> **Tip:** Think of simple cartoon subjects and narratives where overlays of ink wash can help to set the scene and produce a leading focus for the main element, as in the example of the cannon and explosion above. When drawn, use just two washes to tint them and evaluate their success.

Mixed media

Unconventional combinations can be eye-catching. Media such as paint, ink and collage have their own unique properties and combining them in a cartoon can be highly effective.

It is not always necessary to draw everything in a composition and using a real object increases the impact. For example, when photos are collaged, an intriguing collision of real and unreal worlds occurs. Collaging allows you to rearrange your composition until it is right. This highly hands-on approach is

excellent for learning how to place elements successfully in a composition. When using PVA (white) glue, try not to let it drip or smear on the paper, since it will invariably leave a shiny patch that can look messy. Collage methods demand an orderly mind, which in turn requires a methodical workspace.

Make sure that you store any overmatter, collage papers and found ephemera in a small box in case the need arises to create a cut-paper cartoon.

Practice exercise: Composite collage

Envelopes, sticky tape, bubble wrap and wrapping paper all have their uses. Closer scrutiny of your 'rubbish' will reveal an inspiring source of colour and texture combinations for new creations.

Materials
- *brown wrapping paper*
- *scissors and PVA (white) glue*
- *paperclip*
- *red felt scrap*
- *thin white card*
- *1mm fineliner pen*
- *magazine photos*
- *card scraps*

1 Cut out an office worker from brown wrapping paper. Glue on a red felt tie and a paperclip for a nose. Lightly glue the figure on to the thin white card.

2 Pen in the facial features and ears. Cut and glue the red felt carpet in place. Crudely cut out and glue on the filing cabinet photos. Glue on the card scraps for the files.

Combining domestic materials

Before discarding household materials, consider whether they might have a use as a part of a collaged cartoon. Some packaging matter looks like something else that we recognize in the world about us. A link between material and subject can be formed, such as bubble wrap and the suckers on an octopus's tentacles. Where you can make these connections, utilize them in your images.

Bubble wrap ▼
Draw the shape of the tentacles with a coloured felt-tip pen directly on to the bubble wrap, then photocopy and stick down the flat representation.

Fabric ▶
Collage items used sparingly can add great impact to a drawing. The key focus of this composition is a cut-out section of an old leather glove. The stitching adds a convincing touch of realism to the punchball.

Tip: As well as using familiar objects in relative size to your subject, see if you can use unintentional, found shapes and materials to bring new, fresh interpretations to your subjects.

Practice exercise: Simple collage

Drawing every single item in a cartoon is sometimes unnecessary and can make a composition appear stilted. Virtually any 2- or 3-D material can be scanned and reproduced; the name of the game is experimentation. The interest in a book or graphic novel can be hugely

increased with the surprise element of unorthodox materials incorporated into single pages, double-page spreads and cartoon sequences. Children's books are a great example of this creative approach and allow the author freedom to think directly on to emerging designs.

Materials
- *smooth coated paper*
- *pencil and 0.3mm fineliner pen*
- *No. 3 round brush*
- *watercolour paints*
- *fern leaf*
- *PVA (white) glue*

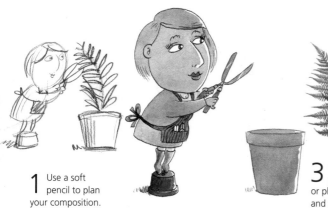

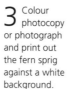

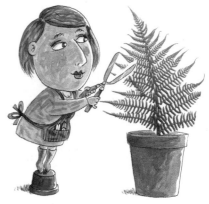

1 Use a soft pencil to plan your composition. Outline your final drawing with a fineliner pen.

2 Colour with light washes of red, green and yellow ochre. Leave a clear space for the fern.

3 Colour photocopy or photograph and print out the fern sprig against a white background.

4 Cut carefully around it and glue it into position. Darken areas of the gardener and pot to add tone.

Further combinations

Mixed-media combinations have become very popular in the age of digital technology, and with the reproduction revolution, virtually anything can now be photographed or scanned and combined with traditional hand-drawing skills.

Trying out contrasting materials and media can be a great deal of fun and provide sparky solutions for drawn gags. Altering the natural sizes of objects that you have scanned can often lead them into a transformative stage. Suddenly they resemble other things, often by colour, shape or textural association.

Spaceman ◀
Black sparkling paper is drawn upon with blue oil pastel and smudged with turpentine. A line and wash combination spaceman is created on smooth Bristol board, cut out and glued to a photocopied pebble. A spattering of white acrylic paint denotes stars. Add other moons, craft and planets to this spacescape to play with aspects of scale.

Scarecrow ▶
A photocopy of a bird's nest is pasted on to a scarecrow body, drawn with charcoal and coloured in with smudged oil pastel. Cut-out pictures of potatoes, onion and broad beans serve as the features: their crude cutting reinforces the roughly constructed nature of the scarecrow.

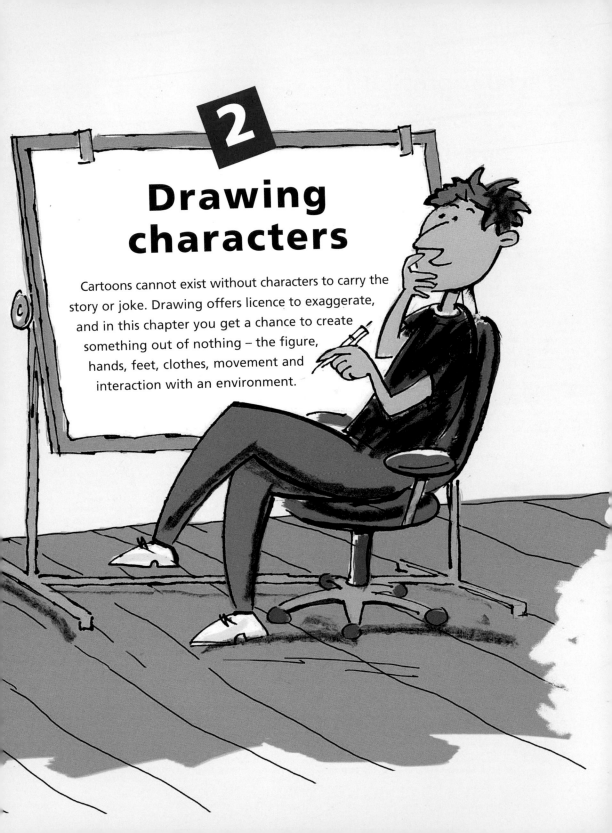

2

Drawing characters

Cartoons cannot exist without characters to carry the story or joke. Drawing offers licence to exaggerate, and in this chapter you get a chance to create something out of nothing – the figure, hands, feet, clothes, movement and interaction with an environment.

Facial expressions

Who could imagine a world devoid of expression? No smiles, smirks or looks of surprise; no frowns, screams or laughter – it would be enough to make you cry! Expression is an essential means of human communication and the most crucial feature that a cartoonist must capture. From happiness to fear, the art is to express every emotion in a few simple lines. Mastering this is the really fun part and it will enable you to convey storylines efficiently and effectively.

Before creating a range of expressions for a certain character, it is important to understand the rules for establishing the main frame: the size and shape of the head and the distinguishing features. The key to getting a character right will lie in your ability to reproduce a basic template and then position the major facial elements correctly so that the expression springs to life through the sum of its parts. The techniques on these pages will help you to establish and develop facial expressions and to move on from basic ovoid (egg) face shapes to more characterful square, circular and triangular forms.

One great thing about cartooning lies in the simplification of detail, especially where facial expressions are concerned. While an accurate portrait requires deep and detailed understanding of the muscular structure and form to bring about a convincing result, the opposite is true of a cartoon. At its simplest, lines and dots do the job, but there is a whole tradition of different eye, nose and mouth shapes to choose from, and as you have a try, you are bound to develop personal interpretations too.

The egg template

A perfect starting point for practising basic expressions is the egg template. It is quick and easy to sketch and uses limited media. To start, lightly sketch an ovoid (egg) shape in a single flowing sweep with an HB pencil. Next, fill the shape with a flesh tint watercolour wash. When it is dry, quickly draw the expression using simple strokes and dots. Light symmetry lines added to the blank shape will help you to fix the position of the eyes, nose and mouth. Don't be afraid to have a go: if a sketch doesn't work, you can simply try again. In an eggshell, that's it!

Blank ▲
Dot two eyes an equal distance apart, then add a central vertical nose line and an expressionless, straight horizontal mouth.

Smile ▲
By simply curving the horizontal mouth line, you will change the expression completely from blank look to brightly smiling.

Contented laugh ▲
Below arching eyebrows, stretch the eyes into slits downturned at a shallower angle. Create a crescent smile from the cheeks.

Looking askance ▲
The eyes are wide, defined by pupil dots glancing sideways from larger eye shapes. One raised eyebrow is offset by a lopsided smile.

Concern ▲
First, raise the eyebrows high to the top of the ovoid, then dot in the eyes. Draw the vertical nose line and the elastic open-mouth circle.

Fed up ▲
Tilt the curve of the mouth down and across the face to capture this mood. Increasing the pressure on the eye dots intensifies the stare.

Anger ▲
Inverted brows slope down sharply and the eye dots are close together. An arching mouth stroke intersects the lip and bares the teeth.

Perplexed ▲
Mark the short eyebrow strokes, eye dots, vertical nose and wavy mouth. The brackets enclosing the eyes set the expression.

Modelling form with expression

Cartoon characters rarely hold the full-face pose for long. They constantly twist, turn and move within the frame. Head movements can be as important in conveying moods as facial expressions, so learning to build a head as a 3-D structure is vital. Use light symmetry lines to help maintain a visual balance in the features. Bear in mind that symmetry here means reflection. If you were to draw a line through a shape to represent a mirror, the shape could be folded along that line and each side would be a reflection of the other. Establish your repertoire of expressive marks, take the time to understand the rules of symmetry and the rest should follow. A vital clue: always have in mind that the ovoid is solid.

Exhausted ▲
Tilt the head downwards. Accentuate the arch of the eyebrows and stroke the upper eyelids parallel to them. Pull the mouth to one side and flop out the tongue.

Laughing ▲
The head tilts upwards. Deft strokes locate the raised eyebrows. Closed eyes, uptilted nose and beaming crescent mouth stretched across the face say it all.

Frightened ▲
Fear is held in the eyes: large ovoid whites with diminished pupils create a rigid stare. The head is set straight ahead, while the elastic mouth exposes rows of teeth.

Mischievous ▲
Keep the eye shapes open and control the expression by offsetting the line of the mouth and by deviating the eyebrow on this side of the face sharply downwards.

Practice exercise: Inking the egg

With the basics firmly in place, start to explore the idea of the egg template using combinations of media beyond the pencil. The template sketch will quickly disappear beneath washes of black Indian ink, flat layers of gouache and added tones of dry mark-makers, such as charcoal or pastel. The egg tapers at the top, allowing for the evolution of natural comedy: features become pinched and elongated into a limited space.

Materials
- *cartridge paper*
- *fineliner pen*
- *dip pen*
- *black Indian ink*
- *No. 3 round brush*
- *gouache paints*

 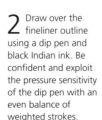 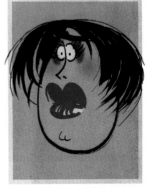

1 Sketch the shape of the egg with a fineliner pen. Add the broad, over-arching hairstyle, surprised eyes, small delicate nose and big luscious lips. Adjust any elements that you are unhappy with.

2 Draw over the fineliner outline using a dip pen and black Indian ink. Be confident and exploit the pressure sensitivity of the dip pen with an even balance of weighted strokes.

3 Make a copy of the drawing using a small, round brush to make all the strokes, then flatly ink in the most prominent features of hair and lips. Do not be tempted to overdo the ink.

Adding colour ▲
A colour version uses flat layers of gouache. First, paint the background lilac, then use yellow ochre and red for the flesh tone, red for the lips and finally add the black ink line.

Shaping the face

A more stylistic approach to expression can be achieved by constructing basic geometric shapes with the existing egg template. Where your subject has a specific expression aided by particular physical features, for example a square jaw or an elongated face, start with the shape that will best represent the expression. Historically, this method has served as a popular standard for many strip and animated cartoons since it creates a successful template from which characters can be formed in a recognizable style.

The logic of manipulating basic shapes through three dimensions simplifies the complexities of human or animal forms. The structure of skull and jawbone, cheeks and neck can be developed creatively from the configuration of square, triangle, oval and cube.

Once the head frame has been formed, the details can be sketched in to add life and personality. When you have mastered the head, extend the same process to the body and limbs by changing the scale and angle of the shapes.

Circle and oval ▶
This haughty-faced lady's expression is enhanced by the overlap of a small circle on to a larger oval. The character's details are added once the basics have been established.

Circle on oval: condensed ▶
Positioning a circle on top of the oval extends the head height, allowing more to be made of the forehead expression.

Square and triangle ▶
The triangle jutting from the square profile indicates from the outset that the jaw is strong and over-shot. This frame was often used in cartoons such as Hanna-Barbera's *The Flintstones*.

Oval and square ▶
The oval protruding from the square enables the thick-set neck to be drawn. This is the major characteristic of this particular composition.

Practice exercise: Triangular head

Create a cartoon using the shape method described above. First, locate the main features, adjusting their position until correct. Next, focus on the style and placement of the details to create the desired expression. When you are happy with your pencil sketch, develop the image further by adding gouache, pen, crayons and charcoal.

Materials
• *cartridge paper*
• *pencil and dip pen*
• *black Indian ink*
• *gouache paints*
• *wax crayons*
• *charcoal*

1 Lightly sketch a triangle, tilted so that one corner juts upwards to form the mouth and chin. Deftly mark the pencil strokes – the eyes, nose and mouth – within the triangle, as shown.

2 Relax the straight edges so that they take on the rounder surfaces of the face. Form the caricatured features, adjusting as necessary and using the locator strokes as position guides.

3 Redraw the sketch using a dip pen and ink. Apply yellow ochre and red gouache for the flesh tint to the face, pale blue to the background and burnt sienna to the hair. Add tone and texture with wax crayons and stubble with crumbled charcoal.

Developing facial character

The principle of structural templates recurs constantly in the cartooning world and the development of stylistic drawing marks often evolves from these underlying forms. For example, features that pinch around the region of the forehead are an indication of an underlying egg template and basic geometric shapes usually provide the framework for a strong, square jawline. When you have become proficient at using these guides to produce faces, try varying the structures with inventive combinations and matching certain types of character to them.

Keep experimenting: if you are able to maintain a sense of inquisitiveness, this will drive forward the evolution of your own unique cartoon and caricature style.

Tip: Cut out faces from magazines and study the features closely to determine character traits, then use these references to build their structural templates. Document these experiments in your sketchbook, and be sure to stick the cut-out magazine pictures next to your drawings.

Dip-pen detailing ▲
Controlling the dip pen is crucial when detailing facial expressions. Keep your lines and hatching simple and let them follow the form of the face with direct strokes of the nib. It is easy to build too much hatching that describes nothing clearly. Use short strokes for wrinkles and blemishes.

Edited line with brush ▲
Sketch characters directly using the tip of a small, round No. 3 brush in order to enhance their quirkiness and offer a greater sense of animation. This 'scratchy' style allows you to deliver slightly less finished brushstrokes. Despite their sparse nature, such cartoons carry an endearing quality and their erratic heavier lines display a comical madness and eccentricity.

Brush-line simplification ▲
The simple sweeps of a dry, Indian ink-loaded brush can produce charming drawings that say a great deal in a few strokes. It is possible to become prolific quickly using this technique, but getting it right takes practice; take time to think carefully before making any marks.

Developing characterization

By combining shapes, textures, line and colour, you can assume the limitless role of the creator of a cartoon population with as many different characters as there are in the real world. The faces below amply demonstrate that varying the combination of materials and marks you use is important: it keeps your cartoon characters lively and fresh, and prevents them from sinking into ordinariness. Cartooning as a genre must keep moving forwards; good cartoonists always leave their options open and never say never to new approaches.

Tip: Occasionally, work energetically and without planning. Free drawing is a good exercise to unlock creativity and release your imagination. This scribble man sprang up from an initial doodle of three squares in a row (the teeth).

Pen line and scribble

Pen direct line

Pencil line

Pen broken line

Pencil line and splatter

Pencil line with scraped ink
(dragged cardboard)

Pen line with added charcoal

Pen cross-hatch

Pen broken line

Brush ink line and
pen dot stipple

Ink line with heavier brush

Pen cross-hatch,
line and splatter

Doodling the line ▲
The doodling pen or pencil moves quickly over the paper surface and rarely returns to the same place. One hit of the line is enough to communicate the mood of the character with economy.

Adding texture ▲
Texture in selected areas can bring a drawing to life. Try an unusual technique, such as scraping cardboard through ink to produce a stranded effect, or build tones with line and stipple.

Stylizing ▲
The complexity of definite shapes or textures can be reduced to simplified patterns. The hairstyle is drawn as 'bubbles' of ink and charcoal, and then joined as a maze of varied lines.

Vigorous line ▲
The active expression of anger requires vigorous attention. The broken line of the dip pen can lead to selective hatching, lending angry 'colour', or the furious spatter of the nib.

Practice exercises: Reducing the template

Templating is an important method of character construction. A solid block is enough for some facial types, whereas others need an amalgamation of shapes to form strong, structural characteristics. The principles of template construction can also work in reverse: instead of adding new shapes, you can remove from the larger ones to create interesting faces. Having a template to work from is useful when you need to create a whole family of similar or related subjects. Once familiar, the lines of construction can easily be dropped.

Materials
- *HB or pale blue pencil*
- *dip pen*
- *black Indian waterproof ink*
- *chalk pastels*
- *No. 4 round brush*
- *watercolour paints*

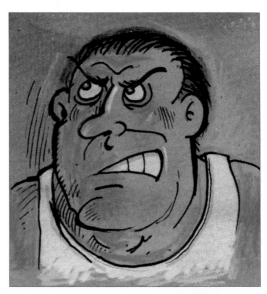

1 The key shape here is the solid oblong that forms a square jaw and flat profile. Sketch this using an HB or a pale blue pencil.

2 Sketch the final outline in pencil and draw over it in pen and ink. When dry, fill the background with an ochre tone of chalk pastel. Add red to the face, blue to the hair and white to the vest. Refine the face by rounding the features and hatch in some tone.

1 The key shape in this case includes a double-ended arrow. It is a guide to positioning the facial features; a reminder of the long drop of the face from a sharp, slanting brow.

2 The expression widening from pointed brow line to puzzled mouth shape follows the pattern and movement of the double-ended arrow. A watercolour flesh tone mixed from yellow ochre and red fills the face and the features are detailed in pen and ink.

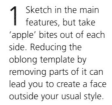

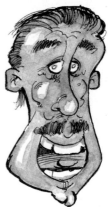

1 Sketch in the main features, but take 'apple' bites out of each side. Reducing the oblong template by removing parts of it can lead you to create a face outside your usual style.

2 Use the initial pencil marks as a template to help you complete the slender-faced gent. Solidify the outline using dip pen and black Indian ink along with pale washes of yellow, ochre and red watercolour. Leave areas of white paper as highlights.

Character faces

There are countless different ways to draw a face, but very few that are appropriate for a particular purpose. For example, a simple approach using uncomplicated shapes, dots and lines for facial features and bold, flat colours instead of tonal gradations would suit a children's picture strip. The 15 character studies shown on these pages employ a variety of techniques and require a range of skill levels to draw them.

They represent all the issues of mood, expression, stereotype and suitability for the various cartoon genres. Setting small targets of achievement in the form of fun projects is a great way of gauging how you are progressing. Testing your knowledge and abilities will also highlight any techniques that need further practice. Where better to start your learning than in a sketchbook, copying the faces of friends and family.

Fifteen face styles

Be open to the range of techniques you have practised so far and consider each face you draw in its own context. Ask yourself who it is aimed at and what information it must convey. Think carefully about how you can communicate these points effectively in terms of facial structure and surface colour, decoration or technique. For reference and inspiration, check out cartoon styles from the many comics, graphic novels and animations that exist in the public domain. A specialist comic shop is a good primary source and the Internet may offer other resources.

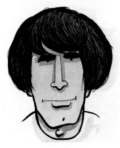

Retro moptop ▲
Hairstyle and shape is important to this face, setting it in a definite time and so triggering other associations. Line and wash creates the 'big' hair in contrast to the limited line used elsewhere.

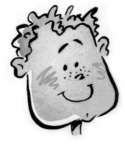

Lively and child-friendly ▲
Simple, clean images can dance from a brush or felt-tip pen, as this sketch shows. Felt-tip pens are associated with children; using them to add squiggles enhances the appeal.

Purple-rinse washes ▲
Old-fashioned spectacle frames, clip-on earrings, gaudy make-up and purple-rinsed hair set this stereotype. The small, pear-shaped head will complement a large, pear-shaped body.

Time-worn face ▲
Weathered, lived-in faces can be quite a challenge to draw. In this instance, media and technique have been used to good effect. The fine cross-hatching is given extra tonal weight with rougher, blotchy watercolour washes.

Exaggeration and simplicity ▲
The car mechanic, denoted only by his hat, is conspicuous for other reasons. The face is grossly over-exaggerated, placing him firmly in an unreal world. The line is broken, but the washes are very smooth on the watercolour paper.

Unshaven look ▲
A stubbly appearance is easily created using an old toothbrush dipped in ink. Once the line work is in place, mask out any areas that you do not want spattered and then gently flick the toothbrush hairs over the sketch.

Felt-tip head ▲
Easy-to-use felt-tip pens offer a good ink flow, and although their line is not as variable as other ink media, such a limitation often forces greater economy of thought and delivery. Simple strokes build up a simple face.

Character interactions ▲
More than one character encourages an unfussy scene. Reducing the colour can unite the elements in a composition. The dip-pen line is accompanied by pale browns and flesh-tone colours, and the red collar matches the red lips.

Loose-brush head ▲
Keeping the line loose and free will help keep a cartoon moving. This technique is especially good where a strip needs to be animated and lively. The squiggly pen-doodled hair is an effective way of adding tone.

Detailed, but child-friendly ▲
Extra detail can still be kept clean, sharp and to the point. The strokes indicating the direction of the hair, the freckle dots and the symmetrical features sum up the face in economical terms.

Simple man ▲
One consistent line chugging across the page delivers broad curves. Two dots and the pressure-led softness of crayon complete what has to be the simplest way of creating a lovable character.

Charcoal and smudge face ▲
The fullness is achieved by using smudged charcoal to create the soft, fleshy form. Leaving the face white and blending tone only into the corners and around the edge accentuates this.

Graphic novel ▲
Once it is mastered, brush drawing breeds confidence and quickens drawing time. A medium brush with a fine tip delivers pressure-weighted strokes. Add soft washes to tint. This is a popular technique for graphic novels.

Continuous-line man ▲
Test your control by drawing the character with a continuous line that follows the contours of the profile. A fineliner pen will allow you to stop momentarily before changing direction. Use felt-tip to fill the shadows and hair.

Splattered red head ▲
The humour is in the hair. A shock of apparently uncontrolled splattered ink is the starting point for this simplistic depiction. The slight awkwardness adds to the charm and the crude pen line equally complements and contrasts.

Detailed faces

With a gamut of techniques at your disposal, detailing faces will put your abilities to the test and also provide excellent practice for your tonal rendering skills. The key to effective detailing is actually to draw on a bigger scale, allowing enough space to relax into the strokes and marks. The slick finish of a cartoon face often masks the difficulty of its execution. The end result is significantly affected by variations of paper, line markers and colour media, and it is worth experimenting with as wide a range as possible. Although cartoons are most commonly drawn on a relatively smooth surface, textured paper can add interest by interrupting the flow of the line or the wash. Adding a textured object can also serve to enhance the life of your creations and to move them away from the norms of stylistic cartooning.

Practice exercise: Indian ink and wash

For this sparkling character, keep the rendering clean and bright. Match his zinging personality by using a crisp, Indian-ink line, which can be filled with light, translucent washes of watercolour. Remember, freshness of application is key and avoid oversaturating the washes with colour that is too heavy. The retention of the highlighted areas maintains the three-dimensional facial structure and illuminates the fresh quality of this illustration.

Materials
- *rough watercolour paper*
- *dip pen*
- *black Indian ink*
- *watercolour paints*
- *No. 4 round brush*

1 Outline your sketch using a pressure-led ink line over the surface of the sheet of watercolour paper. Leave it to dry.

2 Add a first wash of diluted yellow ochre to the face, blue to the shirt and brown to the hair leaving white-paper areas as highlights.

3 Add the second wash of each tint, 'reserving' the white areas. Mix a little red with the skin tone for warmth. Blend it softly into the yellow ochre to avoid streaking in the paint.

Practice exercise: Exaggerating a feature

Once you are able to detail a face using regular proportions, consider exaggerating certain characteristics in order to elicit a humorous response. Knowing what to enlarge, stretch, pinch or squash is vital if recognition is not to be lost.

Materials
- *cartridge paper*
- *pencil and dip pen*
- *black Indian ink*
- *watercolour paints*
- *No. 4 round brush*

1 Draw initially in pencil on smooth paper to develop the character of the pirate. Establish detail on the face and hair, even at this early stage, to keep your intentions clear.

2 Draw over the pencil with dip pen, reinforcing your original marks. Individual strands of hair significantly increase the level of finish on this drawing, and they are easier to draw on this paper. Tint your pirate with soft washes of watercolour, which will not obliterate the crisp outline.

Tip: Get into the habit of exaggerating features: big noses, ears and chins increase the humour of a cartoon and are an ideal main focus.

Practice exercise: Animated line

Match a bubbly character with light, 'fizzy' lines. The stray locks are playful and add more energy to this lively individual. The 'jogging' line of the dip pen nib animates the face giving it spontaneity. Note how this is under control with no stray lines.

Materials
- *cartridge paper*
- *dip pen*
- *black Indian ink*
- *watercolour paints*
- *No. 2 large, soft brush*

1 Lightly sketch the face. Go over it in pen using a loose grip close to the nib to make the hair curls.

2 Drop a pallid red wash over the drawing. Float a pale blue wash on top. Reserve the white highlights.

3 Increase contrast and tonal depth with strokes of blue paint. Add bouncy brush curls to the inked ones.

Practice exercise: Cross-hatch

Cross-hatching is an essential technique that is ideal for the crisply modelled, 3-D face. The idea is to create levels of grey shading with parallel and crossing pen lines. Increasing the number of lines makes the tone blacker.

Materials
- *cartridge paper*
- *HB or pale blue pencil*
- *fineliner pen*

1 Sketch a sharp, regular outline. Widening the facial features will give you a broader 'canvas' so that you fully fill the drawing area.

2 Locate a central focus and create small sections of criss-cross pen lines. Work from dark to light and leave white highlights.

3 The mid-tones are the hardest to establish. Add these only when you have built up your darkest and lightest areas.

Practice exercise: Shadow and colour

A single light source can heighten the drama of a face. Shadows across one side will make it recede because they draw the eye into the background. Colour will vary the mood and counteract this, focusing the eye to the foreground.

Materials
- *cartridge paper*
- *No. 4 round brush*
- *black Indian ink*
- *watercolour paints*

1 Create the basic structure of the face using brush and ink and then fill in the shadow sections. Observe this from life, photographs or comics.

2 Mix yellow ochre and red for the flesh tint. Drop this evenly around the dry, inked line. It warms the character considerably and gives depth to your established modelling.

3 Stain two-thirds of the face yellow. Note how this hue adds suspense. The blue abutting the black shadow heightens the contrast intensely.

The figure

In a cartoon it is the figure that takes precedence. We notice the human character over everything else because it is the element that tends to carry the narrative. Even when an animal or bird is the main character, it is most likely to embody a mixture of features and move with human mannerisms. This is why it is so important to observe people as they engage in their everyday lives.

To draw cartoons well requires a good working knowledge of the human figure: how it is constructed and how it moves. It helps to look at the body as a set of geometric shapes, interlinked and jointed in strategic places, namely the elbows, knees, wrists and ankles. Accuracy is vital, so do not hesitate to redraw figures until they are proportionally correct. When you have mastered the body proportions and understood fully the way in which the anatomy connects, you will be able to distort your figures with ease.

Getting into the habit of keeping a sketchbook will allow you to record humorous incidents, interesting faces and character likenesses. Visit public spaces, such as parks, railway stations and busy shopping areas, and undertake rapid sketches to capture poses, action and speed. These are the essential ingredients for a convincing cartoon.

Aside from facial expression, a range of postures and body shapes gives clues to a figure's personality and feelings. Observing and recognizing these is very helpful when using exaggerated body language to communicate ideas.

Body proportions

The basic proportions of the human figure are measured by the ratio of the number of heads that fit the body. This is between six and seven heads for an adult, depending on gender, race and body type, and four to five-and-a-half heads for a child. The technical term for this rule is the 'canon of proportion' and its principles still underpin how the figure is perceived in Western art. There is no substitute for learning to draw accurate figures according to the canon, even though it is most likely that your sketches will have exaggerated features. Cartoon proportions may be as tall as ten heads or more for an elongated, gawky figure, or as short as four heads for a squat or rotund character. When you are out and about, see if you can, in an inconspicuous way, approximate the number of heads that go into the many body types that walk our streets. Other good sources are magazines, newspapers and retail clothing catalogues

Male proportions ▼
The average adult male is seven heads deep, and is first sketched as a simple connection of shapes: oval head, oblong body, square pelvis, stringy limbs and slightly enlarged hands and feet. The second sketch builds the male figure as an anatomically correct structure, shaped realistically around the neck, ribcage, hips, arms and legs. The final sketch is finished in line and wash.

Female proportions ▼
This average adult female is six heads deep, curvaceously shaped with lighter features than the male. The hands and feet are under-emphasized with narrower shoulders in relation to the head. The classic hourglass figure is built upon flexibly connected softer shapes. Familiarity with shape, and knowing where and how curves are formed, is key.

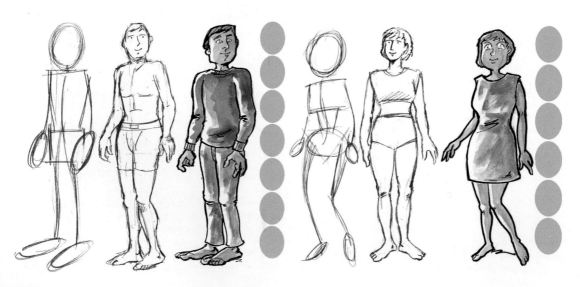

Tip: If you get an opportunity to sit in a life class, or arrange a model to sit for you, set up a strong light source with a definite direction so muscle formations are easily identified. Have a basic anatomy book to identify muscle groups and bones. Remember, a working knowledge of anatomy is useful but not a prerequisite for every cartoonist.

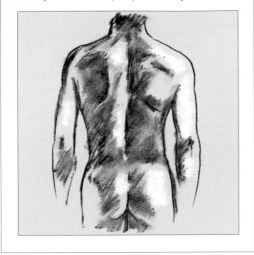

Character profile

Study characters in comics and graphic novels. Pay attention to unusual body positions where they are foreshortening, a position dynamically enhanced and pushing towards the reader. Copying can be a good start for cartoon figure drawing. Comic masters have put in lifetimes of hard work, so, at first, don't expect too much.

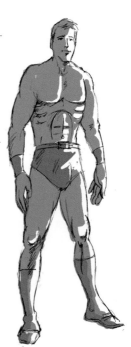

Superhero ▶
Standing at least eight-and-a-half heads deep, superheroes have heads that are are positively smaller, set into broad, muscular shoulders and a powerfully solid torso. The major muscle groups are exaggerated, especially the abdominals and the chest pectorals.

Child's proportions ▼
This teenage boy is five-and-a-half heads deep. He is constructed using the same guiding principles as the male figure, but with less-developed muscles. His head is larger in relation to the rest of his frame. The smaller children are, the larger their heads are in relation to their bodies. A common mistake is to broaden the shoulders too much and allow too much limb extension. Avoid strong defining marks on children. A line stroke is very pronounced and invariably ages the figure.

Tip: For practice drawing the human figure, consider joining a life-drawing class. Regular sessions will help to improve fundamental understanding of the human form and how it is represented. Where you may be unable to attend a class, drawing a relative or yourself in the mirror can be useful. Clothed figures are good to attempt, as garment folds gather and stretch over the human torso and limbs.

Toddler's proportions ▼
Four-and-a-half heads is the recognized 'canon' for a toddler. Expect the shapes to be much rounder and less defined than those of a teen or adult. Note how the skull is especially round with lowering, bulging cheeks and a high forehead. Begin, as drawing one shows, with three circular, equal segments.

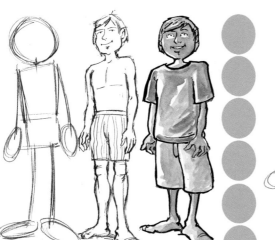

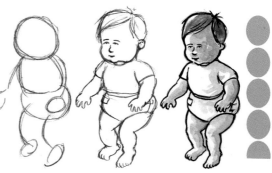

Body types

In reality, few people conform to the average 'ideal' figure. Human bodies are a range of shapes and sizes, and observing different types will help your cartoon representations. Specific age groups, for example, have their own characteristics, and the vitality of youth, middle-aged spread or the infirmities of old-age are diversities that the cartoonist cherishes and celebrates. Capturing the details is important, so it is a good idea to carry a sketchbook wherever you go, ready to jot down the various people types as you come across them.

Middle age ▶
The skin loses its elasticity in middle age and there is often an increase in fat around the stomach; the body is less angular and shapely. Note the man's slumped posture between shoulder and waist and the woman's wide hips.

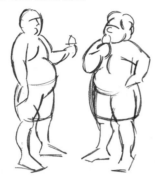

Tip: These are simple delineations of the figure achieved by visualizing the figure clothed. Stance – the angle at which hips tilt in the same direction, or even in opposition of the shoulders, the arch of the back and the turn 'in' or 'out' of the feet, are all important positions to remember as a cartoonist.

Youth ▼
Youths are often slender, because their skeletal and muscular development lack the strong body shapes recognized in adulthood. As a result, they are often reproduced with simple sleek, vertical lines and very few curves.

Young male ▼
The super-fit young male is strong and muscular. In the prime of life, he carries himself with a sturdy, upright stance. The muscle tone is well defined and slightly exaggerated.

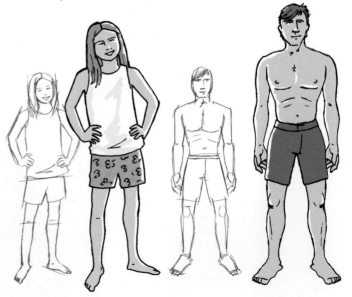

Old age ▼

An old person's body tends to decrease in size as muscle wastes and the frame starts to shrink. A stoop is common and often a stick or walking frame becomes a necessary accessory. There is little or no body tone and the overall demeanour is frail. Sketchbook studies made from life are useful to study elderly movement. The curve of the back is essential to determine agility through their limbs. Stooping deportment will tilt the whole person forward and the legs will appear to drag behind rather than bold, leading strident steps. Every detail is important to sketching.

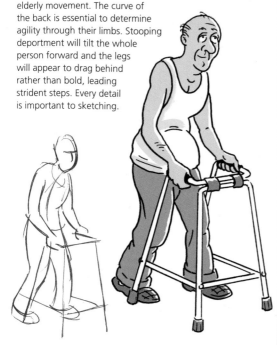

Character profile

Stereotyping categorizes people on the basis of their appearance. Cartoonists stereotype a great deal so that viewers can identify a figure's main characteristics and profile at a glance. Selecting the right body type is important when establishing the profile and makes it easy to define features and clothe a character.

Criminal ▶

In this case, the thick-set adult male figure with shifty glance, casual clothing and crowbar in hand leads the observer to conclude that the character probably has criminal tendencies.

Dressing the form

How a figure is clothed is an important aid to character recognition, so make sure that your research is thorough. Clothing can indicate age, gender, class, occupation and lifestyle. It is also an indicator of time and place. Being able to dress characters appropriately enables the cartoonist to communicate accurately with the audience.

Dressed-up couple ▶

That the woman wears jeans not only reveals her body shape but it also shows that she is from the late 20th or early 21st century when it became acceptable for women to wear trousers. The man is in a jacket that shows off his sturdier frame.

Exaggerating body shape

The point of a traditional figure drawing is to replicate the human proportions exactly. A cartoon drawing uses a process known as 'metonymic distortion' to exaggerate certain parts of the body and adjust the posture and expression. The purpose of this is to give a cartoon figure emphasis and so communicate more directly with the viewer. The simplest exaggeration can depict speed, action, movement or a change of mood or pace. The way in which a character is standing can sum up a situation instantly, for example. Achieving this level of visual communication is crucial in comic drawing where words are kept to a minimum.

Tip: Observe different types of people. Notice how they move and dress. Look for particular movements, mannerisms or features and make a record of them in your sketchbook. Create rapid figure sketches and exaggerate specific actions or body characteristics.

Fat and thin ▶
The basketball coach and his promising young protégé leave us in no doubt as to their roles. The coach is drawn with his ballooning body held by the tight stretch of the tracksuit. Exposing his midriff emphasizes his weight problem, as does the sharp taper of the leg from waist to ankle. The young player leans into the bounce, sprung and steadied by his large feet, which enhance his slim frame.

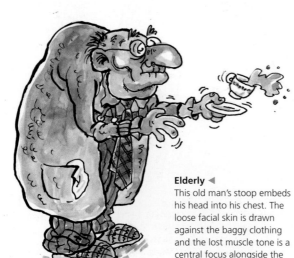

Elderly ◀
This old man's stoop embeds his head into his chest. The loose facial skin is drawn against the baggy clothing and the lost muscle tone is a central focus alongside the sparse hair and teeth.

◀ Poise and posture
The ballet prima donna is a perfect subject for figure exaggeration. She stretches, and can be drawn with more pull, to reflect superhuman moves. Imagine the slender ballerina as a five-pointed star and move the star into the desirable position where points of the toes and fingers are the final extension.

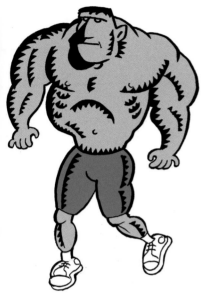

Strong ◄

The lower body of this strong character is disproportionate to the upper frame. It has been drawn with an element of foreshortening, looking down to the feet. The small hands and lack of a neck emphasize how muscle-bound he is.

Oafish ▲

The creature is drawn as a solid bulk, but his moon-shaped face and close-set, pinprick eyes perched above the bulbous nose describe an oafish, yet endearing monster. The impossibility of such oversized, clodhopper feet adds a comic touch.

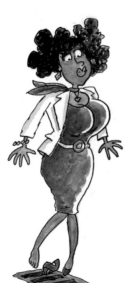

Shapeless ▲

Beyond middle age the body becomes more amorphous. A plump, bean head sits on an equally plump, shoulderless body. Loose clothing over reduced limbs completes the look.

Shapely ▲

An hourglass figure with enlarged chest and slender arms and legs all work together to pull the woman's frame neatly upwards. Exaggerating the legs helps emphasize her slim figure.

Weak ▲

By moulding the figure along the seat of the chair, she is weakened because there is no implied backbone supporting her. There is a deliberate lack of skeletal structure beneath the clothes.

Hands

A person's hand gestures usually take the supporting role to their facial expressions, but they are equally capable of replacing them. This fact makes the ability to draw hand movement with accuracy a vital skill for the cartoonist.

In the cartoon world, hand styles range from the early animators' device of only drawing three digits and a thumb on each hand to more realistic interpretations. It is more important to gain a working knowledge of drawing the ways in which hands move – grab, twist, flatten, release, point, wave, pinch and so on – than to reproduce their anatomical construction. Try these exercises before starting out, as practice will help you to understand this most complex part of the body. With hands so readily available, the cartoonist has all that is needed to get going; there is no need to reach for a copy of *Gray's Anatomy*.

Drawing simple hands ▶
Draw hands from the point of view of drawing tapering boxes. Digits represent one folding box, the palm another. The thumb is made of two smaller tapering cones jointed at the intersection of the palm and knuckle, jutting out sideways. Once the boxes are in place, subdivide them into four separate 'conical' digits.

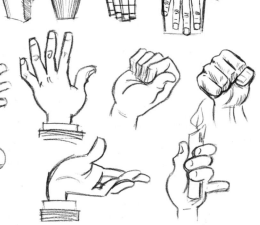

Hands in action ▶
The best way to understand the structure and different expressive movements of hands is by observing and sketching real live hands in action. Start by drawing your own, or use photographic reference. This series of linear studies of live hands focuses on the actions rather than the anatomy.

Practice exercise: Fleshing out

Once you are confidently making linear drawings, begin to flesh out the hands. Start by looking closely at your own hands: observe the differences between the back and palm; notice how the knuckles run in a steady curve across the back, marking where the fingers join the hand; study the palm creases; and note the way in which different finger movements change the shape of the hand – an action made with one finger changes the hand completely when it is made with two. Make sure you vary the poses as much as possible in your fleshed-out drawings.

Materials
- *cartridge paper*
- *waterproof fineliner pen*
- *watercolour paints*
- *No. 4 round brush*

Tip: Devote a sketchbook to hands, recording them at work, rest and play as often as you can. Use different materials to deliver a range of results.

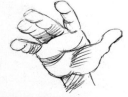

1 Using a mirror or a willing model, place the hand in position in front of you. Sketch in the main lines and the shading.

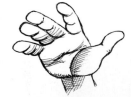

2 When you are satisfied with the sketch, go over it with a fineliner pen. Refine the hatching so that the structure is evident.

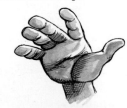

3 Tint with a flesh colour or mix of yellow ochre and red. Assume a light source from the right and leave white paper highlights.

Cartoon hands

The principles behind drawing cartoon hands are the same as those behind drawing live hands. The connection of the joints remains the same, but the drawn style changes. Rounding off the angular edges of the hand and simplifying its parts is the best way to transform your sketches from the real to the cartoon world. Common gestural clichés, such as the clenched fist, open palm, thumbs-up and pointed finger, appear time and again. In animal anthropomorphism, the three-fingered hand is the standard convention, with a paw converting easily to a stubby hand.

Hand style and function ▶
Note how style never affects function. A rounded, ballooning hand still grasps an object successfully. So long as the hand is able to function convincingly and copy a range of real practices, then it is fit for the purpose of being a hand. Squarer styles always tend to look more realistic, whereas the rounder ones add extra comic expression.

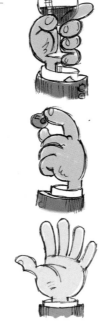

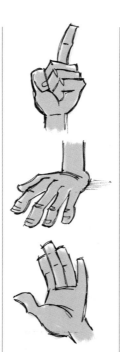

Rounded hand Squared hand 4-digit hand

Male and female hands

A male character can be easily recognized through the pronounced structural definition and physical exertions of the hands. A slender hand, with elegant curving positions of hand and wrist, is instantly seen as feminine.

Gender styles ▼ ▶
These colour ink and line studies show the edited simplicity of male and female and childlike cartoon hands. Lines are drawn solidly and creases kept to a minimum.

Child's hands

Male hands

Female hands

Feet

As essential as hands in shaping a cartoon character, feet are also very difficult to draw convincingly. An arch, a ball, a toe and five digits do not offer too much of a problem, but their role as the contact point between a figure and its surroundings is harder to get right. Their size in relation to the figure can be difficult to judge and footwear can add to the problems of foreshortening if viewed from the front.

A basic understanding of the structure of the feet is advisable rather than critical, and constructing feet out of recognizable shapes is a perfectly valid way to build the form.

When this has been mastered, it is important to consider how real feet move and how cartoon feet will move. Feet can be oddly expressive, especially when their size or movement is exaggerated. They can complement a gag by enhancing its intention or even working against it.

Legs need feet and feet need legs, and together they have a huge capacity for describing the weight and density of a comic character. Footwear is often either grossly distorted or simplified; for example big bulbous boots or floppy clown-like shoes can help to shape the humour in a cartoon.

Drawing simple feet ▶
Like hands, feet are constructed from tapered boxes, connected with a 'ball' socket and by dividing a third from the top of the wedge into four digits and a toe. Constructing this vital section of the anatomy through simple shapes will save you making habitual errors. Shapes help not only with scale, but also with keeping bodies in perspective.

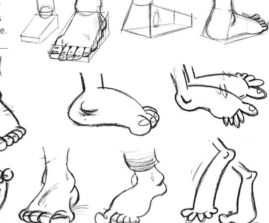

Feet in action ▶
Create linear studies of feet using a soft blue pencil. Begin realistically and stylize them only when you have mastered the shapes within the foot's structure. Cartoon feet still need to display the mechanics of real ones in order to be convincing.

Practice exercise: Fleshing out

So many artists avoid the issue of drawing accurate feet. They cannot consider them like any other body shape which needs to be studied closely to develop understanding. How much

tone, and where it is placed, is crucial to form a foot, because there are so many bones and ligaments working together near the skin's surface. There is little fat, so sinews and veins are highly

prominent. Places that require special attention are the ankle, which juts out above the flat plate of the foot, the long slightly curving arch and the 'ball' of the foot from which the toes emerge.

Materials
- cartridge paper
- pencil
- waterproof fineliner pen
- watercolour paints
- No. 4 round brush

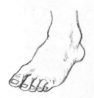

1 Lightly sketch out in pencil first, trying to be as accurate in your initial outline as you can. Adjust any obvious mistakes.

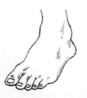

2 Use a fineliner to firm up the outline adding extra line 'weighting' to the joints where more pressure is working between leg and foot.

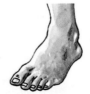

3 Mix a flesh tint from red and yellow ochre and wash over the foot to give it form. The light source is falling on the left-hand side as we look and the tint is diluted almost to nil. Other areas where highlights should be left are on the upper surfaces of the toes and the raised surface of the ankle bone.

Cartoon feet

The principles behind drawing cartoon feet are much the same as those used for cartoon hands. Even though they tend to be bulbous, fatter or oversized they are still modelled on the real thing before being exaggerated for humour. Rounding off angular edges and simplifying parts are the best way to transform feet from their role in the real world to a star part in the cartoon one. Turned-up toes or large clompy, clumsy feet mean that the front of a cartoon foot is often especially pronounced – the big toe is often portrayed much larger than the others put together.

Foot style and function ▶
A foot will always work regardless of detail. Even undefined, rectangular blocks offer a cartoon limited mobility. Some realism will elaborate the movements giving it sophistication. Reduction of digits is a style adopted by cartoonists for hands, but if a character often wears shoes this is less critical.

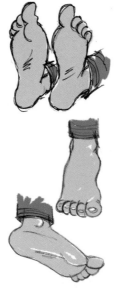
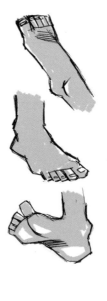
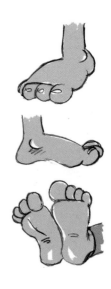

Rounded feet Squared feet 4-digit feet

Male and female feet

Unlike hands, it is harder to recognize a character's gender from the feet alone. Size is the main difference and male feet are often more rugged-looking. The behaviour of feet offers the biggest clue; the prima ballerina pushing up on her toes or dainty feet in high heels give

a stereotyped representation of women. Drawing feet using smoother, softer lines will help to differentiate the feminine from the masculine, while using looser, livelier mark-making will bring the feet to life so that the toes appear to be wiggling.

Gender styles ▼
Here, strong lines show confidence in drawing the most difficult of human subjects. Tone is kept to a minimum, relying on the strength of colour to give weight and depth. The obviously female feet are sleek and elegantly poised.

Male feet

Child's feet

Female feet

Clothing

Characters in strips and pocket gags need to be recognizable at a glance and your ability to describe 'types' according to groups, professions and status in society is fundamental. Clothing and hairstyles greatly help to identify characters to the audience. Many professions are instantly recognizable by their clothing and certain roles can represent particular character types, obvious examples being a nurse, police officer or cleric. In addition, the way in which a character's garments fit their frame implies a type, which in turn directly suggests status and attitude. The right accessories and props are also important in defining characters.

Economy of detail is essential for the cartoonist and it is better to use simple shapes, features and colours when dressing your characters.

Practice exercise: Defining status through garments

A monarch reigns over his or her country: larger than life, full of proud self-importance and infallibility. Building a character's profile in your imagination is the important first step before dressing them for the role. Start by considering the qualities necessary for a king. Think about current royals, notable historical figures and fairytale characters. Choose fabrics and accessories to emphasize the elevated status of your character. Reproduce the traditional regal colours of deep azure and lazurite blue, purple and vermilion red, which historically are the costliest.

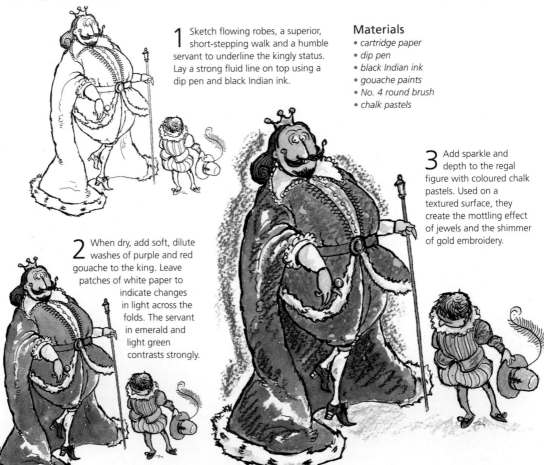

1 Sketch flowing robes, a superior, short-stepping walk and a humble servant to underline the kingly status. Lay a strong fluid line on top using a dip pen and black Indian ink.

2 When dry, add soft, dilute washes of purple and red gouache to the king. Leave patches of white paper to indicate changes in light across the folds. The servant in emerald and light green contrasts strongly.

3 Add sparkle and depth to the regal figure with coloured chalk pastels. Used on a textured surface, they create the mottling effect of jewels and the shimmer of gold embroidery.

Materials
- *cartridge paper*
- *dip pen*
- *black Indian ink*
- *gouache paints*
- *No. 4 round brush*
- *chalk pastels*

Professional attitude

Every profession embodies particular attitudes that can be communicated through stance and enhanced with the addition of appropriate accessories.

Surgeon ◄
This figure is imposing, courageous even, but also compassionate and caring. The face mask and medical instruments display his readiness to deal with serious emergencies.

Tip: Think of six different jobs and consider the dress code which accompanies each profession. Draw a character for each, keeping accessories down to a minimum. Pay attention to how clothing creases over a moving body. Compare your results with photographic reference, and make any necessary revisions where detailing is concerned.

Fire officer ▲
As his at-the-ready stance clearly shows, the fire officer anticipates possible risks and is poised for action, but he also remains cautious. The fire axe is purely a tool and never wielded as a weapon.

Police officer ▲
He appears alert and poised to defend or attack. He wears a dark, imposing uniform and hat, his eyes masked by reflective sunglasses. The badge, gun and handcuffs spell authority.

Tramp ◄
This individual's way of life is instantly made clear by the clothes he is wearing and the things he is carrying, which is everything he owns. A character like this offers the perfect opportunity to let your imagination roam free.

Manual worker ►
This figure wears the clothing that we readily associate with heavy labouring or manual work: a lumberjack shirt, jeans and strong leather boots. He is a rugged, mud-splattered, no-nonsense individual and reveals this forcefully through his emphatic stance.

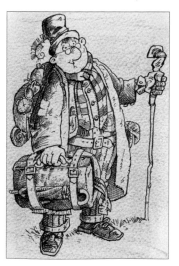

Artist ▲
The female painter/decorator bucks stereotypes as manual trades are usually dominated by men. She wears unisex dungarees and sports a short cropped hairstyle, to avoid hair getting in the way of her face while painting.

Stereotypes

We identify things about ourselves that make us laugh. Cartoonists rely on using generalizations observed in characters to make a point and carry gags. Where certain conventions are used to relay information about people and can be quickly read and understood, is known as stereotyping. Making a joke about people's behaviour, characteristics and dress can border on offensive, and what is considered acceptable can change over time. Some common stereotypes are still used, even though they bear no relation to reality, which might be due to the difficulty society has breaking down long-held stereotypes.

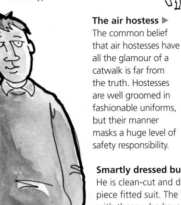

The average family ▼
Casually dressed, the middle-class family stands out here because they do not stand out. Their very ordinariness and lack of distinction are matched by their uninspired characterization, reflected in their similar stances, facial expressions and colouring.

The air hostess ▶
The common belief that air hostesses have all the glamour of a catwalk is far from the truth. Hostesses are well groomed in fashionable uniforms, but their manner masks a huge level of safety responsibility.

Smartly dressed businessman ▼
He is clean-cut and dressed for power in a two-piece fitted suit. The tie is a formality associated with those who have a nine-to-five job, and the identity card denotes access into the private culture of the office. His work is portable, transported in a sturdy briefcase, and he has means of communication at his fingertips.

Tip: There are various ways in which clothing can be used to set the scene. The sou'wester offers weather clues, focusing the viewer on the narrative content without the need for a full scenic backdrop. Obscuring the character's eyes also speaks volumes to the viewer.

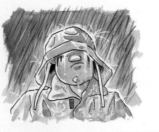

Rich and poor ▼

Comparing opposing stereotypes reinforces the point. The immaculate, streamlined wealthy figure is a superior world away from the huddled, drab street beggar.

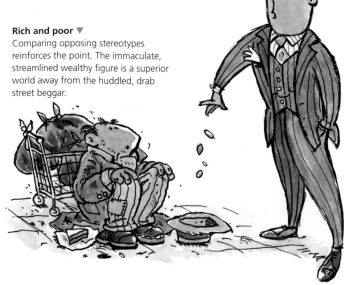

Tip: To perfect drawing figures in clothes requires much practice. When an arm stretches out through a sleeve, the fabric tends to pull from the shoulder, forming strong, directional creases in the sleeve. If you can recognize and understand how garments behave on moving figures, you are able to add more realism or emphasis to a particular action.

Tourists ▼

Dressed loudly and casually, and loaded down with baggage, these guys are clearly on holiday. With pockets and bags stuffed with accessories, guidebooks in hand and cameras at the ready, they typify everyone's idea of a tourist.

Scientist ▶

Albert Einstein was the inspiration behind this cartoon of a laboratory scientist. The mad eyes sparkle over the flat grey washes; colour only appears in the flask. Copy famous people and use stereotypes to reconstruct their full-length portraits. Emphasize distinguishing marks or features, like the way a character peers over spectacles or raises an eyebrow. Accessories are really important, as we generally think of scientists using specific equipment in their work.

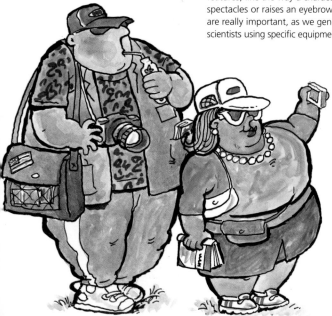

Rastafarian ▶

The rapid growth in popularity of Jamaican reggae music linked to the Afro-Caribbean Rastafarian religion has brought with it recognized fashions – woven dreadlock hair and a knitted 'tammy' hat to hold the locks under. Bob Marley is the icon of reggae and a cool persona who is celebrated on the street.

Shoes and hats

Although creating a cartooning style matters, content is by far the greater consideration. Detailing is essential when you are creating character profiles in your drawings. Their clothing identifies them instantly to the audience, who will interpret what they see from their own experience. Hats and shoes are important because they accessorize the everyday; they are the details that can either make a person stand out from the crowd or blend in with the rest of their peer group. In cartooning they can be used to exaggerate a character's general profile. A flat cap, for example, indicates older working-class men, or a slim, elegant pair of shoes can immediately communicate speed and power.

Shoe styles

When we meet a new person, we scan them from top to toe before focusing on the details. The same is true of a cartoon character, and first impressions count. A character will walk into and out of frames or gesticulate within them and their footwear is as important as the rest of them. Familiarize yourself with all types of shoe and what they tell you about the wearer.

Endearing ▲
Small, growing feet need plenty of room. A toddler's feet are more rounded and chubbier than an adult's and the same applies to their shoes.

Official ▲
Handmade, leather-soled shoes carry their owner well, but are the enemy of small creatures. Unlike soft, rubber soles, their firm, audible stepping can send insects scurrying. The angle of this foot denotes that it is about to land on the tiles with much force.

Cool ▲
The Chelsea boot with its Cuban heel has been at the forefront of fashion for decades. It indicates youth, cool and even a smooth operator!

Teenage ▲
The skateboarder's thick-soled, chunky trainers are mostly hidden beneath tracksuit hems, but they succeed in instantly identifying their teenage wearer.

Power crazy ▲
The wearer of red high-heeled boots wants to be seen and heard. Note the tension created in the extreme curving of the foot arch.

Comedy ▲
This nondescript shoe is used by many cartoonists. The exaggerated length and rolled tops make the legs skinny. They look soft and pliable, ideal for contorting feet into impossible positions.

Elegant ▲
Stiletto heels continue the body line right down to the ground. The wearer's stance is specific: she is tilting forward slightly to compensate for the lack of support at the heel.

Practice exercise: Building shoes

A system for constructing shoes quickly is useful and will provide you with a template that can be adapted for a variety of shapes and styles. As you practise these sorts of drawing processes, you will quickly find that it becomes second nature, allowing you to push the boundaries of your moving figures. Try studying the materials from which footwear is made. Highly polished leather creates strong contrasts and highlights that aid the 3-D modelling.

Materials
- *cartridge paper*
- *HB pencil and dip pen*
- *black Indian ink*
- *watercolour paints*
- *No. 4 round brush*

1 Use an HB pencil to sketch the shoe as a wedge shape, with the narrow end as the toes. Repeat for the other shoe. Draw cylinders for the legs.

2 Refine the shapes by adding trouser creases to the legs and an arch under the shoes. Shape each shoe into a gentle curve.

3 Draw over the pencil outlines using pen and ink, and detail the features of the shoe with cross-hatching. Leave the highlights blank.

4 Add washes of watercolour in blue for the trouser leg and brown for the shoe, keeping the white highlights intact.

Hat styles

Treat hats as an extension of a character's personality that show off or disguise facial features. Depending on the hat, the same face can appear older or younger. Hats deliver statements of class, social grouping or profession. Headwear can be distorted, extended and elaborated to inject humour. Become a keen social observer and make sketchbook recordings of people in hats.

Teenage ▲
The beanie is a 'cool' accessory for the teens. Worn pulled down, its brimless front accentuates the youthful face.

Adult ▲
Baseball caps are universally worn by all age groups. The extended peak can 'lead' the figure in a drawn frame.

Mature ▲
The fishing hat is one that is unlikely to be worn in an urban environment. It is identified with older people.

Retro dressing

Contemporary fashion defines the culture of a time and place. A character who is dressed out of their period is interesting and stands out from their surroundings. Make sure that you research the details thoroughly for an authentic look.

Groovy ▶
This distinctive Sixties look provides all you need to explore patterns and colourways through fabric and a variety of accessories, such as loop earrings, beads, bangle, bag and belt.

Drawing fabrics

Art and fabrics share a special relationship. In paintings by the Dutch masters, the silk sleeves look real enough to reach out and stroke. Not only do the colours and patterns of fabrics enhance a drawing but their texture can completely alter the visual sensation. A figure standing out from the background because the surface treatment of his clothes directly contrasts with that of his setting creates a startling impact. This contrast can be achieved in a number of ways, such as using soft pastel to create a velvety fabric weave against a backdrop painted in blocks of flat gouache paint. Pastel is not an obvious choice for the cartoonist and therefore is a good example of a medium that can add surprise and finesse to your work. Colours can be blended and smudged with the fingers or a rag to soften the tones.

When you are drawing a fabric, consider its textures and tonal qualities and then choose the medium or technique that best replicates it. Studying the fabrics in your own wardrobe at close quarters is a good starting point.

Creating fabric folds

Ink line seems an unlikely medium for rendering fabric folds, but is surprisingly effective. The secrets to success are understatement, pen control and clear stroke direction. In these examples, the cloak folds are suggested with simple black lines and tone is built with hard line hatching using a fine pen, or soft strokes with a brush or soft pen. Using colour with 'soft' media, such as pastels or watercolour, give the fabric a realistic impression and more scope.

Dutch and Danish still-life paintings from the 16th–18th centuries provide a helpful and unlikely source for showing fabric folds. The exquisite layering of colours with fresh directional strokes, then blending with white made these pictures so real that viewers felt they could reach out and actually touch the garments.

Outline ▶
This crisp outline is drawn with a 0.8mm fineliner pen, controlled to round the contours. A finer pen (0.3mm) details the main features, folds and creases, which are indicated with single lines.

Hard line tone ▲
The outline is drawn in the same way as the previous example. Evenly spaced hard line strokes are then added along the folds at approximately 90 degrees to the main lines.

Soft colour tone ◀
Tints and shades of red are worked through the tonal range to create a 3-D effect in this full-colour version. An assumed light source shining evenly from the right helps to achieve simple tonal modelling on the figure. Note the shadowing tones, especially beneath the tunic hem on the legs.

Soft line tone ▲
A brush and ink/brush pen is used to 'pull' tonal strokes with regular upward, even pressure. Closer lines give greater tonal depth and can be reduced in thickness and length the further they are from the fold.

Soft media tone ▲
Here, the cloak is given tone using a monochrome ink wash, softened with water to achieve tonal gradation.

Material gains

The hairstyle is correct, facial expression perfect and the clothing just right, but textural dimension takes a character to another level. Material seems to make him move under the swirly patterns.

Leather ◀
Strong highlights along with numerous creases and folds give this jacket a shiny, reflective leather look. The creases were drawn using an ink line before adding passages of dilute watercolour.

Cashmere ▶
Some textures need subtlety. This smartly dressed figure has been drawn on a soft-grained water-colour paper using harmonizing colours. Any further texture should be added when dry with a smudge of charcoal, to reinforce the description of the folds in a garment as it drops.

Satin ▲
Two colours of pastel (blue and black) are smudged together, making soft, shiny creases that create a shimmer of dark and light. In this drawing, the pastel section was drawn separately and glued in place. The ink line was then applied on top.

Plaid ▲
Simple, broad bands of watercolour are brushed in one direction, allowed to dry and then brushed, overlapping, the other way. It is always best to keep check patterns simple.

Gossamer ▲
The wet-on-wet technique that creates this floating fabric uses a heavy watercolour wash inside the holding outline. Colour is dripped on to the wash and swirled with a brush.

Silk ▲
A combination of watercolour washes with solid gouache spots and smudged pastel strokes for the ruff, highlighted fabric creases and hair delivers this crisp, yet airy effect.

Mohair ▲
Light, 'dash' touches with a brush over a soft pink watercolour wash create a mohair jumper: a simple technique that matches the drawing style.

Creative fabrics

Finding creative solutions to fabric rendering can be fun and easy to achieve. You can invent lively, colourful, attention-grabbing garments by exploiting a blend of traditional and non-traditional techniques. Collaging other materials into a cartoon can add humour, especially where the cutting is irregular, the shapes unexpected or the overall look surprising.

The surface pattern of a fabric or a particular weave can add an extraordinary dynamic when used outside its usual scale. A standard design, such as tartan or check, applied disproportionately to a tiny cartoon character can look surreal and funny. With a little imagination, a comedy character's body can be constructed from a scrap of fabric or paper. Try to experiment: a figure with no dimensional depth whose squat shape breaks every rule of proportion and with limbs to match has the potential to become an amusing and versatile character, capable of defining its own movements and behaviour.

Consider how choice of media can be used to describe different fabrics. A thin, gauzy swatch of silk, for example, may be best replicated using thin, translucent watercolour washes, or perhaps a rougher woollen weave requires short, heavy strokes of acrylic paint to define its texture.

Fun should always be the motivating factor for anyone interested in learning about cartoons, and by experimenting with alternative materials and methods, you will positively sparkle with new ideas and achieve results that you never previously imagined were possible.

Developing an adventurous side

Depart from traditional techniques and consider experimental ways to produce certain textured effects using alternative materials. Monotonous cross-hatching or labour-intensive painting are no longer necessary labours of love in the contemporary world of art and design, where virtually any material can now be scanned and converted into 'print-ready' artwork for publication. Even 3-D work can be photographed and the images easily uploaded into image-manipulation programs, such as Adobe Photoshop. Costumes are a good place to begin experimenting.

Towel ◄
Vertical strokes of blue crayon on the towel indicate texture and folds. They are in direct contrast to the bold, charcoal-and-wash figure. Contrasting textures are becoming more popular now that households can scan most materials.

Tip: Get into the habit of collecting interesting scraps to incorporate into your cartoon work. These can be fabric samples, textured papers or a variety of other materials.

Polka dot ▲
Spotted polka-dot fabrics or those with a consistent pattern are great folded materials, because the dots chop off naturally by folds, delivering an illusion of fabric being wrapped or folded.

Denim ◄
Use real denim for denim trousers and jeans because it is much simpler than trying to paint the tight weave and washed out seams.

Aztec pattern ▼
Finding new uses for existing fabrics is fun. This hankie, with its South American pattern, was made into a large shoulder shawl, its strength of pattern scaled beautifully.

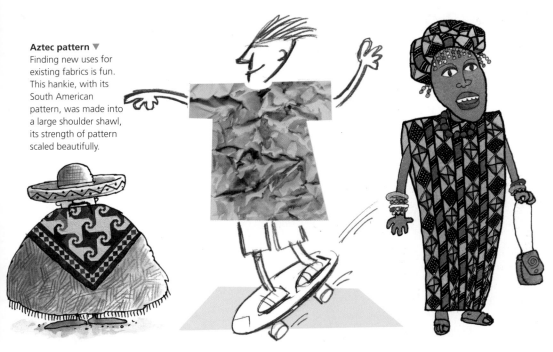

Tartan ▼
A unique pattern of criss-crossed horizontal and vertical coloured bands, tartan is specific to Scottish, Irish and Welsh clans. As the weave is heavy, the chances of folding it successfully are limited, but this offers the cartoon a charming flatness.

Camouflage ▲
This realistic camouflage effect is produced by soaking thin paper in coffee, crumpling it when dry and loosely brushing with olive green watercolour. The sheet is ironed flat and the neat T-shirt shape cut out and glued on to card. The character details are drawn with red pencil.

Ethnic ▲
A repeat pattern of flat, coloured gouache shapes tapers as the fabric drops to the feet. Use patterned fabric or paper for a short-cut solution. Lighter washes are used elsewhere and the coloured dotted beads and bold outline added at the very end.

Gingham ◄
A popular pattern found on tablecloths and shirts, as well as being the standard uniform of a chef, gingham is a very versatile material. Scan a piece and use the seams to show bagginess.

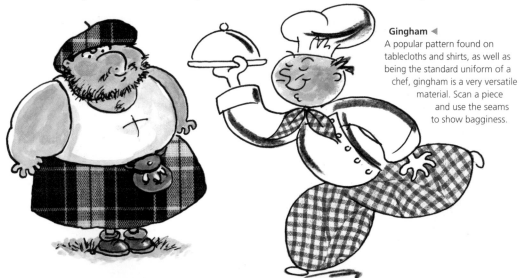

Injecting life

One of the greatest cartoon challenges is making a static image appear to move. Movement can be shown through a sequence of images or through devices that imply motion.

It is important to be able to sketch characters in active positions or postures: the right configuration of legs, arms and body twists will bring your drawings alive. Actions are greatly exaggerated in the cartoon world and emphasizing angles is essential. Techniques for animating figures include drawing multiple images and the simple use of 'whizzy' marks called motion lines. Trailing behind a character, these parallel strokes jettison in all directions, implying high-speed activity. Overstating the body language and experimenting with the positioning of these marks will heighten the effect and increase the element of humour.

Get moving

The right medium is all-important when it comes to animating characters. A mechanical even-flowing pen, for example a rollerball or a fineliner, will automatically create static marks, making the job harder. Pressure-sensitive mark-makers are the best choice and a soft-grade pencil, felt-tip pen or brush pen will naturally deliver the liveliest results. The figure studies on these pages are all created using a brush pen. Its flexible brush tip allows you to deliver thick and thin lines easily. It is this lively variation in strokes that achieves the impression of energetic action.

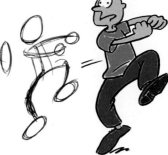

Fleeing ▲
A whole-body shift to the right with all the weight and balance on the right foot denotes anticipation. The swing of the arms to the left allows motion lines to be drawn along the same axis.

Falling ▲
The pose here is centred around the character's mid-point, where his bottom will land. The limbs flail accordingly and his expression is one of surprise.

Sitting ▲
The legs are at right angles to the body and the knees are slightly bent. The arm leans on the ground to confirm the stance.

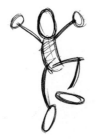

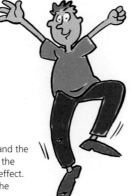

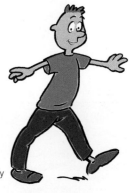

Leaping ▶
Arms are raised high into the air and the stretch of the body follows. Keep the pose open for maximum leaping effect. Note the motion lines that echo the upward sweep of the legs.

Balanced and slow ▲
Everything is held firmly within the frame of the body and the hands and feet are symmetrically placed. Evenly balanced shapes will always appear the most static.

Flowing movement

A sequence of movements is created from a series of single poses that flow from one to the next. Although cartoon people can move in ways that are impossible for real people, the course of their actions must appear to be believable – the jumping man below moves convincingly through the smooth curve indicated by the dotted line, for example. Spend time observing actual human or creature movement.

The key is to draw simplified movements initially in a skeletal kind of way and when the body posture and position of limbs are correct, flesh out the figures and stylize them to suit your cartoon task.

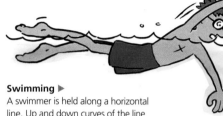

Running ▼
The angle is dynamic, with a forcefully placed leading arm and leg, counterbalanced by their opposite limbs. The motion lines trail the body at its most static point, allowing the limbs to be free to express themselves and direct the motion of the figure. Motion lines should not be overused as they can actually have the counter effect of appearing to hold the figure back.

Swimming ▶
A swimmer is held along a horizontal line. Up and down curves of the line give the appearance of swimming. Longer, more flowing lines give a greater illusion of movement.

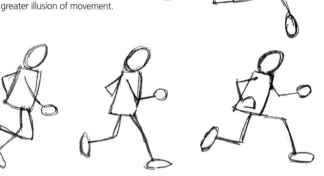

Action sequence ▶
The figure runs with arms opposed and the body's weight over the leading leg. The arms swing back on take-off and the legs thrust the body forward. The right leg lands first, bent under the momentum of the upper body. The hips follow the curve of action. Returning to ground involves the body swinging forwards as it follows the landing limbs.

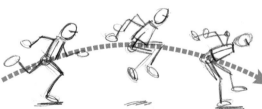

Tip: Practise drawing the shapes and body positions that support the key movements. Sketch active, flowing movements in pen or pencil, applying pressure to the areas where the body weight is centred. Heavier lines should correspond to the origin of the movement. When proficient at the moving stick figure, progress to add bodily characteristics.

Diving ▶
The diving action is definite and dynamic. The leap into the unknown is made in the belief that the diver's fall will be broken by the tension of the water. This is why the diver's extensions are so powerful and so extended over a very short phase of time frames.

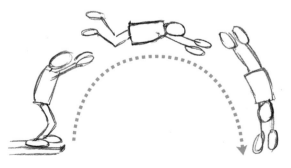

Cause and effect

Objects added to a scene can give clarity to the action because an explanatory narrative has been set up; movement can be more fully defined when a cause is added to the drawn 'effect'. The prop acts as an extension to the body, which in turn helps to exaggerate the shape of the pose. A good example is a figure struggling to carry an object that is too large, heavy or uncontrollable. Build your confidence by making simple pencil sketches of the key poses shown here. Focus on illustrating the action with clean lines; the detail can be added later. The best place to practise is in your sketchbook, scribbling down real-life situations where people interact with objects in their daily routines.

Exaggerating movement

To show cause and effect clearly, exaggerate every movement, body position, counterbalance and displacement. Movement can be even more fully defined when a cause is added to the drawn outcome. Remember that the viewer must be able to catch the meaning of the sequence immediately or the gag may be lost. If there are strong contrasts between cause and effect frames, the meaning will be understood.

Slipping ▶
This action shows the body tipping away through a definite arc. This is achieved by tilting the body back through the pelvis and foreshortening one leg. The banana skin is vital in that it centres the action of the figure, and presents the origin of the slip.

Opening ▼
Framing figures is a neat device which can develop a narrative interplay between inside and outside activities. The figure is placed centrally holding the frame and anticipates what is to occur from the left.

Carrying ◀
The backward lean is a pose that demonstrates overcompensation at its most exaggerated. It clearly tells us that the load is heavy. The toppling books add a touch of humour. The facial expression underpins the angst felt by the character, and the viewer knows that a tumble is imminent.

Catching ▶
A critical drop of a catch in a baseball or cricket game could mean losing. The expression says it all. The figure lunges forward extending his right leg and foot. The ball drops along a trajectory angle, where he anticipates the catch. The 'will he, won't he?' clause anticipates cause and effect.

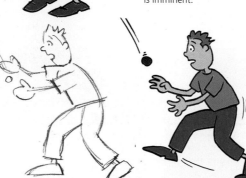

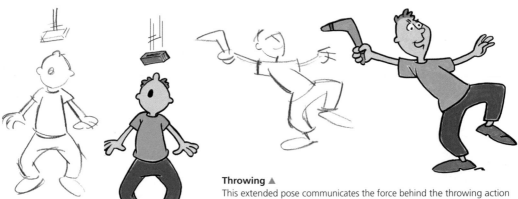

Throwing ▲

This extended pose communicates the force behind the throwing action and the distance the object must travel. The figure stretches back so far that one leg lifts up, while the other is bent under the body's weight. A boomerang or ball is effective because it forces the figure to stretch back, thereby producing a counterpoint for the stretching out of the left leg.

Startled ▲

As the brick hurtles towards him, the figure is frozen helplessly in the moment. Exaggerating all movements and holding them motionless emphasizes the pose. The brick dictates the focus of the cartoon. The figure beneath will respond to it and engage with it, wherever it drops in an attempt to avoid being hit.

Cautious ▶

The retracting action of this figure implies controlled, tentative movements. The wary expression on his face is as telling as the pose. Dynamite is small, but deadly! It is absurd that a figure should be so cowered over something so small and static. But this set-up enhances the joke, and increases the suspense.

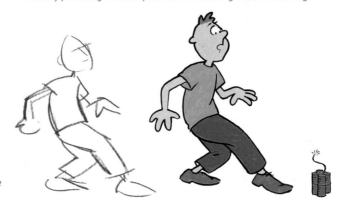

Objects and light

Light physically attracts the viewer's eye – a very practical device to ensure that a cartoon is read in the correct way. Photoshop and Illustrator blends do this well and have become a stock-in-trade of the contemporary cartoonist's techniques. Dark from the right leading to light on the left moves the viewer's direction from right to left.

Light and meaning ▼

In this frame he is seen fleeing from the ghost, with light at its centre, and in the other frame running for the beer, with light illuminating the bar. The figure is identical in both frames, but the meaning is totally different with the addition of selected, relevant objects, their placement and light direction.

Distortion

It is a natural progression in cartooning to use distortion to emphasize action. Such shorthand can be used to convey a range of meanings and also increase the comic effect by giving ordinary subjects larger-than-life qualities. Reducing or enlarging details beyond the norm, for example, draws attention and highlights meaning. This very useful technique is an important part of the cartoonist's repertoire. A good start to grasping its capabilities is by distorting a regular shape, such as a cube, in a variety of ways and noting the effects, then applying them to your cartoons.

Regular cube

Force from one side

Equal force from top down

Downward force from one edge

Equal force from below

Stretched

Applying distortion

Knowing how much exaggeration to apply must be learnt. Always weigh decisions against intention. Consider carefully which parts of the drawing will benefit from more attention, then test the effect. Remember that the point of distorting certain features is to communicate the cartoon's meaning more forcefully. Bear in mind that distorting a character's features transforms them into a caricature and enhances comic effect. This often increases as the story becomes more critical. There are no limits to levels of distortion in cartooning.

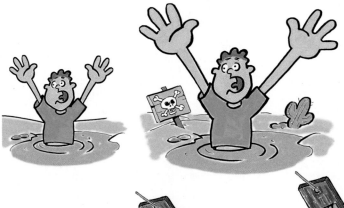

Part-body distortion ◄
Sometimes distorting only part of the body will achieve the desired effect. In this case, the large hands literally extend a cry for help from the sinking figure.

Increasing effect ▼
The figure remains the same size, but the agony of the foot's predicament is amplified in a series of three separate drawings, each a quarter size larger than the one before.

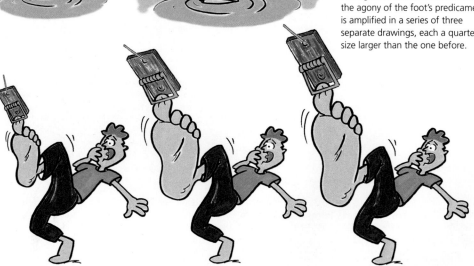

Exaggerated foreshortening ▼
In the second drawing, distorted foreshortening makes the body look pushed up and squashed. Compare it to the first and its purpose (to show the figure from the ants' viewpoint) is clear.

◄ **Extreme distortion**
Narrative sequences can benefit from extreme distortion. Here, the sudden mouth enlargement to cope with an escaping spaghetti strand is unexpected and comical. The jump in size is highly animated, even though this occurs over just two frames.

Tip: Observe how often foreshortening is used to distort figures and create movement in action comics. Collect examples and keep a scrapbook as reference for your own drawings. Foreshortening can be a particularly effective technique for showing movement, especially where a character moves through a limited sequence of frames. Below, the mummy's grabbing hand dramatically stretches out of the frame towards the viewer.

Practice exercise: Metonymic distortion

The technique of twisting, enlarging and stretching bodily proportions for a comical or enhanced effect is called metonymic distortion. It is a visual substitute for a character's physical or emotional attributes.

The fact that children's bones are naturally more pliable than those of adults is a gift for the cartoonist. Flexibility and suppleness are ideal characteristics for producing animated, humorous drawings.

Materials
- *cartridge paper*
- *pencil*
- *No. 2 round brush*
- *black Indian ink*
- *coloured inks*

1 Sketch the springing child in pencil. Keep the lines flowing and think of the figure in terms of simple shapes: ovals for the head and feet; flexible rectangles for the body and limbs.

2 When you are happy with the shapes, proportion and pose, carefully load the brush with black Indian ink and go over the pencil lines. Remember to maintain flowing lines.

3 When dry, brush relaxed washes of dilute blue, orange and red ink on to the T-shirt, hair and shoes so that they are just tinted. Mix a touch of yellow with slightly more red for the flesh colour and dilute with water.

Object interaction

A cartoon character rarely appears on the page out of context. There is usually a setting and any number of objects to dress that scene and help the viewer to understand the background to the developing narrative. People in the real world interact with their surroundings in the simplest of ways – sitting on chairs, lifting, moving or placing objects – and the same is true in the cartoon world. In complex interactions, characters may work through an intricate series of tasks with objects, such as using machinery.

Not only are objects essential to the construction of the cartoon narrative but they can also considerably enhance the character and his or her comic routine. Think of the early movies. Where would Buster Keaton or Charlie Chaplin have been without their sets and props? In the cartoon world, these props can even come alive and interact with the characters. Characters also interact with one another, which carries the

narrative structure forwards. Dialogue is the obvious form of interaction, but expressions and body language also speak volumes, especially in a group context where the storyline must rely on action instead of words. Perhaps this is why cartoons are such a successful narrative form. Their mimicry of real life imitates the subtle body language that we use instinctively and recognize immediately. Hence, our response to an embarrassing, humorous or unfortunate situation played out in a cartoon is to smile, laugh or sympathize.

Learning the art of interaction will widen the scope for creating more powerful visuals and interesting narratives. To be able to sketch a scene from your head with any form of interaction is to be using the skills of an actor or director. Style and content are of key importance to the effectiveness of the interplay, as the following examples and exercises show.

Practice exercise: Interacting with furniture

It is worth learning to draw all kinds of furniture from all kinds of perspectives. Keep a sketchbook with you and never miss an opportunity to practise. Unusual specimens can be particularly useful, so

the next time you visit a stately home, do not disregard the four-poster bed or ornate garden seat. The more you consider the construction of a piece of furniture and how it looks from a range

of different viewpoints, the more convincing your narratives will be. Observing and sketching people interacting with furniture from every angle is the obvious next step.

Chair sketches ▶
Pose chairs and other items of furniture and draw them. Chairs that are obviously old or well-worn are especially interesting. They have seen a lifetime of interaction and can be imagined as characters in their own right.

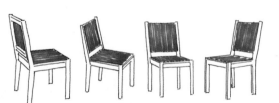

Materials
- *cartridge paper*
- *fineliner pen*
- *black Indian ink*
- *No. 2 round brush*
- *coloured inks*
- *black charcoal pencil*

1 Use a fineliner pen to sketch your cartoon, taking extra care over the position and shape of the chair and how the diner is sitting on it. Next, draw the ants and sausages.

2 Add form to the line with a wash of dilute ultramarine blue ink. Choose a direction of light source, in this case from the right. Leave the lit areas on the right-hand sides blank, as shown.

3 Add the yellow ink wash to show light thrown on to the highlit areas. Finish the cartoon by deepening the areas of shadow using lightly smudged black charcoal pencil to make a grey tint.

Styling and scaling objects

The way in which you draw objects is every bit as important as how you draw figures. We are all well aware of our surroundings and the relative sizes and scales of the inanimate objects they contain. Exaggerating or giving life to those objects is a great way to enhance the comical content of a cartoon. It also opens a pathway to a world of fantasy or illusion. It is this licence to alter reality that makes cartooning so enjoyable. Trying out different styles and drawing or painting techniques brings mood and attitude to your settings and a chance to learn what works best with your scaling and positioning of objects.

Contrasts of interaction ▼
The bulky weight of a subject interacting with both a lightweight object and a contrasting subject emphasizes the humour of this gag.

Fantasy interaction ▲
Through the anticipation of the 'suspended' moment, the floating alarm clocks tell us that the character is about to wake up. They provide enough setting for such a simple narrative.

Continuous interaction ▼
The panting man, the sweaty brow, the impossible climb and the broken shopping bag draw out the idea that he is struggling against the odds. A huge flight of stairs is implied by showing neither beginning nor end.

Armchair interaction ▲
The plump enveloping contours and soft folds of the armchair personify the act of gentle cradling. The cosy subject matter of a cup of tea and a good book, coupled with the woman's serene expression, and use of warm, harmonious colours give us a message of comfort and security.

Tip: Break the rules of scale to make a point. The contrast of the huge mobile (cell) phone against the figure allows the phone screen to metamorphose into a mirror. This brings home the gag's point of the difficulties of trying to talk to oneself.

Character interaction

How characters interact can determine the development of a cartoon narrative and allow a storyline to change with ease. The dynamic of a scene alters at the point where new personalities are introduced. Expressing their characters subsequently defines their dominant or secondary roles in the narrative. The focus of a scene is also determined by the behaviour of its characters and the cartoonist has the power to move them, like pawns in a chess game, to bring about certain outcomes. People and animals are social creatures and their complex interactions are often revealed in particular, if not peculiar ways. This inevitable fact is something for the cartoonist to exploit.

Understanding dominant and secondary relationships

Complex cartoon figures do not need to be drawn to grasp spatial relationships. Sphere shapes are perfectly adequate to reveal how the two subjects of different sizes and positions affect the visual impressions of objects in a pictorial space. These types of exercises are crucial if you are to master the design of cartoon frames, and the interaction of figures within them. With such knowledge you can confidently construct exciting and challenging narratives with pace and interest.

Dominant and secondary ▲
Pitching a more important character against a minor character is a dynamic contrast commonly used by cartoonists.

Dominant and distant secondary ▲
This interaction subtly changes the relationship. Being at the same eye level allows their 'conversation'.

Dominant and multiple secondaries ▲
The power and energy of the dominant character is clear when the scene is crowded with secondaries.

Interaction at a distance ▶
With careful positioning, two figures can interact even though they are far apart. The flight of the love letter links the characters, and being placed on the same eye level permits the interaction. As a result, a silhouette is all that is needed to define the secondary character's role and importance.

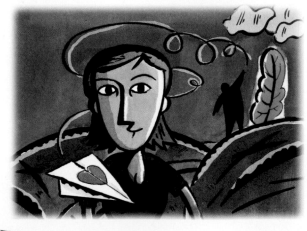

◀ **Superior versus inferior**
This confrontation would not be as powerful without the contrast in the characters' sizes. The viewpoint from below – the worker's eye level – acts to reinforce the scene. The cartoon offers two possible interpretations: does the worker's size show that he is aware of his guilt and inferiority, or has the interview with the enraged boss diminished him?

Dominant and multiple secondaries ▼

The pirate captain opens the treasure chest only to find it empty! His crew are clustered around expectantly in the immediate background, framing this central moment and adding drama and suspense. Their position also enhances the primary role of their leader. The viewer knows instantly who is in command and the monotone light grey wash over the secondary characters helps to reinforce the message.

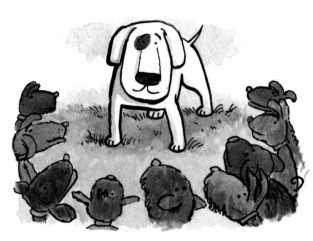

Dominant and multiple secondaries ▲

A major character who is different, a dog of a different species, larger and standing apart from the pack, is undoubtedly its leader. The others in a semi-circle around him, with all eyes on him, bring the focus to the centre making the viewer position on an par with them. In their uniformity they are multiple secondaries and he is the dominant. With the major character looking straight ahead there is an opportunity to develop detailed facial expressions.

Interaction of thought

Subjects can appear to share similar thoughts and intentions, even when the outer differences between them are quite considerable. The style of drawing and careful direction of lighting, positioning, colour and expressions can establish interaction between characters that would be impossible to achieve in other ways. The immediacy of the cartoon medium means that visual signals such as these can be clearly transmitted to the audience.

Two faces interacting ▶

The stare of the eyes, depth of the brows and similarity of the marks used to draw the two faces links them. They are closely positioned and the use of black shadows helps to merge their faces, reinforcing the idea of an identical reaction.

Tip: Work out the composition of an interactive cartoon using simple shapes, such as spheres. Move these around, altering their relative sizes and positions, until you are entirely satisfied with the outcome. This process of art direction will lead to stronger final results.

Enhancing interaction ▼

Here, the same cartoon has been redrawn, but this time using strong, saturated hues of blue and yellow as a way of unifying the picture, making the two characters seem inseparable.

Multiple characters

A scene that includes multiple characters can create or draw attention to a background, or it can be a device that spotlights a leading character. Equally, a whole crowd can become the centre of attention.

Illustrator Martin Handford's famous *Where's Wally?* books hide the woolly hatted, scarf-wearing hero in vast crowd scenes for the reader to find. The success of the game relies on the hundreds of similar-sized, distinctive figures that create a camouflage for Wally. It is important that multiple character drawings are used with care. Their purpose is not to clutter a scene or, more importantly, detract from the central focus. Your choice of colours or varying the strength of mark can alleviate this. Not forgetting either that including too many figures can exhaust the artist!

Practice exercise: Dominant and multiple secondaries

It is important to realize that you cannot possibly include every detail. Work out your composition in simple shapes before starting the final artwork. First, define the area below the stage for the crowd that is swaying, singing along and calling out. Devote the remaining third to the empty stage on which you will place the singer, the focal point of the composition.

Materials
- *cartridge paper*
- *0.5mm, 1mm, 2mm fineliner pens*
- *No. 4 round brush*
- *coloured inks*

1 Draw the main elements using a variety of pen sizes to give good weighting and depth. Use a 0.5mm fineliner pen for the background figures, 1–2mm for the singer and the stage. Draw the crowd head-to-head as simple caricatures. Having no space in between them will give an even tone.

2 Drop a pale blue ink wash into the farthest, uppermost part of the picture in order to differentiate the foreground from the background.

3 Dilute the blue further and lay a faint tint over the crowd to knock back the blackness of the drawn lines. Add dilute stains of yellow ochre and red to selected areas so that they are totally coloured. Lay stronger colour washes over the foreground stage, guitar, hair, jeans, shoes and shadows on the shirt.

Tip: In your sketchbook, practise drawing quick, non-detailed caricature faces bearing a range of expressions, should the need arise. See how far you can edit out the facial information and still hold a likeness, or a definite characteristic or emotion.

Focus and viewpoint

As the creator, you have the power to use characterization, gesture and emotional response to direct eyes and minds to a selected section of a drawing and to tell a specific story. Learning to control your focus, and therefore the focus of the audience, is hard work. Through experience you will gain the confidence to leave spaces where nothing is happening, which is very liberating. Look at published cartoons and note how universally this particular principle is applied.

Subject and audience ▶
The barbecue is amusing as it draws attention to a single hamburger. The dramatic flourish of the designer chef tossing herbs is reminiscent of a conductor holding a concert audience under his spell. A simple, light approach ensures that the earnest expressions of the guests are not lost. Broad washes of three colours only keep the whole picture simple and focused.

Simplifying viewpoints ▼
Where there are many figures to sketch, choose an easy viewpoint. This drawing keeps a low viewpoint on the crowd. What is visible of them is limited, but successfully implies a large gathering. The focus falls on the man just left of centre. He is drawn in slightly more detail than the rest and is gazing upwards in contrast to everyone else's downcast eyes. His interaction with the UFO is defined by the dramatic yellow highlight running down the side of his face.

Densely populated scene ▶
Hunting a figure in a crowd is a popular game popularized by the illustrator Martin Handford. The thrill of picking characters out in a crowd is not new; satirists, like James Gillray, had been doing variations on it for years. Typical tricks include creating figures with similar characteristics – skin tones or clothing – who are doing similar things.

Anthropomorphism

The technique of giving an animal human characteristics is known as anthropomorphism. It works the other way too in that human characteristics can be attributed to animals. In cartooning, anthropomorphism is often further extended to giving inanimate objects a life of their own.

Depicting animals as human or even superhuman is neither new nor exclusive to cartooning. Many ancient Egyptian gods, for example, were drawn as a combination of an animal head with a human body. The role of animals in cartoons is often as an accessory to a central human subject. The animal is a foil, fool or spoof character, set against the main subject in order to enhance particular qualities. Where an animal is the central focus, its persona is based firmly on recognizable human qualities. Walt Disney's Mickey Mouse was one of the first examples of a popular cartoon animal character, and today anthropomorphism is the commonest format used by the big-screen animators.

Cartoonists can apply the same techniques in giving life to inanimate objects. If an object has a particular function, this can be amalgamated into the cartoon character you wish to create. Similarly, the outer appearance of an object can suggest personality; for example on a simple level, a shiny mechanical object may suggest a tough or forceful character, while a soft, tactile one implies warmth and generosity.

Practice exercise: Anthropomorphizing everyday objects

A toaster springs to life as soon as the lever is pushed down. It heats up, glows red and chars the toast. Red not only symbolizes heat but is also associated with evil or danger. Its menacing personality is evident and it is clear that if you get too close there is the risk of getting burnt. The full transformation into a demonic character, complete with a tail, prodding fork and flames, is apt.

Materials
- *cartridge paper*
- *soft blue pencil*
- *black Indian ink*
- *No. 3 round brush*
- *coloured inks*

1 Study and sketch the toaster. Look for the most dynamic angle to portray your character. At this point, also decide whether any of the levers or buttons can be made to resemble facial or body features.

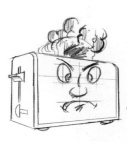 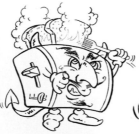

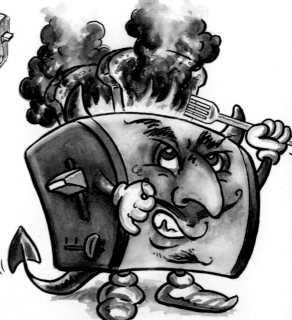

2 Draw the toaster and add eyes, nose and mouth pulling a hot-tempered expression. Relate the expression to the smoke billowing from the top of the appliance.

3 Redraw the toaster, curving the body and adjusting the expression. Add demonic features, a tail, glove- and sock-type hands and feet, a prodding fork and twirled moustache.

4 With everything in place, ink over the lines and add subtle washes of sepia, yellow, red and blue to give solidity and form. Note how the colours do not have to be vivid in order to carry the message successfully.

Practice exercise: Anthropomorphizing animals

A fierce crocodile can be tamed with just a few human touches. Plumping him up gives an air of friendliness and his proportions are like a child's, with chunky feet, stubby arms and big eyes. The jaws are rounded into a benign, almost toothless mouth. Flowered Bermuda shorts complete the transformation into a cool guy who would not hurt a fly.

Materials
• *cartridge paper*
• *dip pen*
• *black Indian ink*
• *No. 4 round brush*
• *coloured inks*

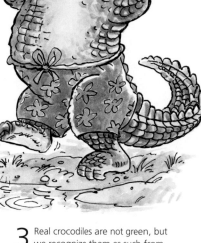

1 Pencil sketch a crocodile and make him friendly by shortening his arms and giving him a tubby belly with similar proportions and actions to a toddler.

2 Study and sketch pictures of real crocodiles, then adjust them by rounding and shortening the body and jaw. Bring the animal upright and make him walk slightly on tiptoe. There is no need to draw all the scales.

3 Real crocodiles are not green, but we recognize them as such from children's books. Lay down olive green washes, then do the same for the shorts, using cobalt blue and crimson red. Finally, add a yellow ochre wash to the ground.

Simplifying ideas

Anthropomorphic touches can simplify and make complex ideas accessible. The notion of green energy can be difficult or lengthy to explain, but its relationship to the domestic user is easily shown through this friendly cartoon.

The self-sufficient happy house ▶
The house is squashed, making it less real and giving it a soft facial structure. The windows make natural eyes, which look up admiringly at the friendly wind turbine. The colours combine warm contrast with harmony.

Tip: Look out for and compile examples of anthropomorphic animals from children's literature or films. This rat's human-like character is made believable by the familiar clothing and artefacts he carries.

3

The cartoon environment

Characters work best in a setting. This chapter offers the opportunity, through consideration of viewpoint and perspective, lighting, scale, focus and mood, to place your characters in believable worlds, which come to life and tell their story.

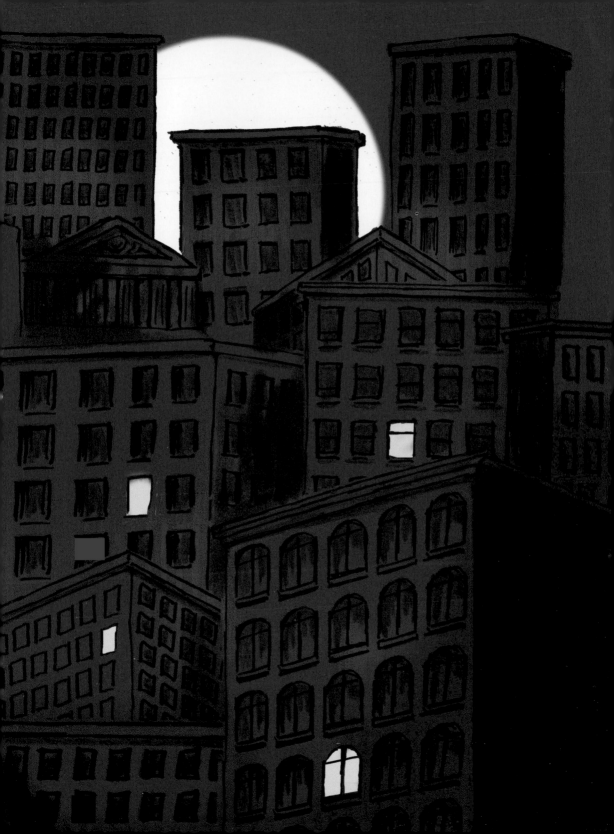

Settings

Setting the scene so that ideas are easily transmitted to the reader is vital. Your choice of background needs to be correct, with enough detail to contextualize the story, but not so much that it detracts from it. Having said this, the scene can be as complex as you wish and observed from any number of viewpoints, real or imagined.

If you wish to place your cartoon characters in a realistic space, it may be necessary to apply the rules of perspective and draw the figures and objects accordingly. The rules can be relaxed for smaller gag cartoons, but are essential for the delivery of action-packed comic or graphic novel-style spreads, where a constantly changing viewpoint enhances the dynamic and is standard layout practice.

The positioning of figures and objects within the picture planes will determine the way in which the cartoon conveys its message. Your three picture planes – the fore-, mid- and background – need careful consideration.

The foreground tends to lead the viewer into the picture and conveniently frames the setting with a window-like boundary that assists focus. Most of the cartoon's action, dialogue and interaction resides in the midground. It is also where a full, objective overview of the setting can be made. The background establishes the setting by anchoring its features. The placement of the horizon line here determines scale, depth and perspective, unifying all the elements of the picture and ensuring that their juxtaposition makes sense.

Two- and three-point perspective

The theory of perspective, based on mathematical principles, scales and places relative objects in the reality that we observe. The laws of optics state that the farther away an object is, the smaller it will appear. Where objects recede into the distance along a straight line, they appear to reduce in height and converge to a point known as the vanishing point, which sits on the horizon line, also known as eye level. By drawing lines radiating out from it, and placing the straight lines of an object along them, you create what is known as one-point perspective.

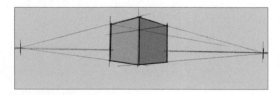

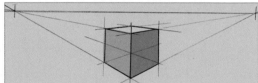

Two-point low horizon ▲
In two-point perspective, two separate vanishing points are visible, both of which reside on the horizon line and the lines slope away to converge at them. When the object is placed above the horizon, the lines slope downwards making it appear as though we are looking up at it.

Two-point high horizon ▲
Where the object appears to have been placed below eye level (the horizon), the converging lines travel upwards to meet the vanishing points, making it appear as though we are viewing the object from above. Note how the top of the cube is visible when seen from above, giving a stronger sense of its 3-D form.

Three-point low horizon ▼
In three-point perspective, you get the added dimension of lines converging to yet another viewpoint, this time on a vertical axis at right angles to the horizon line, above or below it. Where the object is suspended or sits below the horizon line, its base is clear. You will use three-point perspective when drawing buildings.

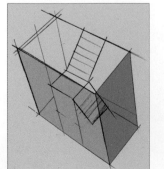

Three-point high horizon ◄
This is a very useful device when drawing interiors. The verticals slope inwards and converge at a vanishing point which is located far below the base of the object. Always draw in the point and the converging lines to ensure accuracy.

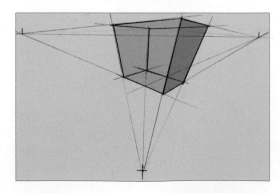

Practice exercise: Low viewpoint

The smallness of the mouse can be emphasized by the use of a low viewpoint to make the bed appear to tower over it. This offers the setting far greater dynamic and diminishes the stature of the mouse to believable proportions, even though he still remains the important main character.

Materials
- *cartridge paper*
- *pencil*
- *dip pen*
- *black Indian ink*
- *coloured inks*

1 Outline the drawing using a light pencil, then go over it with a dip pen and black Indian ink. Keep your lines pressure-sensitive and fluid.

2 When you have completed the initial drawing, let it dry, then drop confident washes on to the background, starting with a diluted ultramarine blue. Leave the main story elements as white. Add full-strength blue to the bed awning and cover, and a sepia tint to the bedposts. Use an ochre-sepia mix to colour the mouse and a vivid scarlet-red colour for the trousers.

Practice exercise: High viewpoint

The building-block construction of this sketch gives easy-to-follow clues to drawing the steps. The construction lines are shown in the three-point perspective diagram for high viewpoint on the opposite page.

Materials
- *'Not' watercolour paper*
- *pencil eraser*
- *0.3mm fineliner pen*
- *No. 3 round brush*
- *watercolour paints*

1 Draft a detailed sketch in pencil, then erase any unnecessary lines. Draw carefully over this outline using a 0.3mm fineliner pen.

2 Softly add washes of yellow ochre and sepia on to the walls and stones. Use vertical strokes to assist the illusion of dropping walls. Detail the bather with turquoise blue and cadmium red, mixing a flesh tone from yellow ochre and a little cadmium red. Leave unpainted areas of paper for sparkling reflections on the water surface.

Detailing settings

Familiarize yourself with the shapes of furniture and other everyday objects. Build up a good working knowledge of their construction and appearance by drawing them in different positions from all viewpoints. You can adapt furniture from basic cube and cuboid shapes seen in two- and three-point perspectives (see page 82). Practise often; the more varied you can make your room settings, the more interesting your picture will be.

◄ High three-point viewpoint
An airy modern room is suggested through the curved placement from a very high three-point viewpoint. Space is shown in an optimum way using this setting. To keep interest, cartoonists should always consider a wide range of viewpoints and vary them in their sequential frames. Consider yourself as a particular viewer, such as the fly on the wall.

Midground setting ▲
Placing the furniture in the midground offers open space in the foreground, thereby creating the illusion of depth.

Fore- and midground setting ▲
Juxtaposing the armchair and TV in the foreground with the furniture in the background gives the room more interest.

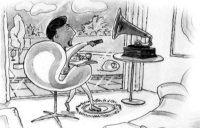

Office ▼
A marginally higher viewpoint allows us to take in more of the relevant information. The two employees sit opposite one another, yet only communicate through their webcams. Only the simplest objects have been necessary to set the scene without obscuring the joke. For the lightness of touch, a 0.3mm fineliner pen was employed. General office and desk ephemera are important too. Familiarity with detail within a scene often elicits humour, as observers recognize aspects of their lives played out in cartoon frames.

Contemporary room ▲
Placing the furnishings in the fore- and midground suggests a large, airy room. The curve of the sofa, the indication of the rug and the large picture add to the illusion. The focus of the joke is on the seated figure attempting to operate the old-fashioned gramophone using a modern remote-control unit. The clash of two opposing cultures strikes up such strong contrasts that they spark humour in the absurdity of the situation.

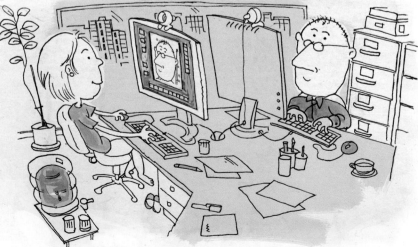

A setting using objects

The key to drawing settings is to use only what is necessary to tell the narrative. We are so familiar with a range of surroundings – our homes, offices, shops and streets – that it does not require many everyday objects to set a scene. Keep it edited and focused to optimize the element of humour.

Supermarket clues ◄

A few clues set the scene clearly in a supermarket: the trolley, large floor tiles, the posters in the background and the unstable stack of 'special offer' chocolate biscuits just waiting to be knocked down.

> **Tip:** Build up a reference stock in your sketchbook of objects seen in everyday contexts. Try to draw them later from different viewpoints too. Your knowledge and ability to render them will continue to improve with practice.

Using stereotype ▼

It is a known stereotype that women will spend many hours shopping for beauty products and the same time or longer applying them. By just showing the mirror image, there is no visual obstruction to the amusing array of cosmetics that fill the foreground table.

Practice exercise: Setting the incidentals

The soldier requires certain objects to set the miserable scene and convey the cartoon's narrative through its context. The bayonet fork toasting bread over a small fire while the rain pours down relentlessly are details that are key in communicating the message.

Materials
- *cartridge paper*
- *0.3mm fineliner pen*
- *No. 3 round brush*
- *coloured inks*
- *charcoal*

1 Use a 0.3mm fineliner pen to map out the basic outline of the soldier and his environment. Pay close attention to the details of rifle, sandbags, barbed wire, toast, fire and uniform.

2 Lay a pale yellow ochre tint across the drawing, excluding the stream of water. Leaving this important detail mostly white will focus the viewer's eye.

3 Add colour with washes of olive green (uniform), sepia (rifle barrel), pale orange (fire) and a blend of yellow and ochre (face). Charcoal strokes will add an appropriate grubby effect.

Lighting

Think about it: without light the image cannot exist to the viewer. Light describes form, explains the shape of an object and the direction of its surfaces and when light falls directly on to a surface a shadow is cast. Playing light and shadow is a powerful cartoonists' game and one that determines the mood and atmosphere of a situation, affecting how it is read. A night scene is fully comprehensible when the merest slither of light is used to illuminate a critical detail or action. Grasping the principles of using light will enable you to create more evocative and arresting cartoons.

To use light and shadow effectively, you need to understand the basic concept of light sources. Observe carefully the direction of light in your everyday surroundings, which means assessing where it is coming from and where it is going. Also take note of how an object that is blocking a stream of light casts a deep shadow.

Always feel in control of the lighting and do not avoid complicated lighting directions because it is more difficult to calculate the fall of shadows on people or objects. Follow your idea and recreate the effect live using lamps and models or a photo, then draw it. Where cartoons are not based in the real world, you can heighten effects and manipulate images to deliver the impossible. A scene that should have shadow may be devoid of it and bold, flat colour used instead as a stylistic substitute for form. The key point is that light should work successfully in your drawings and achieve the result you want.

Practice exercise: Creating mood and atmosphere with lighting

Artificial light can evoke anticipation and heighten tension within a scene. Here, the yellow glow shines in narrow bands directed downwards from the lamps. With its stark, suffusive rays, it makes any innocent bystander look mean when they are caught in its beam. It helps to consider the directional nature of artificial light in much the same way that a stage director does.

The light you cast on your players will bring them to the attention of the audience, giving them due focus and allowing them to perform to their best. However, with cartoons the reverse technique can be employed. With time to ponder each cartoon frame, placing characters in partially lit or unlit corners serves to make them conspicuous in their inconspicuousness.

Materials
- 'Not' watercolour paper
- pencil
- dip pen
- black Indian ink
- No. 4 medium flat brush
- No. 2 medium flat brush (for bouncers)
- watercolour paints
- charcoal

1 Start with a pencil sketch of the bouncer figures standing on steps in front of double doors, redraw it using the pressure-led line of a dip pen and black Indian ink. Use a medium No. 4 flat brush to deliver four broadening, downward strokes of yellow watercolour from the lamps towards the steps.

2 Using a smaller brush, drop a medium tone of Paynes grey watercolour on the men's suits and a mix of yellow ochre and red for the flesh tint on their faces, hands and the steps. Add a patch of yellow light streaming down the steps from under the door. Yellow has strong staining properties, so keep strokes light and don't apply too much initial paint.

3 Add a broad wash of Paynes grey over the area around the door and on the outer parts of the men, leaving the yellow intact. Note how the colour tints still show through. Outline the bricks with the pen and leave to dry before adding charcoal to roughen the texture.

Practice exercise: Creating a bright mood

The open sea is clear of obstacles that can create shadows. The sunlight reflects upon the water's surface, flooding the scene with bright, clear colour. The light,

summer mood is undeniably optimistic, relaxed and cheery. Shadows can add atmosphere, but they are unnecessary in this bright, vibrant composition.

Materials
- *cartridge paper*
- *0.3mm fineliner pen*
- *No. 4 round brush*
- *watercolour paints*
- *gouache paints*

1 Outline the inflatable and bather using the fineliner pen. Add a wash of ultramarine blue on to the background sky, guiding it around the figure. With a little more variance of stroke, repeat for the sea using cobalt blue.

2 Detail the figure with flesh tones blended from cadmium red and yellow ochre. Use ultramarine for the shorts and crimson red and cadmium yellow for the raft. Add a second stain of colour to give more form. Draw the foamy wave crests and seagulls with white gouache.

Practice exercise: Creating a dark mood

The pose of props and figure remains almost the same here, but the dramatic lighting changes everything. Successive layers of darkening tones bring intensity and depth to the colours. The still

shadowless figure is illuminated by the lightning flash, allowing the optimum contrast between the very dark and very bright tonal colours. The overall lack of shadows causes the picture to glow.

Materials
- *cartridge paper*
- *0.3mm fineliner pen*
- *No. 4 round brush*
- *watercolour paints*
- *gouache paints*

1 Draw the figure and inflatable in fineliner pen and drop a dark mix of ultramarine blue and Paynes grey into the background. Reserve the whites of the figure, the props and the lightning. Add a choppy wash of viridian green blended with a little Paynes grey in the bottom half of the picture.

2 Tint the man's flesh a pale mix of cadmium red and yellow ochre, his shorts ultramarine blue and the raft in crimson red and cadmium yellow. Use thick white gouache straight from the tube for adding the sea spray and dramatic highlights. Make sure you fleck it in a different texture so that the spray stands out from the rest of the picture.

Scene styles

A scene can be set in many different modes. The colours you choose, for example, might induce a mood that pervades an entire picture. It is also common for cartoonists to contrast the midground and background with the foreground action. This approach gives depth to the set, and space to work up the detail on one or more focused areas within a drawing.

A soft watercolour background that offers an overall impression is the perfect backdrop for a harder-edged line drawing. Where line is used throughout a scene, important elements can be drawn using a broader mark-maker so that they stand out from other drawn features. A translucent colour can also overlay a line drawing to reduce its sharp blackness to a tamer shade of grey. Minimal information in a picture, such as flat colour, allows the main subject matter to command the onlooker's attention. At the same time, this lack of reality demands that the viewer uses more imagination to read the image.

Deciding on the exact content, texture, level of detailing and colour of an image is to exercise creative powers over the whole of a cartoon world. Such freedom is not always easy to handle, especially when the success of a drawn frame or a running strip is hugely dependent on your choice of style. It is never wise to leave such a decision to chance. Instead, undertake thorough visual investigations and test out the techniques you are considering. The more you research and refine in the area of styling, the crisper and more polished the final result will be.

Practice exercise: Balancing line against selective colour

It is best to keep a complicated street scene to a limited media. Where the foreground and background are equally busy, reducing similarly toned colours is a good approach. It results in creating an overall harmony that is gentle on the eye and modifies the stimulation of too many hues. Applying the detailing using a crisp, solid ink line also brings benefits to the viewer.

Materials
• cartridge paper
• 0.3mm, 0.6mm fineliner pens
• watercolour paints

1 Draw most of the scene with the 0.3mm fineliner pen in a linear manner that delivers a solid, blocky style. The main couple should have an added holding line in a 0.6mm pen.

2 Give the drawing depth by colouring selected areas of the background in a monochrome cadmium orange, including walls, clothing, signs, shoes, windows, doors and hairstyles.

3 Add a pale wash of warm blue (cobalt blue with a hint of red) over the whole picture except for the main figures, where you should brush around the outline, to ensure that they stand out.

4 Detail the couple in crisp, bright hues: yellow ochre and cadmium red mix for the skin tones, cadmium red for the bench behind, pale blue for the bag and the shadows on the T-shirt and cadmium yellow for the dress. Remember to reserve areas of white paper for highlights.

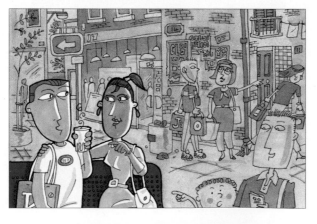

Tip: Silhouettes and strong, bright washes make an effective combination. The bold simplicity of these figures against the broad, colourful background strokes creates a clear, punchy impression.

Practice exercise: Using the contrast of soft wash and hard line

For some settings, a painterly approach may be the answer to achieving a bold final result. The combination of ink lines and soft washes always works well, provided the use of the line is kept to an

economical minimum. Its ability to hold the concentration within a drawing gives you licence to play with broader strokes and more artful interpretations with the watercolour wash.

Materials
* *rough watercolour paper*
* *watercolour paints*
* *dip pen and black Indian ink*
* *chalk pastels*

1 Add a purple watercolour wash on to the sky and sap green on to the foliage and leave it to dry. Add wet stains to form the volcano and smoke. Draw in the dinosaur using the dip pen and Indian ink.

2 Tint the dinosaur with a drier colour, dabbing the brush over its neck to create the illusion of scales. Dab gently over the foliage to create a sense of depth. Add yellow ochre highlights.

3 To enhance the mood and create more textures, gently drag the flat side of a purple chalk pastel across the sky and volcano and red pastel on to the eruption, to reveal the paper surface.

Practice exercise: Employing mixed media to promote unusual settings

Trying out new and unusual effects can positively affect the development of your own cartooning style(s). Try abandoning the usual white paper and coloured ink approach from time to

time and be a little more radical. A strongly coloured paper is a simple starting point. Continue the theme with creative use of limited media, such as sponged-off inks, collage or oil pastel.

Materials
* *red paper*
* *No. 2 round brush and dip pen*
* *coloured inks*
* *white oil pastel and charcoal*
* *calendar page from old almanac*
* *PVA (white) glue*
* *holographic star stickers*

1 Cut the red paper into an irregular shape. Draw the dreamer in brown ink and paint it with red ink. Sponge off the residue, leaving a speckled texture. Use white oil pastel for facial highlights.

2 Reinforce the outline using a dip pen and black Indian ink. Next, add an atmospheric cloud setting by using the broad, crumbly side strokes of a stick of charcoal.

3 Cut the calendar page of an old almanac into four rectangles. Add window shapes and lines using a round brush and black ink. Glue into position and add holographic star stickers.

Subject and background

Knowing what should dominate in a scene is a difficult choice and a number of factors come into play. Does the background need to create an intense or atmospheric space in which your characters have their adventures? If the answer is yes, then consider employing a dominant landscape. The choice of colours and range of textures you decide to use are vital in setting the scene successfully. For example in the case of a strip cartoon, the surroundings will be explored in finer detail as the narrative progresses.

Decide if you want a central character to dominate. If so, should he or she define their importance within the scene by being bigger than the others? If the answer is yes, it is a good idea to make initial working sketches to define scale and

contrast. This exercise will also serve to highlight any possible implication that such contrast may have on the composition of cartoon frames.

A setting without a dominant character or object, or group of characters or objects, often needs to be balanced, for instance in a narrative where all the characters take the leading role at various times throughout the story. Equal weighting can be achieved by using variations of mark, colour or texture to draw attention to different parts of a scene. An equal division of space between characters can work well, with each area able to display prominent characteristics without stealing all the limelight. It is worth considering these important questions at the start of every new project.

Practice exercise: Creating a dominant setting

A troll warrior is dwarfed by the cave he has entered. The vertical exaggeration of the frame accentuates the dominant setting. Light from the torch emphasizes the dark interior of the character's new-found world. The space above allows for adjusting the emphasis on dominance. The darker your washes in the cave, the greater the impression of dominance.

Materials
- 'Not' watercolour paper
- 0.3mm, 0.6mm fineliner pens
- hard sponge and kitchen paper
- No. 4 round brush
- purple coloured ink
- watercolour paints

1 Sketch the main shapes of the rock strata directly with the 0.3mm fineliner pen. Use the 0.6mm pen to draw the main outline of the troll in the lower section of the rectangle. Add the detailing with the 0.3mm pen.

2 Add a soft wash of cobalt blue from top to bottom. Work carefully around the outline and do not allow your brush to veer over the lines. While it is still wet, sponge off the centre of the wash to leave the palest tint.

3 Cross-hatch the interior of the cave to give it form and texture. Add a fluid purple ink wash overall. Be spare nearest to the centre where the light dominates and the figure takes centre stage. Remove any excess ink with soft kitchen paper. Colour up the figure: terracotta red for the tunic, pale blue for the helmet, weapons and buckle. Make flesh tones from a yellow ochre and cadmium red mix. Use cadmium yellow to highlight the side of the face and the torch's beam.

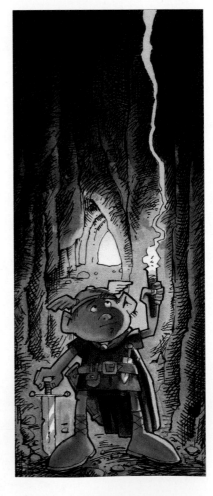

Practice exercise: Creating a dominant character

King Kong trounces Manhattan and works powerfully in the drawing due to the absurdity of the scaling, given the size of skyscrapers in the real setting. Humour and balance is provided by the minuscule, tinted banana advert.

Materials
* *cartridge paper*
* *pencil and 0.3mm fineliner pen*
* *dip pen*
* *black Indian ink*
* *watercolour paints*

1 Consider how Kong's hugely exaggerated proportions loom over the skyline. Make a soft pencil drawing. Do not be afraid to make any necessary adjustments to your composition at this stage.

2 Carefully outline the scene with the strong, even lines of the fineliner pen. Lightly detail the fur and features, and sketch in the building windows. Ensure that Kong's gaze is directed at the banana.

3 Hatch broadly with the pressure-led lines of the dip pen to evoke action, energy and terror. The long motion strokes around the ape emphasize the mood. Embolden the hatching on the buildings in Kong's shadow. Spot-colour the banana in cadmium yellow watercolour.

Giving equal weighting to subject and background

Striking a balance works for some subjects and should not be regarded as glib or compromising. Equal weighting is given to figure and background where no single element dominates over another. Sample a range of cartoon images from books or comics and discover how balance works with various subjects in the hands of the consummate masters.

Maze ▼
Sometimes the subject and background are linked so that it is impossible to separate them. Here, the connection is based on the concept of the map as the vital accessory to escape the maze. For the maze to be a functional part of the image, the figure must be trapped within it. Equally, the man is meaningless without the maze.

Catwalk model ▶
The subject dominates the background in size, but the activity of the crowd balances the scene. The use of pink pastel to indicate the curtains is all that is needed to link model with audience.

Scale and focus

Cartoonists need to be able to see from the viewpoint of their audience if they are to communicate with them effectively. The ability to direct the viewer's focus with ease to a particular event or an unfolding storyline is an art form in its own right, and gauging the scale and position of objects and figures in relation to one another is key in achieving this.

Scale in the cartoon world is governed by the shared experiences of audience and artist. We all know the relative size of a real person to their surroundings, to other living creatures and to buildings because we experience it ourselves. By using spatial organization – perspective, compositional

devices and overlapping picture planes, such as where foreground and background meet – we can then alter the relationships of scale by amplifying objects or diminishing them, and even create impossible circumstances.

The ability to experiment like this provides focus and gives cartoonists the chance to play with ideas, and create effects that would cost a Hollywood film director a fortune to enact in a film studio. Broadening your thinking on a grander scale will assist all aspects of your creative image-making. Try to consider the picture from the view of all 'players' in this production when making scale and focus decisions.

Focusing narrative structure

Unless it is carefully managed, an overcrowded scene can be confusing and distracting. To communicate the storyline instantly to the audience, it is essential to bring the key characters and the action clearly into focus.

▼ First draft
In the first attempt, four elements in the period room setting – the smoke, clock, oil lamp and plant – are misplaced. They are blocking the clear view to the unwelcome midnight visitor.

Second draft ▼
A slight rearrangement of the room and the subject and objects begin to work together. A clear, diagonal path can be plotted from the base of the lamp through the crystal ball to the plant pot.

Final image ▶
Having realized the best composition, the next consideration is colour. Mood is important here, as is the need to remain focused on the suspense of the moment. Using the single colour red, with its associations of power, danger, anger, horror and bloodshed, readily deals with the issue of focus. The stark white facial highlights and the window background stand out, and the dark silhouette of the monster is the most solid element.

Tip: When deciding on a colour to assist focus, make testers on photocopies or scanned printouts of your initial drawings. Never just accept the first version you try. Other options could be better.

Contrasts of scale

How do we know when the scale is correct? A character that is too small may be so insignificant as to lose their voice; too big and there may be an unintentional power struggle, or the force of a foe could be diminished. When the balance of scale is correct, all the elements should hold together at their varying sizes and the message will be clear.

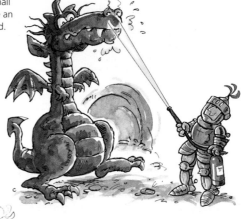

◄ **Overbearing dragon**
This first sketch reveals a very threatening dragon. However, it does not work because its size has reduced the knight so much that his most important accessory, the fire extinguisher, cannot be easily seen.

Non-threatening dragon ►
The knight is too large in this second sketch and on an equal footing with the dragon. The result is that the beast is no longer a threat.

Correctly scaled and placed dragon ▲
You know when the scale is correct because all intentions are clearly met. The cave no longer looks like a background afterthought, and by allowing space around it, the scene is offered a greater sense of depth. You should always be thinking to keep the drawing as simple as possible so that the narrative can speak clearly.

Scale and the subconscious

You can use scale to convey a hidden, almost subconscious message. What is merely suggested takes on the role of meaning and casts teasing doubt in the viewer's mind. Cropping out parts of a composition heightens the element of anticipation. What will happen next? Who might be lurking behind a door? The unknown increases the danger levels, so that when the main character's features are also partly obscured, we are left in a further state of disquieting uncertainty. What are they going to do? What is it that they can see that is causing such great concern?

Distant spaceship ▲
The spacecraft is in full view, but the distance of the astronaut from his ship lessens the impact. At the same time, it raises a question for the viewer. Is he endangered by his distance from the ship? In an emergency, can he safely return?

Nearby spaceship ▲
The image still reads perfectly clearly when only a quarter of the spacecraft is in view. The revised composition has more impact and intrigue to offer, though it raises fewer questions in the viewer's mind.

The comic page

A blank page requires planning to create a structure that can be followed easily by the reader. This chapter focuses on the cartoonist's skills to alter pace and emphasis through cropping images and sequential frame layout. The placement of words is important, as is the correct use of colour, tone and contrast.

Conveying action

The development of cartooning from static frames into action depends on one major element: time. Images set in time become a sequence that is viewed through a set number of seconds, minutes, hours and so on. The images themselves may not be intended to be perceived in real time; it could be implied that time runs faster or slower. For example one image may show the bright sunlight of midday, while the next the deep-orange skies of dusk.

Creating a sequence of images demands that you plan and develop them with an idea of a story or events taking place. Each frame in the story should focus on a particular event that occurs in time, seen from a particular viewpoint. When the different frames are viewed in an ordered sequence, the viewer runs them like a film before their eyes, and the illusion of movement is experienced. This principle is skilfully played in the hands of the film director; cartoons are films that are never shot with a camera nor intended for animation.

Showing action well in a frame depends on the cartoonist drawing as though they were inside the frame, watching intently from a strategic position. It is the variety of different frames connected in a sequence that brings the comic strip to life and holds the viewer's attention. Wherever contrast exists, interest is bound to follow. Pacing a sequence is one of the hardest lessons in cartooning, and in many ways is of greater importance than the ability to draw. If a strip does not offer variation in action, the reader's attention may waver.

The close-up

A view at close range, at times only 1–2cm (3/8–3/4in) from a face, hands or an object, is known as the close-up. Focusing attention on something brings it into greater significance in the frame. Close-ups are usually designed to work in conjunction with medium and long shots for optimum interest.

Tip: Close-up views can become abstract and often unrecognizable. Zoom in tightly on a familiar part of an object or objects and note the visual changes that occur.

Running a sequence ▼
Decide how many frames you wish to break the movement down into and think of it in the same way as a fast-stop frame camera. Whether you run the sequence along a line or in a vertical drop affects interpretation. Little position change infers split-second timing.

Action close-up ▶
The hand opens the door with caution, and the deliberate cropping of the frame succeeds in holding the tension in the scene. For the sketches, use your own hand as a reference and draw a simple part of the door. The long crop ensures a tight edit.

Freezing time

A classic way to show the transition of time is by freezing the subject in the foreground while making changes to the background. At the other extreme, repetition of a background scene can be used to represent monotony or, with small alterations, longer time changes.

Using background action ▼
Here the subject remains constant while the surroundings show movement in time. The bonfire has burnt to ashes, lights have appeared in the buildings and the sunset has turned to twilight.

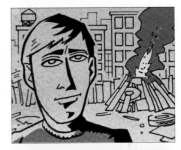

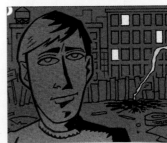

The long shot

A shot that shows a scene from a distance does so to stress the environment or setting. A long shot that does not develop along the line of a narrative is known as an establishing shot, because it provides the audience with an overview prior to the action. Sometimes this is a bird's-eye view or in other cases simply a very wide-angled overview. Long shots should still have a focus or point of interest – in this frame it is the moon buggy which attracts the attention, as this builds up a sense of anticipation in the viewer.

◄

The time taken for the moon buggy to approach is intended to be several minutes. To convey the span of time in pictorial terms, three frames – the long, medium and close-up shots – are created and overlapped in a diagonally stepped configuration. The three frames are then linked using repetition on three different scales.

Silhouettes in sequence

To eliminate the distractions of colour and fine detail, convert the identifiable shapes of people and objects into flat, black silhouettes. The stark contrast and heavily edited scene result in forcing the eye to appreciate the movement and placement of the characters and objects in terms of picture planes and spatial relationships. Silhouettes also offer an effective way to simplify the elements of a composition at the rough working stage. To elaborate on detail at this point is wholly unnecessary and may in fact make it harder to appreciate the flow and construction of an animated sequence during planning.

Tip: Cut some random shapes from black paper; then with little premeditated study, arrange them on a number of white sheets of paper representing a sequence. Where the sequences work strongly, sketch these compositions as a future influence.

Less is more ▲
This story is told in five frames and understatement is used throughout. In colour, the dog's personality could interfere with the simple concept. The empty frame increases the drama.

Devising layout

The art of the comic page relies as much on well-constructed layout as it does on superbly imaginative images. When it was first introduced in the late 19th century, the cartoon narrative took the simple form of a series of rectangles that were read from left to right. These strips usually appeared on the back pages of journals and newspapers, and consequently were given very little space.

The evolution of comic papers and comic books saw an increasingly dynamic use of layout, reaching its height in the 1950s, 60s and 70s in the superhero fantasy worlds invented by DC and Marvel Comics. Frames suddenly altered their shapes and sizes across double-page spreads, which enhanced the narrative and released energy and excitement in these amazingly popular comic books. The development of the format into that of the graphic novel originated in the 1980s in *The Dark Knight,* a new Batman epic by the artist Frank Miller, which was produced as a comic-book series.

Under these influences, comic artists have been pushing the boundaries of the structure that composes the layout: the panel grid. A sound understanding of the basic formats will give you the confidence to construct your own panel configurations in ways that are visually exciting and enliven your cartoon narratives. Begin with the universally understood formats, and once you understand what it is that makes them work so successfully, begin altering the size of frames or their number on the page. Your audience is key at all times.

Panel variations

A basic panel grid of 3 x 3 panels equal in shape and size makes a good starting point. The regularity of the format offers strict boundaries for testing your skills. They will keep your drawing 'tight' into the subject and well-focused, thereby encouraging you to harness your creative energies. Once you have grasped the concept, you can begin to alter the page layout and explore the impact of your narrative by using half-size panels, double panels or even overlapping panels. But remember to keep your audience in mind.

Tip: Devise your own panel grids and test them with your cartoon narratives. Assess these experiments and learn which are the most successful. Develop these first ideas into more complex layouts.

3-column, 9-panel grid

3-, 1-, 2-column, 6-panel grid

multi-column, 5-panel grid

◀ **Panel examples**
You can manipulate a three-column, nine-panel grid (far left) in a number of ways. One long panel offers cinematic scope to the layout, while having two equal panels offers balance (centre). To make the layout more dynamic, you can either expand or compress the panels (right).

Panels and shapes

Panels overlapping shape

Overlapped panels and shape

◀ **Creative panel interpretations**
Using a mixture of regular-shaped panels and free-form shaped panels can add so much excitement to your layouts. In all these examples there is still considerable structure, which is necessary for the storylines to be followed with ease.

Breaking the box

The freedom to break out of the box and draw outside its confines can heighten tension. It also allows one drawing to be a little larger than the others on a page. This is a device that is commonly used in cartooning, not only because it draws the eye of the reader but for the beneficial effect it can bring to a layout that is over-structured or even verging on the dull. Like all such devices, however, it should be used sparingly, such as when the page needs a lift or to emphasize a detail. Overuse will inevitably reduce it to a cliché.

Adding drama ▼
The vampire is made scarier if he appears to be stepping out of the frame. The border emphasizes the break-out, but should be used only as a last resort in place of a breaking point. In the coloured version, the background has more depth than in the one below, where it floats as a ruled vignette.

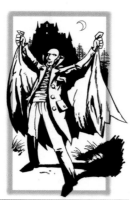

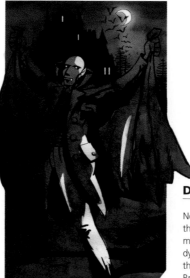

Break-out, close-up ▼
The monster is more threatening for breaking the frame, and demonstrates how this effect works equally well in close-up. Although the enlargement is relatively small, it creates a significantly bigger impact on the page.

Dynamic composition

Not all drawings should be kept within the box-panel format. It can restrict movement and action, preventing the dynamic interaction of characters with their environments and with each other. Breaking the box panel can have a liberating effect on a page.

Natural break-out points ▲
Most drawings will have a 'natural' point at which it is reasonable to break out of the rigidity of the frame. Usually the breaking action will draw the eye and direct it to the next frame. Here, the spaceman's pointing hand and outstretched foot make this obvious.

Breaking sequential panels

The technique of breaking through panel boxes can be used to show accelerated movement through time. Demonstrated in a fun way here, it is another common device in cartoon storytelling that works for all styles.

Time and motion ▼
The baseball player's powerful swing is emphasized by breaking through the lines of the three panels. Each panel represents a fraction of a second in time, 'slowed' by its separation.

Speech bubbles

Not all cartoons have an obvious running pictorial narrative and may require words to carry the theme through from beginning to end. Some are intended as conversation pieces, where characters speak to one another within the frame, conveyed through white oval shapes known as speech bubbles or balloons. Many variations exist around this theme and it is important that they are easy to follow and prominent, but that they do not cause overcrowding in a frame.

There is a specific protocol that artists adhere to so as to avoid legibility problems or confusion in the order of conversation. This has been largely derived from the strip cartoons, which have traditionally been published in newspapers and journals.

A single 'gag' cartoon normally placed within the width of a column of a newspaper tends to be captioned above or beneath with one or two lines of concise text. Sequential strip cartoons have running captions (in a thin white rectangular box above or below the frame), as well as speech bubbles. These help to set the scene by relaying information on place or time or by giving the context or development of events in one or more frames.

The importance of speech bubbles should not be underestimated and it is vital that lettering inside them is clearly formed with accurate spelling and grammar. Stylized hand-lettering is still the favoured method, although suitable fonts have also been developed to enable setting by computer.

Word and picture partnerships

Words and pictures always work together and they should not be considered in isolation of one another. The expression on a character's face speaks as loudly as the words which accompany it. Care should be taken to ensure that figures are correctly placed and address relevant characters in the frame. Minor characters may sometimes be drawn in the distance and have smaller speech bubbles.

Be sure to have your script for a cartoon drafted with the roughs for your sequence of frames. All adjustments

should be made before any drawing is attempted on the actual artwork. Too many words in a bubble can become crowded, confusing and overcomplicate the communication of the message. Revise the speech as many times as it takes for it to become effective.

One final note; if you choose to initially plan the pictures ahead of the words, allow spaces for the speech bubbles to be placed.

Multiple speech-bubble styles ▼
This witty gag involves speech being communicated by three different means. First, the spaceman 'thinks' aloud on the page and a 'thought' bubble is identified inside a dreamy cloud-shape. His language translator speaks in alien bleeps and this mechanical voice is encapsulated within a jagged-edged bubble. Finally, the alien bubbles duplicate the exact word in the same peculiar font to show recognition of an identical language being spoken.

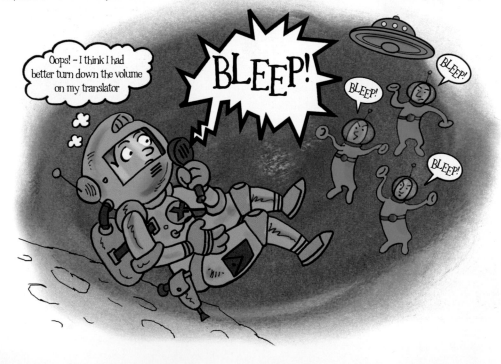

Speech-bubble styles

Styles of bubble are dictated by the nature of dialogue within. External dialogue (speaking) is commonly enclosed within a word bubble or balloon with a pointer or tail angled towards the speaker's face. Internal dialogue (thought) tends to appear

within a bubble shaped like an oval cloud. It has a trail or small circles leading down to the thinker's head. Speech bubbles can have different edges to denote various types of speech, such as exclamation and outburst or whispering.

Joining and splitting speech bubbles ▼
It may be necessary for a character to make a longer speech and you may wish to adopt a device for effective splitting to allow the character and reader a break. Speech bubbles link easily by joining them with a short, narrow 'path' or morphing the shapes of two or three bubbles can create an interesting shape to complement the artwork in the frame.

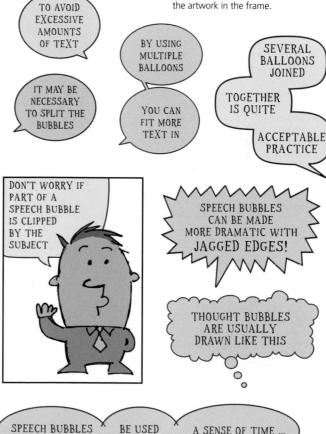

Dialogue inside the frame ▲
The smaller figure begins the conversation as his speech is at the top of the frame. At the end of his sentence, the eye naturally flows to the second bubble belonging to the other character. The first speaker's second bubble is joined to the first by a path, dispelling the need for two pointers heading for the one head.

Expression through bubbles ▲
The snappy growl of the dog is illustrated by the toothy-edged bubble and the upper case onomatopoeia (a word whose sound defines it when spoken). The exclamation mark at the end offers graphic description.

Time-based speech bubbles ▲
It is not just a running sequence of frames or the use of repetition that give a cartoon its sense of time, captions which overlap or run into each other have a similar effect. Dividing the words of a sentence or phrase equally and placing them in several joined bubbles makes that phrase seem transitional and passing between the pictorial content.

Directing the comic strip

Think of your gags and strip cartoons as small examples of 2-D theatre. The actors are on stage, the props are in place, the story has been scripted, but no one knows what to do, where to go or how to put on a convincing performance for the audience. A director is needed to put everything and everyone into order, from improving the first drafts to perfecting the final piece. As well as being the scriptwriter and set designer, you, the cartoonist, are the director of your own creation.

Directing the comic page demands that each frame is staged so that it communicates the story properly to the audience. A key part of the process lies in knowing how to edit your material to leave just the right amount of visual information. Details that add nothing to the narrative or explain very little about

a character should be stripped out. This may sound daunting, but you will find that it improves the action enormously. Make sure that you capture the right mood in each frame by carefully considering the intensity and direction of the light source and the 3-D modelling required. Also consider your colour choices: too many colours will cancel out the page in a jumbled mass of hues and tones; too few colours could deprive the cartoon of its spark.

There is no shortcut to this necessary methodology. Just as the director revises a script or rehearses again and again, the visual artist must get into the habit of drawing and redrawing until all pictorial problems are solved and the final piece is as good as it can be and ready for public display.

Removing unwanted scenes

A comic strip is sometimes at its most effective when the content is reduced to the barest essentials. Cultivate a ruthless attitude to your work, chopping it back where you see the need. Always have the reader in mind; think about how

they will read the sequence of frames and interpret the visual language you use, and how you can stop them from 'switching off' by sustaining their level of interest. If a frame duplicates an idea or adds little to the storyline, remove it.

The final sequence ▼
The inquisitive visitor touches a serpent's egg with dramatic consequences. The use of a limited colour palette and overall blue-tinted background assists the focus of the comic strip.

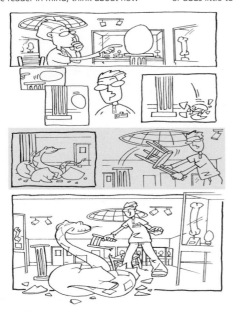

Sequence pre-edit ▲
The sketches on the third row (tinted blue) repeat similar information to that shown in the final frame. It is surplus to requirement, so strip it out. Overstatement – saying too much or repetition of information not used for effect – is as bad as understatement, where not enough information is given to make full sense of the cartoon.

Dramatic focus

Two comic-strip versions of the same storyline show how much punchier a cartoon can be when the image sizes are varied and laid out in a more dynamic way. The subject of this narrative is an explosion and the frames present a clear build-up and a dramatic conclusion. By only showing the hand of the protagonist in frame two, the reader is left with a strong sense of mystery, a teaser of unknown character identity which may or may not be revealed in later frames.

Cartoon strip pre-edit ▼
Using limited colour also delivers impact to the sequence. Black, white and red are a known powerful colour combination. Limiting the range and view, and specifying limited colour, all heighten the subject and keep the viewer strongly focused.

Cartoon strip post-edit ▼
In this post-edited version of the same narrative, the variation of the panel sizes and the cropped images within the frames lead the viewer to focus more closely on the events. The decision to change the delicate, pointed finger to a slamming fist offers a more appropriate continuity to the three frames, and also gives a clear signal that the explosion is no accident, but rather a malevolent action. The staggered 1, 2, 3 diagonal layout that takes it to the final moment serves to heighten the drama.

Tight scripting

Consistent simple images work best for the quick gag. You should aim to get to the point as quickly as you can, and keeping the build-up to only a few frames will help. Maintaining a strong thread of humour will also enable you to hold the viewer's attention.

Bitesized frames ▲
Practise illustrating a simple storyline to understand how to edit your narrative. Four frames are the maximum number needed: the first two show the discovery and inspection of the apple; the third illustrates its active demolition. The final frame displays the stripped core and bloated caterpillar. The whirling action of the third frame is key.

Cartoon style

The comic narrative opens up whole worlds of possibilities for cartoonists in which to express their creativity and let their imaginations run free. The genre includes dark, brooding fantasies, whimsical stories of everyday life and thrilling tales of superheroes, to name but a few. Choosing the medium and drawing style that matches the subject matter is crucial if a cartoon is to deliver its intended meaning and also evoke the appropriate response from the audience.

A subject that is intended to convey accurate information might be drawn using the traditional techniques of dip-pen cross-hatching with added tints of colour. On the other hand, a narrative strip may employ relaxed brushstrokes without a keyline to anchor the details. The power of black ink cannot

be overestimated: line images in black and white can have little subtlety on a page and appear stark when passages of shadow are inked in. Children's comic strips and picture books are created in a much lighter style that often uses a definite pencil line with added watercolour washes or colouring pencil shading. The children's author and illustrator Raymond Briggs is known for his unique drawing style of soft-pencil shading in harmonious, naturalistic colours.

The interpretation of the characters in a strip can have a huge impact on the style in which it is illustrated. Children's author Lauren Child is a case in point. Her eccentric figures demand an unconventional world to inhabit, and their bright, flat digital backgrounds use collage and sketchy drawing.

A hard-hitting image

Images that are striking should have a strong focus, dramatic composition and effortless appearance. Don't expect a perfect composition the first time you put pencil to paper. Remember that revising and editing always brings out the best in drawings and therefore it is more likely to be your second or third draft that succeeds. Adopting sharply foreshortened viewpoints and making extreme comparisons of scale are techniques that play an effective part in creating a forceful image. Add strong lines, black ink shadows and densely saturated 'danger' colours to the mix and you will have created a cartoon that emanates great power, tension and atmosphere.

First draft ▶
The page needs to be filled with a dramatic robot figure. In this first sketch, the robot is conceived as being gigantic in size and only half of him is seen. This is conveyed by comparing the robot to a boat.

Second draft ▶
This view is much more imposing. The robot still clutches the boat, but is striding across the city. The viewpoint has been lowered in order to overemphasize the sheer scale of the robotic monster. The tilt of the figure and the lifting of the leg into an action pose add dynamic force to the image.

Final image ▲
The final artwork is carefully drawn in Indian ink using a No. 4 round smooth-hair brush. The intensity of the colours is obtained by combining dyes with watercolour. The white highlights infer the gleam of metal.

A whimsical approach

Subjects that cannot be illustrated in a straightforward way can benefit from a whimsical approach. Here, the split frame breaks up the picture and offers a visual conceit: the robber is at liberty to hop frames to where he is out of the reach of the police car. It provides a good opportunity to offer the reader a chance to focus twice on the narrative from the point of view of the police officer and the robber, especially as both characters are essential to make it work.

Using stereotypes ▼
Drawn with no attention to realism, the cartoon carries light-heartedness into what is actually an extremely serious situation. Note the robber's stereotypical dress and 'swag' bags.

Keeping it light ▲
This series of sparsely detailed frames carries the simple narrative of a barefoot walk along a gravel path. It is the light touch that gives this strip its particular charm. The humour is focused on the different characters and their uncomfortable journey. The precise gait of each figure is determined by body size and shape. For example, the slimmest figures have greater limb mobility, enabling them to move on tiptoe.

Tip: The application of drawing style is rarely actually shown in the cartoonist's gag. Using a dip pen, black Indian ink and watercolours to tint the image, have fun showing the pen nib drawing a calligraphic moustache. By doing this the viewer is allowed to share the workings of the illustrator's mind as he or she doodles the face and moustache.

Practice exercise: Line and wash

Choosing a style that is appropriate for your comic strip is essential. Here, the Victorian horror tale of Jekyll and Hyde works best employing the traditional techniques of dip-pen line and ink wash. This approach mimics the engraving styles of the 19th century, where depth of field and atmospheric shadows were created using heavily layered cross-hatching techniques.

Materials
- *cartridge paper*
- *dip pen and black ink*
- *coloured inks*
- *No. 5 round brush*

1 Lightly sketch the composition, allowing plenty of space for adding colour and tone to your drawing. Try to work your roughs up to a high level of finish so that you have less work at the next stage.

2 Closely hatch the main figure, objects and background using a dip pen and black ink. Deepen the shadows on and behind the character yet further using a relatively dry brush and ink. Retain areas of unused paper for highlights.

3 Tint your drawing. In the centre background, a wash of yellow and pale blue ink merges on the paper to make an eerie green, which provides the perfect creepy atmosphere.

Tip: This image employs a 0.3mm fineliner pen, white gouache paint and black Indian ink on smooth paper. Blacks and whites are exploited to display the form of an object without using any tone whatsoever. Draw the snail outline clearly with the fineliner, add the texture pattern of its flesh, before creating a 3-D walnut whip shell, first with whorls of black and then similar marks with opaque white gouache.

Practice exercise: Dyes and masking fluid

Cartoons that require a crisp, clean style need to be executed in definite stages. This image of young people on a city street corner is created in a style that is equal to its contemporary setting. The figures are drawn using a brush outline and then masking fluid brushed over them to prevent the background wash

from touching them. The masking fluid dries to a rubbery texture that can be peeled off to reveal a hard-edged, reserved area of unpainted paper. The focal features are then painted in clear, bright colours, which stand out in strong contrast to a background that is almost monochrome.

Materials
- *watercolour paper*
- *black Indian ink*
- *No. 2 round brush*
- *masking fluid*
- *watercolour dyes*

1 Sketch the figures and foreground details using black Indian ink and a brush. Lessen the pressure for the background outline so that the buildings appear lighter on the page.

2 Use the masking fluid to mask out the meteorite trail, some of the background windows and the interior of each figure. Leave the masked-out areas until they are completely dry.

3 Lay a smooth, graded colour wash across the paper. Brush from the top of the drawing, starting with pale blue and then changing to yellow about halfway down.

4 When the wash is dry, gently peel the masking fluid from the applied areas. Note the clean-edged whiteness of the paper where the fluid has masked it. Using undiluted colour, to retain the luminescent qualities characteristic of inks and dyes, paint the main figures and add tone to the other focal features, such as the wall.

Tip: Masking fluid is a latex/ammonia solution that should be treated with caution. If spilt on fabric and not washed immediately with water, it dries to form a rubbery, elastic crust. Brushes must always be washed out immediately after using masking fluid, or they will become coated and hardened. Do not allow yourself to become too reliant on this medium – wax or oil pastel resists offer masking out with softer edges and texture.

5

Projects

In this chapter you will undertake a range of projects focused on caricature, strips with and without words, mixed media, animal characters, nightscapes, different scenes and new drawing styles. Each task offers the opportunity to practise and ground the disciplines you have learned and bring them to a satisfactory completion.

Political cartoons

Humour can cut through the complexity of serious issues and bring them to the attention of the public. Political cartoons have a long tradition of using visual jokes to make comments intended to evoke a response, convey a message or express an opinion. In order for a joke to succeed, it must hit the right chord with its audience and be visually striking and therefore memorable.

This project is about the threatening issue of global warming. Continual media coverage has provided a wealth of powerful images that can be used to sum up the message. The cartoonist might select one as a starting point from which to adapt a cliché, or develop an original narrative. The humorous touch is light, but ensures that the point is effectively made.

Final image

Ensure that you have followed your original intention to convey a heavy mood without being completely pessimistic. Subtlety and sensitivity in displaying the polar bear's innocence are key to retaining a strong sense of hope. Consider how you worked through each stage of the project and how you might improve a future attempt.

Materials
- *layout paper*
- *2B and 4B pencils*
- *black watercolour*
- *'Not' watercolour paper, A3*
- *dip pen and black Indian ink*
- *light box (optional)*
- *oil pastels*
- *charcoal*
- *No. 2 round brush*
- *white gouache paint*

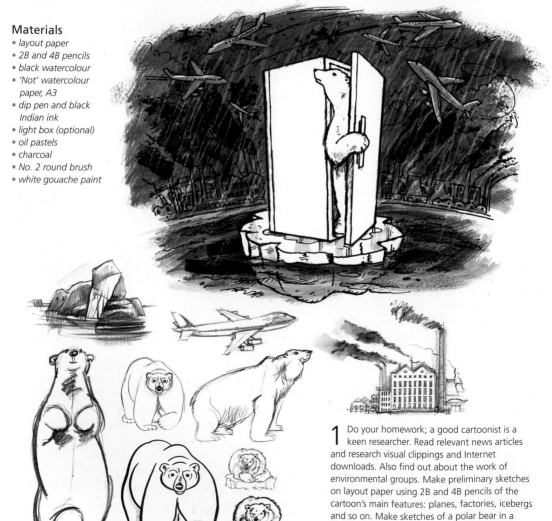

1 Do your homework; a good cartoonist is a keen researcher. Read relevant news articles and research visual clippings and Internet downloads. Also find out about the work of environmental groups. Make preliminary sketches on layout paper using 2B and 4B pencils of the cartoon's main features: planes, factories, icebergs and so on. Make sketches of a polar bear in a variety of styles and poses. Keep drawing and experimenting until you are happy with the results.

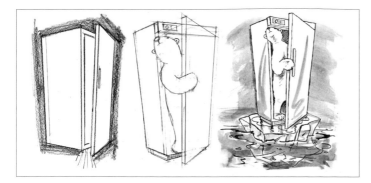

2 Plan the focal point of the cartoon. Begin with the main idea: the polar bear in the fridge. The thinking behind this concept is that if the Arctic ice is melting, where else might a polar bear go to find ice? As a familiar domestic object, the fridge is one environment that is guaranteed to raise a smile. So the bear in the fridge it is! Confidently sketch out the idea in pencil, making sure that the polar bear's pose conveys the key message of inquisitiveness and confusion. Then set the central image in context, placing the fridge on a melting ice floe afloat at sea. Now outline the finished sketch using a dip pen and black Indian ink and add tone with soft, dilute washes of black watercolour.

3 Take the layout paper and trace the outline of the polar bear on the ice floe. Refer back to your preliminary sketches and add the background details of swooping planes and belching factories. Revise this composite stage as much as is necessary, paying attention to the polar bear's expression as a focal feature of the cartoon.

Melting planet

There are many solutions to getting a message across in an arresting way. Above, an anthropomorphized Earth is equipped with two hairdryers, which are plugged into the world's economy and melting the ice caps.

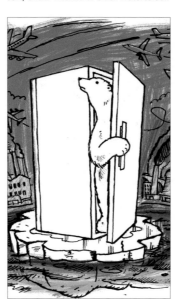

4 Transfer the finished sketch to the 'Not' watercolour paper. Trace it using a light box or against a secure window. Convert the image to line using a dip pen and black Indian ink, varying the pressure and width to give life and movement.

5 Create the atmospheric skies and sea using coloured pastels and charcoal. Spatter the background lightly with black ink by flicking the end of the brush. When dry, use the No. 2 brush to slash in the rain with diagonal strokes of white gouache from the tube.

Here, another interpretation of global warming depicts the world as a melting ice-cream cone.

Portraying children

Children are important as cartoon characters: they are cute, funny and innocent, and these traits can be used to convey big ideas. Cartoon history is full of classic examples. Charles Schultz's *Peanuts* strip features the wisdom of Charlie Brown and his friends, while in the children's comic *The Beano*, the anarchic Bash Street Kids strive to outwit authority, as does the impish yet lovable Dennis the Menace. More recently, the ethical and intelligent character Lisa from *The Simpsons* family spotlights all kinds of moral issues.

Cartoon children can also play their real-life role of endearing small people delighting in and discovering the world around them. Follow the usual rules of proportion when drawing children, and keep features unfussy and complexions and clothing bright. Simplified drawing styles are the most successful.

Final image
This image's success relies on the harmonious linking and direct contrast of the lines. Ensure that each child is displaying a a unique expression and an individual personality. Clarity of drawing and use of fresh colours will unite the final result of the composition.

Materials
- *layout paper*
- *soft, blue pencil*
- *A4 smooth watercolour paper*
- *0.3mm fineliner pens*
- *watercolour paints*
- *No. 3 round brush*

Tip: Begin by sourcing a range of children's illustrators and cartoonists. Imitate their styles in your sketchbook and note how simplicity of features is common to all. Practise fullness of expression with simple shapes and lines.

1 Sketch your playground composition on layout paper. Consider the best viewpoint to show all the action. From above, the interaction of the children and the shapes of the equipment are easily seen. Make any adjustments to character placements at this stage.

2 When you are satisfied with the basic layout and its main elements, carefully draw the children using a 0.3mm fineliner pen on smooth watercolour paper. Make sure the angles are correct and lines are clearly drawn, with no ambiguous details or sketchy marks.

3 Colour each figure with strong, flat washes applied with a No. 3 brush. Note that every child wears colours that link to the red equipment and contrast with the green of the playground floor. The contrast is strongest where these colour complements meet.

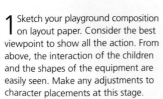

Skipping child

This study, made with a 0.3mm fineliner pen, is trying out a more sketchy, broken line on smooth paper than the previous example. The face is also more modelled with fully formed, naturalistic eye sockets and cheeks.

Stilt walker

For this character, a loose, brushy line was employed, made with black Indian ink on watercolour paper, to assist the movement within the activity. This technique matches the freedom of washes for the hair, top and trousers.

Hoodie

Smooth paper allows bright washes to be brushed over the surface, strengthening the impact of the figure. A brush outline lends a solid feel to this colourful character. The finer details are added using a 0.1mm fineliner pen.

Skipping child

This child is slightly plump and in need of some exercise. The roundness of the body, arms and legs cannot match the almost spherical moon face, with the long, downturned line of mouth arcing across it. Note the size of the shake.

Yo-yo kids

The style used here imitates the typical drawing style of a child in which the body tends to be elongated and the hands and facial features are greatly simplified. The heads are important and therefore exaggerated in scale, but the ears look as if they are merely stuck on and the hair is drawn as short line strokes or curly scribbles.

Dancing kids

This drawing is about the interaction of the figures with each other and with the music player. A 0.3mm fineliner pen delivers a broken line on textured watercolour paper, and bright watercolour washes are added to keep it lively. The slightly curved backs and fully extended arms and legs of the characters suggest the sense of movement. Defying actual possibility adds humour to these dancing kids, as seen with the breakdancing boy on the right. Giving him the same smiley, effortless expression emphasizes the absurdity of the situation.

Capturing street life

Teenage life certainly has edge. It is a vibrant, energetic world in which dress code, language and music are key elements of identity. Recognition matters, and certain colours and designs are worn as 'tribal' signifiers. In addition, body language and the way in which they hold themselves capture the character of young people.

Colour is important too. Choose the colours of the environment carefully, so that the all-pervading mood seems authentic and consistent with current social and fashion trends.

To inject social realism into characters, the cartoonist must become a keen observer and recognize the subtle traits and tiny details that demarcate the different social groups amongst teenagers. British cartoonist Michael Heath is a practised observer of the everyday who understands the vast amount a small detail or accessory can tell the audience about a character.

Final image

In this project, a skateboarding crew has been chosen as a visually clear statement of contemporary youth. The teenagers stand out well from the arty, experimental background colour and texture, although there is a colour harmony between the background and foreground of the image. Observation of minor details, such as shoe style, cut and length of trousers and T-shirt logos, as well as capturing the pose, is crucial.

Materials

- cartridge paper
- soft pencil
- rough watercolour paper
- light box or tracing paper
- dip pen and black Indian ink
- No. 4 round and medium, flat brushes
- coloured inks
- watercolour dyes
- wax crayons

1 Start by sketching the main figures on cartridge paper in soft pencil. Pay attention to the body shapes: teenage boys have angular body lines, squared features and slender, healthy physiques. Keep in mind that attention to detail is essential, including baseball caps, baggy shorts, chunky trainers, fringes, goatees and sideburns. Assess stance and character, and adjust as necessary.

2 Once the composition is established, transfer it to the rough watercolour paper. Either use a light box or a piece of tracing paper to save time and maintain the accuracy of the original. Ink over the lines, varying the pressure on the nib so that the different thicknesses of black enliven the image.

3 Feather the outer lines with a brush to denote freedom and give a sense of energy. Attitude is important to the message of this cartoon. If young people are your intended audience, you should endeavour to maintain sharp, authentic character studies.

4 Colour clothing according to the latest fashions and apply as flat ink tones. Use subdued hues of yellow and red mix, green, blue, yellow and reddish-brown. Set the figures against a lively background of wet dye colour washes and wax crayon scribble in blue, red and brown hues.

Tip: Background texture is sometimes all that is needed for a character scene. An assortment of experimental marks, using a mixed-media cocktail of liquid dyes and controlled waxy scrawls, enriches the foreground scene. The texture and tonal ranges give substance without crowding.

Students and shoppers

In this character study, two students lounge and sprawl. The armchair assists the student's slouch, the lamp is a focal point for their chat and the books imply that they are studying.

These girls binge on fast food with a casual attitude to match their carefree age. The phones and shopping bags say it all.

Creating caricatures

The key to good caricature is a practised understanding of portraiture, and it is for this reason that some cartoonists never venture into the genre. However, those who have a natural flair or yearning to develop their figure-drawing technique will enjoy testing their skills. The subjects do not necessarily have to be as famous as the personalities featured on these pages, but they should be readily recognizable in the context in which their representations will be seen.

A caricature of a person should be far more than an illustration with exaggerated physical features; it should also aim to express their personality with accuracy. It is important to give the viewer as much visual information as possible about the person, and distinguishing features, height, stance, distinctive body movements or poses are essential clues. The more famous or publicly exposed a subject, the more a caricaturist must sharpen and hone the character study. The musician Jimi Hendrix was renowned for his blistering guitar playing and psychedelic improvisations. He would set light to his guitar on stage and so is often personified in caricature as a fiery, god-like figure.

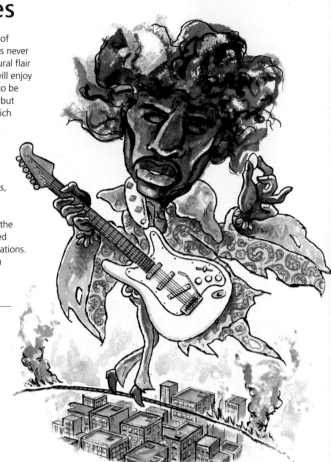

Caricature: **Jimi Hendrix**

Final image

Jimi Hendrix's incendiary guitar and lifestyle are shown here in the flaming tightrope burning at both ends. His position above the city skyscrapers reveals his towering status among rock guitarists. Throughout this project, it is key that you have not simply copied and exaggerated a portrait, but that you have considered his larger-than-life personality.

Materials

- cartridge paper
- pencil
- rough watercolour paper
- dip pen and black Indian ink
- No. 6 round brush
- watercolour paints

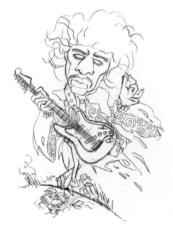

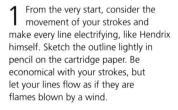

1 From the very start, consider the movement of your strokes and make every line electrifying, like Hendrix himself. Sketch the outline lightly in pencil on the cartridge paper. Be economical with your strokes, but let your lines flow as if they are flames blown by a wind.

2 Transfer or redraw the sketch on the rough watercolour paper in black Indian ink. Mix plenty of slate blue paint and brush it over the head using light strokes. Although the colour blue is far from reality, it offers a 'monumental' quality. Leave areas of white paper for highlights and more colour.

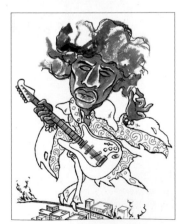

3 Deepen the washes to define the facial features further. Leave the eyes blank and statue-like to emphasize the focus on Hendrix's music played out through the fingertips. The hands and fingers should be carefully formed with delicate washes.

4 Add colour with a layer of yellow brushed across the flowing shirt and trousers. Build the shadowy folds using a darker burnt sienna. Pick out the paisley patterns in the same colour and use it to paint the neck of the guitar. Colour the wrist beads in smoky green.

5 Paint yellow flames at either end of the tightrope. Use a drier brush to tint the skyscrapers in a mix of slate blue and yellow ochre layers to give tonal depths. Brush in the blue slate smoke plumes above the flames and add dashes of cobalt blue to the sky.

Caricature: Bruce Lee

In contrast to the out-of-control Hendrix, Bruce Lee was a highly disciplined martial arts film star, precise in knowledge of his artistry.

Materials
• *smooth watercolour paper*
• *dip pen and black Indian ink*
• *No. 2 and No. 1 round brushes*
• *watercolour dyes*

Final image
Successful action and strong suggestion of movement should be the most prominent visual qualities here, allowing a wider interpretation of Lee's features.

1 Match Lee's finely controlled style to your own delivery of strong, clean sketch lines to suggest Lee's smooth, powerful movements are delivered with speed.

2 Watercolour dyes produce a strong stain with a flat, matt quality. First, ink the outline, then paint the flesh colours using the No. 2 brush. Try to get a direct 'hit' with single strokes.

3 Colour the remaining areas of hair and clothing, catching the pale blue spot highlight on the trousers and top of the head. Tint the lips and bricks in cadmium red and dilute red with yellow ochre to colour the tiles. Use the No. 1 fine brush to add the precise woodcut-line effect.

Caricature: Van Gogh

This caricature of the artist Van Gogh depicts him holding a sunflower and a paintbrush. Linking style to content will work well for this subject, so he is to be painted in thick, Van Gogh-like brushstrokes.

Materials
- *rough watercolour paper*
- *pencil*
- *No. 4 round and flat brushes*
- *gouache paints*

Final image
The quality of the marks and colours applied here should be consistent with those of the master, Vincent Van Gogh, so that your final image is irrefutably accomplished in the painting style.

Tip: Get into the habit of making colour tester sheets on various textured papers. This Van Gogh caricature benefited from a series of gouache paint experiments on various types of paper before the final one was chosen. Annotate the swatches so that you are able to access the right hues and paper types in the future.

1 Begin by making an edited pencil sketch on rough watercolour paper.

2 Add the base washes in dilute gouache using the round brush: yellow ochre for the hat and beard; burnt sienna for the sunflower and paintbrush; ultramarine blue for the jacket and trousers; grey for the shirt, and a flesh tint mix of cadmium red and yellow ochre for the face and hands.

3 Squeeze plenty of each colour on to the palette, then apply short strokes with the flat brush using a dabbing technique. Note the tonal qualities of the burnt sienna and cadmium red flecks on the yellow ochre base. Refer to a portrait by Van Gogh to help you to learn his technique.

4 Build up another layer of brushstrokes on top of the first when it is dry, but do not allow the life of the stroke to be diminished. Enhance and correct facial details; here, the eyes have been refined between steps 3 and 4 with small touches, such as highlighting the whites of the eyes to emphasize the tortured expression, making the caricature true to life.

Caricature: Shakespeare

The bard writing on a laptop melds two Elizabethan ages. The symbolism is important – a large forehead suggests intelligence; and the quill, paper and laptop show how a writer can adapt, yet retain relevance across the ages.

Materials
- *cartridge paper*
- *rough watercolour paper*
- *dip pen and black indian ink*
- *No. 5 round brush*
- *watercolour paints*

Final image
The controlled passages of ink and the delicately drawn line image offer this subject a period feel. You should have improved your ability to lay fluid washes with subtlety and accuracy.

> **Tip:** A working colour sketch should always precede finished artwork. View it as an opportunity to experiment, make mistakes and try out colour combinations before beginning the final piece.

1 Make a clear sketch on cartridge paper of the figure with its oversized, intelligent cranium and add costume and accessories.

2 Transfer the drawing to rough watercolour paper and go over the outline using a dip pen and black Indian ink. Keep the lines strong and direct, and allow the texture of the paper to dictate the look of the sketch. Lay a flesh colour wash over the face and hands.

3 Systematically colour the different sections of the drawing using cadmium red for the jacket and on the ruff, burnt sienna for the hair, grey for the chair back and ink, green for the ink bottle and diluted light blue for the creased shadow tones of the collar fabric.

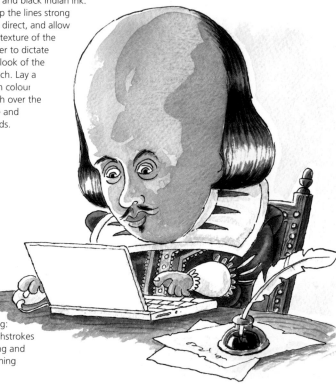

4 The final stage is the opportunity to make adjustments and add the finer detailing: colour the eye pupils grey, add burnt umber brushstrokes to the hair and colour the chair studs, the braiding and buttons on the jacket in yellow ochre. These finishing touches brighten and warm the composition.

Quick-draw caricature

Drawing a convincing caricature of a living subject can present a challenge. Experienced 'live' caricaturists are the fast and furious artists of the cartoon world. Although the subject is likely to be unknown to them, they are able to capture the essence of a character in a few accurate and directly delivered strokes. The ability to 'read' the personality of a subject at a glance is an essential skill.

The classic drawing tools of the live caricaturist's trade are mark-makers that can quickly fill the paper with both line strokes and shading. Felt-tip marker pens, dip pens or brush and ink are among the most popular choices, with each option delivering a different style of drawing. It is the immediacy of the drawing that makes it so attractive as a minimal art form.

Final image
What should be apparent from having undertaken this project is the level of forethought necessary before actually making a pen stroke. One false mark and the whole drawing could be in jeopardy. The key is to have made only one continuous stroke each time the pen touches the paper.

Materials
- *bleedproof designers' layout paper*
- *fine felt-tip pens*
- *chisel-tipped felt-tip pens*
- *black italic calligraphy pen*
- *charcoal*
- *colouring pencils*
- *broad felt-tip pens*

1 The face is always the main area of focus. Lightly sketch the exaggerated head shape in pale grey felt-tip pen on bleedproof layout paper, then outline the eyebrows, eyes, nose, cheeks and mouth using a black felt-tip marker. Enlarge the mouth as a key, distinct feature.

Tip: Practise stroke length and thickness in sketchbooks to gauge the potential of each pen you use. Treat this exercise merely for the sake of pen marks and do not try to sketch recognizable faces.

2 Draw the rest of the head using a fine black marker. Keep the lines around the head fast-moving, but consider the marks you intend to make before putting pen to paper. Remember that too much detail can detract from the personality of the subject.

3 Only a little tonal work is necessary in black, medium and light grey. Using the broad edge of the felt tips, sweep strokes in long stripes. Keep them to a minimum, allowing the white of the paper to stand in for the lightest tones or highlights. Freely scribble rapid single strokes for the hair.

Happy and assured

This character has strong, round features, which emphasize his broad grin and offer an assuring presence. Remember too that hairstyles, skin tones as well as size and shape of facial features are key elements of caricatures. Maintaining strong light and dark contrasts is vital for dark-skinned subjects.

Bubbly

The bubbly personality of this young woman is enhanced by the style of the drawing. A light pencil sketch is worked up in an italic calligraphy pen. The chisel shape of the nib enables both thin and thick lines to be made within the same stroke. Quickly smudged charcoal adds immediacy and soft tone.

Caricature: Young girl

Chalk pastels are a suitable medium for caricaturing children. The soft marks they make add a glow that perfectly suits young skin.

Materials
• cartridge paper • chalk pastels

1 Start by lightly sketching the face shape and features with the pastel tips.

2 Execute the main tones, leaving white paper highlights. Maintain an even balance of line strokes and soft blending, achieved by gentle smudging. Delicately sketch in the eyes, nose and the mouth.

3 Define the features firmly and also re-establish the hair texture and the outline of the face. Take time to shape the eyes and add fine detail, such as the highlights in the pupils. Keep these details sharp in contrast to the tonal softness and avoid overdoing the pastel layers.

Larger than life

Enlarging features enlarges the ego. Props, such as the wine bottle and glass, offer more information. Felt-tip markers are used on bleedproof designers' layout paper (semi-translucent tracing paper), which keep the edges of the strokes crisp and reveal that they were rapidly drawn.

Gone to seed

A mixture of fine and broad felt-tip pens and colouring pencils is employed to bring subtlety to this study of an ageing face. The reddened areas of the character's complexion are made using brighter-coloured pencils sketched across pale, fine felt-tip pen strokes.

Background incidentals

Not every cartoon needs to be sparse to communicate its point. Clutter and chaos are part of real life and the incidentals in a picture can be as intriguing to the viewer as the main plot. Some cartoonists delight in inventing small sub-plots to run alongside the main theme; others revel in adding ephemera as a social statement, personal opinion or because they simply enjoy making things more interesting.

However, building what appears to be chaos into your compositions carries the obvious danger that the cartoons might lose focus. Careful consideration of weighting,

medium and technique can help to avoid this, allowing you to include plenty of information, yet keep the message clear.

Weighting is the balance or imbalance of elements within a picture, which aid successful composition so that the image reads with clarity. A central figure might be drawn with an outline technique that is slightly heavier, thicker even; this helps to make it stand out from the other elements. Using lighter strokes with a thin-nib fineliner – or even a pale ink or watercolour wash – over a light drawing can also help to recede less important parts.

Final image
Within chaos, the housewife is easily identifiable as the main focus. Giving her a heavier outline 'weighting' and adding specific washes to the background elements should provide enough contrast to make this final image work. If the clutter is still in conflict with the character, the content and composition may need revising.

Materials
- *cartridge paper*
- *sharp HB pencil*
- *dip pen and black Indian ink*
- *waterproof fineliner pen*
- *No. 4 round brush*
- *watercolour paints*

1 First, make an initial sketch to establish the figure, the setting and the clutter of objects within the composition. The lighter your lines, the easier it will be to make any adjustments and corrections.

2 When you are happy with the arrangement, check that all the elements are correctly positioned in relation to the perspective of the room. Then ink in the sketch using a dip pen for main items and a fineliner for lesser items and details.

3 Paint a broad yellow ochre wash over the room and its contents, brushing around the main character so that she remains white. This simple action has the effect of separating her from the business of the scene and draws attention to her as the focal point.

4 Now bring her presence to life using bold watercolour hues: yellow, blue and a lighter dilution of the same blue for the T-shirt, a rosy flesh tint for the skin tones and a rich brown for the hair and cushion. Colour the magazine in a light wash of blue and brown.

Incidental meaning

5 Add colour to the rest of the cartoon. Choose naturalistic ones for items such as the oranges and bananas, white for the washing machine and dishwasher, pale red for the worktops and cat bowl, dark brown for the stool legs and skirting and a warmer red-brown for the drawers. Finally, 'knock back' the tonal strength of the setting and objects by applying another yellow ochre wash overall. This will diminish the cluttered effect of the

picture and make the line work far less heavy, allowing greater contrast with the strong reds and blues that dominate the foreground.

> **Tip:** Whenever you create a busy scene, consider the colours that you are going to use. Always try to keep the background in a few predominant colours so that it does not distract the main area of focus in the mid- or foreground.

This illustration is the antithesis of the kitchen project in that the clutter actually enlightens rather than confuses the image. Without the 'floating' shoes, we would be unable to deduce that she is trying to choose the correct pair. The eyes are a central focus and act as the windows to her mind, and the larger vertical and horizontal shoes make a good substitute nose and mouth. The hidden question mark indicates her thoughts.

The psychology of colour

Employing the psychology of colour and carefully selecting the media to match the mood or look of a picture are big-hitting techniques with cartoonists. Ensuring that the audience can differentiate a friend from a foe in the blink of an eye, for example, leaves the cartoonist free to spin more complex threads into the narrative.

Planning, testing and developing ideas are essential if your cartoon is to succeed in communicating everything you want it to say. Of course, establishing the characters comes first, but selecting groups of colours that work the best, the appropriate

style of mark-making and the best paper surface are also fundamental factors for success. This may seem daunting for the beginner, but the cartoon world is full of superb examples to study and learn from.

As a first step, try to understand how the experts instantly communicate mood by looking closely at a wide range of cartoon genres. As a general guide, children's comic strips come across as bright and cheerful; tension and struggle are paramount in superhero narratives; and graphic novels can ooze dark menace.

Final image

There is a good deal of optimism relayed through these bright and strongly contrasting colours. The blue simplicity of the sea and sky set an open scene for the galleon. By drawing with an improbable sense of scale – the king is far too big – the fantasy quality is increased and the overall freshness of the image brings it to life on the printed page.

Materials
- *cartridge paper, A3*
- *smooth watercolour paper, A3*
- *dip pen and black Indian ink*
- *No. 4 and No. 6 round brushes*
- *watercolour dyes*

1 Plan your composition on a sheet of A3 cartridge paper. The basic shapes are all that are necessary at this stage. The details can be added to the final drawing once you have the main idea worked out.

2 Even though this is a fantasy drawing, it is a good idea to refer to an accurate reference so that you locate the main features of the ship in the correct places. When you are satisfied with your composition, copy or transfer the sketch to an A3 sheet of smooth watercolour paper. Outline the sketch using a dip pen and black Indian ink. Embolden the main line of the crescent-shaped hull to give it due prominence in the composition.

3 Have ready enough full-strength red-brown dye to ensure the fluidity of your brushstrokes as you colour in the hull. Dilute the colour to a paler brown for the rest of the timber parts: the steps, rails and ship's wheel. Use yellow ochre to clarify the forecastle, mast, crow's nest, horn of the figurehead, rudder and window frames. Add a neat brown shadow beneath the planks on the hull to indicate the overlap.

4 Finally, add the colour detailing, leaving some areas blank. Paint the sea beneath the foamy crests of the waves in fluid washes of cobalt blue; your strokes should follow the spirit and direction of the wave pattern. Gently tint the interior of the sail and its exterior edge with watered-down cobalt blue. This will give it the appearance of billowing in the wind. Add yellow to the sun emblem on the flag and the sail. The distinctive purple colour of the king's clothing marks him out from the rest of the picture.

Practice exercise: Sinister war machine

This imaginary war machine is a threatening amalgamation of mechanized soldier and tank. The solid panels are constructed into a strongly angled face that rests on recognizable caterpillar tracks.

Materials
- *rough watercolour paper*
- *dip pen and black Indian ink*
- *No. 5 round brush*
- *coloured inks*
- *soft chalk pastels*
- *waterproof fineliner pen*

1 Form the outer casing on rough watercolour paper with a dip pen and black Indian ink. Introduce a slightly jagged, 'crazed' edge to your drawn lines but keep the drawing controlled and convincing. Your invention should present itself as fully mechanically functional.

2 Tint the main panels with mixed stains of rust or chestnut-brown ink in a variety of dilutions. Add sepia tints to the outer socket of the eye, the helmet, gun and caterpillar tracks The matt finish of the heavily textured paper creates a sinister mood that suits the subject. The bright yellow eye serves to bring focus to this personification and draws the viewer's attention.

3 Crumble soft chalk pastels in various shades of brown over the surface of the paper inside the painted shapes. Sharpen up the drawing using a fineliner pen to add ink-line panels and dotted rivets. The major benefit of using a rough watercolour paper is that it adds an extra textured dimension and a ready-made depth.

Creating a sinister narrative

This street cat image combines drawing and collage, and demonstrates just one of a myriad of approaches to creating a menacing theme. The drawn section is strongly contrasted with the layers of printed areas, and the range of textures that overlap in the collage provide considerable interest.

Collage can be a quick and easy medium to work in so long as you select the right images to begin with and use them to best effect. Experiment with black-and-white copying techniques to discover the effects you want. Black-and-white copies of colour photographs, for example, can create a very dense effect, especially in areas of saturated blues and reds. Also, the more times an image is photocopied, the grainier it becomes, rendering it perfect for backgrounds where the setting needs to be strong, yet not too defined.

Final image

The panoramic format of this collaged cartoon has filmic connotations that suggest a sinister narrative. Despite being dark in colour, much depth exists within the different layers. Consider this throughout and take a bold approach to using stark black against white! In any cropped, small section of this final image there should be strong contrasts to give the picture 'edge'.

Materials
- fineliner pen
- dip pen and black Indian ink
- 2B pencil
- cartridge paper; A4 and A3 black paper
- black-and-white photocopies of street features, full moon
- PVA (white) glue
- coloured inks
- No. 4 round brush

1 The cat is the only drawn section of this image, and the figure's portrayal is central to the meaning of the picture. Sketch different cat characters, outlining them using fineliner and dip-pen linear strokes. Look at classic cartoon cats for inspiration, such as Snagglepuss, Top Cat and the Pink Panther. Redraw and refine your chosen character until you are satisfied with the result.

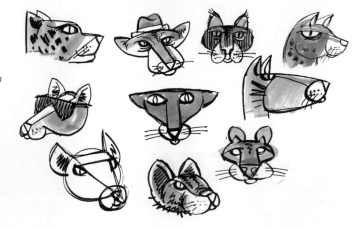

2 Visualize your intention for the cat and its environment in the form of a 2B pencil sketch on A4 cartridge paper. Although collage brings a certain amount of freedom to the creative process, it is always best to sketch your idea first. Doing so anchors your thoughts and ensures that you start with a definite concept for development.

3 Print high-contrast black-and-white copies of the scenic elements. Surfaces, such as textured brick and corrugated iron, and dark windows in varied scales and sizes will enhance the brooding feeling. Glue the elements in a disjointed layout on the A3 sheet of cartridge paper. For a naturalistic sense of depth, position complete buildings as a background.

4 Sketch the full cat figure. Experiment with his stance so that it emphasizes his shady character. Here, the chosen cat carries a crowbar – a simple detail that adds threat, as does the turned-up coat collar. Draw over the sketch in a bold line using a dip pen and black Indian ink and cut it out.

Guardians of the gateway

5 Extend the scene by gluing a black paper sky with a full moon in position. Glue the cut-out cat figure into the composition. Brush washes of highly diluted black ink (grey) over the cat to unite him with the background. Tint the moon using a very pale yellow, adding a strong yellow colour to the whites of the cat's eyes. Now lengthen a shadow behind him so that he looms larger.

The disquieting atmosphere of this cartoon is achieved by combining specific colours with an unexpected juxtaposition of elements. The smiling cat figures guard a gateway that is also a cat form. The twilight colours of yellow and the deep shadows communicate an air of foreboding: what lies beyond the gate? The cartoon is created using Indian-ink line and coloured-ink washes. Three further layers of varnish increase the colour depth.

Ghoulish characters

The Halloween theme is an opportunity to create some freakishly ghoulish characters. The bizarre shapes of pointy hats, distorted features and abnormal skin tones offer the cartoonist broad scope for creativity and inventiveness. Using traditional media – spidery and scratchy dip-pen hatching, the heaviness of black Indian ink and the layering of gouache or watercolour tonal washes will evoke a suitable mood and atmosphere within this subject genre.

Final image
The witch image works because she transcends the norms of human appearance. Filling the frame gives the impression of power. Exaggeration in the nose, close placement of the eyeballs and green-tinted skin all work to present sinister yet grotesquely humorous physical characteristics.

Materials
- *'Not' watercolour paper*
- *pencil*
- *dip pen and black Indian ink*
- *No. 5 round brush*
- *watercolour paints*
- *gouache paints*

1 Begin with a simple yet accurate pencil sketch of the witch on 'Not' watercolour paper. Since you are making a caricature, exaggerate some features grotesquely. When you are happy with your interpretation, draw over it line for line using a dip pen and black Indian ink.

2 Start building up your colour layers on the top of a broad background wash. Set the tonal range with an overall tint of yellow ochre watercolour paint, then add deeper washes of green to the witch's clothing. Create shadows with darker washes where the garments overlap.

3 Gradually build up the colour strength using yellow and Paynes grey or indigo blue. Deliver more green to the face and hands, and tint the broom in burnt umber. Using a dryish brush, hatch orange around the background.

4 Now add all the finishing touches. Strengthen all the shadows to accentuate tone and depth; the extra shadowing on the grass beneath the witch helps to enhance the picture's mood. Paint extra highlights direct from the gouache tube on to the tip of the nose, the tip of the ear, the fearsome necklace and the backs of the hands. A touch of orange around the pupils of the eyes adds a spooky glow.

Practice exercise: Woodcut demon

The contrast of dark versus light of the primitive wood-cut style is most effective.

Materials
- 'Not' watercolour paper
- dip pen and black Indian ink
- coloured inks

1 Sketch the demon with a simple, slightly broken line and outline it using a dip pen and black Indian ink. Edge inside the line with 'chiselled' jagged marks.

2 Paint the entire background using black Indian ink. Leave an area around the demon unpainted and a few background 'specks'. This gives the impression of carved marks to the woodcut look. Apply a wash of heavily diluted cadmium red coloured ink to the unpainted areas.

3 Brush a second undiluted layer of red over the face, arms, hooves, chest and tail. Note the effectiveness of this simple process in portraying the demon's character using colour. The final touch of vivid orange to the eyes and mouth confirms the wicked personality.

Witch's hands

Regardless of an artist's ability and experience, hands are among the most challenging body parts to be tackled. Incredibly expressive, they can accurately describe a character's mood or personality. These three examples are drawn using the same techniques as for the main cartoon, but they communicate three quite different messages.

Practice exercise: Woodcut

Flat colours are effective for Halloween subjects and work best in conjunction with a bold, variable black line.

Materials
- *No. 5 round brush*
- *black Indian ink and gouache paints*

1 Ink over your initial sketch using a brush so that you can vary the line thicknesses with ease.

2 Colour the cartoon in traditional hues of gouache paint applied with a medium round brush: midnight blue, grey and orange. Colour the interior of the pumpkin a lighter yellowish-orange, created by mixing orange, a spot of cadmium yellow and white. Use the same colour for the glow of the eyes.

Tip: Use gouache paint when you want to achieve density of colour and depth. Often it is better to apply the gouache guided by a pencil outline, adding an ink line on top once the paint has thoroughly dried for a much crisper appearance.

Sequential cartooning

This project gives you the chance to test your communication abilities through the vehicle of sequential cartooning. It involves devising a comic-strip page that projects its narrative without using any words. Here is the story:

A teenager is leaning against a wall happily listening to music when he is accosted by the grim reaper who steals his MP3 player. The puzzled reaper plugs in the earpieces of the alien object and begins to dance madly to the music. Finally, he gets totally carried away to the point of losing his head – quite literally – as a result of his wildly circling scythe. It is a highly visual storyline, with recognizable key elements standing in for words to explain the action.

Tip: Practise creating a 'no-words' strip using a simple three- to four-panel vertical or horizontal format. Remember that the action must make the intention clear. Here, a simple carton interacts with a question mark and an exclamation mark in a very simple story. Keeping the visual elements basic allows you to focus on telling the story.

Materials
- 'Not' watercolour paper
- No. 5 round brush
- dip pen and black Indian ink
- gouache paints
- black watercolour paint

Final image
Approach the final artwork with the simplicity of not more than three colours, a clear drawing style and frames set in a three by five rectangular grid. These will ensure that this unconventional narrative of the grim reaper's undoing is a success.

1 Begin by planning the narrative sequence, sketching the action frame by frame. Try out different grid layouts until you find the one that tells the story most effectively. Adjust your sketches and edit your grid for maximum impact.

In this initial layout, the last frame on the top row (tinted blue) repeats the bigger image below it. The first frame on the third row adds nothing to the story and neither does frame one in the bottom row (both are tinted blue). Axing these and redesigning the grid will help to tighten the narrative.

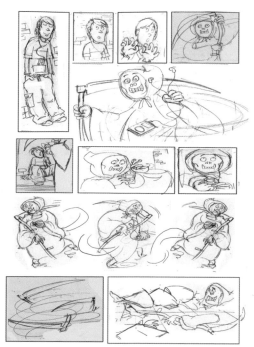

2 The props of the grim reaper's scythe and the MP3 player are central to the storyline and should be represented correctly. Don't be tempted to make up the drawings of these items; copy them from accurate references. Practise sketching them in a variety of angles and positions. The more advance preparation you do, the better the final result. Careful attention should always be offered to props that contextualize the narrative and offer a chance to refocus the viewer on detail.

3 Explore a range of colour combinations. Any of the variations above might work well in this strip, but one will usually strike you as being the most suitable for the job. The blue appears slightly too vibrant, while the variations on the straw/ochre colours seem insipid. The ash-grey hooded skull against the reddish-pink background strikes just the right note.

4 This cartoon detail shows how effective it is to mix close-up and wider-angled panels in the strip format. By focusing closer on the face, attention is drawn to the MP3 player, enhanced by the stark contrast of white with dark grey and black. The images of the dance in the larger frame offer a highly animated quality in comparison with the static panels directly above.

A cartoon world

Developing an entire imaginary world populated by a cast of diverse characters is a fascinating exercise in creative thinking. The challenge is not only to conjure up a background setting and range of personalities who will naturally interact but also to develop the best style and use the most appropriate media for your chosen subject.

As a first step in creating a cartoon strip for children, revisit the kinds of illustrations that captured your imagination as a child and also look at contemporary examples. Think about the qualities that children find so attractive, such as quirky characters, bright colours or lots of detail, and try to reproduce these in your own work. Stories for very young children are often fantastical, designed to stimulate their imaginations. At the same time they can help children learn about the world around them by mirroring situations they can easily recognize. The characters that act out the stories usually display human qualities and behaviour; they pursue similar activities and talk our language. Most importantly, children identify with them, whatever form they take.

Children universally accept the 'unreal' without question, so the only limits on creating your cartoon world are those imposed by your own imagination.

Final image

This jolly cast has been composed to work harmoniously within the scene. Each personality should be distinct, using a colourful, mixed-media style. Setting them at different levels and heights helps retain a bouncy vigour.

Materials

- *2B pencil or fineliner pen*
- *cartridge paper*
- *No. 1 and No. 3 round brushes*
- *watercolour paints*
- *brown colouring pencils or soft black charcoal pencil*
- *photocopies of textured fabrics and found objects*
- *PVA (white) glue*
- *dip pen and black Indian ink*
- *old scraps of fabric*
- *scissors*

1 Begin with the lesser characters. Sketch the mouse crew in 2B pencil or fineliner pen. Draw simple shapes with strong features: large ears, whiskered noses and expressive tails. Anthropomorphize, but don't get too complex; allow your style to develop.

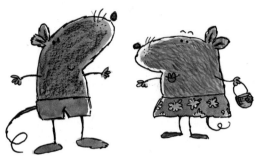

3 Explore conventional and unconventional ways of suggesting furry textures. Individual hairs can be drawn using a No. 1 round smooth-hair brush for maximum control. Be sure to choose a colour that is darker or lighter than the base so that the hairs show up. You can create a more sketchy effect by using colouring pencils. Shading over the base colour using a black charcoal pencil will also create a textural look.

2 Develop your character style further, trying out colours and refining the small details. Subtle touches to the eyes, whiskers, lips and clothing will differentiate male characters from female and young ones from old. Don't be afraid to test the effects of unusual or seemingly unnatural colours.

> **Tip:** Including discarded pieces of fabric and other materials in your drawings not only saves time but makes recycling sense and can give edge to your designs. Start a collection of fabric remnants, including unlikely household materials, such as worn dusters and cleaning cloths. Paste a very small scrap of each material into a sketchbook to make a handy reference source when you are looking for ideas on texture or colour.

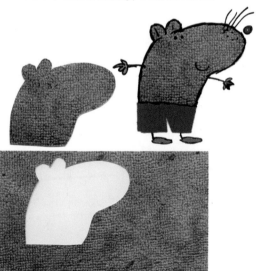

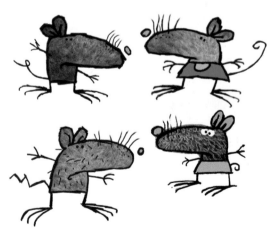

4 To achieve instant colour and texture, use collage to create some characters. Photocopy a piece of coloured towelling, cut it out and paste it on to a sheet of paper. Outline the main body shape using a dip pen and black Indian ink. Now cut out and glue on to the red-fabric shorts. Ink in the rest of the features and colour with paint.

5 Develop this concept further by trying out a range of photocopied fabrics to create the mice and their garments. Ensure that you 'hold' all your cartoons within an ink outline drawn with a scratchy, dip-pen delivery. The photocopies may require colour or tonal changes, which can be administered using colouring or charcoal pencils or watercolour paints, allowing the photocopy to show through. *continued overleaf*

6 Develop the character of the 'sea-dog' captain. His slightly flattened shape adds comic value. Define his key physical features: exaggerated muzzle, squared body and stubby arms. Dress him in wide bell-bottom trousers, white uniform top or fisherman's sweater and captain's hat. Consider using a collage technique and experiment with denim and wool fabrics, with furry material for head and arms. Once dressed, make him move.

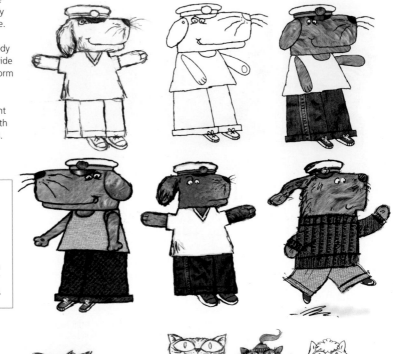

Tip: If you are creating a cartoon world, research all aspects of your subject. If your setting is historical, accuracy is paramount. Once you know how things really were, you can alter them to suit. Having the freedom to add your own take on a theme can be artistically liberating, and breathe life into your creatures.

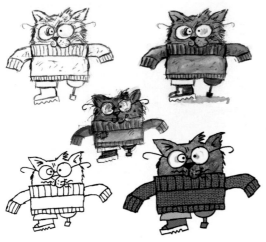

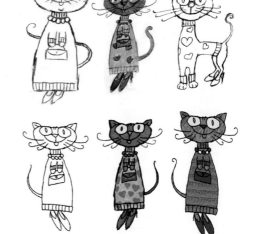

7 This ship's cat is a stereotypical peg-leg sailor. Outline him in the flattened style of the other crew members and personify him as an unkempt, bespectacled character. His oversized, baggy sweater reflects his eccentric nature. Again, explore colour and texture through paint or collaged fabrics, or a combination of the two. Having the cat's body drawn wider than it is deep increases the humour.

8 This 'lady cat' is a very different type of character to the others, and her inclusion adds diversity and interest to the cast. Use clothing, accessories, fashion styles and colours to suggest her personality. The costume jewellery, retro colours and drawing style express her individuality. She is deliberately drawn to contrast with her male, feline counterpart. The elegant elongation shows her dressiness to the full.

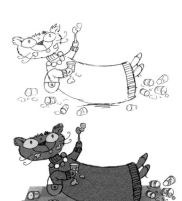

9 Define your characters further by deciding how they will behave and move. Sketch them in a variety of active poses and situations. The cat may have overtly 'ladylike' human qualities, but this relaxed, typically feline posture as she consumes pots of cream reveals her fundamental animal nature.

10 Choose an environment for your characters that complements them and is created in a style that matches theirs. If you intend the setting to appear frequently, keep the subject matter simple and practise scaling it up or down so that its presence varies according to the action.

11 Substitute some of the boat's features with photocopies of objects. The portholes, for example, are colour copies of brass ferrule rings, and the wheel is a photocopied large and small red cog. The technique of mixing drawn cartoon style with pictures of real objects works very well in this setting.

Developing your cartoon setting

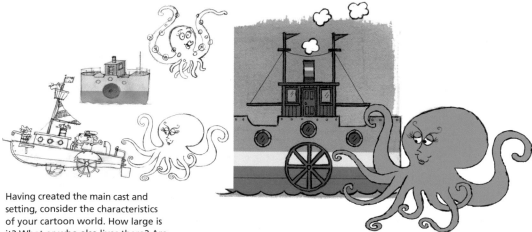

Having created the main cast and setting, consider the characteristics of your cartoon world. How large is it? What or who else lives there? Are they friends or enemies? Work on this as you hatch storylines, but try to keep things simple. Remember that you will have to repeat the same background scene many times.

Introduce a new character and see what develops. This leggy octopus provides the chance to play around with scale. Here she is immense and, despite her attractive face, looks ready to curl her tentacles around the boat. Is she being friendly? How will the crew react? The interaction of your elements – scale and position – is essential to the continuation of the narrative.

Decorative collage

Give free rein to your creativity with this hare-brained collage project. It is fun to to do and clearly demonstrates that the more extreme your choice of materials, the more magnificent the result.

The theme is obvious: an exuberant celebration of hair decoration. The use of colour alone makes a huge statement and the added fusion of pattern and layer emboldens it further. The weighty juxtaposition of the free-flowing ink strokes with the airiness of real feathers provides a visually explosive mix that intrigues the eye, as do the various tinted papers overlaid by a pattern of coloured plastic discs. It is this mixture of conventional and unconventional materials and media that is so exciting.

Final image

A small comb and coloured-paper stripes on the dress complete the vibrant look. The effect is very simple to achieve if you are brave enough to experiment. This is the key to a successful outcome. Abandon your artistic inhibitions and exploit fully the materials at your disposal to let truly creative results occur.

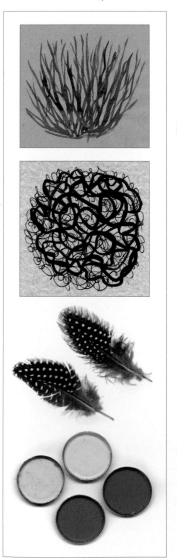

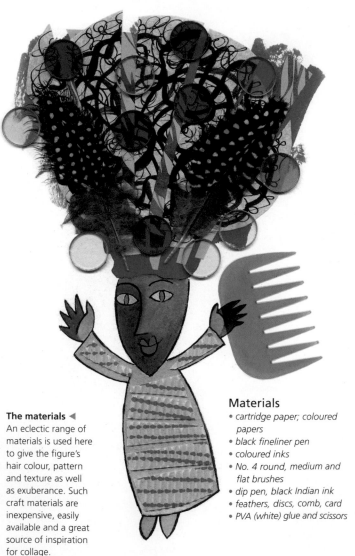

The materials ◀
An eclectic range of materials is used here to give the figure's hair colour, pattern and texture as well as exuberance. Such craft materials are inexpensive, easily available and a great source of inspiration for collage.

Materials
- cartridge paper; coloured papers
- black fineliner pen
- coloured inks
- No. 4 round, medium and flat brushes
- dip pen, black Indian ink
- feathers, discs, comb, card
- PVA (white) glue and scissors

1 Draw a shapes-based stylized figure using a black fineliner. Paint a wild shock of hair fanning out from the top of the head using bright red ink and a medium, flat brush.

2 Paint a green, branched bush shape on yellow paper. Angle it at 45 degrees and cut it into narrow strips. Glue these on to the hair. Paint the hands, face and dress using the round brush.

3 Use both ends of the round brush to make a swirling pattern of black ink on marbled taupe paper. Cut the paper into broad wedges and place them on top of the previous layer.

4 Adjust the position of the swirls if necessary before gluing in place. Now add a feather to either side of the hair to balance the shape. Choose feathers with strong colours or patterns.

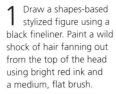

5 For the finishing touch to the hair, arrange the translucent coloured discs on and around the hair, then glue them in place. Like tinted windows, they reflect the light superbly and cause the colours and patterns underneath to glow.

Robot

This mixed-media approach uses no conventional drawing at all. Scissors take the place of your pen as they sculpt the shape of the figure from yellow corrugated card. A novelty bagatelle game ingeniously replaces the head, a walkie-talkie handset is the added techno accessory and 3-D card glasses flatten across the face. All the shapes work well together to interpret the robot form.

Coffee-bean man

The two coffee beans are all that is needed to imply a coffee addict, and this one is clearly sold on shots of caffeine! The slits of the beans give the effect of peculiar cat-like pupils and their skewed angles add craziness.

Teenage characters

Designing a cartoon character with appeal to a teenage audience can be challenging. It's important to establish an instantaneous rapport with the audience or risk losing their interest. Getting it right demands creative thinking on several levels: the character needs to be appealing in terms of gender and interests, the action should play out in a context that is exciting and attractive and the illustration style must match the mood of the narrative and reflect contemporary taste.

This cartoon stars a young female DJ in something of an underdog role, who is determined to realize her musical ambitions in a male-dominated world.

Final image

The simplicity and effective use of tonal harmonies in this single story-frame imparts an uneasy mood while providing a strong contextual background for the visual narrative. Highlights and textures are strategically added and extra body is provided by the chalk pastel marks across the quilted jacket, scarf and record-case surfaces. The highlights on the top of the head and jacket heighten the drama.

Materials

- *cartridge paper*
- *dip pen and black Indian ink*
- *No. 4 round brush*
- *coloured inks*
- *grey-blue watercolour paint*
- *chalk pastels*

1 The intention from the outset is the development of an androgynous figure: a female but without the usual stereotypical adornments of make-up or curves. Remember that she is a 'cool' character and research fashions for suitable 'crossover' clothing. Outline the drawing using a dip pen and ink.

2 Tint the background in light ink washes of three colour bands: scarlet, orange and burnt sienna. Leave the main features white.

3 Paint the DJ in a moody blue watercolour hue, which raises a sense of unease as she walks along the alleyway. Paint her record cases, the bin and the shifty-looking man in the same colour. Assume a main light source from the left and paint a second wash of shadows down one side of her face and hair, and in the creases of the puffer jacket. Add shadow to the man and to one side of the bin. This shaded side emphasizes the record case so that it appears to be in the foreground.

4 The advantage of translucent inks and paints is that when one is laid over another, the colour beneath shows through the new layer. Apply a wash of light blue ink over the walls in the background. Note how the pale scarlet area turns purple and the brick area becomes a deeper and cooler brown. Add a more diluted wash of blue over the floor to subdue the brightness of the ink stain.

Tip: A strong outline creates a strong silhouette, which is an indispensable feature for a main character. The shadow of the dancing DJ outlines her distinctive clothing and hairstyle, and identifies her immediately to the viewer. Capitalize on this advantage by using lighting wherever appropriate. For example, strong artificial lighting will blend colours and blur lines, but a strong outline will remain distinct.

DJ in action

Now put your DJ in true context. Draw her mixing music at the desk, still in the puffer jacket but now wearing headphones and about to play a CD, a bottle of water at her side. Her image is made strongest drawn with a firm keyline from a pressure-led dip-pen line.

Tint the figure with monestial blue. Then gesturally paint, with broad loose strokes, a combination background of scarlet and orange inks, blended together with smudges of white chalk pastel.

Strokes of green and mauve pastel are dragged with the side of the stick pressed on to the paper. More solid layers of chalk pastel colour the jacket and hair, reflecting the multi-coloured, artificial lights. The mixing desk should be strong monestial blue and the bubble shapes added with a dip pen.

Anthropomorphizing animals

Many animals make great subjects for cartoons. They are characterful, like people, and we humans have a strong tendency to personify them.

Anthropomorphizing animals can be achieved in a variety of ways: at one end of the scale, by using a human-like facial expression or eye shape; at the other end, through creating an entirely humanized animal that walks, talks and performs dextrous manoeuvres with hands and feet. Recognizing expressions of a person's character through their gait and unique body positioning matters. Animals are superb to display human characteristics and emotions. Consider: cute kittens = mischief; snake = wily; sheep = stupid; tortoise = slow.

Final image

The two last details are a light yellow ochre layer representing the floor and pale olive green tinting on the leaves. The modelling on the body and face, as well as the subtle bends of the knee, overall stance and deportment – as recognized in humankind – make it a success.

Materials

- cartridge paper
- pencil
- rough watercolour paper
- dip pen and black Indian ink
- No. 6 and No. 4 round brushes
- watercolour paints
- coloured inks

Tip: Building up short strokes as tone may look easy, but using a brush that is too dry or too wet can result in difficulties. Practise a repertoire of these strokes on a separate sheet of paper to help you discover the best technique.

1 Begin with some simple pencil sketches and practise drawing the camel from all angles. Choose the best sketch and develop it further, but avoid referring to reference; allowing it to develop from your imagination will result in a character with a distinctive personality. This particular camel's persona is defined by its overly large feet, extended skull and prominently protruding lower lip, along with its lopsided humps and large eyes with noticeably long eyelashes.

2 Redraw your final sketch using a dip pen and black Indian ink on rough watercolour paper. Note how the camel's unhurried air is communicated through its bended knees, drooping neck and even the plant in its mouth.

3 Paint your first wash of raw sienna watercolour within the outline using a No. 6 round brush. Mix plenty of pigment and allow it to flood the area evenly. Let image dry completely before moving on to the next stage.

4 Define the contours of the camel's body shape by building up short, dappled strokes of burnt sienna watercolour in selected areas. Look closely at photographic reference to help you understand the range of tonal variations you will need. Layer these drier marks using the No. 4 brush and note that the more marks you add, the deeper the tone becomes. Finally, accentuate the details using inks: eyes, lashes, nostrils, neck ruff and tasty branch.

Adding accessories

Dressing animals in an anthropomorphic way serves two purposes: it makes them more human-like and it adds colour and interest; a kangaroo in a pink jumper has impact! Supplying animals with unexpected accessories is an anthropomorphist's dream. Allow your imagination to run riot; who says a lion shouldn't be able to ride a scooter?

Practice exercise: Metaphorical tortoise

Making use of an animal's familiar characteristics in an unexpected way can send a provocative message. This cartoon of the tortoise on the running machine can be extended into a metaphor: are we looking at a tortoise or a hitherto idle human being reluctantly forced into an exercise regime?

Materials
* *cartridge paper*
* *pencil and fineliner pen*
* *watercolour paints*
* *No. 4 round brush*

1 The metaphor is turned on its head with the slow tortoise running on the treadmill. Sketch it out in pencil and make any adjustments you feel are necessary. Draw over the pencil outlines using a fineliner pen.

2 Add light layers of watercolour in the appropriate greens and browns and grey for the treadmill, and dilute the colour with water to lighten the tones.

Symbolic figures

Clearly recognizable characters who encapsulate a wealth of meaning broaden the cartoonist's opportunity to create a parallel or sub-plot within an image. They are commonly used as a device in all kinds of topical images and political cartoonists in particular are well-known for using symbolic figures to get their message across.

The rules of the game are clear: the more strikingly simply the figure is depicted, the greater the likelihood that the concept will work. Strong lines and shapes coupled with bold colours will reinforce the success of an image by making it stand out on the page.

The setting should not be permitted to overwhelm the main figure and the composition needs careful planning. For maximum impact, aim for a bold design that incorporates contrasting shapes, tonal ranges and hues.

Final image

Symbolism lends itself to universal themes; here, two figures, isolated by their individual lives (the books), are unable to form a bond – note the reach of the stretching man falls far short of the lady's towering height. Humour is also present, as her expression is one of total unawareness. Such simplicity works well with more complex articles or structures.

Materials
- *rough and smooth watercolour papers*
- *black fineliner pen*
- *colouring pencils*
- *felt-tip pens*
- *dip pen and black Indian ink*
- *No. 4 round and flat brushes*
- *coloured inks*

Tip: A strong concept is key to the success of the simple figure principle. Sketch your character inventions and give them appropriate words, sayings, stories and proverbs. Aim to develop a range of drawing styles, each one equally apt.

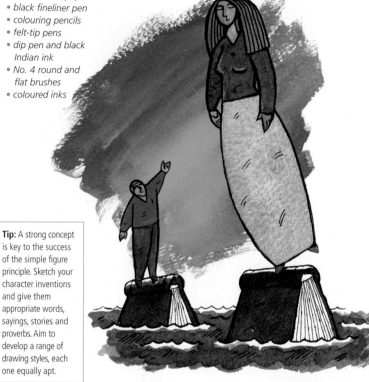

1 It is important to gauge the success of the design before beginning the final piece. Start by making a rapid, strong working sketch in fineliner pen, then tint it using colouring pencils and felt-tip pens. Note that the pen lines are neat and follow a single direction.

2 When you are satisfied that the elements of the idea are correctly sized and positioned, draw the final image on rough watercolour paper using a dip pen and black Indian ink. Tint the paper in dashed, flat strokes of purple, brown, turquoise, ultramarine blue, yellow ochre, warm red and sepia, using a flat brush for the broad areas of colour and a No. 4 brush for the smaller areas.

Action

Simple figures can still be active and full of movement and life. Drawing in profile is the easiest way to illustrate action. Here, simplifying the shape of the chasing bees and exaggerating their scale works well. The choice of colour is also important: the bright yellow and white tint of the bees makes them appear busy.

Symbolism

Objects can be drawn out of proportion to figures and yet appear acceptable. Using familiar items as powerful or meaningful symbols is a common technique used by cartoonists. To prevent the smoke rising the figure holds a large collaged photo of a dustbin lid over the smoke to stop its spreading.

Think of Egyptian art and you will soon realize that this style uses symbols for objects or people rather than direct representations. This cartoon of a designer is fun, and so far removed from reality that we accept him as a graphic creation not that different from his own work.

Traditional figures

The harlequin is a traditional symbol of the mysteries of life and death. He is a bold, decorative figure in this depiction, and is used to imply a fatalistic outcome. An exploitation of the associations of familiar characters from traditional culture underpins the concept of using simple figures and is worthwhile. Many storylines in cartooning have their basis in traditional myths or tales.

Using metaphor

Working lives have become increasingly target-driven. This cartoon, depicting a businessman as an archer, firing at a target fixed to an office building, has a clear message. The metaphor displays wit at its best; such an image may help to enliven a dull business article.

Getting the message across

Presenting facts in a way that is easy for an audience to understand can be a challenge. The nature of the cartoon as a carrier of complex visual information makes it the ideal medium for delivering a message. Not only can cartoons break down information into manageable bites so that it is easier to understand but they can make it more memorable. Layout and format are also critical to conveying information effectively. In the case of a set of instructions, it is often essential that they are followed in a particular order, and it is the layout of the drawings that governs the sequence of the information.

Final image

A step-by-step approach is an effective way to present information to children and young people. Here, a friendly chef demonstrates the art of cake-making. Linking the figures with speech bubbles builds a strong narrative within the frame. Also, the bakers' plump shapes echo the bubbles found in the design of the chef hats and their bulbous noses.

Materials

- *watercolour paper*
- *gouache paints*
- *No. 2 and No. 4 round brushes*
- *dip pen and black Indian ink*
- *watercolour paints*
- *black fineliner pen*

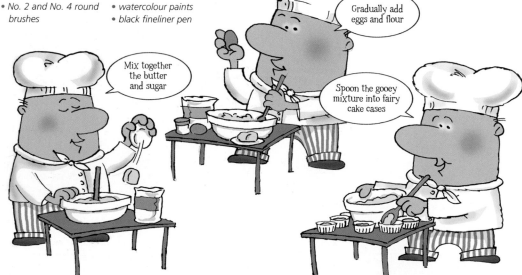

1 Rough out the composition, making adjustments as you go. Note that the figures are drawn at different sizes and angles. It is worth making practise sketches of all the objects you want to include before starting the final outline. Leave space for the speech bubbles.

2 When you are satisfied with your initial sketch, outline it clearly using dip pen and black Indian ink. Now add flat gouache colour washes in tones of flesh pink, blue and yellow. Add light washes of blue watercolour on the hat and uniform.

3 Add tone with light washes of blue watercolour in the white areas. Sketch the speech bubbles and outline them in fineliner pen. Ensure that they are the right size for the words they will hold. Make the text clear and direct to match the simplicity of the image.

Fruit fiends

The pests that attack an apple are surprisingly numerous, as this chart shows. The simple approach is fun, memorable and informative rather than alarming. The focus is the photo of the apple, cut out and mounted on cartridge paper. Its central position leaves the viewer in no doubt about the subject matter. Placing each pest around the apple makes them all equally threatening, while the anthropomorphic drawing style implies friendliness. This could be a public-information poster.

Tip: Give yourself a drawing test. See how many serious subjects you can illustrate in a humorous and stylized way without compromising the message. Use as many different media as possible.

Visual maps

Maps are perfect subjects for cartooning. A fun approach draws the viewer's attention and helps them to retain the information. Don't allow real issues of scale or distance to bother you: remember that you are only drawing a representation. In this particular map, all the small details have been removed, leaving only the basic information we need: that the airport is north-west of a service station and that we can grab a snack nearby.

'How to...' guides

The most mundane of explanations can benefit from a cartoon treatment. Following the assembly instructions for flat-packed furniture is much easier when they are illustrated and humour can lighten a dull task. This visual dialogue between the little nut and the bolt describes a simple instruction that is impossible to misread. The directional arrow and use of the same colour for the elements that fit together help to reinforce the message.

Portraying machine encounters

Advances in technology have made it impossible for us to live our lives without encounters with automotive processes on a daily basis. Human dependence upon machines has now more or less transformed them into our copartners, making them ideal candidates for the cartoonist's repertoire.

Machinery makes an effective metaphor for all that is contemporary, but it is your choice whether to portray it as working with or against the human race. The threat of robot domination is not a new concept, nor is it entirely far-fetched, since human workers have been replaced by machines in a number of industries.

It is the logical nature of machines that offers the cartoonist the greatest scope. In the real world, machinery takes a passive role: it functions on command and does not have the facility to think or rationalize. In the cartoon world,

however, anything is possible, and the theme of a malfunctioning machine can present opportunities for entertaining interplay between the rational and irrational. A cartoon machine has the freedom to lose control and turn the tables on a situation, interacting with a human in a way that can be very amusing or darkly sinister.

Final image

A threatening machine is a common cartoon theme. Note how easy it is to personify the machine's features. Make sure that you do not overcomplicate the final image. Keep the details to a minimum so that it is instantly recognizable, and treat the colours in much the same way.

Materials
- 'Not' watercolour paper
- pencil, dip pen and black Indian ink
- watercolour dyes
- No. 2 round brush
- chalk pastels

1 Follow up your initial pencil sketch with a clean, clear outline of the composition on the 'Not' watercolour paper using a dip pen and black Indian ink. The success of your cartoon will be largely dependent on how accurately you draw the ticket machine and personify its key features.

2 Tint the main areas with fluid washes of watercolour dyes. Use a diluted red for the background wall and floors and a diluted mix of light blue and red for the exterior of the ticket machine. Let the wash run across the surface of the paper and occasionally be absorbed. A blotchy effect does not matter at this stage.

3 Use blue chalk pastel for the trousers, case, hair and the shadowing on the body. Blend more blue into the machine panel, adding red chalk pastel into the red areas to give them extra depth. Add a flesh tint to the face. Emphasize the highlights using white chalk pastel and colour the ticket using red and blue dyes.

Familiar machines

This simple vacuum cleaner illustration uses a dip pen and black Indian ink, light blue watercolour paint and white chalk pastel on pale blue tinted paper. We can relate humour best if the machine is familiar to us. Here, in a reversal of roles, the resting cleaner reminds us that he is the master over us – the slaves to cleaning!

The robot human

In this image, an idea is reversed and the tentacled alien is looking warily at the human astronaut, who it perceives to be a machine. Split into two frames, the first image is an overview, showing the two figures' differences; the second is a close-up, stretched anamorphically across the width of the frame.

Androids

Alienation is another popular theme in cartoons. The fascinating concept of androids – machines that appear in human form – is often explored in sci-fi comics and graphic novels, which gives the cartoonist the opportunity to reconfigure the human face and form. Perhaps unsurprisingly, the best outcomes use the basic life-drawing structure as a starting point. In this cartoon, the use of complementary colours illuminates the contrast between man and machine.

Robots

Machines that walk and talk were first introduced to the public audience in futuristic stories and films of the 20th century. Their unique appeal endures in the form of robot toys, models and as film, TV and comic-strip characters. With distinct personalities, they can be friendly and funny or very threatening. The squat shape of this cartoon robot is cute, but its menacing side is evident in the glowing red eyes and shooting ray. The stance and distortion of the rectangular shape make it appear to move, and placing it in a context of destruction makes the message clear.

Computer trash

Computers can be seen as a blessing or a curse. This image reveals a homemade solution to junk mail. Often, technical subjects, such as computers, benefit from images that strip away the jargon.

Dynamic viewpoints

The viewpoint we adopt within a cartoon and the relative sizes of the elements inside its frame can determine whether it will be dull or interesting. Part of the artist's task is to create an image with its own internal energy through dynamic composition, contrasts of size and the use of light and dark. All of these qualities are all influenced heavily by viewpoint.

To a fly on the wall, a scene looks very different than the view from a more normal perspective. Dedicated cartoonists are constantly stretching their powers of imagination and try to consider scenes and situations from a range of perspectives. Keeping this in mind when planning your cartoons will help you to realize projects that are original, freshly perceived and provoke a reaction from your audience.

Transferring a skateboarder to the interior of a room immediately changes our view of him and his environment. This unexpected refocusing implies the existence of many other situations that are beyond the acceptable perspectives of reality. The probability of the scene entering the realms of fantasy and physical impossibility is, therefore, consequently stepped up.

Materials
- *cartridge paper*
- *soft blue pencil*
- *'Not' watercolour paper*
- *dip pen and black Indian ink*
- *No. 6 round brush*
- *watercolour paints*

Tip: Seek out new or unusual viewpoints, then make sketches of them and work hard to achieve the correct perspectives and relative sizes. This will fire your imagination, to create scenes for new cartoon projects. Having an understanding of perspective can help a cartoonist to achieve more exciting and complex settings and figure angles, which prevent a strip becoming dull.

Final image
A skateboarder is testing a ramp of books in his bedroom. By filling the room with the child's energy, the dynamism spills out of the frame made by the walls and grabs the viewers' attention. For your image to have worked successfully, there needs to be a tension within your composition between the straight walls and the regular, containing interior space and the free movements of the skater within. His path, determined by the makeshift skate ramp, arcs around the room.

1 Make a basic sketch of the room in soft blue pencil, keeping the outlines simple in order to make it easier to adjust them until the image is working. The upward curving flow of energy is the most important element. Not only does it hold the central focus of the image but it forces the figure to break out of the frame of the cartoon and present the viewer with an image that is both contained and uncontained. Adjustments to the initial idea should be made now before it is painted.

2 Outline the composition on 'Not' watercolour paper using a dip pen and black Indian ink. Alter the pressure on the pen nib to keep the lines lively. Load the round brush with dilute raw sienna pigment, then paint a wash over the three walls so that they are all lightly tinted. When the paint has dried, brush a second wash over the middle wall panel to darken it slightly. Add patches of vertical hatching beneath the books and to the walls on either side.

Bird's-eye perspective

3 Brush diluted red colour over the book covers, shirt, trainers and checks on the duvet and pillow. Detail the lampshade in purple and the skateboard deck and trousers with sepia. Paint the boy's skin in a range of flesh tones. Finally, brush on a layer of warm burnt sienna for the hair, adding flecks of brown burnt umber.

Altering the viewpoint can add extra drama, suspense or a sense of danger. This bird's-eye view sharply focuses the viewer's attention on the plight of the bird on the branch. The waiting cat is of secondary importance. Strong, fluid stains of coloured inks offer prominence and depth to the main elements, and a flattish, ochre wash is employed for the background.

Fly-eye view

4 This detail shows how the paint strokes have been allowed to flow across the paper, to puddle and stain as they please. This approach to applying a watercolour wash is a traditional painting technique that adds to the life of the image. The tones are darkened in places to represent shadows, which give the figure and objects form: under the sleeves, down one side of the lamp and on the backs of the trousers. The hair was painted in stronger colours using downward strokes from a dry brush. The action strokes add movement.

The fly swatter fills up most of the space as it bats towards the fly. We can only sympathize, as we share the fly's lowly perspective. The colours are lively washes of ink in yellow ochre and blue, which add depth to the figures and elements. Linking parts is important. The blue of the swatter links to the blue of the eyes, which in turn link to the fly's body.

Using colour to spotlight

Unusual coloration, texture and drawing styles all help to isolate central subjects in a narrative cartoon image. This technique enables them to appear in a believable fantasy world.

Using limited colour throughout, with the exception of a small area – a third or less of the picture space – can draw focus to the central theme of the narrative. At the cocktail party, the lights are dimmed, and the room is quietly atmospheric. A combination of blue ink and crumbled charcoal laid on top of the initial line drawing adds depth to the room and pushes the other guests into a merging background. The flesh coloration of the chatting figures and the echoes of the same colour draw the viewer into their conversation over a pleasant aperitif.

Final image

Everything is carefully calculated, with colour used perceptively to focus the viewer's attention on the male character on the left and the woman in the centre. The simple technique of gradually eliminating the tonal hues on the lesser characters and in the background is enough to turn the spotlight wherever you want it to fall.

Materials

- *cartridge paper*
- *'Not' watercolour paper*
- *dip pen and black Indian ink*
- *0.1mm fineliner pen*
- *No. 4 and No. 6 round brushes*
- *coloured inks*
- *watercolour paints*
- *stick of charcoal*

1 The use of subtle colour placement will only succeed if everything is strategically and purposefully positioned. An accurate sketch is critical therefore, so plan your composition with care. Paying attention to details such as body shapes and posture, the direction of a character's gaze and gestures, will draw the viewer's eyes to the centre. Keep things simple with direct, clear lines.

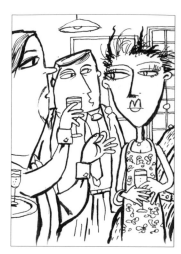

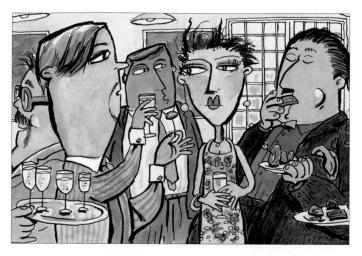

2 Outline the sketch combining a dip pen and brush with black Indian ink. Give the lines full weighting – accentuating the woman's jawline diverts attention towards her face, for example. In contrast, use a more delicate fineliner pen line to activate the characters' hands and allow body language to be seen clearly.

3 Paint the faces of the secondary characters in washes of dilute light blue ink using the No. 4 round brush, and the wall panels in sepia. Don't worry that the tones seem bright because further layering will knock them back into the composition. Use watercolour paints and a smaller brush

to deliver hair colour, champagne and the more controlled patterns on the clothing. Mix a rosy flesh colour and add the skin tones of the couple at the centre of the conversation. Note how the deeper purple hue on the right draws the eye in towards the central lady.

Silhouette

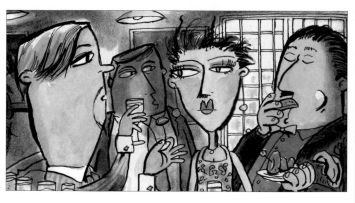

4 Create the final detailing by reducing instead of adding to the fine mark-making. Knock back the brightness of the lesser figures in the group using charcoal. Its gritty texture gives an enclosed interior feel to the scene, causing everything that is unimportant to recede softly. Add form to the man's head using charcoal strokes and carefully blend it around the lamps so that they appear illuminated. Leave the brightness of the window too.

Tip: Knowing the limits to which a medium can be worked is an important skill and by understanding your materials you will save many future cartoons from being overworked. Try the scene again but this time test the limits to which charcoal can be used to significantly reduce the focus of the drawing without destroying its meaning. Experiment with other ways of reducing colour too – a limited range can also produce quite startling effects.

Silhouetted figures against a light background, such as a window, can effectively create a mood of tension, suspense or isolation. This can be very useful if the palette is limited to a single colour, with just the odd detail picked out in a suitable shade (i.e. here the purple lips).

Imitating woodcut styles

The black-and-white composition is perhaps the most powerful visual arrangement in the cartoonist's portfolio. In part an imitation of the traditional woodcut technique, this method is about working to limitations. As such it is suitable for beginners or for anyone who has less confidence in their drawing skills. The key to success is to reduce the subject matter to a series of strong black-and-white shapes, which contrast well with one another.

Adding colour should only be considered when the black-and-white design has been conceived and accurately worked out. It is at this point that variations in drawing style, the use of 'cut' marks and limited colour can be brought into the equation.

Final image

This design is strong with bold shapes of black-and-white 'space' working within the vertical frame. If you have exploited the contrast in this image – shadows against spotlight – then a live music atmosphere should be achieved.

Materials

- *cartridge paper*
- *watersoluble pencils*
- *stick of willow charcoal*
- *'Not' watercolour paper*
- *dip pen and black Indian ink*
- *No. 5 round brush*
- *watercolour dyes*

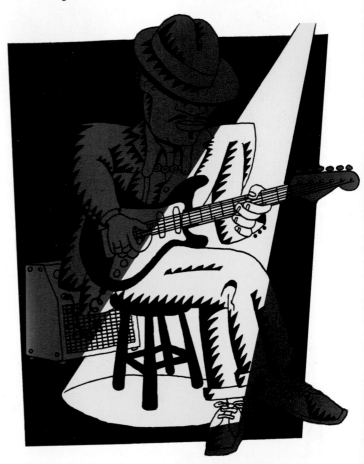

1 Sketch the guitarist, preferably from reference to capture the precision of the player's attitude, his finger positioning and the shape of the instrument. Now sketch direct solid lines on cartridge paper. This way, you will build up the composition in clearly defined shapes.

2 It is worth making a tonal working drawing to give you a sound visual idea of the final image. Loosely shade all the colours using watersoluble pencils and charcoal. Remember that this draft confirms the tones you intend to use for the final piece. Make adjustments until you are satisfied with the result.

3 Transfer the black-and-white outline to the watercolour paper using a dip pen and black Indian ink. Ink in the solid areas using a brush. Edge the outline of the guitarist in woodcut style marks. Breaking the irregular panel gives the composition a dynamic boost.

4 When you are sure that the pattern of black-and-white 'shapes' holds together, add the colours. Start by tinting the spotlight in an even shade of dilute yellow dye. Bend the beam of light over the left shoulder so that it distorts, as it would in reality.

5 Leave the yellow to dry, then add the deeper purple shades, blending them into crimson to suggest a further hidden light source. Work with care and keep your watercolour dye washes fluid at all times. Keep these washes fresh and undertake the task once only.

Lighting for mood

Sometimes the rules of how light falls on an object can be broken. This image differs from the musician as it has a symmetrical composition. Again, the woodcut-type effect is used, but the proportions and style of the drawing are simplified so the objects in the picture are easily recognized. No black fill is added to the left side of the figure, or pitcher: a light blue tint is laid over the whole of this side except for the window, which is left white to show it as the light source. To emphasize the candle's low-lit glow, darkness is added to the right side, excluding the eye and a highlight runs down the side of the hair and contour of the body. Spot red links suggest emotional content: heart = romance, wine = social context, red lips = clarification of female gender.

Using explosions to add drama

An explosion paces a set of sequenced images more effectively than virtually any other drawn device. Whether they are used to give emphasis to a verbal exclamation or sound effect, or to add power and energy to a narrative, explosions are an essential part of the cartoonist's kit. They can be used effectively in all types of cartoons and in all types of situations, but are the indisputable mainstay of any comic narrative in which the dominant theme is the struggle of good against evil.

An explosion used as a dramatic device can stop the audience in its tracks. Once their attention is held, the opportunity is there for a change of mood or a shift in the narrative.

Final image
The limited colour range and minimal details enhance this image's dramatic appeal, with the wizard's body framing the action. Successful explosions are achieved by using drawing conventions that link to directional movement – emanating lines fan out from their centre, with twisting clouds and fiery colours.

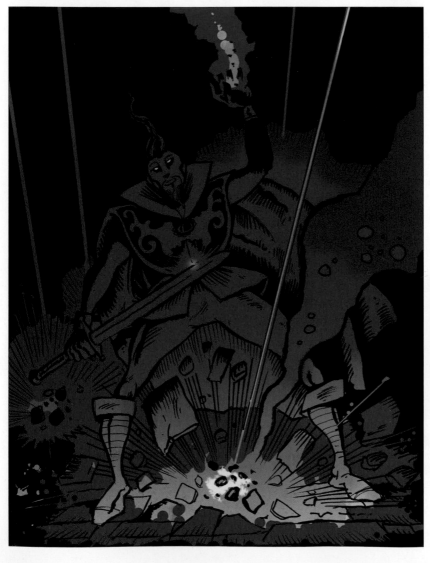

Materials
- cartridge paper
- felt-tip pen
- chalk pastels
- smooth watercolour paper
- No. 4 and No. 7 round brushes
- black Indian ink
- fineliner pen and ruler
- black coloured ink
- watercolour dyes
- white gouache paint

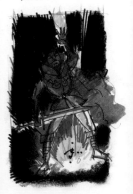

Pre-sketch ▲
The pre-sketch on white cartridge paper is a mixed-media profusion of colour and energy. Tightly controlled felt-tip pen strokes collide with the soft cloudy passages of chalk pastel. White paper is left bare at the very heart of the explosion.

A puff of magic

1 Sketch the fantasy wizard in super-hero comic style. Refer to comics and figure reference manuals for extra guidance in drawing the superhuman proportions and movements. Make sure that your figure is centrally placed holding an active pose over the blasting rocks splitting also from the centre.

2 When you are satisfied with the composition, ink it in using a brush and black Indian ink. Draw freely with the brush and enjoy the level of control that you can maintain with only a little practice. Use a fineliner pen and ruler to deliver the high-tension lines firing from the centre of the explosion.

Here's an explosion that is far removed from fireballs and flames. Vibrant wet-on-wet watercolour dyes are allowed the freedom to roam over the paper resulting in an exuberant eruption of colour. The shiny silver foil shapes collaged into the dye marks add a sense of sparkle and energy to the comic explosion.

3 Fill in the background behind the figure with a dense, black ink wash, leaving the explosion lines and flame area above the hand as white paper. Note the considerable weight this black background adds to the picture and how the stark contrast of black and white gives form to the flickering fire in the wizard's hand. Be careful not to obliterate the subtlety of the outer edges of the flames when you are blacking around them.

Fireball

4 Apply the colour dyes and bring the picture gloriously to life. As you brush on each wash, note how the highly saturated colours subtly blend into one another to create a gradual, realistic-looking glow. Mix magenta with red to get the slight coolness in the background and lighten the yellow closer to the heart of the explosion, adding drier brushstrokes of white gouache paint as the white heat at the centre.

A limited range of flat colours is used in conjunction with a tumbling, dynamic figure whose pose suggests the fireball that has sent him hurtling through space. Black Indian ink is used to stress the strong male physique and fills the background to give a 3-D effect overall. The intense brightness of the orange, yellow and white flames adds drama and power.

6

Digital techniques

Cartoons like all other artistic expressions have embraced the digital world. Far from making drawing skills redundant, they have blended them with diverse imagery programs to increase visual possibilities. Software, and how to use it appropriately and successfully, is extensively covered in this chapter.

The digital environment

Digital media has revolutionized the world of art and design. Before the advent of computing, processes such as changing colours, making adjustments and alterations, duplicating and archiving artwork required much extra effort. In addition, effects such as seamlessly smooth colour gradations were time consuming and demanded the skilful use of a very fine brush or airbrush. Now these things and more are easily and quickly achieved using single keystrokes and mouse skills.

Digitally created imagery is constructed from pixels – tiny, flat squares of colour, which are neatly duplicated in rows of thousands or millions to give an accurate, crisp appearance.

It is the perfect medium for creating flat, polished graphic art, and can be easily combined with traditional methods where a more textured or fluid style is wanted.

The advantages of using the computer are the ease with which minor changes can be made to pictures and the extraordinary provision of having artwork ready for publication as digital files, be they comics, books or websites.

While digital software packages greatly assist basic drawing and painting skills they can never replace them, and all artists who produce computer-generated artwork are invariably grounded in these traditional skills.

Vector and bitmap

There are two principal types of digital imaging programs. Vector programs use mathematical algorithms (a language known as Postscript) to describe colours, lines and curves. A Pen tool existing in an on-screen 'toolbox' plots a series of lines and curves with points connecting each section of the line or curve. The areas can be filled with colour and 'stroked' by altering the line thickness or its colour. Vector programs, such as Adobe Illustrator and Freehand, allow the user to create complex drawings. With 'Bitmap' or paint programs, such as Adobe Photoshop, users draw freely on screen using a mouse, stylus pen or drawing tablet. The smallest unit of computer storage – a 'bit' – is mapped on to a grid. An image that is created or scanned-in is displayed on-screen as an arrangement of bits. Such files can take up a lot of memory.

Bitmap digital photograph ▼
This digital photograph of a guitarist is a bitmap image of 300dpi (dots per inch is a term denoting screen and print resolutions). It is imported into the vector program Adobe Illustrator, where it acts as a base template.

Vector digital drawing ▲
The Pen tool is selected from the toolbox palette in Adobe Illustrator and used to draw the outline around the guitarist. Vector and bitmap programs use 'layers', which are the digital equivalent of transparent overlays. Each layer can be allotted to a different portion of the illustration, such as outlining, colouring and textures. Here, the outline has been copied to a new layer and the gradient added in order to blend the red into the yellow.

Bitmap digital painting ▲
The vector digital drawing is 'cut, copied and pasted' into Adobe Photoshop, the bitmap program that manipulates images. The layered Illustrator drawing is partially removed around the guitar section of the image beneath using a selection of toolbox brushes. The Photoshop file of the guitar will appear as another layer – as parts of the top layer are removed or altered, the image on the layer below appears, as though someone has physically cut through a mask or tracing paper. The background is painted blue and a halftone filter is applied, then partially erased from around the figure.

Digital equipment

Digital artworking requires high-specification equipment. You will need a powerful Apple Macintosh computer or Microsoft Windows compatible PC, plus a high-definition monitor with a screen at least 15 inches wide. As well as a mouse, pen or graphics tablet and software, a desktop scanner capable of scanning line and halftone images and a colour inkjet or laser printer are essential. A back-up device or external hard drive is also very useful for storage.

Computer and monitor ◄

Most computers now house dual processor chips of at least 500MHz, which is powerful enough to deliver 7 billion calculations per second. Most monitors are LCD flat display panels with 1600 x 1024 resolution.

Digital camera ▼

It looks like a conventional SLR or instant camera, but instead of capturing the image on light-sensitive film to be developed, it converts its picture into a form that can be downloaded and stored on your computer.

Digitizing tablet ▼

They are useful, some say essential, for making digital pictures. With a cordless pen-like stylus, the artist presses on to a flat, plastic tablet and the 'drawn' movements correspond with that of the cursor on screen, graphically displaying the result.

Printer ►

Laser printers, such as Epson's EPL 6200, use reflected light and static electricity to deposit toner on to the paper, while inkjet printers spray microscopic jets of electrically charged droplets of ink deflected by electromagnets on to moving paper.

Scanner ▲

Desktop scanners, such as Epson's Perfection 3590, allow artists to input images already created into a computer format – the bitmap – for further manipulation or reference purposes. The most common scanners are flatbed of A4 size, allowing an image of that size to be laid and copied.

Conventional versus digital imagery

The question of whether traditional or digital methods of image-making are better will always be governed by the results you are looking for. So long as the final image is well executed and fits the brief you have set, it really does not matter how you go about creating it. However, certain styles or effects are better achieved by one or the other medium. A cartoon consisting of flat colour or soft blends is less painstaking to create on the computer than by hand, whereas a rough textured look or mixed-media collage work to best effect using traditional methods.

Traditional drawing ▲

The leopard is drawn by hand using a dip pen and black Indian ink. The very lively line is due to the changing delivery of the ink flow controlled by the nib.

Vector-based drawing ▲

This drawing was made with the Pen tool in Adobe Illustrator. The line quality is slightly lighter although extra points were added to give the effect of pressure.

Vector-based colouring ▲

Still in Adobe Illustrator, the Brush tool was set at various sizes to add colour on another layer. A gradient was applied to form the smooth brown to yellow blend.

Essential software

Your computer hardware needs the right design software to activate it and enable you to get creative. Before purchasing software, check that it is compatible with your computer's operating system. This is Microsoft (Windows) on a PC and Apple (OS) on a Mac and they are totally different. Most application software is available in CD-Rom format or can be downloaded from the Internet. All versions are named or coded to differentiate the new from the old. Sometimes Internet 'updates' are available supplied free from the

manufacturer, not requiring you to buy the latest versions. However, newly developed packages are often much improved and it may be better to purchase these instead. If you are planning to submit your cartoons for publication, it is essential to be aware of the version you are operating to ensure compatibility with a client or recipient of your work.

The cartoons in this book are created using the drawing and painting programs Adobe Illustrator, Adobe Photoshop, Corel Painter and the animation programs Flash and ImageReady.

Drawing and painting programs

Adobe Illustrator and Macromedia Free-hand create vector images and are known as 'draw' programs. These programs are mathematically devised through the accurate plotting of points. Joined points

form a line and joined lines form a shape to which flat colour can be applied. The format of this program results in images which look crisp, slick and clean. Adobe Photoshop and Corel Painter are 'paint'

programs and, as this suggests, employ a more freehand style of picture creation. They construct pictures using individual 'bits' which replicate textures familiar to the traditional artist.

Adobe Illustrator image ▲
Like all 'draw' programs, Adobe Illustrator has close links to page-layout applications. The Illustrator tool kit allows boxes, ellipses and curves to be drawn. Pictures are created using an on-screen Pen tool by connecting points along so-called Bezier curves. When two points connect, a line is formed with new 'handle' points that can be pulled out to curve or change the direction of the line.

In addition, scanned images can be imported and 'traced over' and Illustrator is excellent for manipulating type. The layering feature enables image sections to be edited separately, and stretching, skewing and rotating are all possible. Although the skill of dragging handles out from points takes practice, the advantage of this program is that it creates complex images with very low file sizes which hold their sharpness even when enlarged.

Adobe Photoshop image ▲
This 'bitmap' program was first developed as a photographic retouching tool, which rendered the manual airbrush obsolete. A user-friendly application, its vast scope and flexibility mean that it is recognized worldwide as the industry standard for retouching and art creation. Pictures are made by physically moving a mouse or stylus pen and the program gives the user access to a huge range of tools, techniques and effects. As with Illustrator, the system of working in layers gives the freedom to experiment and rework.

A major asset of Photoshop is its ability to manipulate, retouch or recolour digital pictures, whether uploaded from a camera, downloaded from the Internet, scanned or 'grabbed' as a screenshot from a DVD. In addition, final images can be converted into a range of file formats that are compatible for use in other applications or systems.

Corel Painter ▲
This program emulates traditional paint effects, such as watercolour, pastel, oils and acrylic. The program's extensive range of brush palettes are specifically geared to the sensitivities of the traditional artist: they range from soft round or flat watercolour brushes to firm bristle varieties for dabbing and stroking on acrylic and oil paint. The ability of the pressure-sensitive stylus pen to create corresponding marks on-screen is another feature which makes it attractive to the traditionalist. The system of layers enables changes to be made quickly and easily.

Although bitmap programs are easier to use than vector-based applications, image file sizes are usually large. However, all digital files can be saved in other formats for sharing and a full-colour A4 image of about 34MB can be compressed without too much distortion.

Making an image using more than one program

Each program has cornered its own niche, whether infinitely scaleable illustration, digital image manipulation or the reproduction of natural media. While you can approximate many specialized features with just one program – such as painting digitally with Photoshop – combining different approaches can lead to startling and original fusions of artwork. Creating such composite images couldn't be easier, as today's programs are designed with mutual compatibility in mind. You can import a vector-created design into a bitmap program, such as Photoshop, by dragging the vector image into a new document window or opening it with the application. Either way, it will appear as a new layer in the layers box. From this point on, further work on the vector image can only be applied using Photoshop. The advantage of the layered system of working is that it allows you to adjust individual sections of your illustration and move them between applications, playing to the strengths and different styles of each program.

Illustrator ▲
The flat artwork for the hands and trousers is created in Illustrator, but the shoes, bottle, drinks carton, shirt front and tie are sourced from magazines and scanned.

Photoshop ▲
The various textures and patterns of the shirt and tie are created using Photoshop's style palettes. They are selected and built in layers.

Painter ▲
The strong tonal image of the head is created in Painter using an acrylic paints palette and Brush tools. The smooth almost buttery texture is worked using the Blender tools.

Scanned image ▲
The cake is a scanned photo imported into Photoshop with an airbrushed-effect drop shadow. The flat table artwork is an Illustrator creation.

Painter, Photoshop and Illustrator ▲
This caricature is created using Painter, Photoshop and Illustrator applications. The composite image was made in the two vector programs and finalized in Photoshop. Its composition reveals the level of compatability between the three programs and is proof of the pixel's ability to unite different styles and techniques, textures and colours.

Scanning an image

You can input 'real' pictures, such as magazine cut-outs, and convert them to digital images via a desktop scanner, all of which come with their own scanning software. This connects to the computer via a USB port or via a faster, high-speed interface known as Firewire. Although more expensive than A4 size, most artists prefer the flexibility of an A3 size scanner. There is no limit to the types of images that can be scanned and photos, transparencies, halftone illustrations or line drawings will all maintain their original quality. As a general rule, images are scanned at a resolution which is double the size of intended use. So an image scanned at 300dpi (dots per inch) will reproduce a sharp on-screen or printed image which is 150 lines deep. In general, the greater the number of dots, the greater the intake of information and the better the quality of an image.

Scanning a line image

The method for inputting an image is similar with most software packages. There is the opportunity to select a 'cropping' area and to pre-scan and preview your work before finally copying it on to your computer. You will also have the chance at any time of recropping in the program you have chosen.

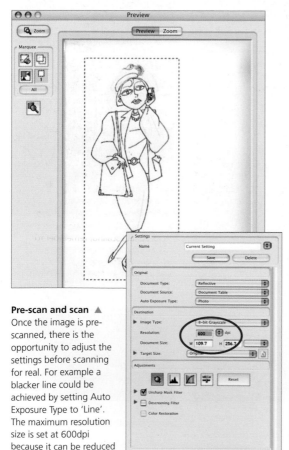

Pre-scan and scan ▲
Once the image is pre-scanned, there is the opportunity to adjust the settings before scanning for real. For example a blacker line could be achieved by setting Auto Exposure Type to 'Line'. The maximum resolution size is set at 600dpi because it can be reduced later on.

On screen ▼
Once scanned, the image should be opened in Photoshop or equivalent bitmap program for further tidying. Adjusting the Levels settings (Image > Adjustments > Levels), and sliding the histogram sliders to the left, brightens the scan and removes unwanted dirt or pencil graphite. The sliders in the Levels box are known as 'end dots' of a print screen and are the very darkest and lightest tones visible. Moving the right-hand slider too far to the left, deletes the lighter dot.

Tip: It doesn't take a lot of technical know-how to adjust scans. Try out test pieces and play with the histogram sliders on the Input and Output levels and see what happens to your image. Only hit the OK button when you are satisfied with the result.

Scanned levels

Adjusted levels

Tidying a scanned image

Repairs ▲

If your grayscale scan has 'broken' – a piece of line isn't strong enough to hold colour or has become thin and 'brittle' in the scanning process – you can use the Pen tool to strengthen the line or strengthen the offending segment by multiplying it. Select the area using the Lasso or Marquee tools in Photoshop, then copy and paste the line over the broken area on a new layer and set to 'Multiply'. When you're content with your fix, flatten the image (Layer menu > Flatten image) to reduce it back to a single line drawing.

Hue and saturation ▼

It is possible to change any part of any line by first selecting it with the Marquee or Lasso tools and then adjusting the colour or density values using the Hue/Saturation sliders (Image menu > Adjustments > Hue/Saturation). Experiment on a tester before making the final changes to your artwork, as this will assist your thinking processes and save you time in the long run.

Refining ▲

Use the Zoom tool to check for areas from the original drawing that need refining. Use a 3-pixel brush (solid, not feathered) to retouch the area. Keep in mind, you have multiple levels of undo.

Image inversion ▶

To check how clean a scanned image is convert it into negative (Image menu > Adjustments > Invert). It should have a solid white line and no speckling.

Image proportions ▼

Any image or part of an image can be reduced or enlarged using Transform (Edit menu > Transform). If you want proportionate scaling, remember to hold down the shift key while resizing it or it will distort as can be seen in the middle figure below.

Colouring a scanned image

The beauty of adding colour to an image in Photoshop is that you can make as many changes as you like on numerous layers without affecting the original. Any colour or painting technique that you no longer wish to display is simply deleted.

The range of colouring effects and application methods of this program can be overwhelming for the beginner. The best way to learn is by experimenting, safe in the knowledge that

provided you work in separate layers, nothing will be lost. This learning process is common to all artists: it helps them to pin down working methods and define drawing styles.

This practice exercise shows you how to set varying levels of colour tones to suggest highlights and shadows, and even add some textures into the mix, which are essential if an image is to have good overall balance.

Practice exercise: Adding colour, tone and texture

Transforming a flat single-line drawing into full-colour 3-D artwork is a simple process that gives a stunning result. The 'hands-on' experience of working in multiple layers allows you to take a logical step-by-step approach. Expect slow progress while you are learning to use and control the various tools, safe in the knowledge that your speed will pick up as you grasp the technical know-how. It is always better not to rush through, but gain understanding carefully, even if this means taking extra time.

Tip: The layers panel has a lock, eye and brush icon. 'Locked' images cannot be worked on – scanned images are locked automatically as layers until you add another layer. To separate out your line work and begin colouring, copy your locked image with the 'Duplicate Layer' command. Use the Magic Wand tool, with 'Contiguous' unchecked, to select all areas of white on your image and delete them. Meanwhile, delete the original background layer, which will become unlocked – use this to add your colour, working *behind* your untouched black lines. Clicking the eye icon makes a layer visible or invisible – useful for checking your compositions, isolating layers or testing out filters. The brush icon shows which layer you are currently working on.

1 The line drawing is scanned as a bitmap 600dpi 'Grayscale' image (Image > Adjustments > Grayscale). To add colour it will need to be converted to a colour image (Image > Mode > RGB Color) and then significantly reduced in size. Go to Image > Image Size > Resolution and adjust Pixels/Inch in dialogue box to 300dpi. You are now ready to start colouring.

2 Duplicate the line image as a new layer with the 'Duplicate Layer' command or copy and paste the entire image. It will automatically appear in the layers palette. Change 'Normal' to 'Multiply' by scrolling down. Now click on the original background layer and delete it so that the new layer is now the colour layer. Label the specific layers to avoid any chance of confusion.

3 Apply flat colour with a 'flat' 100–200 pixel brush. You can access Colours either by clicking on a square in the toolbox that offers a colour palette or from the colour palette or colour slider bar on the desktop. If your colouring goes over the lines, simply clean around the line on the Colour flat layer with the Eraser tool (toolbox palette). The outline has its own layer and rests intact.

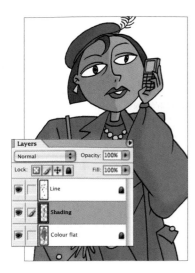

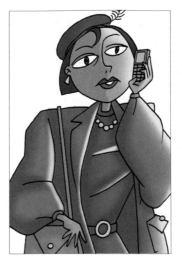

4 Create a new layer, position it above the Flat colour layer and label it 'Shading', as the screengrab shows. Select the areas to shade with the Magic Wand tool (toolbox palette). Select the shading layer and add 15% black to your original colour. Apply this shade colour using a soft brush.

5 Create a fourth layer and label it 'Highlighting'. To make new colours in the same hue range, simply reduce its strength by 20% and it is significantly lightened. Lock the other layers and select a soft brush to add the highlights. Experiment to see what effect you get by altering the colour Opacity, for example.

6 Create a 'Texture' layer and lock the other layers. Select within the outlines of the bag and strap and add the texture from the Filter menu (Filter > Texture > Craquelure). Select a different texture for the dress. Once areas are selected and made as new layers, you can experiment with textures and patterns.

Making colour changes

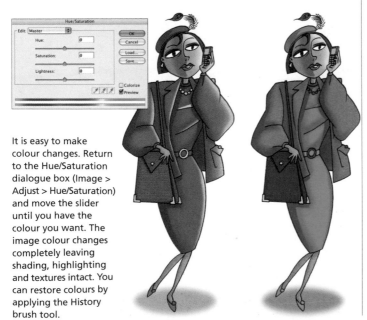

It is easy to make colour changes. Return to the Hue/Saturation dialogue box (Image > Adjust > Hue/Saturation) and move the slider until you have the colour you want. The image colour changes completely leaving shading, highlighting and textures intact. You can restore colours by applying the History brush tool.

Colouring comic artwork

A common process for digitally colouring comic book cartoons is to build layers of flat colour beneath the original 'line' layer of a scanned-in ink drawing. The highlights and shadows are applied using the methods shown on these pages, and the areas around the lines neatened with the Eraser tool.

The vector drawing program

The benefits of a vector drawing program, such as Adobe Illustrator, are most clearly seen when it is the sole program used to develop a sketch from draft to final colour artwork. It produces digital images in a distinctly slick style that combines crisp, clean lines with smooth flat colour. It by no means produces quicker results than other programs – in fact, creating shapes with the level of accuracy offered by a vector program can take time as you meticulously plot points, but as with all skills you will get quicker with practice. Another key advantage to using a vector program is that it uses far less memory than a bitmap program, so there are fewer problems with opening or storing images. This gives you the freedom to work on large-scale illustrations or on sequences, such as comic strips or cartoon narratives.

Practice exercise: Creating a vector cartoon

Computers cannot replace artistic skill when it comes to creating images. They are an excellent tool but their only role is to respond to logical commands. Traditionally, an artist will 'think' and redraft a composition many times on paper and thinking remains a vital part of the process of refinement for a successful outcome. Using a computer program instead of paper changes nothing except that it is generally a speedier process. Create a file for the storage of sketches so that you can access them with ease and efficiency at any time.

> **Tip:** Name each layer you create for ease of use. Save the image twice at the end – once with layers open, the other flattened with another name, as a flattened image won't allow you to adjust any stage of your work.

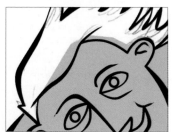

1 Scan an HB pencil sketch which you will use as a guide for vector drawing. Import it into Illustrator and reduce the file size to 100dpi ready to make an accurate Illustrator line trace (the resolution does not need to be large for tracing). Label the layer 'Trace'. If the scan is too dark click on it, then type 50% in the 'Opacity' box.

2 Now create a 'Line' layer and trace the outline of the sketch using the Pen tool, ensuring you click on the 'no fill' box. Give the Pen tool a 2pt stroke. Give the line extra weighting by clicking on the drawing and selecting Expand (Object > Expand), then use the Direct Selection tool to drag out anchor points to thicken the line in selected areas.

3 Lock the 'Line' layer and then create a new 'Flat colour' layer below it. Choose the hues you want from the palette. Colour the different parts of your cartoon figure by selecting within the vector drawn points, leaving the background for a later stage. Use smaller brushes for small areas, and the 'Bucket Fill' tool for filling large shapes.

4 Create another new layer and call it 'Shading'. Darken the colours you are going to use for shading by adding 15% black to each one. Draw in the shadow areas and fill these shapes with a colour block from the selected palette; click on more colours in the palette for a more extensive range. Remember to lock the 'Flat' colour layer before you begin.

5 The pattern on the bathing shorts is composed of simple flower shapes. Create a single shape and locate it in the symbols library. Select it using the Sprayer tool and it will spray multiple flowers across the shorts area. Use the Direction Selection tool to remove stray flowers or rearrange the pattern. Create the gradated circle highlight on the rubber ring by selecting the white colour, clicking on the Gradient (next to layers) and selecting 'Radial'. Move the slider bars to adjust the size.

6 Make another layer and create the waves. Outline their shapes and add movement strokes (above). Select a brush from the Artistic Ink range (click on brushes arrow in the palette, scroll down to Open Brush Library > Artistic Ink > select Brush) and fill the areas with blue (right). Add colour gradients to the sea and sky on this layer: select an area with the Marquee tool or Magic Wand and click the Gradient tool to fill the area with the default gradient; black fading to white. The Gradient palette allows you to edit the colours and the 'gradient stops' (where a colour blends into another). To change the gradient's direction, draw a line with the Gradient tool across a previously selected gradient. Return to the Line layer and outline the seagulls, the strokes behind the surfboard and the foam bubbles.

Combining programs

Moving between programs provides more opportunity for creative image play. For example, a standard vector-drawn cartoon character imported into a bitmap program, such as Photoshop, can inhabit surroundings created in an array of styles, from the photographic to the painterly. This freedom to juxtapose the usual and the unusual and bring about striking contrasts invariably unleashes new levels of creativity.

The fact that Photoshop and Illustrator are complementary Adobe stablemates is liberating. The two applications share enough similarities of style and usage for anyone familiar with one application to switch between the two without difficulty. Following this lead, software packages from other manufacturers, such as the Corel Painter program, are deliberately intended to be similar.

Practice exercise: Combining Illustrator and Photoshop

It is important to explore the potential offered by marrying vector and bitmap systems with a wide-open mind. Let go of all expectations of digital precision in favour of more relaxed collisions of broad shapes and colours. Unlike conventional drawing and painting, the Photoshop (bitmap) painting being on a layer can 'go over' the line that you have drawn in Illustrator (vector). When the colouring layer is physically placed beneath the line (vector) layer and the layer 'eye' icons clicked on, it is an easy task to erase colour that has extended over the lines.

Such freeform digital images show that computer-generated concepts can be as inventive as traditional mixed-media collage. There is a benefit too of easily moving layers on top of each other with no need for using glue, which makes it hard to remove the pictorial pieces.

2 Find a photograph of pumpkins or other fruit or vegetables. This can be sourced from the Internet, a magazine or it could be a photo you have taken on a digital camera. Scan or import the picture into Photoshop where it automatically becomes a new 'Photos' layer. Position and scale the picture to the size you want using the Transform tool (Edit > Transform > Scale), and remove unwanted areas with a soft Eraser tool.

Tip: Don't think too long and hard about how you will develop an idea before testing it on screen. Start your exploratory journey straightaway, knowing that any wrong turns are easily corrected or eradicated if they have been made on separate layers.

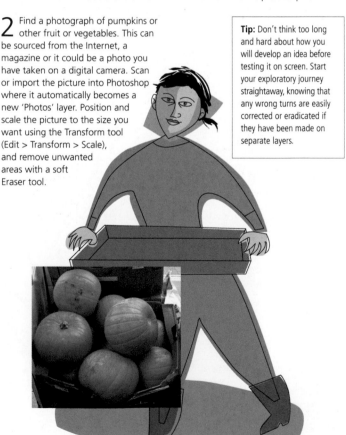

1 Draw the figure outline in Illustrator, using the Pen tool with a 0.5pt stroke. Label this layer 'Line' and lock it. Now make a new layer named 'Colour' and fill the outline with the different shades seen here. When you are happy with your image, save it for safekeeping, and open Photoshop. In Illustrator, click on 'Select All' to collate all image layers, and drag the picture into your new Photoshop window. Alternatively, you can import the picture by dragging your Illustrator document from your folder or desktop on to the Photoshop icon, where it will open automatically as a new layer in the layers palette.

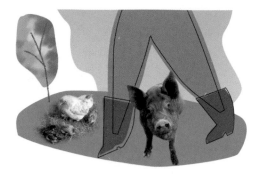

3 Import the animal pictures into the Photos layer, position them and erase any extraneous details. Create the background layer and sit it below the others. Outline the tree and the amorphous shape behind the figure using the Pen tool. Fill them with gradated colour blends.

4 Distort the blend within the tree shape using the Smudge tool and add digital images of apples as a new layer above the rest. On another layer add a shadow beneath the pumpkins using a soft brush. This gives them extra realism and enhances the 3-D quality. You could refine the shadow using filters.

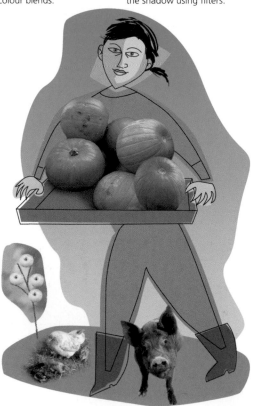

Composite variation

Blending Illustrator and Photoshop applications can produce great results and they are not too difficult to grasp with a little practice. The hardest challenge lies in creating the initial sketch and controlling the tools for the best effect.

City man ▶
A sketch is created in Illustrator using Brush tools, which give a fluid line of varying thickness. The colour is then filled in and the image dragged into a new Photoshop document which contains layers of scanned magazine pictures with adjusted hues. Applying filters adds drama to the background.

Composite programs caricature

Illustrator is the best choice for creating the extended lines and curves in this composition. The stylized shapes of the body, guitar, amp and microphone are tinted using flat Illustrator colours. The brushed acrylic layers of the more realistic caricatured head are produced in Photoshop.

Guitar man ▼
The flatness of the Illustrator body is in direct contrast with the formed, more painterly textures of the Photoshop head. This has been pinched, tweaked and distorted using an array of brushes and filters.

Digital faces

Speech bubbles are rarely the first point of contact in a visual story and can even be replaced in a dialogue scene by the facial expressions of the characters. It is essential to portray expressions so that they are instantly recognizable, or else risk losing the meaning or joke they are aiming to convey. You can avoid this by reminding yourself that a digital program is only a tool and continue the habit of observing and sketching a range of faces

and expressions to keep your skills intact. A portrait that is built using conventional methods can be ruined if something goes wrong at an advanced stage. The advantage of developing a portrait on the screen is that it is almost impossible to go wrong – you just erase the work on the layer and start all over again. The exercises below outline the strikingly different results that can be produced when using different programs to draw faces.

Practice exercise: Using Bezier curves and flat colour in Illustrator

Illustrator is ideal for creating strong controlled lines thanks to the sharp precision of its Bezier curves. While the colouring style limits itself to fairly flat hues, these are perfect for those cartoons where bold graphic definition

is necessary. Cartoon artwork produced for television and web pages especially benefits from this flat saturated colour style because they are transmitted by light passing through a dense network of tiny dots.

> **Tip:** Practise the exercises on these pages again but change the brush shapes and sizes, alter the effects used and, in the case of Painter, try out different media or different combinations.

1 Scan in your pencil sketch at a high resolution and then resample it at 100dpi. Draw over all the lines of this image using the Pen tool. Make the pen drawing into a 'Line' layer and knock back the layer Opacity to 50%. This enables the new image to stand out from the original sketch beneath which was used as a guide.

2 Expand the pen line by pulling out selected anchor points using the Direct Selection tool. This simulates the result you would get if drawing with a springy brush where the pressure would be constantly changing as you delineate the facial curves.

3 Establish a 'Flat Colour' layer and position it below the Line layer in the layers palette. Colour the main areas using a flesh tone for the skin and brown for the hair, beard, eyes and eyebrows. Outline a new shape for the zigzagging edge of the beard.

4 Create the final layer to include the shadows and highlights, which are fairly simple. The lighting effect on the top of the hair is made by reducing Opacity and by softening using the Blending tool. The highlight tones on the skin are created by reducing the percentage value of the colour saturation. The shadow on the left has an extra 15% of black added. Take care not to overdo the contrasts on these effects as this could overwhelm the line/colour style of the cartoon.

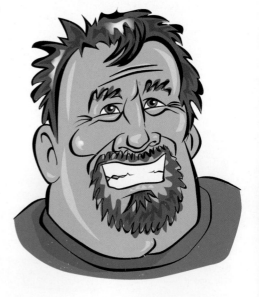

Practice exercise: Modelling in Painter

The tactile joy of painting need not be totally lost for the digital cartoonist. The methodology for building and refining a character portrait through stages of modelling can be successfully employed using the bitmap program Painter. The stylus is sensitive and can take a bit of getting used to, but its readiness to respond to the slightest alteration of hand pressure is a real plus point, and will result in the subtleties which bring a painting to life being retained.

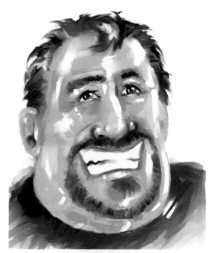

1 Scan in your pencil trace for the base layer. On a new layer, block in the 'Acrylic' colours using broad strokes on a medium brush setting.

2 Smooth the colours using the Blending tool, using the same stroke directions that you would if you were actually painting. Add highlights and smooth them with the same tool. Dash in the T-shirt colour and smooth, first the blue, then the white, then blend. Use a smaller brush to detail the eyes and hair.

Practice exercise: Balancing line with tone in Photoshop

The versatility of Photoshop can be fully realized in this exercise, in which it is used to construct the same face. A quick comparison shows that this Photoshop version creates a happy medium. The lines are crisp yet maintain much of the freely drawn nature of the original pencil sketch. The depth of colour and modelling is convincing enough to add form to the character without making it appear heavily laboured. The evenness of the tonal passages echoes the controlled manual application of gouache or acrylic.

3 Create another layer for shading. Darken the flesh tone by adding a further 15% of black. Darken the hair colour by at least 20% and locate shadows below the hairline and down the right side of his face. Create a gradated blend for the T-shirt on the same layer, extending it from white to blue. Return to the 'Skin' layer and remove the colour on the teeth with the Eraser tool, making them bright white.

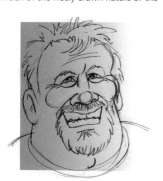

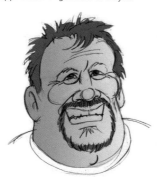

1 Scan your pencil sketch in grayscale at 600dpi, reduce it to 300dpi and convert to RGB colour. Under Image > Adjustments > Hue/Saturation move the slider so that the pencil line changes to warm brown. Make a new 'Skin' layer and place it beneath the Line layer. Use the Sprayer tool to apply a gradated skin tone, carefully erasing any excess.

2 Add a new layer between Line and Skin and use a flat brush to paint in warm brown strokes for the beard and hair. Select the same hue to paint in the pupils of the eyes. It is important to use different types and sizes of brush for the various sections of this painting. Opting for one or two choices will limit the contrasts you are aiming for.

Digital face styles

The versatility of computer-generated cartoon faces is seen below. Paint and draw programs are capable of creating styles as wide-ranging as those produced by traditional methods. It makes sense to take inspiration from the master cartoonists when developing a look, whether square-jawed Hanna- Barbera or wide-eyed manga. Clarity of expression and good definition are essential to whatever style you create, and digital media delivers this.

PHOTOSHOP

Sketch ▲
A lively pencil sketch is coloured brown in Photoshop, then a new layer overpainted for a flattish surface form.

Highlighted ▲
A Photoshop image drawn on screen. The ultra-pale highlights and strokes are made with a 1-pixel brush.

Airbrush ▲
A line sketch is scanned and coloured in Photoshop on a new layer. Airbrush Eraser creates highlights on the face.

Flat tones ▲
A Photoshop creation executed with the broken line of a Brush tool and painted in flat hues.

ILLUSTRATOR

Highlighted ▲
The entire face is created in Illustrator with point-created shapes, expanded lines and white highlight strokes.

Gradated tint ▲
The lines are expanded in Illustrator by pulling anchor points. The gradated tint is created on a new layer.

Conventional ▲
An Illustrator drawing that uses Bezier curves throughout, expanded line and layers of flat colour.

Strong shapes ▲
The strong flat-coloured shapes of this face make the most of Illustrator's Bezier curves.

COMBINED

Painter layers ▲
The face was drawn and filled in Illustrator, then imported into Photoshop where a halftone pattern was added.

Broad line ▲
This face fully utilizes expanded Illustrator lines and dots. The pale hair is Photoshop-created.

Line and airbrush ▲
An expanded Illustrator outline that has been coloured in Photoshop. The stubble is airbrushed.

Soft brush and airbrush ▲
The Illustrator outline is coloured in Photoshop. A soft brush defines the hair and the stubble is airbrushed.

Photoshop hair effects

Like faces, distinctive hair styles can be a useful way of defining character and displaying personality traits that are easy to recognize. Exploring the wide range of custom brushes and filter effects in Photoshop and applying them to simple sketches will enable you to spend less time creating techniques, and discover more ways of bringing hair to life. The simple sketches on this page demonstrate some of the effects that can be achieved.

Stage 1 ▲
A pen sketch is scanned and imported into Photoshop. The first duplicate layer is filled with flat medium brown.

Stage 2 ▲
On a new layer the Pencil tool defines hair strands and darker brown brushstrokes soften the edges.

Stage 3 ▲
White highlights are added on the final layer with a medium brush and blended with the Smudge tool at 60% Opacity.

Soft volume ▲
With the charcoal brush selected (Brush Palettes > Brushes), broadly sketch the soft curls. Offer a more life-like balance of tones throughout by altering the 'Opacity', which here is 60% and 30%.

Dune Grass custom brush ▲
Use the custom brush 112 – 'Dune Grass' – from the brushes library to recreate a thinning wispy head of hair. To tidy, use the Eraser tool to remove unwanted strands.

Sampled brush ▲
The variety of custom brushes is wide, the choices peculiar, but they bring strong textural qualities to the drawing in contrast to the flatness of outline and solid, facial colour.

Creating backgrounds

The importance of backgrounds in anchoring cartoon figures, setting scenes and generally assisting the narrative of a gag or strip is undeniable. Creating settings by hand can be laborious but a task such as painting a soft gradated blend or cross-hatching a texture is achieved quickly and easily using digital techniques. Not only is it possible to add uncomplicated backgrounds in seconds, they can be constructed in multiple layers to give you the option of changing textures, colours or line work at will. The freedom of creating settings digitally also allows you to be more inventive in areas such as tonal contrast and surface quality, which can add significant interest to your scenes. Take inspiration from the digitally devised settings of many graphic novels and children's books and don't be afraid to indulge in creative play. Photoshop's wide selection of filters and effects can make for a polished end result, whereas Painter is best able to mimic traditional painterly effects.

Practice exercise: Creating a background in Photoshop

It is especially easy to create, manipulate or duplicate images or sections of images using Photoshop. The typical 'copy and paste' method can be used to build a background, where manual methods would need to employ collage techniques to achieve the same results. As well as its compatibility with other programs, a major benefit of Photoshop is that colours are altered with ease and layers are stacked on top of each other with varying degrees of Opacity.

Tip: Photoshop and Painter have a huge range of filters and effects. Search through these before you create a new texture – the effect you seek may already exist.

1 Draw the outline using a dip pen and black Indian ink (the single window is deliberate) and scan it into a new Photoshop document. Duplicate it as a layer and rename it 'Line'. Set the layers box on to 'Mutiply'.

2 Lasso or Marquee the single window with the appropriate tool and duplicate (Item > Step and repeat) on a new layer. Create the distant windows by scaling (Edit > Transform > Scale), and duplicating the single window. Play around, moving and scaling the shapes until you get the sense of depth you want.

3 Make a new layer and create a brick pattern on it by drawing boxes and fill with two reddish tones. To duplicate the boxes, take them into pattern mode (Edit > Fill > Pattern).

4 ▲ ▶ Scale the pattern as you did for the window in step 2 and apply it to the buildings receding into the distance. When the buildings are covered, erase the pattern over the windows.

5 Create a new layer to go behind the bricks. Fill it with gradated colour from pale yellow to glowing orange-red and add pale block shapes to indicate the far distance. Fill the bell pushes with red and tint the figure a blue shade that contrasts with the glowing eyes. Draw and fill a darker shadow on a new layer.

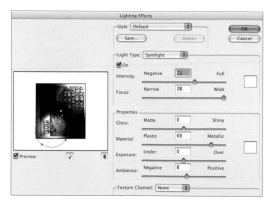

6 Finally enhance the mood using the Lighting Effects palette (Filter > Render > Lighting Effects). Select the values shown in the screengrab above for the light around the bell push. You can adjust the circumference, shape and position of the flare by clicking on the lamp icon and dragging the Pointer tool. Feel free to experiment with new values to discover different effects.

Painter backgrounds

The subtle colours, textures and geometry of this background setting for a tree-planting 'eco-hero' character is created in Painter. This program comes closest to reproducing traditional drawn and painted effects, while Photoshop's range of filters and effects can produce a slicker, more polished look.

Rainbow ◄

To make the rainbow, a series of vertical bands is drawn on a new layer and filled with a spectrum of colours. The colours are then blurred by applying a filter. The bands are distorted and rotated to imitate the rainbow curve. This layer is placed on top of the pastel one.

The figure ▼

The last step is to detail the figure. The scanned image is outlined in broken-edged pencil and filled with colour – acrylic paint tones for the costume and skin, with white chalk pastel highlights. The clouds and rain streaks are pastel, and blocks of grey and brown acrylic tones are duplicated on to a grey background for the buildings.

Scan and pastel effects ▲

A pencil sketch of the superhero and the background details is imported into Painter from the scan application and converted into a layer. The sky is a construction of blues and violets using broad brush tools on a pastel setting. The larger shapes are duplicated and overlapped.

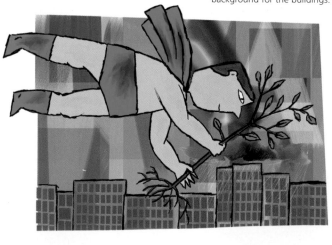

Practice exercise: 3-D illusion in Illustrator

Not every cartoon background works as a simple tone or texture, or a figment of the artist's imagination. For certain subjects it is often necessary to opt for a more lifelike 3-D setting. Converting a flat surface pattern to one which converges at a vanishing point can be a time-consuming exercise by traditional methods but is a relatively problem-free task on the computer. The accuracy of Illustrator makes it the ideal tool for making such drawings. However, their success or failure will depend on the user's grasp of the principles of perspective. A sound understanding, plus the ability to combine different elements convincingly, will enable you to be ambitious in your creations.

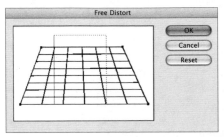

3 ▼ Use the Bucket-Fill tool to colour the squares in a chequerboard pattern. Click the box marked 'Gradient' on the desktop to apply a gradated tint to the colour as shown below. This will greatly enhance the 3-D effect.

2 Lay the grid in perspective along a horizonal plane using Free Distort. Click and move the two end points of the top horizontal line closer together. Adjust their positions until the shape is at the correct perspective. Click 'Reset' if you want to begin again.

1 On your base layer, start by making the grid pattern for the floor. Use the Pen tool to draw small squares – duplicate one six times to make a row, using the 'Copy and Paste' commands, then duplicate the row eight times to make your grid. Arrange the rows as shown above. Make sure you apply an outline stroke to the grid. Select and group the composite parts of the grid into a single entity (Object > Group).

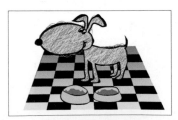

4 Create a new layer for the dog and food bowls. Position the dog in the midground and the bowls in the fore-ground. Draw their outlines using the Brush tool, expanding and thickening the lines to add character. Colour the body grey, then select Effect > Stylize > Scribble for a textured look.

5 Select, duplicate and scale the food bowls at different sizes on a new layer. Locate them in the foreground, midground and background. Make a 'Shadows' layer beneath the bowls, outline an ellipse and fill it with grey at 50% Opacity. Duplicate, scale and position the shadows beside the bowls.

Tip: Keep perspective grids simple so that you are able to judge the perspective convergence easily. Refer to one, two and three perspective template drawings to help you to understand how settings and objects converge into the distance.

Practice exercise: Stylish realism using combined programs

A modern setting needs a style to match. Amalgamating the accuracy of Illustrator and the versatility of Photoshop gives you the means to produce an image with a bold and contemporary look. The broadly painted background of this setting is made in Photoshop while the Illustrator line, strong graphic shapes and accurate perspective refine the picture and add realism. The creative process of laying down colours, textures and marks in distinctive layers is as involved as the traditional technique of screenprinting.

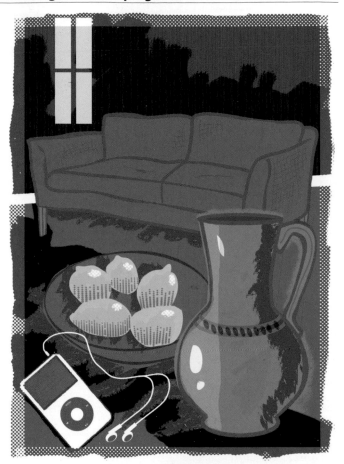

1 The room and its contents are outlined in Illustrator using a range of brushes to give a free loose style. The flat colour is applied in Illustrator and the series of dots for shadow areas on the lemons is created using the Blend tool.

2 The image is then dragged into Photoshop where the colours are adjusted and the larger areas filled with broad brushstrokes. A refined Brush tool is employed to create the smooth lines of the MP3 player.

3 Finally, a 'Halftone' filter creates a border. A regular coarse pattern of halftone dots can be applied in Photoshop to interrupt the smooth surface of Illustrator-generated images. The settings used here are shown on the right. Adjusting dot size, shape and contrast will give different effects.

Tip: Adding scanned or 'found' imagery to your hand-drawn compositions, as with the iPod above, can grant them greater legitimacy than as images alone. Think of the photographic trees, people and vehicles used to bring the latest digital architectural renderings to life. Keep a cuttings file of useful photographs or magazine clips that could be scanned and cut out digitally using Photoshop. Collect subjects that have a strong shape and not too much tonal subtlety.

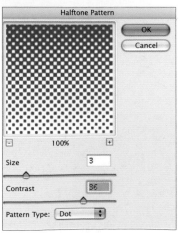

Portraying motion

The computer counterparts of drawn action lines have much in common with the speed effects seen in fast-action photography and film. All the main vector and bitmap programs can replicate the effects of suspending a high-speed moment in time, often with only a few simple steps. Illustration devices that signify movement can be digitally enhanced using a gamut of action effects and distortion tricks. Features such as blurring, speed lines and superimposing multiple images on top of one another all create a convincing illusion of activity. Short of actually making it move, selecting the right interpretation of your moment of frozen time or mixing manipulated digital photography with your cartoon will be enough to animate your image with energy and dynamism. The exercises below outline the creation of composite pictures that refuse to stay still!

Practice exercise: Creating a speed blur effect

To produce a cartoon with digitally animated qualities requires a good balance of elements. A well-constructed composition is vital: the main focus should be emphatic and its descriptive action lines surrounded by enough white space to take the motion effect. Directing the viewer's eye contributes more to the concept of motion than a host of clever tricks. In this exercise the simple device of a looping motion line provides a visual journey starting at the goldfish bowl at the bottom of the picture and leading to the flying fish at the top. Here, a blur effect on the blades is sufficient to focus the full attention of the viewer on its rapid, whirling motion.

1 Create the static rounded fish in Illustrator, expanding the points of your drawn lines with the Direct Selection tool as in previous exercises. Draw the multiple helicopter blades in a lighter line to help them move.

2 Import this line drawing into a new Photoshop document and create a 'Colour' layer. Add the soft yellows and greens to the body using an Airbrush tool. Fill the rotor blades with flat red and paint white in between.

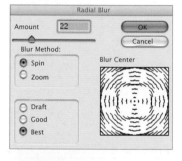

3 Select the elliptical rotor blades area and open the Blur filter (Filter > Blur > Radial Blur), setting the method to spin. Select a second tighter elliptical section in the centre of the same area and repeat the process.

4 Draw the goldfish bowl, the action strokes and twisting line which traces the motion path in Illustrator. On a new layer, position the earlier Illustrator outline of the fish. 'Select All' and open in Photoshop for colouring, positioning the outline beneath the existing colour layer.

Practice exercise: Creating a superimposed effect

Creating the sense of movement in a still image by superimposing is traditionally done using clear acetate layers. The same image is duplicated on each layer, each time in a slightly different position to give the effect of movement trapped in freeze-frame. Creating this type of action in Photoshop offers the advantage of varying the Opacity of the layers, which allows the transition of time to be more strongly conveyed.

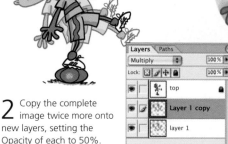

1 Sketch the outline of the boy and his football in pen and scan it in as an oversized line art image. Reduce it in scale and size to 300 dpi, convert it to RGB colour and copy to a new layer. On separate layers, add flat colour, shadows on the left side and a white highlight to the ball.

2 Copy the complete image twice more onto new layers, setting the Opacity of each to 50%. Drag the three layers into a new document and position so that the lower two are slightly offset. Rotate the lower images (Edit > Transform > Rotate) and erase any area overlaps.

3 Finally, add the radial blur motion effect from the Blur filter to the two images on the lower layers (Filter > Blur > Radial Blur). Decide on the frequency value for the blur and set it to spin. Feel free to play around with the settings, experimenting with different values, and only click OK when you are completely satisfied with the results.

Practice exercise: Combining media

Combining images that vary in quality is an easy and effective way of portraying speed. In this example a static Illustrator-generated cartoon character is imposed on a digital photograph which has been 'speeded' up.

1 Choose a digital photograph with a strong one- or two-point perspective, such as the advancing train used here. Import it into Photoshop as a .jpg, then convert it to RGB colour mode (Image > Mode > RGB Colour). Make the photo a new background layer.

2 The outline of the cartoon character is created in Illustrator and imported into Photoshop. The flat colours and highlights are added on a new layer. The speed effect is applied to the digital photo on a new layer using the Radial Blur filter set to 'Zoom'. The layered cartoon is then imported. Finally, an elliptical shadow is drawn in Photoshop and softened using 'feather' at 20 pixels. It is then filled with blue and reduced to 50% Opacity.

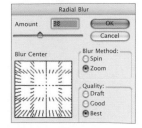

Digital improving

One of the fantastic things about computer enhancement is that it does just as it says: enhance! Each picture that is drawn, painted or manipulated in some way is bound to be an 'okay' picture, but getting it to the next level and making it a little more special can be a really simple task that merely requires you to have the tricks of the trade to hand. Every day that you use graphic applications on a computer your learning will

progress and, second to picking up tips from other people, there is a strong argument for exploring and experimenting with the program's filters and effects libraries. Many of the improvements that will transform your cartoons are achieved by making simple adjustments to one of the wide range of filters or via the Image > Adjustment menu in Photoshop. The preview option always allows you to test the effect.

Practice exercise: Retro style

A return to the retro styles of the 1970s brought with it a desire by image-makers to take another look at the grooviness of swirling patterns, modish pop art circles, tangerine dreams and lime-green walls. Although the colours of the revival are more refined, the defining feature of this retro style remains in its clean lines and strong colour definition. Such specific demands are most successfully met by a combination of Illustrator and Photoshop.

1 Begin with a manual pen drawing that has plenty of life in its line variation. The focus of the sketch is on the listener in the chair with his accessories so keep the background plain. Import this image into Photoshop and tint it using a Colour palette and Brush tools.

2 Construct the rest of the room in Illustrator using the Pen tool. Place the coloured figure into Illustrator at the same time to assist with the scale and construction of the room. Drag everything back into a new Photoshop document. Draw an irregular shape on a new layer beneath the line drawing and colour it green. Draw a box with the Rectangle Drawing tool. 'Posterize' a scanned or downloaded tower-block picture (Layer > New Adjustment Layer > Posterize) and import into the box.

3 Create the swirling wallpaper pattern in Illustrator, and place it back into Photoshop for duplication as a pattern (Filter > Pattern Maker). Select the background area above the skirting boards, and darken it using the histogram slide (Image > Adjustment > Levels). Next choose 'Multiply' on layers, and fill your selection with your chosen pattern (using the Pattern Bucket tool). This will duplicate the pattern into the space.

Practice exercise: Motion in Photoshop

Adding an airbrush-style motion effect is a very uncomplicated process in Photoshop. It is made using basic brushes and any of the blur filters, grain filters or pointillizing filters, singly or combined. The end result can enhance a simple

visual gag enormously. In this practice exercise, it can be clearly seen that the definition of contrast between the crisp characterful line and the soft out-of-focus background lends a heightened sense of depth to the final image.

Tip: Using noise, grain and pointillism filters is a quick alternative to sourcing real-world textures to use in your imagery. They have the added bonus of meshing and integrating more naturally with your art.

1 Sketch the 'dog and man' gag by hand as a simple, fineliner pen drawing. Keep your lines lively by varying their weight – it keeps them animated. Scan your drawing and import it into Photoshop, duplicate it as a new layer, delete the background layer and set it to Multiply.

2 Add colour using soft brushes and create the background as a Gradient image (Layer > New Fill Layer > Gradient (set to Multiply)), from light to dark. Further soften the soft coloured banding of the sky and accentuate the effect of motion using the Blur filter (Filter > Blur).

3 Fine action lines deliver effective motion. Add a Horizontal Grain filter (Filter > Grain) to the back of the dog's body. Check the settings against the screengrab (right), but feel free to experiment with intensity and contrast. When you are satisfied click OK.

4 Extra details can really enhance the character of a drawing. Marquee/Lasso the jumper area (Select > Filter > Pointillize), set the cell size and click OK. Adding texture to the man's jumper brings him into focus as a foil to the leading character of the pooch.

5 Finally, add white speed lines around the feet of the characters and in between them.

Words

A cartoon with a strong visual sense won't need the help of text to communicate its message. Despite this, words traditionally accompany many cartoons and perform a variety of functions. In general, self-contained panel cartoons have a simple caption or one-liner beneath them, whereas comic strips include dialogue placed inside speech bubbles. Lettering is also used as a means of communicating sound effects.

Cartoon words must be clear, legible and integrate with the overall design. Lettering style, size, weight and consistency are therefore important considerations. Traditionally, cartoonists use hand-drawn lettering to achieve this, a technique that is easily replicated using selected computer fonts. Unless it is being used for emphasis, cartoon lettering is usually black on white so that it plays a secondary role to the image.

Speech bubbles

Digital software is of huge assistance to the cartoonist where accuracy and neatness are essential. A vector drawing program, such as Illustrator, can produce a range of faultless speech-bubble ellipses. Once created, they can be saved into a file and used as a style library for ready access as and when they are needed.

Calligraphic bubbles ▼
Select different brush-drawn styles in Illustrator to produce quirky speech bubbles with varying weights of line. Go to brush style under 'Brushes' and choose the style. Next select the bubble, add the stroke weight of your choice and click on it.

◄ ▼ Basic bubble process
The basic construction of speech bubbles is best done in Illustrator. Draw an ellipse with the Ellipse tool, and then use the Pen tool to make a small inverted triangle at the base of the oval. Go to View > Pathfinder > Make compound shape to unite these two selections.

Only use bold and bold italic where it most **effectively** expresses the idea.

Offer **emphasis** to speech by simply setting in bold**.**

Italic bold can alter pace or **intonation** in speech.

For speech to have strong impact within the narrative, set it all in bold or bold italic.

Plain speaking in a standard, plain bubble

This pressure-led bubble indicates movement and life.

A more basic bubble, in a broken drawn style, is suitable for lighter gags.

Brush style palette

Pen and Pencil tools

Place informal lively speech in a direct, square box-type bubble.

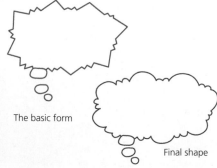

The basic form

Final shape

A thought cloud ▲
Construct the basic form in straight-edged lines using the Pen tool. Then curve the points by adding and subtracting points within the shape, using the range of either Pen or Pencil tools.

Lettering effects

Whether they are vector-drawn or bitmapped, all type forms can be manipulated – stretched, compressed, enlarged, reduced or skewed – and tinted by building layers. Both Illustrator and Photoshop offer a broad range of effects which are useful when you want to exaggerate or emphasize lettering. Effects such as a blended or gradient fill, drop shadow or other tinted or textured surfaces are the most commonly used. If you start to explore the Filter menus you will find not only alternatives for toning and texturing the letters, but also distorting them.

| Back Fill | Outline, no fill | Drop Shadow | Drop Shadow (layer effects) | Chisel Emboss (layer effects) | Custom Brush (wavy line fill) |

| Distorted | Radial Fill | Twist, blend | Duplicated X offset to new layer | Custom Brush (advanced palette) | Halftone Pattern (partially erased) |

Special FX in Illustrator ▲

Although Illustrator does not offer the same breadth of tools for manipulation as Photoshop, it is a very good program for adjusting type forms.

Special FX in Photoshop ▲

The above examples show the variability of type effects that are available in Photoshop. The majority show the results that can be achieved by manipulating surface decoration.

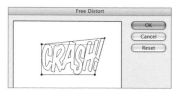

Expressive type in Illustrator ▲ ▶

When you have typed the word in your chosen font go to Type > Create Outlines; then Object > Ungroup and use the Direct Selection tool (white arrow) with Alt key depressed to overlap the type. Next go to Filter > Distort > Free Distort and extend the points outwards to alter the scale and shape of the typeface. Finally, apply a Gradient Fill from the gradients palette on your desktop.

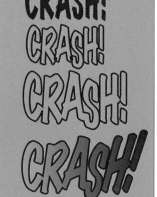

Transforming type ▼

The dullest of lettering can be given a visually exciting make-over by manipulating it. Explore the different effects that Illustrator has to offer and experiment with already familiar techniques, such as varying and expanding line widths.

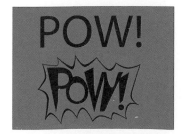

Digital shortcuts

Achieving a complex visual effect using traditional manual methods requires skill, patience and time. When working on a computer the critical difference is that you can gain maximum effects with minimum effort, often after a single keystroke.

Understanding and implementing digital shortcuts to create effects such as the complexities of reflections in glass or on water, or the subtle folds of fabric are indispensable skills for the digital image-maker. Begin by exploring and experimenting with the range of different filters that are at your disposal. Each filter has an accompanying tool option panel which allows you to apply effects and distortions. For example, in the case of the Bas Relief filter, it includes surface texture choices and the depth of the relief dictated by the direction of the light creating the 3-D effect.

Practice exercise: Creating a fabric fold

This exercise demonstrates a digital approach to suggesting the smooth undulating movement of a weightless, shimmering fabric by replicating the complex interplay of light and shade on the surface of the cartoon character's cloak and pantaloons. The huge range of effects and filters that are available in Photoshop makes it the ideal choice of program to achieve such a high standard of description easily, quickly and effectively.

1 For the cloak create a rectangle in Photoshop at the approximate size you need and fill it with red. Add broad, horizontal bands of light brown using a selection of soft brushstrokes to give a streaked effect.

2 Lock the first layer and make a new one. Select a lighter shade of red and brush it across the red areas, ensuring you leave narrow bands of the deeper colour to establish a consistent tonal depth and rhythm.

3 Make another layer and select a smaller soft brush to add tapering white highlights across the centre of each paler colour band. Don't worry about precision. No two fabric folds are ever the same.

4 Now for the digital trickery: go to the Wave filter (Filter > Distort > Wave) and experiment by moving the slidebars until you achieve the desired effect. Click OK when you are happy with the result.

5 To achieve further distortion which is less regular and looks more like silken folds, apply the Pinch filter (Filter > Distort > Pinch) and adjust the level of distortion by moving the slider along the bar. Form the flowing cloak shape by cutting it out using the Pen tool.

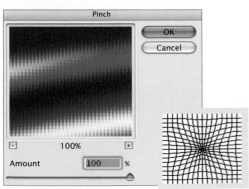

6 Apply the effect by dragging it into the document containing the cartoon image and position it over the appropriate section. As it is on a layer, it can be set behind the main figure, as shown here. Now repeat the process to create the same silken effect for the purple pantaloons.

Practice exercise: Rendering embossed metal

In this example the embossed bronze sheen is created by applying a filter known as Bas Relief. Note that filters can never be a shortcut for working through the creative process and that final effects should only be applied to finished artwork.

3 When you have achieved the filter effect, you can apply small finishing touches. Here, a subtle shadow tinted in soft pale green is centred beneath the figure to prevent him from 'floating'.

1 Scan the line drawing of the Roman warrior into Photoshop. A new layer is created and placed below the line layer. Flat colour and simple shading are added to bring the character to life.

2 Select the area in question using the Lasso or Marquee selection tool and apply the Bas Relief filter (Filter > Sketch > Bas Relief). It imparts a kind of solarizing effect to the colours and gives a raised appearance to contrasting areas. Set the light direction, level of detail and smoothness you want by operating the sliders.

Practice exercise: Reflections in water

To replicate the reflection in water of an object or figure by hand requires a huge amount of visual understanding and time. Computer drawing programs contain filters designed to produce the effect automatically, releasing you from a very painful learning process. If such an option had been available, the Great Masters might have plumped for it too!

2 To add the water surface shimmer, reset the Blending Opacity to 'Hardlight' in Edit > Fill, to give the reflection the correct level of shine. Other options are Filter > Liquefy or Filter > Distort > Glass.

1 Draw the diver freehand in Illustrator and bring into Photoshop on a new layer, where he is reduced in size to fit the area of pool reflection. Apply the Distortion filter and adjust to the required percentage.

Practice exercise: Creating a mirror image

Achieving a realistic reproduction of a reflected mirror-image is a relatively simple task in the hands of the digital cartoonist. It can be made to look even more convincing with added enhancements, such as reflected light, distortion and reduction. The artists should still rely on their knowledge of how reflection and distortion actually look when seeking to replicate the visual outcome. Reference photographs can help, especially if your subject is moving.

> **Tip:** Use the Ripple filter to distort reflections. Note the differences between a reflection in a moving surface, such as water, and a solid surface, such as glass.

1 Make a pen drawing of the cartoon, scan and import it into Photoshop. Colour it using multiple layers. Create the soft-edged flooring by feathering it (Select > Feather > Feather Radius > 15 pixels). Leave the mirror blank at this stage as you will create the reflection in three stages.

2 Next return to the scanned cowboy. Reverse his image using Image > Rotate Canvas > Flip Canvas Horizontal. Apply the Transform tool (Edit > Transform > Distort) and pull the points of the rectangle around the figure to distort it. Place the reversed image inside the mirror frame.

3 Go to the Gradient Editor and set the gradated blue tint for the surface of the mirror. Play with the settings until you achieve the result you want. Apply the effect to the mirror on a new layer that is set to Multiply. This overlays the mirror effect on to your reversed cowboy image.

4 Finally, make the mirrored reflection look more realistic by softening the image so that it appears slightly blurred. To achieve this, apply a Linear Blur to the figure, then use the History brush to partially erase it. Select white from the colour palette, decrease the Opacity to 40% and add white highlight streaks across the surface of the mirror.

Practice exercise: Adding texture with filters

The array of filters available in Photoshop enables you to add various atmospheric effects to your cartoons. A playful attitude is likely to achieve interesting results, so see what happens when you apply a particular filter effect to a layer or two. Juxtaposing texture filters enriches images, for example. Once you have mastered the ordering of the layers palette it is then just a case of adjusting the image to fit and interpreting the cartoon appropriately.

1 Make a line drawing, scan and import it into Photoshop. Duplicate this Background layer and delete the original. This unlocks the copy layer so it is ready to work on.

2 ▲ ▶ Use the oval Marquee tool to create an oval shape and soften its painted edge with a Feather (Select > Feather > Feather Radius > 15 pixels). Fill the shape with a blend of blue and pink using the Gradient tool. To do this add a layer of pink to the blue and reduce the Fill and Opacity settings.

3 ▶ Colour the plane by selecting the fuselage section and imposing a Halftone filter on a new layer (Filter > Sketch > Halftone Pattern). Set the filter to Line so that the aircraft body has a lined texture running along its length. Select grey as the tint colour and place this layer above the sky oval.

4 ▲ ▶ Erase the filter effect overlapping the sky oval and colour the rest. On separate layers: add a Spin filter to the propeller; select Smoothing and Protect Texture presets for the smoke; blend the flames and clouds with the Smudge tool; and balloon highlights using Filter > Render > Lighting Effects > Flare.

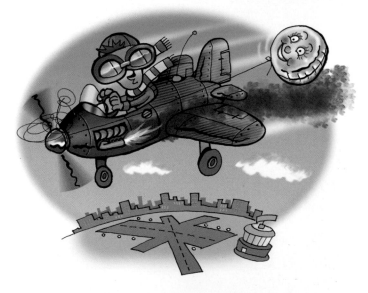

Animation

A sequence of individual pictures that are slightly adjusted as the series progresses can literally come to life before our eyes. According to the Persistence of Vision theory, our brains hold on to each image for a fraction of a second after our eyes have left it. When we see a rapid succession of individual images we think we are witnessing movement. An animated cartoon is a very long series of altering static frames. For the cartoonist who wants to explore this next progression, there are computer animation programs which enable frames to be viewed as a moving sequence. Adobe Flash and ImageReady will provide the beginner with the basic knowledge needed to create moving 2-D cartoons. Those wishing to explore 3-D animation will need software such as 3-D Studio Max or Maya, or cheaper, shareware alternatives available on the Internet. However, depicting a moving figure is a skilful undertaking requiring a keen understanding of animal and human movement.

Basic techniques

The simplest forms of effective animation do not need a movie camera to produce results. A sequence of images, each with a slight alteration, drawn on consecutive pages of a sketchpad results in a moving 'film' when the pages are rapidly flicked. The humble flick book is a commonly used prototype for developing the movements and characteristics of animated characters and a must for cartoonists who want to bring their creations to life. As well as creating action it is also a means of experimenting with the effects of distortion. Exaggerating the natural forces of gravity and motion on characters and objects brings them into the sphere of the humorously absurd. Getting your figures moving around the cartoon world is a powerful trigger for generating new and fresh ideas.

Flick book ▼
The simplest form of drawn animation can be tested by making a flick book. A series of images is sketched on consecutive pages so that each 'traces' over the top of the next. Each new drawing is slightly altered so that the images seem to move when the pages are rapidly flicked. For best results, make sure the pages are flush and evenly cut.

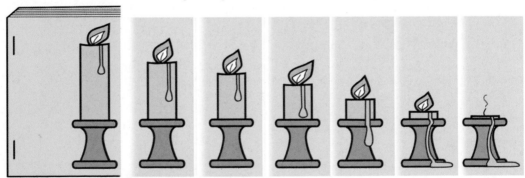

Deformation: bouncing ▼
This sequence illustrates the deformation of a ball as it falls and lands on a flat surface. The distorted shape is most marked at the impact stage, returning to normal as it prepares to bounce up again. The exaggeration of the altered shape is much greater than it would be in reality and the illustration of the process as a frozen moment provides a strong sense of movement. A cartoon animation that did not jump and move would seem static and dull.

Tracking movement ▲
How you draw a character and the devices you use can lend it strong animated properties. The bee in both pictures has active features: the feelers have eyes, the overlapping wings suggest flight and the vertical body stripes bounce the viewer's eyes from left to right. The dotted trails effectively confirm the direction of the movement.

Deformation: Compression and stretching

The great thing about animating an image is that it does not have to mirror reality. The goal is to create a movement that is believable in the surreal cartoon world where people and objects are malleable and can spring back into shape as if made of rubber. Techniques such as exaggerated compression and elongation are commonly used in cartoon animation to enhance or emphasize a movement, lending the action additional impact and power.

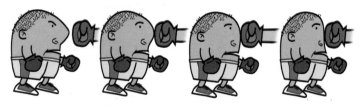

Compression ◄

The repeated images and the depression of the nose on the impact of the glove are essential. The shape and size of the nose gives it all the focus. The fact that the images remain identical serves to enhance the effect of the increasing indent as the nose is punched.

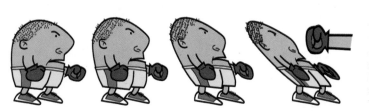

Elongation ◄

The same repetition but this time the boxer's stance steadily becomes more elongated as he ducks away from the second blow. The fighter begins to tilt back in anticipation, before his body stretches out of all proportion as the fist makes its first appearance.

Flash animation program

Flash is a vector-based program that can manipulate vector and bitmap graphic images and also supports audio and video files. It operates a language called ActionScript and as a package enables animations to be created for games, movies and Internet uses, such as online greetings cards, website navigation bars and advertisement banners. The content of Flash documents can be embedded into mobile phones and other portable players too. Files are saved in the SWF format (Shock Wave Flash) and are most commonly played through software known as a Flashplayer.

Flash is being used with more frequency to display video clips on web pages and it has compatibility for both Microsoft and Macintosh operating systems. With its user-friendly menus, tools and its frame-by-frame approach to building the animated sequence, it is relatively simple to use and the perfect beginner's introduction to animation. A running timeline dealing in frames per second helps you to keep track of your work in progress, and you can isolate individual frames or divide them into 'scene' sections and work in layers in much the same way as you would with Photoshop, Painter, Illustrator or Freehand. The key processes of Flash are included in this section to enable you to bring your cartoon creations to life.

Typical Flash window ▲

A toolbar runs down the left-hand side of the document, and the layer icon is to the right of it. The timeline runs across the top and the slider bar can be placed at any point on it to select a specific moment. The drips of the spaceman's lolly between frames will show sequential movement.

Connecting the moving parts

A cartoon animator has a multi-part role: first as inventor of a cast of characters and their narrative; next as image-maker, storyboarding and creating artwork sequences, either manually or digitally. Finally, with the images imported into an animation program, the cartoonist becomes editor/director. The success or failure of the animation, however, depends on how convincingly a character moves within and relates to its setting. Aspiring animators must grasp the connection of the moving parts of a cartoon figure. To achieve this, animators often use starting points which might easily be dismissed as child's play, even when the end product is highly sophisticated. In much the same way as a simple flat card puppet is created out of body parts, so might the animator initially approach the subject of movement in this way.

Construction ▼

This cartoon witch is constructed from a series of simple flat coloured shapes created in Illustrator or Flash. The parts are then built into a figure with a life and character of its own. The freedom to make corrections and changes along the way is part of the process.

Pivot points ▶

The red circles indicate the chief pivot points which will allow the witch to move freely. All animators use these same central points of movement as starting points. In fact, it is traditional practice to construct a jointed card maquette.

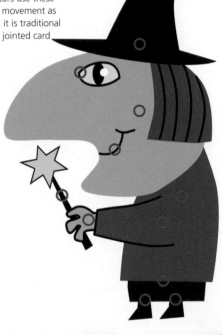

Sequential duplication ▶

This duplicated sequence demonstrates the subtle movement achieved by slightly manipulating each of the pivot points. Our senses are attuned to the tiniest changes and very little alteration is needed to communicate a sense of animation. The smaller the change is, the smoother the transition to another position and the more convincing the animation.

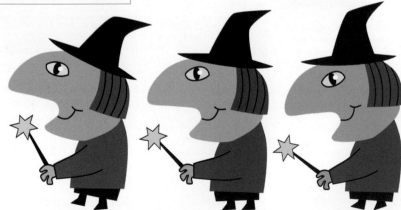

Keeping backgrounds simple

Perversely, in animation you do not necessarily have to make the elements physically move to describe it or create its illusion. When the brain realizes the 'jump' in information, carefully planned scaling and placing of objects in a setting can give the effect that the

viewer is in a sense the animator. Since animations tend to be busy, a 'breather' is welcome between frames. Any artist or designer of images should always be thinking of ways to create the illusion of movement with as few flashy effects as possible. A scene with too many

elements can become overfussy, and the viewer may not know where to look. Check out some of the best animations and you will find that the backgrounds are fairly plain and understated with very little movement, allowing the characters to take centre stage.

Movement in space ▶
By increasing or decreasing the scale of both the background and the foreground (the head and shoulders of the girl) it's possible to suggest movement. By moving the girl around the frame and depicting her in a range of different sizes, the illusion of depth is naturally suggested. The simplicity of this concept offers the cartoon a charm – the motion will be jaunty if frames are animated.

Movement and 3-D illusion ▶
Much can be achieved through the use of Illustrator or Photoshop layers. Trickery of scale and positioning gives the images their illusory, moving qualities.

The spaceman enters the screen from the left, where he is fairly large. The trail of the spaceship offers direction to the astronaut – streaking from left in the first image and from the right in the second, where he is considerably smaller, indicating distance.

Simple sequencing

It is vital to plan the narrative of an animated sequence with care. Breaking down the action into single frames that present concise visual information is a key part of the process. Keeping consistency between the frames will offer a believable transition between them.

Key frame 1

Key frame 2

Key frame 3

Key frames ◀
The top row reveals the key frames of the narrative: spotting the fly; catching the fly; and eating the fly. The information is clearly presented and no more than the necessary elements are included in each frame.

— Interim frames —

More frames ◀
Adding interim frames containing a lesser degree of movement will make the motion appear smoother and less abrupt.

Digital projects

With the technical knowledge in place, you can now apply it to set projects, considering digital caricature, developing the digital collage, creating the graphic novel and cartoon strip and simple, computer animation. This final chapter will get you started as a digital cartoonist and point you in the right direction so that you may develop your own personal vision and interpretation.

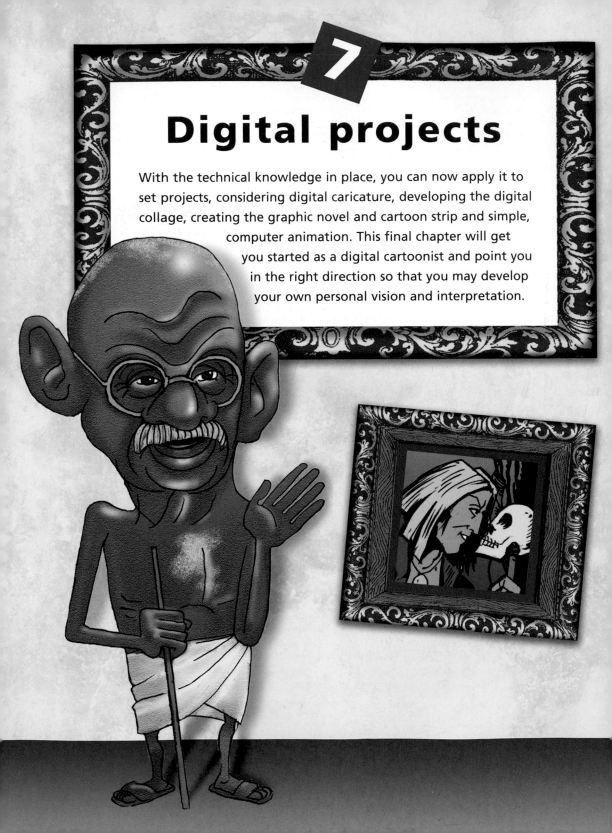

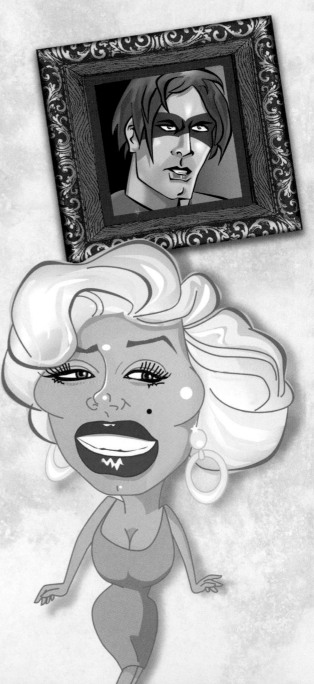

Creating caricatures

The cartooning tradition of caricaturing famous people is essentially a hand-drawn process. However, combining traditional and digital skills grants you the opportunity to work up an initial drawing into an image that wholly encapsulates the personality you are portraying. With digital drawing and painting programs, it is easy to correct mistakes, work the same image up with different media and experiment without consequence. You are also able to add background elements and build up vivid colour through easily adjustable layers. The following projects are created using Photoshop and Illustrator programs.

Final image

This final image is coloured and built using Photoshop. It has been created through the relatively easy process of layers, stacked from the background up. Once the image was essentially in place, Marley's facial features were refined using Photoshop to reshape the eyes, nose, brows and mouth. The changes are subtle, but the result is an image that looks that much more like its subject.

Caricature: Bob Marley

1 Make a loose line drawing in pen and black Indian ink. Overemphasize the head for comic effect. Your aim is to capture the essence of the subject, so be sure to add in iconic props, such as Marley's microphone and Rastafarian hat.

2 Scan the image at 300dpi, then open it in Photoshop. Set up a new layer and set to 'Multiply' mode for the colours. Using a variety of Photoshop's textured brushes with medium (50%) Opacity, build up sketchy, appropriately laid-back areas of colour and shade. Don't worry about fully colouring any of the areas – you don't want your final piece to look too 'finished'.

3 Continue with the rest of the face and clothes, gradually adding strokes of different strengths and direction until the subject becomes more solid without losing its lively energetic qualities. Notice that the light direction is from left to right – even when working in a loose, free style try to be aware of this.

4 For the background, make the flag of Marley's beloved Jamaica on a separate layer, sitting beneath all the others. Create three rectangles of flat colour, blurred using the appropriate Filter (Filter > Blur). Erase the white areas on both the Colour and Line Art layers so that the flag shows through – the quickest way to do this is to select the white with the Magic Wand tool (set to 'Contiguous' with around 25 'Tolerance'), then press delete. Clean up stray areas of white with the Eraser tool.

Caricature: Mahatma Gandhi

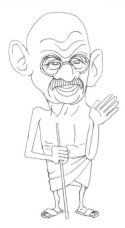

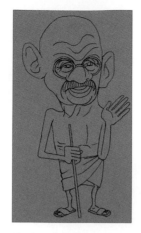

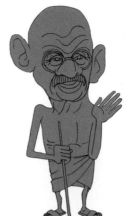

3 Remove the excess background colour by carefully tracing around the drawn outline with the Eraser tool. Click on the Zoom tool (the magnifying glass icon), to get close-up views of the different areas. This is especially necessary for deleting colour between the fingers, for example. Clicking the mouse will zoom in closer. When the area outside your figure is selected, return to the Colour layer and press delete. This will remove the brown areas outside your linework. Clear up any loose areas of brown with the Eraser tool.

1 Make a simple outline pen drawing of Gandhi referenced from a source using a black fineliner or the equivalent. Here, we draw attention to his modest attire, his famous spectacles and warm, good-natured eyes. The oversized, imbalanced ears add humour.

2 Scan the image and open it in Photoshop. Duplicate the layer, delete the 'Background' layer, and set its options to 'Multiply'. Make a new layer, call it 'Background Colour' and tint a rectangle light brown.

4 Create new layers for the shading and highlights. Using a soft brush for each, model the muscles and give definition to the face and body. Create another layer for the white highlight strokes – these are also made using a soft brush. Caricatures tend to benefit from a single, strong light source (here off to the top right of the drawing). At this stage, we have also finished off the eyes and mouth with pupils and teeth drawn in on the flat colour layer. Use a hard, spherical brush for the pupils and white highlights in the eyes.

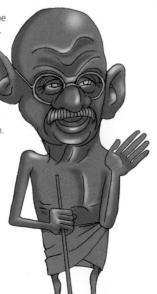

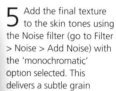

5 Add the final texture to the skin tones using the Noise filter (go to Filter > Noise > Add Noise) with the 'monochromatic' option selected. This delivers a subtle grain to the picture which is then slightly 'formed' using the Emboss filter (Stylize > Emboss). Select a stippling brush for the grey hair. On a new background colour, layer spray-in colour at 50% Opacity, using a soft brush.

Final image
Gandhi has been created through a definite layer process: First, the bold outline drawing offered a template for filling in with colour and tone. Next, an overall colour on the whole figure became the base on to which soft brush effects and highlights were built in consecutive layers to make him appear more 3-D. A final, softly sprayed background and subtle use of filters offered the image 'polish'.

Caricature: Elvis Presley

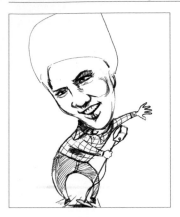

1 Use a soft B pencil to sketch and shade the Elvis caricature in head-larger-than-body style. Note how the pose chosen reflects Elvis's 'snakelike hips' in the form of a reverse 'S'. Block in his expanse of characteristic hair, but leave it unshaded for the moment. Scan the drawing and open it in Photoshop. Create a duplicate layer and delete the drawing on the original background one to leave you a layer for colouring. Go to Image > Adjustments > Hue/Saturation and change the pencil line to blue using the sliders.

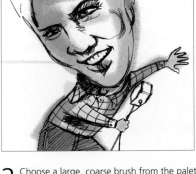

2 Choose a large, coarse brush from the palette, set it to 'Dissolve' and sweep washes of colour on to the new layer crossing the pencil lines. Dissolve creates colours with broken, speckled textures. Select blue from the colour palette for the jeans and yellow for the shirt. Add some blue into the flesh and use the Eraser for highlights.

3 Select a very large soft brush and draw the hair in black. On a series of new layers (or on the same layer, if you are feeling confident), add a swathe of white on top at a lesser Opacity, so that the black underneath shows through. Use this wash as a base for the vertical white highlight strokes (use a new layer if you need to), which are modelled using a crescent-shaped brush from the brush menu.

4 Blur the white highlight strokes and add tints of blue and brown. Finally, re-establish the detailing by adding a few hanging strands of black hair trailing across Elvis's forehead, again on a new layer. Now revisit each layer, adjusting marks or colours as needed. When you are satisfied with the result, go to the Layers > Flatten Image command. Elvis has left the building!

Final image
Elvis is treated with more traditional use of techniques to match the 1950s' rock 'n' roll years to which this image pertains. The selection of colour palettes, their layered transparency and use of soft, Photoshop brushes have helped to achieve this dated effect, which in turn communicates to the viewer the singer as an icon of his time.

Caricature: Marilyn Monroe

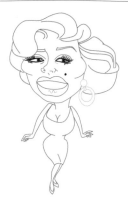

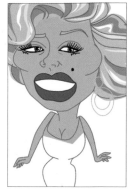

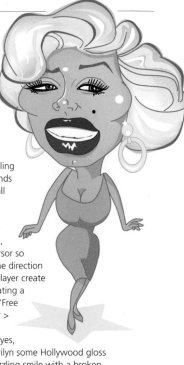

Final image
A line drawing provides a framework for blocks of soft tonal hues which are blended using tools and filters in Illustrator. Shadows and highlights add a strong, graphic quality with clean, contrasting shapes. Equally strong shapes in the facial detailing of the eyes and hair strands offer a crisp, linear and all together sparkly finish!

1 Draw a pencil caricature of Marilyn Monroe. Scan it, then open it in Illustrator. Go to the 'Window' menu, select 'Transparency' and change the Opacity to 90%, so that the pen lines will show up on top of the sketch layer. Create a new layer (Pen Outline) and draw over the scanned outline using a different colour for each area of the portrait – hair, lips, skin.

2 Still in Illustrator, block in the coloured shapes on a new layer or series of layers, placed beneath the Pen Outline. Use complementary tones to the colours used in your outline – the outlines should be the darkest colour, from which you can select warm midtones for most areas. Work up extra detail by filling the brows and adding eye shadow.

3 Soften the hair tone using the Blend tool, carefully stroking the cursor so that the blends follow the direction of the waves. On a new layer create a star shape by manipulating a basic polygon using the 'Free Distort' filter (go to Filter > Free Distort). Finally, add white highlights to the eyes, face and lips to give Marilyn some Hollywood gloss and shine. Suggest a dazzling smile with a broken grey line across the white expanse of teeth.

Painterly style of Photoshop

The sophisticated performance of Adobe Photoshop as a paint program cannot be overestimated. It is the most versatile application available to computer artists and a digital tool that can take a user through the same stages of the artistic process met by a traditional painter. The beauty of this package lies in the relative ease with which mistakes can be rectified. Artists can take a scanned sketch, lay down base tones and transform this into a fully 'painted' image by adding layers of colour in a way that recalls working with acrylics or oils.

Initial drawing ▲
A painted-style digital image always starts with an outline. Whether this comes from a sketch imported via a scan, or from a series of rough lines laid on the digital canvas with the mouse or drawing tablet, is a question of personal preference.

Building tones ▲
The first stage is to lay down a series of base colours that provide a midground spread of colour on to which you model shadows and highlights. The options in Photoshop allow you to mimic natural media, from oils to acrylics and more.

Final details ▲
Varying Opacities, sizes and hardnesses of brushes, plus the Blur and Smudge tools, allow you to blend colours and textures as on a traditional canvas. Here, the skin tones are softened using Blur, and the fine lashes are added using a fine brush.

Caricature: Charlie Chaplin

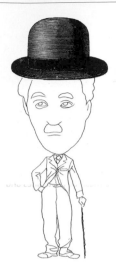

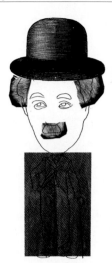

Final image

This caricature combines a very simple pen-and-ink drawing with a variety of found textures and sourced imagery. The bowler hat is a significant symbol of Chaplin as is the moustache, shaped in Photoshop from a scanned 'fur' sample. This project enables you to access a number of useful Photoshop tools for creating Charlie Chaplin, then manipulating the image with filters to present him within an early filmic atmosphere.

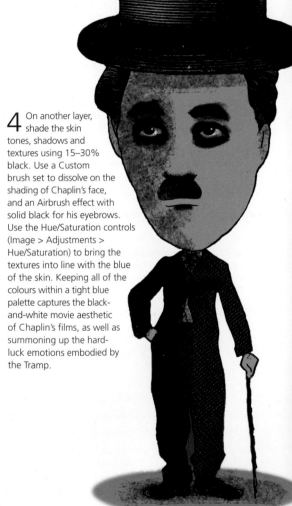

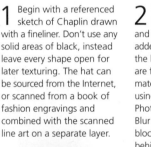

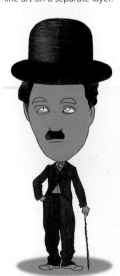

1 Begin with a referenced sketch of Chaplin drawn with a fineliner. Don't use any solid areas of black, instead leave every shape open for later texturing. The hat can be sourced from the Internet, or scanned from a book of fashion engravings and combined with the scanned line art on a separate layer.

2 When finished, the image is scanned into Photoshop, and a series of textures are added on a new layer behind the line art. These textures are found scans of existing materials, manipulated using a variety of filters in Photoshop, such as Noise, Blur and Free Distort. Add a block of suit mesh material behind the body, and some scanned fur – perhaps from a winter coat – for the hair and moustache.

3 Using the Eraser tool, carefully remove any of the scanned elements that are overlapping the line art. Alternatively, create a clipping path with the Pen tool, or use the Magic Wand tool on the line art layer to select the background white, before flipping back to the colour layer and pressing delete. This should remove any colour or texture outside of Chaplin himself. Next, colour in his skin and visible shirt in a pale blue. Place a feathered blue ellipse at his feet.

4 On another layer, shade the skin tones, shadows and textures using 15–30% black. Use a Custom brush set to dissolve on the shading of Chaplin's face, and an Airbrush effect with solid black for his eyebrows. Use the Hue/Saturation controls (Image > Adjustments > Hue/Saturation) to bring the textures into line with the blue of the skin. Keeping all of the colours within a tight blue palette captures the black-and-white movie aesthetic of Chaplin's films, as well as summoning up the hard-luck emotions embodied by the Tramp.

Caricature: Marlon Brando

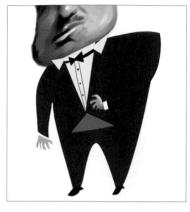

Final image
This image is created using a combination of Painter, Illustrator and Photoshop. The painterly treatment added to a sourced photo of Hollywood actor-legend Brando provides a strong focus for the project. Centring on the power an image derives from contrast of texture and colours, a stylized shape-constructed body enables the Brando portrait to be connected and brought into an architecturally suggestive mesh of white lines and shapes. Simple, but very effective.

1 The head is created in Painter using an Acrylic Paints palette and Brush tools, working from photographic reference of Brando, which is abstracted and exaggerated so that the famous Godfather looks like a melting peanut. The head is then saved and imported into Illustrator.

2 The flat artwork for Brando's dinner-suited body is created on a new layer in Illustrator, using a variety of pen-drawn shapes and simple, flat colours. Keep this portion of the drawing iconic, so that the viewer's attention is drawn straight to the face. Even the triangle of the cummerbund at Brando's waist points back up towards his head.

4 Bring everything together in Photoshop for the final tweaks. Add a strong white line down the right-hand side of the head and figure to link the two disparate portions and separate the figure from the background. On a separate layer, create Brando's shadow by duplicating the Illustrator body, filling the selection with a gradient, and using Free Distort and Rotate to offset it to the right. Add the metaphorical pool of blood leaking from the city by filling a new shape with a gradient of black to red. Colour correct all the layers as necessary in Photoshop to fuse them into a complementary single image.

3 Create a new layer in Illustrator for the background. A few simple shapes, assisted by a Shallow Gradient, are enough to suggest the shadowy stage on which Brando's most famous character worked. Thin, criss-crossing lines and white gradients in rectangles are enough to suggest the windows. Note how the background pulls the image together by reflecting complementary colours from the body (the grey of the suit) and the head (the pink shadow).

Futuristic style

Vector cartoons are characterized by their sharp, even lines and smooth transitions of flat, solid colour. A modern theme, especially science fiction or fantasy, is well-suited to a vector package. In addition to clean, clear styling there is the chance to experiment with a wide range of colours and patterns which will give the right contemporary look to your cartoon. Since vector art can be infinitely scaled without losing resolution, your illustrations of 50m-tall (165ft) robots will look just as good at 5cm (2in) as on life-size posters! A hand-drawn sketch is the starting point for this project which is then constructed and completed in Adobe Illustrator.

> **Tip:** For complex coloured digital images, it is useful to make a rough colour sketch by hand first. Having this reference to hand will solve compositional and colour problems easily. To save time, print out small scans of your line art four-to-a-page and experiment with thumbnails before committing yourself.

Final image

This final image displays the many versatilities of Adobe Illustrator with a wide range of computer drawing techniques being coupled to a harmonious, pastel colour palette. Note how the various complexities of colour and outline contribute to a sense of depth in the image – the thicker lines and additional shading on the window-cleaning figure throw him to the absolute forefront, while the outline-less, two-tone colours of the buildings in the background push them back into the distance. The vapour trails of the rockets and skycars are simply line paths, expanded and blurred. When you are finished, why not experiment with different colour schemes using Photoshop's Hue/Saturation (Image > Adjust > Hue/Saturation) slider?

1 Make a neat pencil sketch of your chosen scene. There's no need to ink it traditionally at this stage, as you will be going over all of the lines digitally. Scan the drawing and import it into Illustrator.

2 Create a new layer (Layers palette > New Layer), and use the Pen tool to accurately trace around your pencilled image, following the original. Select the Pen tool and make sure that it is set to 0.1pt. This is not a job to hurry and will take a while to complete.

3 Select the outline with the Arrow tool and click on a mid-blue hue in the colour palette. Give the line character and shape by varying the line thickness – expand lines using the Direction Selection tool (white arrow) and go to Object > Expand. Create a new layer beneath the line layer, tint the background in blue and fill the character shape in pink.

4 Add the texture to the main building. On a new layer, draw three or four hexagonal shapes, tint them a paler pink colour and drop them on to the building as a fill, using the Pattern brush. This will cover the area in a repeating pattern of the shapes. Using more abstract shapes, without outlines, block in new buildings in the background, copying and pasting smaller shapes in to form windows. Rotate or 'free transform' a few of these so that they retain their individuality.

5 Finally, give the image greater tonal depth overall by adding detailed, darker areas of shading to the main figure and background elements. Create these shapes on a final layer and colour with the Opacity set to 30% so that the patterns show through. On the same layer, add white highlights to the windows using thick, stroke-like shapes. Select and delete the windows behind the office workers to reveal the sky layer behind.

Mass-producing characters

The original toy shape – Illustrator ◀
Draw freehand, and tint and shade in flat colours on a new layer that sits beneath the line art.

Copying and pasting the toy ▼
Adjust the scale each time so they appear to recede into the distance (Object > Transform > Scale). There are endless connotations – create a clone army of toys or an assembly line of automated machines delivering uniform toys.

The toy machine ◀
This is also drawn freehand, and coloured in gradated tones, to suggest industrial metal, rather than shiny plastic. The components falling into the funnels at the top of the machine are created by 'disassembling' your toy image – parts of the toys are selected, copied and pasted into place. Use Rotate or Free Transform to suggest motion and distance.

Touchy-feely textures

Digital technology allows cartoonists the freedom to play with surface decoration across a range of media. The projects on the next four pages centre on combining drawn animal cartoon characters with digitally created textures, photographic imagery or scanned fabric. The resulting 'real' fur or skin texture gives each cartoon a surprise edge. The surrealism is increased when this texture is manipulated in Photoshop. Where traditional collages rely on the disjunction between line work and texture for their effect, Photoshop allows you to literally paint with your found media, blending and integrating disparate elements like never before.

Woolly textures

1 Sketch a quirky representation of a sheep, enlarging the endearing facial features, friendly smile and curling lashes. At this stage, reference a suitable digital picture of a sheep (which focuses in sharp detail on the woollen textures), either scanned or downloaded from the Internet. Scan the line drawing at 200dpi or above and import it into Photoshop. Next, copy the line work to a duplicate layer and delete the original background layer. You are now ready to continue.

2 On the digital image, use the Clone tool (tool box) to select an area of the face texture on your chosen photograph (you can have this photograph open in a separate window to your line work). Hold down the Alt key and click the mouse on the photograph to select the Clone tool's starting point, and then paint freely on to your line work. The Clone tool works by linking two points, duplicating whatever is underneath the first. You can enlarge the area being duplicated by increasing the size of the Clone 'brush', as if you were painting – you can also adjust the Opacity and Hardness in the same way. Once you have reproduced this texture on the head and legs on the drawing layer, return to the digital image and select a point on the wool to start cloning.

3 When you have filled the wool with the appropriate texture, go to Filter > Distort > Ocean Ripple and add a ripple pattern to enhance the twisted texture of the wool. Finally, import a cloned selection of grass from the digital image and place it in a feathered oval section beneath the sheep.

Tip: Displaying real textures within a cartoon context offers your drawings real impact. Experiment with Photoshop filters to increase the wackiness of your images. Where you may think that a filter serves a limited purpose, it is often a surprise to find it has other unexpected uses too.

Final image

The success of the image depends on scanning a clear source reference at a high resolution. Photoshop allows you to test out all kinds of enhancements. For example, you can increase the contrast using Image > Adjustments > Levels, alter colours or adjust textures using the filters.

Scaly skin

1 Draw the outline of the snake in Illustrator, expanding the line to thicken it and give a sense of movement. For the skin pattern scan a good-quality image of a rattlesnake and import it into Photoshop. Place the outline as a 'Multiply' layer in Photoshop and select elements of the snakeskin to clip out of the image using the Pen tool. Make a new layer and paste these behind the snake outline, then tidy up the edges.

2 Copy and paste your rattlesnake image as a pattern on the new layer until all of the areas of the snake are covered. Note how the pattern alters slightly as it curls around the body. At this stage, the repeat pattern will probably blend with little definition between the segments in places, but don't worry, as this will be refined and defined at the next stage. Choose a beady, glowing yellow for the snake's eye.

3 Increase the definition between the different segments of the snake on a new layer located above the line drawing. Adjust the contrast by using the slide bars on the Shadows and Highlights panel (Image > Adjustments > Shadows/ Highlights). Consider the direction of the light falling along the length of the body. Here, a strong light source is almost directly above the snake serving to neatly delineate the underside of each coil.

4 Further refine the definition by making more detailed Marquee tool selections. Manipulate these using the Shadows/Highlights function under Adjustments and the Levels function under the Image menu (Image > Adjustments > Levels), where you can alter the dark tones, the light tones and the mid-tones.

Rough skin

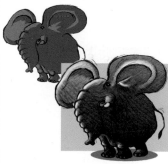

5 Finally, separately colour the patterned bands in strong, yet lifelike hues such as blue, deep pink and bronze. Change these using the Hue/Saturation facility (Image > Adjustments > Hue/Saturation), by moving the colour slide bars in the panel.

Final image
The ability to be able to import textures with ease and open within a selected path area using Marquee and Selection tools is the key to this Illustrator and Photoshop combined image. Colours are easily changed or modified by adjusting the slide bars in the Hue/Saturation panel.

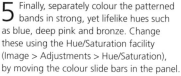

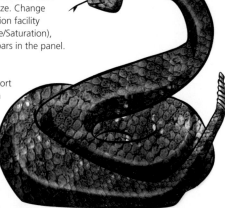

An elephant line drawing is scanned into Photoshop, darkened and then added as a new layer beneath. Basic shapes are drawn and filled with flat colour to render form through tone and highlights. An elephant-skin digital image is selected and used with a Brush tool to colour a new layer at 30% Opacity. This is placed on top of the coloured shapes. With the layers set to 'Multiply' the Eraser tool is used to clean around the outline. The flat colour-filled ellipse and rectangle background shapes are created on a layer placed beneath the rest.

Slimy skin

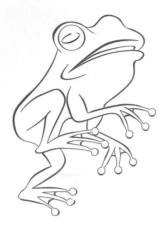

1 Draw the frog outline in Illustrator using the Pen tool and expanding the line (Object > Expand). Colour the line a dark green (Stroke > Colour) to reduce the harshness of the black line. Leave a white circle in the pupil for the highlight.

2 Create a new layer below the first and tint the outline in a light green (select colour from Swatches > use Paint Bucket tool to fill), with yellow and black for the eye. Make a shading layer, adding 15% black to the green.

3 With the basic drawing and colouring complete, Select All of your drawing and drag it from Illustrator into a new Photoshop window using the Selection (black arrow) tool. Create a new layer and add the coarse skin texture in selected areas, using different brushes to vary the texture.

Final image

Three layers are all you need to create a colourfully textured frog. From an initial Illustrator outline the image progresses into the addition of bold colours and skin textures, which can either be sourced, or developed with an array of brushes and filters. A shaded final layer placed beneath the frog assists the three-dimensional illusion and prevents the appearance of a hopping creature apparently suspended, floating in space.

Experimental styling

Illustrator contains a considerable range of patterning and blending options. When you are satisfied with the final colour, you can begin to play with the patterns in the graphic style library. Don't worry if an effect isn't working – a click in a box will change everything.

Check patterning ▲

This check pattern is selected from graphic styles, and the transparency palette set to 'Hard Light'. The pattern floats above the base colour and shadows without losing definition.

Distorted spots ▲

In this pattern, the spots are distorted so they appear to run across the curved surface of the frog's skin. Draw a circle, duplicate it as many times as you need, then distort it (Filter > Distort > Pinch) to achieve the desired effect.

Leathery wings

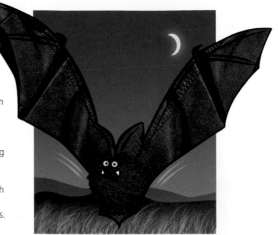

1 Scan your line drawing of a bat and open it in Photoshop. Scan a suitable piece of leather – a section of leather jacket is used here – and import it as a digital image. Using layers, place the texture layer beneath the line layer and remove the excess around the outline using the Eraser tool. Create a new layer for the background, beneath both the line and leather layers.

2 For the sky, select blue from the colour palette and add a tint that fades from dark to light using the Gradient tool. Draw a crescent-shaped moon using the Pen tool and fill it with a pale cream colour, which is softened with a feather of 10 pixels. Stroke it with solid white. Create and fill the blue-green hill shapes. Draw the grass texture using a custom brush in a lighter green–blue. Lines in a soft brush under either wing suggest movement.

Final image
This variation on the texture theme uses leather to simulate the bat's natural skin. The smooth surface of the leather will reflect the light shining through the scanner bed, giving its creases a 3-D appearance. The darkness of leather leads the choice of hues with deep saturation. Against these, the creamy white of the diffuse moonlight and grass blades offer the drawing a stunning lift.

Chicken feathers

1 Scan the key structural elements of this cartoon into Photoshop – a real chicken tail feather and body feather. During scanning, take time to adjust the Levels so that the image is strongly visible (Image > Adjustment > Levels). Doing so will capture the subtlety of the quills that are central to the project. Cut both feathers out with the Marquee tool and place them on separate layers.

2 On a new layer, arrange the scanned feathers to form the body shape, tail plumage and wing shapes. Do this by duplicating the feathers and also by using the Clone tool to clone smaller areas. You can overlap the feathers and make other adjustments using a number of new layers. However, aim to keep the image as simple as possible so that the basic concept of a cartoon chicken made from real feathers is not lost in a complicated design.

3 Add the beak, eye and comb on a layer above the last feather layer. These can either be drawn or created from a scanned digital image. Add a textured effect to the comb using filters. Go to Filter > Sketch > Bas Relief, then apply Filter > Noise > Add noise. On another layer add the drop shadow using a soft brush and adjusted feather (Select > Feather). Finally, add the scanned digital image of the wellington boots.

Final image
Real chicken feathers have been used to plume and preen the virtual chicken's identity. The clipping of such finely featured objects provides fantastic practice opportunities for refining your skills at drawing paths and cloning in Photoshop. Subtle use of filters is essential with such a delicate subject and soft brushes are necessary for dropping shadows and enhancing colours and textures.

Graphic novel style

Characterization for graphic novels is an in-depth and lengthy process. Once conceived as an idea, your character needs to be worked out on paper, and if you are choosing to create them digitally, transposed into graphic shapes and colours through Photoshop and Illustrator. Variations of style are wide and it is important to be aware of the techniques available in these programs. Background imagery is also important, but tantamount to success is your level of comfort with your creations. The average graphic novel is around 96 pages long, so be aware you could be working with the same characters for a long time!

Final image

For this urban narrative, Illustrator was chosen, for the simple duplication of bricks and also the creation of rigid, architectural lines, to help give the impression of an urban environment. A story needs to develop in a setting and this project considers the juxtaposition of the created scene and the narrative presented through the main figures.

Urban narrative: characters and background

1 Scan your outline pencils into Illustrator and create a Line layer. Digitally ink the outline using the Pen tool, contrasting the weights of line to create depth of field as shown here. Elements such as the windows and bricks can be easily duplicated by copying and pasting a single finished shape.

2 Drag the outline from the Illustrator window into a new Photoshop document. Drop some gradated colour fills into a new layer using the Gradient tool. Place this beneath the line layer. Having started with basic tones, you can now consider the best colour and texture choices for the image as you go along.

3 Now apply flat hues to the two characters using layers. It is best to use easily identified clothing and hairstyles in this first frame that can be duplicated and repeated throughout the whole storyline. Create the shadowing on a new layer to add depth and tone to the composition. Next, create the leaf by filling a new shape with a scanned leaf texture. The final touch is to add the dotted white path by manipulating and importing an Illustrator line.

Duplicating faces

Multiple characters are a necessary part of the graphic narrative and you will save time by creating a template library of key character styles for reuse in other frames. Keep the focus on body shapes, clothing and colours so that only a minor change of facial expression or body position is sufficient to place them with ease into the unfolding story. Take advantage of the compatibility of paint programs and work between them.

Photoshop style ◄
The line art was drawn directly into Photoshop with the Pen tool. The colours and textures were built up sketchily in layers.

Illustrator style ◄
The line art from Photoshop was opened as a new layer in Illustrator, where it was drawn round, tweaked and coloured.

Illustrator: adjusted colours ◄
Adjusting the colour palettes as shown here is an effective trick for altering the mood of your piece.

Painter head ▲
The first heavily brushed head is drawn 'live' in Painter. Once the structure and rendering of the face are complete, it can be altered to create the second and third characters. They are created by altering

features, colours, shadows, mid-tones and highlights on new layers. Saving the structural layer as a template enables new characters to be produced quickly and efficiently, which can only aid your creativity and experimentation.

Dramatic realism

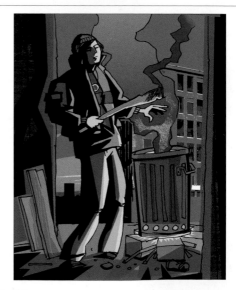

1 Scan your simple outline sketch into Illustrator and go over it with the Pen tool to create a precise outline. A line that is too sketchy does not fit the graphic novel style and is harder to segment into selected colour fill areas.

2 In Photoshop, select and fill the drawn sections with flat colours from the palettes. Alternatively, apply gradated fills using the Gradient tool. Assume a light source on one side to add drama.

3 Enhance the realism by adding scanned photographs of real buildings and skies as background. Alter these images by Solarizing (Filter > Stylize > Solarize) to break them into strong slabs of colour, and experiment with the dissolve and overlay blends (layers palette) for added effect.

Final image
For this final image, buildings, a distant sunset and shadows have been added for dramatic effect and to put the character into the foreground of a slightly unsettling urban landscape.

Traditional fantasy style

The traditional approach to the comic supports hugely popular horror and fantasy styles. These require the ability to render the human form accurately in several active and emotive positions. For this style, it is still best to draw in pencil and ink – with a dip pen or brush – with the confidence displayed by the top artists of Marvel and DC Comics,

but it is also fine to adjust and improve your line work in the digital arena. The key to effective horror styling is in the use of strong contrasts between areas of highlight and shadow, as well as the ability to create well-defined human characters that anchor the more esoteric or outlandish elements of your story or composition.

Final image

Here we have a 'Lizard Man' character, developed from an initial pencil sketch that is then inked in the traditional way, and imported into Photoshop to be defined in colour. Working digitally allows us to import a separate line drawing of a wind-blasted cliff to combine with our figure into a finished illustration.

1 The first stage of the illustration is a pencil sketch, in which pose and proportions are both defined.

2 Next, the Lizard Man character is inked by hand over the pencils, using a dip pen or brush and black Indian ink. The majority of comic books, though digitally coloured, are still drawn using the traditional pencil-and-ink method. The inking stage is when you define your light sources and strong contrasts, as well as apply organic textures with brush or nib. See how the upper left arm and curled right fingers are thrown back by being inked completely black. When you are happy with your inks, erase the pencils (be sure the inks are dry) and import the scan into Photoshop.

3 Create a fresh layer and fill it with the appropriate skin tones and clothing colours. To save time, you can select areas of the drawing using the Magic Wand tool on the line art layer, then flip to the colour layer and use the Fill Bucket tool or delete key to fill them with an appropriate colour. Create a twilight feel with a gradient tint fading from brown to yellow. Draw the moon on a separate layer by filling a circle with white. Back at the drawing board, create an image of a gnarled tree and cliff, and scan it into Photoshop on a layer behind your character to complete the scene.

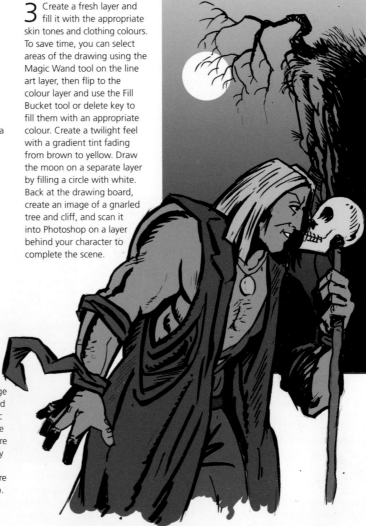

Considering character profile

Profile is key to an effective narrative, and for this to work, your areas of shadow and light should flow from one to another, not overwhelm single areas of the page.

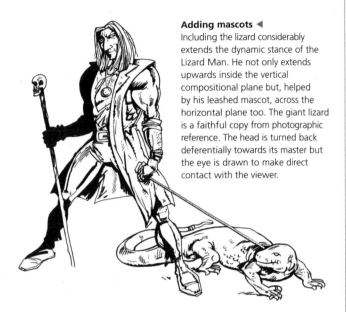

Adding mascots ◄
Including the lizard considerably extends the dynamic stance of the Lizard Man. He not only extends upwards inside the vertical compositional plane but, helped by his leashed mascot, across the horizontal plane too. The giant lizard is a faithful copy from photographic reference. The head is turned back deferentially towards its master but the eye is drawn to make direct contact with the viewer.

Use of gradated panel ◄
You don't always have to complete a full background to set characters into context within a narrative. If they are detailed and strongly coloured, it may be enough to indicate the background using a gradated panel that prevents them from floating. A character's coloration should be consistent and strong – a tight palette that can be repeated through a sequence of comic book panels.

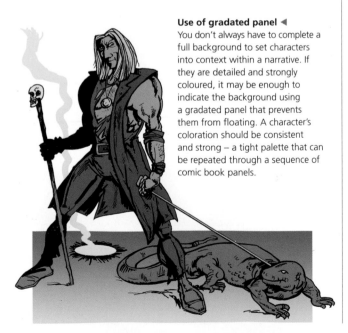

Dynamic characterization

Heroes and anti-heroes are often polarized in war and need to display dynamic traits, such as a ready-for-action stance, strongly defined body lines and totemic accessories.

Power stance ▲
Drawing a character with a commanding stance instantly conveys his ability to wield power within the graphic narrative. The turn of the body is essential: the side tailing away into shadow emphasizes the leading side.

Tattoos and body paint ▲
Photoshop is excellent for branding warriors with tattoos and body paint. This blue 'woad' face mark is added by using a Pen tool to draw the shape on a new layer, then selecting it and creating and adjusting Colour and Opacity using the Hue/Saturation sliders.

Manga style

Although 'manga', and its animated cousin 'animé', contain as many different art styles as you will find in western comics, there are certain characteristics that have become synonymous with the form – chief among them the vibrant 'big eyes, small mouth' school. Rooted equally in the Japanese illustrators of the 19th century and the imported cartoons of Walt Disney, 'manga', which

is Japanese for 'comic' or 'whimsical pictures', is home to a far broader range of subject matter than we are used to in our graphic novels, from universal themes of love and lust, power and politics, and the journey into adulthood, transposed to any number of exotic and everyday locations, to series rooted in the worlds of sport, mahjong, videogames, music, business and politics.

> **Tip**: Manga is an art form predicated on extremes of motion, punctuated by occasional, poetic stillness. Even 'at rest', your characters will need to be dynamic, poised for the next exaggerated spring into action. Everything is made to feel that it is bursting forth from the page.

1 Start with a pencil sketch that uses the main features associated with manga females: high cheeks, large, round endearing eyes, sensuous lips, square jaw and 'choppy' hairstyle. Include the basic outlines of your setting.

2 Scan the drawing and import it into Illustrator. Use the Pen tool to digitally ink over your pencil outline, expanding the lines as you go where you feel it needs most emphasis, such as in the definition of the hair shape, and in the curves of the body and limbs. In this example, we will be colouring using a 'cell-shaded' style familiar from the majority of animation, so don't add any areas of solid black for shadows as these tend to overpower the subtleties of colour, which keenly denote this unique style.

3 Drag the layer into Photoshop and select the areas to fill with flat, bold colours. Draw random shapes on the clothing for the camouflage patterns using the Pen tool, and fill with the appropriate flat colour. Add shadows to the skin by adding 15% black on another layer. Add white highlights to the grey weapons and on the body.

4 On a different layer, create the background scene, accessing all the major techniques for Photoshop painting, a gradated blend for the sky, a drawing line and fill for the setting sun, and blended paint strokes for the white vapour trails heading for space.

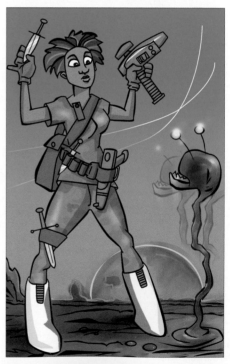

Final image
Here's a fusion of the western and manga cartoon styles. A tough, well-armed female soldier confronts a bizarre alien life form on a distant world. The soft gradient of the background pushes the bold character forward, while a motion blur effect on the alien creature gives the impression it has just vaulted up out of the topsoil.

Manga figures

While exaggeration is crucial, manga figures are still based around a confident understanding of human anatomy. Body shapes are fit and stylized – but in a more down-to-earth way than classical superheroes – with large heads, narrow waists, small, nimble feet and streamlined, fashionable clothing. Your figures should all be clear individuals, with unique hair, build, costume and accessories – check that you can tell them apart, even in silhouette.

Manga action ▼
Extreme poses and angles are the order of the day when capturing an action moment. Examine sample manga artwork to see how even moments of emotional drama are imbued with hyper-kinetic energy. Manga makes heavy use of motion lines to sell the concepts of speed and movement. These can be time-consuming to replicate in Photoshop or Illustrator with the Line tool – but will prove much less hassle than using a fineliner and ruler.

Creating the male face ▲
The line work is created in Illustrator, with a stylistic expanded line, and the areas of shadow and defintion are kept to a minimum so that he appears contemporary and flat-featured. This simplicity is distinctive of manga.

Creating the female face ▲
The line work is created in Illustrator, using a rough pencil sketch as the base. A stylistic, expanded line lends weight and interest to the hair, eyes and brows. Note that the elements of the face still conform to the 'eyes halfway down' rule, even though they are out of proportion with one another. Basic tones are applied in Photoshop.

Defining the female face ▲
The unreal blue of the eyes draws our attention to them, and forms the focal point of the face. Shading is achieved with a strong two-tone shadow. Highlights are kept to a minimum – on the lips and on the reflections in the eyes. Pay extra attention to the shading and highlights of the hair, as it is easy to make this look like a plastic wig if you are not careful.

Defining the male face ▲
The next stage is to soften the drawing considerably in Photoshop using the Airbrush tool, especially for blending the subtle highlights on the skin and hair. The final result blends cartoonish two-tone colours with naturalistic shading to suggest a more mature art form.

Science fiction style

The digital revolution has brought a new sophistication to the genre of science fiction, demanding no less skill than traditional methods, but substantially reducing practice time. Photoshop filters and the ability to be able to blend semi-translucent layers have considerably influenced the techniques and the resulting outcome. Digital trickery and futurism (the prediction of a future world and its attributes) go hand in hand. The cartoonist has the freedom to conjure up imaginary scenarios that are painlessly realized via keystrokes and mouse commands. In the digital art future in which we live, creativity truly knows no bounds making possible the imaginary worlds of our furthermost dreams.

Mixing media

1 Scan the rough coloured sketch of the time traveller and import it into Photoshop. Draw over the lines with the Pen tool, expanding as necessary as you go. Convert the black outline to a soft blue line via Image > Adjustments > Hue/Saturation. Drag the image into Photoshop and render it in simple colours on a new layer below the line art, using a range of brushes from the brush palette.

2 With the idea set, spend some time dropping in careful brush blends within the variably stroked outlines. Pay attention to smaller details, such as the shadows beneath the control console and the underside of the sleeves. Adjust the Hue/Saturation to add reflected light to the face and use the History brush to soften colours in the final stage.

3 Draw the clock faces on the floating instrument panel as a new Illustrator document, using the Ellipse tool for the dials and the Pen tool for the hands. Stroke the outline in white. Create a single dial, and then duplicate, scale and free distort it to form the rest. Import a scanned or digital galaxy image into Photoshop and create the vortex through the Twirl filter (Filter > Distort > Twirl). Drag the dial into the Photoshop window and sit as a new layer on top of the galaxy background. Duplicate and distort the dials by pulling out the shape from the points on each clock face.

Final image
This image effortlessly blends the past and present into an amalgam suitable for a man torn out of time. The simple, cartoonish line drawing and industrial-era machinery contrast sharply with the swirling, all-digital maelstrom of the timestream in flux, literalizing the 'collision' between two different media.

4 Set the long line of dates on a spiral line in Illustrator using the Pen tool and the Text tool. Drag this into the Photoshop document to sit above the dials layer.

Android

1 Select and scan a suitable photographic image for the head. The blank eyes, smooth modelling of this mannequin's head, and the surface cracks make it a perfect choice for a humanoid robot.

2 In Photoshop, draw the simple body shape using the Pen tool. On a new layer, select and fill the drawn shapes in grey. For the darker grey shadows set the layer blend to 'Dissolve' and select a deeper hue. This blend results in a smoother tonal sweep, but with plenty of contrast remaining. Add a soft textured effect to the clothing by experimenting with filters – try Filter > Noise > Add noise. This will differentiate the clothing from the smooth, strongly featured head. Use the Colour Dropper tool to select a shade from the digital image of the head to colour the hands.

Final image

Photographed objects can form the major part of a Photoshop cartoon. The dead, soulless gaze of the mannequin is perfect for the aloof robot, and easily allows the rest of the body to be drawn and attached. The joining of the two images is made simple through layers, the depths of hue and texture through limited use of colour slider bars and filters.

3 Combine the two image layers so that the head rests on the body. Use the Hue/Saturation sliders to adjust the head layer to a greenish-grey hue. Make a gradient background tint on another layer which fades upwards from deep green to black. Create the lightning on another layer using a white brush line, feathered and stroked with green set at 5 pixels. Make the 'airwave' cloud by selecting a patch of green, painting it with a brush, then modifying it via Filter > Halftone > Circles. Finally, draw the shadow under the feet using the Ellipse tool, softened with a feathered edge. Place the shadow on the layer beneath the figure.

Sci-fi options in Painter, Photoshop and Illustrator

Knowing how to juxtapose images and programs can give you a great result in a short time-frame. Opting for small vignetted illustrations is an effective way to make the whole task simpler.

Crazy scientist ▲

The head is created and distorted in Painter before positioning on to a hand-drawn pen sketch scanned into Photoshop. Experimenting with filters works a two-part magic process. First, use the Pointillism filter to create the test tube fumes, then alter them further with the Curl and Twist filters.

Space travel ▲

This light-hearted image expounds the notion of interstellar travel using the gravitational pull of black holes. It is drawn and tinted in Illustrator, and would be perfect for a popular science magazine.

Mixed media collage

Combining real-life and drawn elements is a technique much practised by cartoonists and other illustrators. You see it used in all kinds of media, from spot newspaper illustrations to graphic novels, strips and fine art. Animation has used this merging of real and imaginary worlds to great defamiliarizing effect for many years, with the early Disney films *Mary Poppins* and *Bedknobs and Broomsticks* among the first to fuse whimsical cartoon worlds with traditionally shot actors.

In those pre-digital days, it was a highly complex achievement involving numerous artists and endless hand-drawn images placed on top of extant film footage. Today, whether for moving or static images, vector and bitmap computer programs make it easy to seamlessly mesh the 'real' and 'unreal' together.

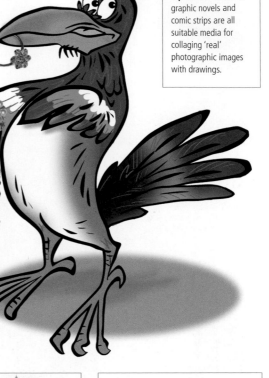

Tip: Pocket cartoons, graphic novels and comic strips are all suitable media for collaging 'real' photographic images with drawings.

Final image

This magpie is so persistent and successful in its efforts to get its wings on the shiniest of baubles that it has reached out of the cartoon world and into our own. The metaphorical, cheeky quality of the drawing makes this illustration of avarice much easier to swallow, while the use of real jewellery is a simple and effective addition to the picture that reinforces its value.

1 Lightly sketch your design and scan your drawing at 300dpi. Import the scan into Photoshop. Choose Image/Image Size and then reduce the file size by resizing the resolution to 100dpi. Make sure that the 'Resample' box is ticked. Drag your resampled image into a new Illustrator document set to the same dimensions. Double click on the layer and reduce the Opacity to 50%, then rename this layer 'Trace' and lock it. As it is just a sketch, feel free to add placeholders for the elements that will later be collaged digitally. Here, we've started with a bird selling watches. The pleasure of working digitally is that it allows you to change your mind – and the direction of your piece – late into the process.

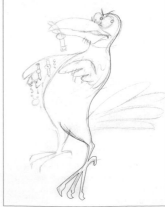

2 Create a new layer above the trace layer and name this 'Line'. Using the Pen tool (set to black, no fill, 1pt), trace over the sketch until the drawing is complete.

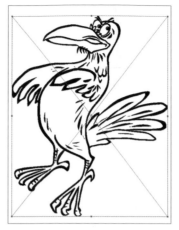

3 Expand the line to make it more interesting by choosing Select All > Object > Expand. Use the Direct Selection tool to drag anchor points of the line apart. Use the Pencil Smoothing tool to reduce excess points.

4 When you are satisfied with your line drawing, import it back into a new Photoshop document, set to 300dpi. Set the layer to Multiply, name it 'Line' and lock it. Make a new layer behind the line art.

5 On the new background layer, begin colouring basic shapes using the Paintbrush tool set to 100%. Erase stray colour using the Eraser tool. Gradually build up the blocks of colour.

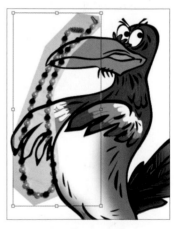

6 Use the Lasso tool to isolate areas for special treatment, such as the tail. Airbrush the feathers using a 200-pixel soft brush to blend the colours.

7 On a new layer, create the shadow by filling an ellipse selection, with feathering set to 20 pixels. Use the Eraser tool to remove overlapping grey on the feet.

8 Scan and import the jewellery. Use the Transform tool to scale each object. Erase the scan backgrounds using the Magic Wand and Eraser tools.

9 Place each object on a separate layer and when you have placed enough, make another new layer above the background layer. Use this layer to add the shadows to the beak, feet and behind the jewellery, which will give the image depth and tone. Darken the colours in the shadow areas by about 15%. Select each one using the Eye Dropper tool, go to the colour slider palette and move the slider a little to the right. Draw the shadows with a soft brush.

Tip: Use layers to help you to build depths of colour and mark within your compositions, or to juxtapose graphic elements. The best way to think of layers is as sheets of transparent acetate which lay one on top of another allowing you to see what lies above and below. Layers can be easily created or duplicated and lifted into the most suited position.

Using advanced colour theory

The digital production of images offers a limitless number of colours to play with, and a similarly wide range of methods with which to apply them. However, sometimes a simpler, restrained approach will net you the best results. Images decked out in subtle tones can often be the most effective. By not dazzling or crowding the eye, they allow the viewer to concentrate fully on the narrative. The considered use of small areas of hue – known as 'spot colour' – brings focus to bear on the most significant elements. All digital painting programs lend themselves to creating images in a limited span of tints and tonal 'keys' – the name given to tones which all fall within a small range of colour increments. Over the next four pages, we shall explore the benefits of spot colour and limited palettes, as well as more advanced techniques including ambient glows and expressive textures. Why not try colouring the same image multiple times, summoning different moods through different palettes and techniques?

Using hue with a two-colour limited palette cartoon

1 Draw the ink and charcoal sketch. Scan the image into Photoshop and duplicate the background layer. Drop a neutral colour layer, set to Multiply, on top of the image, to act as a background hue. Create a new layer named 'Spot Colour Overlay', set it to Multiply, and use the Marquee tool to select areas to colour: the sign, car keys, lips and dress. Fill these with a red-based brown, adjusting the colour using the Image > Adjustment > Hue/Saturation sliders on the red channel.

Final image
The strength of a two-colour limited palette cartoon is evident here, and the highly selective use of the hue works harmoniously with the quality of the line and charcoal tone with no conflict of elements. The careful blending with soft brushes working closely in relationship with the buff-tinted paper, lifts the texture of the image and evokes the gritty atmosphere.

Limited pastel palette

1 Import the same scanned drawing into a new Photoshop document. Scan some buff textured paper and save this to a new layer, set to Multiply, placed on top of the drawing layer. As before, select the shaded charcoal areas to colour with the Marquee tool, this time focusing on the background of the drawing. Convert these areas – the car, the cactus, the burger joint – to sepia, using the Hue/Saturation sliders.

2 Photoshop's expressive colour ranges allow you to easily match the moods and effects you are trying to create in your images. Here, using restraint and minimalism, select a range of pastel tints from its colour palettes. On another new layer, colour the remaining main elements and their details, bringing the two characters forward from the monotone background. For the sky and clouds, employ a soft brush, blending the edges of each block of colour so that they appear to merge into the tint of the buff paper.

Final image

Using a limited pastel palette for this more muted final image has been key, allowing for a slightly changed, possibly more positive overall tone of the cartoon, but it is also important to retain the black outline around the figures to help pull them out from the sepia background. You must also keep your colour shading minimal, allowing the original charcoal lines to do your toning work for you.

Colour swatches

The Adobe packages contain a wide array of swatches to help with choosing colours. The opportunity to see the colour families grouped as they are on the artist's colour wheel makes light work of selecting complementary tints and shades.

Pastel shades ▲

These shades are typical of the types of colours that result when white is incrementally added to a pure base colour. By clicking on a tile in the palette, you can select a hue for use with the Brush or Pen tool.

Neutrals ▲

Colour neutrals are variations of grey which have a hint of brown, green, blue or red as their base. They work in harmony with most other colours.

Tints and shades ▲

If you were mixing up tints and shades in paint, the tints would be colours with a hint of white added and the shades with a hint of black. Shades are the colours most commonly used for shadows and tints for highlights.

Gritty shadows and glows

1 Sketch an exaggerated cave scene, contrasting the manic form of the caveman with the relaxed cavewoman. Note the bold, outsized hands and feet on the caveman, which draw attention to his flailing and stomping. Scan the sketch into Illustrator, and outline using the Pen tool. Create a tight selection of colour swatches in brown, blue and flesh tints down one side – use these for later colour selection in Photoshop.

2 Import the drawing into Photoshop as a new layer. Below the line layer, paint a new background layer in dark blue. Colour the characters, smoke and cave elements with flat colours, shadows and highlights as before. To create the glow effect on the flame and cave entrance, 'knock back' the black line around each element by selecting the line on the line art layer and colouring it a slightly darker shade of the flame using the Fill tool.

3 On another layer positioned on top of the flat colours, add the shadows and blurs. For the gritty texture of the dark cave shadows, select a 300-pixel soft brush from the Brush palette and set it to Mode > Dissolve. Spray this brush around the arc of the cave mouth and curved walls. The same brush, coloured white, can be used to add flavour to the border of the background.

Final image
Here, a combination of a variety of elements contrasts the frenzy of the caveman with the relaxed demeanour of the cavewoman. The motion blur on the arms, the glow of the fire and the harsh light outside are simple effects which all serve to inject depth and dynamism into the image.

Ambient glow

1 Scan the simple line drawing and import it into Photoshop, leaving the image open for colour. Plan your colours before you start by creating swatches of no more than nine shades on a separate layer for later reference.

Tip: Colour swatches play an important part in understanding the continuation of sequences in cartooning. Always choose base hues that work well together to create the correct mood, and be sure to include them in all the frames making up the running frames of the story.

2 Create the dispersing background glow emanating from the lamp by selecting the Gradient tool and setting it to 'Radial Gradient'. Choose the two colours to gradate from the swatches – white to mid-brown. Click to choose the central point of your radial blend, and draw the line to indicate the extent of the first colour (in this case, white). The longer the line you draw with the Radial tool, the greater the percentage of white in the final mix, and the larger the 'bloom' in the centre of the gradient. The shorter the line, the larger the percentage of brown.

3 Use the Lasso tool to isolate areas of the face, arms, T-shirt, lantern and body. Fill these with a mixture of linear and radial blends as appropriate, on new layers, using the Gradient tool. In this example, we've used radial blends on the face and left arm, to reflect the gleam of the lamp, while the other elements have been coloured with a linear gradient. On another layer, paint in the trees, grass and barn using flat colours and a soft brush for the occasional highlight. Place each new layer you create above the overall background radial gradient layer.

4 When you are satisfied with the gradient and colour layers, Flatten (Layer > Flatten Image) and duplicate them. Set the duplicated layer to 'Multiply' – this will intensify the depth of your chosen colours and throw up the contrast between the areas of light and dark more keenly. Make the bright lights of the fireflies with a soft, round brush (size 30) dabbed on to the image in a combination of white and creamy yellow hues. Draw the flight trails using the pressure-sensitive stylus pen on the drawing tablet. This will give you maximum control over their movement and direction and enable you to taper the line as it trails into the distance.

Final image
The completed cartoon shows the kind of depth of field and atmosphere that can be accomplished with a very limited palette and a judicious use of gradients. Note how the use of complementary shades and gradients draws the eye across the image in an unfamiliar direction – we focus first on the strongest light source, the lamp, then on the glow on the boy's cheek, then follow his upturned eyes to the true centre of the image – the fireflies themselves.

Monstrous textures

Inventing an imaginary creature allows you to give free rein to your creativity. Monsters are excellent subjects – the only rules that apply to them are that they must be both freakish and scary to some degree – but remember too that the most successful monsters of print and screen are sympathetic to some degree. They present the ideal opportunity to merge aspects of fantasy and reality, creating a range of digital Frankenstein's monsters for you to bend to your will. The advantage of using the computer as your main tool is that it allows you to experiment freely while still being able to roll your image back to any part of the process. Essential elements, such as shape and scale, colour contrasts and textures, can be tried out to your heart's content, without fear of compromising the final result. Don't be afraid to throw on new filters or play with as-yet untouched settings – the perfect piece may arise from a happy accident.

Creating a sympathetic 'monster'

1 Build the broad face in Painter, using layers of paint in your favoured medium, working from mid-tones to shadows and highlights. Pay attention to the furrowed, horizontal lines at eyebrow level and around the thin-lipped mouth. A strong centre-line down the brow and nose, formed of shadow, grants the image weight and depth. The face is lit from either side by diffuse light sources, so pay attention to the different coloured highlights (blue on the left, orange on the right) that suggest each light. Strongly angle the cheek muscles up to meet the nose, and note the thickset shadows beneath the brow and mouth.

2 Import the head into Photoshop. On a series of new layers, create a body using real, scanned garments – or portions of fabric cropped and shaped in Photoshop using the Lasso tool. Smooth any misfitting edges between cloth and head with the Blending tool.

3 The shoes are created from shaped portions of a scanned texture. Place scans of real hands, scale them in size and make them more purple by adjusting Hue/ Saturation. Tangles of string, scanned, form shoelaces, and images of rusty bolts complete the Frankenstein cliché.

4 To give this misunderstood monster a hiding place, scan a photograph of a dilapidated barn and place it on a new layer behind your creation. To give the barn an eerie, unreal quality, add a new Adjustment Layer > Hue/Saturation and bring the Saturation down to -60. Scale the barn so that it sits behind your monster, with the creature breaking out of the rigidity of the boxed background to add interest to your composition. Like Frankenstein's original 'mixed-media' creation, this monster is just crying out for animation! Why not experiment with different facial expressions or a range of hands?

Final image

This creature is a combination of painted features, found textures and scanned photographic elements. Switching between Painter and Photoshop allows you to intermingle a variety of source materials in an organic fashion. Using the slider bars of the Hue/Saturation adjustment layer, you may wish to completely change the ambience of a benign scene to something far more sinister – or you can also brighten up the image by intensifying all the colours.

Gnarled skin

1 Scan a pen and ink drawing of a morose monster into Photoshop. Apply a flat purple hue to the creature on a new layer beneath the line layer. An easy way of doing this is to select the white area outside your creature on the line layer, choose Select > Inverse, then switch to your colour layer and Fill the selection. If your image is a joined-up ink rendering such as this, you'll find this method quicker than painting the whole image with the Brush tool.

2 Apply the lighter and darker purple tones using a soft brush on a layer placed above the flat colour. Apply a linear gradient blend of red/green above this layer, set to 'Hard Light' (in the layer blending box and scroll down to 'Hard Light'). This creates a glow effect in the area of the two-colour blend. Finally, use the Eraser tool to remove excess colour around the monster – or select the white areas on the line art layer, flip back to the gradient layer and press delete.

3 Add a skin texture using the Craquelure filter (Filter > Texture > Craquelure > Distort > Spherized). Use a soft blue-white/mauve-white brush to add the fine detailing on the eyes and horn. Draw the bristly hairs using a small, hard brush. Finally, on a new layer beneath the figure, spray on an ellipse with a soft feathered edge as the monster's shadow.

Final image

Only a handful of 'real' features in a drawing are required to convince the viewer of its veracity as a character, no matter how outlandish the physiology. Here, the well-rendered reflections of light on the creature's eyes, and the bristling hairs and textured skin, are enough to bring life to a horned, ambulatory bowling ball.

Quick digital monsters

Photoshop is perfect for developing monstrous characters, allowing you to experiment with a wide range of styles, and summon a cast of spooky characters for use in cartoons, comics, graphic novels or simple animations. Simplicity of design is this key – build your creations from exaggerated and distorted geometric shapes. Start with an identifiable silhouette, and work back from that.

Monster faces ▲
These Photoshop portraits are rapidly sketched using a stylus and drawing tablet. Lay down a face shape first and fill it with flat colour. Employ the Brush tool with a darker hue to tint the shadow and facial details. Add interest by using a textured brush.

T. Rex ▲
The expanded line of this Illustrator drawing is stroked in hues of blue and green. It is imported into Photoshop for texture and colour: Filter > Pixilate > Pointillize (cell size 5) is applied to a gradated blue-green tone. Filter > Render > Lighting Effects > Texture Channel (set to green) is the next step, set at 60% 'Mountainous'.

Metallic surfaces

Like monsters, robots offer your imagination the opportunity to run wild. As long as they display mechanical workings, robots can consist of shapes, colours and textures in any configuration you prefer. Robots in popular fiction can range from benign automata to laser-wielding machines of death, so it should be easy to find a droid that fits the mood of your project – contrast the robots of Asimov, *The Wizard of Oz*, *Terminator 2* and *Doctor Who*, to name but four. The only thing that cartoon robots have in common is their metallic 'skin', which can be achieved through a wide variety of effects, to replicate the different methods that went into their various processes of construction.

Creating a metallic 'skin'

1 Scan a simple pencil sketch of a weeping robot, and import it into Illustrator. Trace over the lines with the Pen tool, and use the Direct Selection tool (white arrow) to expand the line by pulling on selected points (Object > Expand).

3 Select the white background portions of the image on the line art layer, using the Magic Wand, and use Select > Inverse to capture the robot. Create a new layer, selecting 'Use Previous Layer To Create Clipping Mask', and fill the mask with a blend of reddish-brown and black. Apply the Pointillize filter (Filter > Pixelate > Pointillize) with a low cell size – this will add the simulated texture of rust. Make sure all your colour layers are set to 'Multiply' so that the rust blends with your colour textures. Erase parts of the texture so that some of the original blue-grey shows through. Flatten your image so far. Create a new layer from a Clipping Mask of the puddle, duplicate your coloured robot and use Transform (Edit > Transform > Flip Horizontal) to create the mirror image. Now distort it using the Liquify filter (Filter > Liquefy). Add highlights on a new layer to selected areas of the surface.

Layer 1

2 Import the Illustrator outline into Photoshop. Create a new layer for colour and set it to 'Multiply'. Paint the drawn areas in flat colours of blue and grey. Fill the buttons on the chest unit with bright primary hues. To add depth, create a new shading layer and place it above the colour layer. Pinpoint your areas of shadow and stroke on the darker shades using a soft brush. Don't worry about the metallic texture or the contents of the puddle at this point.

Final image

This image employs multiple layers beginning with the simple outline drawn in Illustrator. Photoshop layers help to build depths of colour and these are vital to shade in certain areas to create the 3-D illusion on a 2-D digital drawing. The metallic textures, which bring a touch of realism to the robot, are applied effectively by actually erasing colour and texture from a 'Clipping Mask', the layer covering the whole of the image.

Metallic shine

1 The outline of the robot siphoning a drink of oil from a vending machine is drawn directly into Illustrator. This method forces an economy of line from the beginning. The work involved encourages you to keep detail to the essential minimum, which makes for 'cleaner' and more readable art.

2 Import the line drawing into Photoshop, and place a flat colour layer below the line art. Choose four or five flat metallic colours to fill the outline – in this example, a selection of greys, mingled with blues and browns. Select and fill the shapes using the Magic Wand and Fill tools.

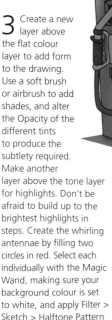

3 Create a new layer above the flat colour layer to add form to the drawing. Use a soft brush or airbrush to add shades, and alter the Opacity of the different tints to produce the subtlety required. Make another layer above the tone layer for highlights. Don't be afraid to build up to the brightest highlights in steps. Create the whirling antennae by filling two circles in red. Select each individually with the Magic Wand, making sure your background colour is set to white, and apply Filter > Sketch > Halftone Pattern > Circle to them.

Final Image
The simplistic shapes and basic shading on this image nonetheless combine into a finished piece that has a great deal of character and dimensionality. The shadow of the claw arm draped across the robot's chest, along with the burnished tones of the vending machine, adds depth, while the blues and the reds help define and contrast the conscious robot with the unthinking drinks vendor. The easy effect of the flaring antennae adds a further dash of personality to the illustration.

Alternative automatons

Creating robot figures is a fun way of combining shapes and experimenting with colour and expression as well as movement. See just how easy it is to anthropomorphize even the most outlandish of shapes with the addition of a pair of eyes!

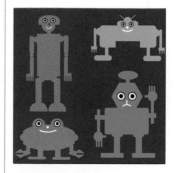

Simple robots ▲
Illustrator is the ideal choice for quick-fire designs or the execution of simple cyber characters. Shapes are quickly and easily drawn, selected, coloured and duplicated – and the Pathfinder tool groups them into a single shape.

Robot power ▲
This Illustrator/Photoshop image blends the cliché of the superhero with a robotic shape. The cape and trunks clothe the body in familiar, yet unnecessary attire (for a robot!), and the massive mechanical forearm embodies the concept of superior force.

Characterful cartoons

Cartoon characters are a fantastic tool for cartoonists involved in social commentary and parody of everyday life. The benefit of creating a family of such characters in the digital domain is instant access to your past illustrations and character designs – whether for reference or reuse. Ideal for a one-off cartoon or comic strip, these creations also gain currency when allowed to persist, turning up repeatedly to deliver their thoughts in a representative – if humorously off-kilter – fashion.

A contemporary family supplies a range of characters of different ages and stations in life, at once irrevocably yoked together and at odds with one another. Everyone recognizes these interactions, and this provides instant engagement with your audience. While we've used a white, suburban family here, never forget that single-parent, second-marriage and multi-racial families all represent slabs of society equal to the traditional nuclear unit. While it's harder to boil these down to stereotypes, the rewards for breaking free of cliché are great.

Cartoon couple

1 Draw a cartoon sketch of a couple, perhaps using photos as reference: get friends or family members to model difficult poses for you. Pay close attention to the positions of the hands, facial features and body language. When you are happy with the sketch, scan it into Illustrator and trace over the line with the Pen tool, set to 1pt. Adjust the outer lines of the characters to a 3pt width.

2 Import the completed outline into Photoshop – we've added flowers to the wife's dress at the Illustrator stage – and colour the different areas of the image in flat colours. Select areas to Fill on the line art layer, using the Magic Wand tool set to Contiguous, then flip to the colour layer in order to Fill. Keep the colours light and bright, as you will be adding only a single pass of shading.

3 Apply tonal shadows on a new layer to give the figures form. Add a 15% tint of black to each flat colour and apply using a wide-textured brush. Finally, employ a fine black brush for the lines which detail the shading of the hair and the folds in the clothing. Although highlights are suggested on the glasses by starting with a bright shade and adding a swatch of deeper colour, real highlights are added on a separate layer to the hair and on the wife's lip.

Final image

The final image is a skilful piece of body language that can be interpreted in several ways. The wife's arm is wrapped around her husband – a gesture both supportive and playful, but do their upraised fingers suggest a mild disagreement, or are they completely in tune with each other? The glare on the husband's glasses means we can't see his gaze. Just as the dialogue in a strip depends on the quality of the cartoon to succeed, so the mood of a drawing can often only be decoded by the speech attributed to it. What would your caption or speech balloon say?

The family in context

Here we progress to rendering full figures of the family against a background, in this case, a supermarket, focusing on how the characters relate to each other.

1 Make a pencil drawing of the family group and their background setting using direct and open lines. When you're happy with the layout, scan the drawing into Illustrator.

3 Import the outline into Photoshop and select the main sections of clothing, skin tones, dog's coat, building and accessories to fill with flat colour, using the Magic Wand tool as before. Add form to the characters by adding tones and shadows on a separate layer, selecting areas to colour and darkening them with a soft brush and a 15% tint of black added to the base colour. Note the angular light reflections on the windows, and the arc of the bouncing ball, which has been 'knocked back' to white by filling in the black on the line art layer.

2 Trace over the pencil lines using the Pen tool, set to 1pt. When you're done, adjust the outer line of each character to be 3pt in width (Object > Expand), leaving the inner lines at 1pt. This defines each family member, but leaves variety and interest in the line weight. The supermarket is left at 1pt, helping to push it into the background, while still allowing its horizontal form to tie together the disparate figures.

Final image

Each character's posture and position say much of their relationship to one another. The pregnant mother forms the focus, with her husband, proud and a little possessive, on one side. Her son, lost in his music, is on the other. The dog's long-suffering expression – ignored by the daughter – speaks volumes. The mother, at least, is looking out for the smallest of her brood.

Defining and styling figures

Do research to plump your family figures into full-featured individuals. Flip through magazines for tips on clothing, and try to keep up with hairstyling and pop culture trends.

Young girl with her dog ▲
With the energy and enthusiasm of youth, this girl's wide-eyed approach to the world is significant. Her movements speak of irrepressible excitement, a good contrast to the more weary viewpoints of her brother and parents.

The teenager ▲
The long-haired, laid-back look is stereo-typical of a teenage boy. The facial expressions and body language speak of a character at once removed from the world, and passing judgement upon it. While he maintains some of the openness of youth, the mop of hair is equally successful at hiding him away. Angular, awkward features capture the indignities of adolescence. Teenagers are ideal for experimenting with clothing and hair colours as they can change styles from week to week.

3-D Illustrator effects

The ability to create hyper-real 3-D objects in Illustrator opens up a wealth of new opportunities for image creation, whether combining a 3-D shape with hand-drawn characters or generating intriguing, abstract landscapes. Though limited in comparison to a fully featured 3-D program, these effects can add an appropriately thrilling new dimension to your drawings, when used correctly. As with all new filters or tools, use it wisely and sparingly for the most impact. First though, a light pencil sketch can get the imagination firing.

Final image
This psychedelic fantasy landscape challenges the viewer's perceptions with its shifting depth of field, hyper-realistic background elements and humorous alien figure – who alone has evolved to navigate the surreal landscape. Not bad for a quick Illustrator sketch.

Abstract landscapes

1 This project is created directly on the screen, so plan it before you begin. Make a light pencil reference sketch of an otherworldly composition and decide which elements will be applied using the 3-D tool. Remember to keep all object shapes simple, and revise your thoughts until you are satisfied.

2 Go live in Illustrator now and create a 3-D shape using the Effect filter – go to Effect > 3-D > Extrude and Bevel > Complex 1 Bevel (and choose 50pt extrude depth). Repeat the process to make a variety of simple shapes, which you can then group together to form the alien tree.

3 Create a simple stick shape to form the tree trunk and turn it by applying the Revolve tool (Effect > 3-D > Revolve). Place the tree on a gradated colour background of yellow and purple formed using the Gradient tool.

4 Create the spheres from a drawn semicircle (always made to the right of the vertical guide) using the Revolve tool (Effect > 3-D > Revolve), and place them on a number of layers both in front of and behind the tree. Draw the alien outline on a separate layer, applying a yellow and green gradient fill. Apply the green circle pattern using the Halftone filter (Filter > Sketch > Halftone Pattern > Circle) on a new layer set to 'Multiply'.

Imitating plastic

As before, plan your composition and layout with a quick sketch before taking the plunge into Illustrator. We're going to create an iconic image of a 3-D flying saucer, rendered to look like a plastic toy, laying waste to a 2-D city. The 3-D Revolve tool is perfect for creating simple, symmetrical, plastic-looking items – so it's great for capturing the nuances of early sci-fi toys.

1 Draw the saucer profile in a new Illustrator document using the Pen tool. Remember to only draw half of it, to the right of the vertical guide. Stroke the outline using a 1pt pink colour fill.

2 Use the Effect > 3-D > Effect > Revolve tool, with a blue shading colour selected (these options can be found by clicking the 'More Options' button in the Revolve options menu that appears). Add extra highlights to your shape as necessary, and make sure that the 'Cap' option is set to 'solid' (the left of the two Cap options, located next to Angle in the Options box). Click OK, and Illustrator will create a plastic-looking saucer in three dimensions.

3 Create the setting using the Simple Illustrator Pen tool to shape and colour buildings placed against a gradient background of red to reddish-brown. Place the saucer on a layer above the buildings and import the image into Photoshop. Using a 20-pixel brush yellow outer line and a 5-pixel brush white inner line, create the laser beam, holding down Shift to draw a perfectly straight line. Add the impact flash in the same way, starting with large yellow and white brushes for the explosion, then stroking out thin white points.

Final image

This picture playfully tweaks its nose at the science-fiction concept of aliens invading from another dimension, as the power of the third dimension is literalized: the chunky toy saucer vaporizing a 2-D cardboard city. Whether escaping from its box into the wider world of the toy store, or asserting the box-office dominance of CGI cartoons over their traditionally animated brethren, this flying saucer certainly means business!

Creating depth with drop shadows

This project provides another strong contrast between 2-D and 3-D, but this time it is the setting which is fully realized, and the figure that is drawn to resemble a cardboard cut-out.

1 Draw a very simple chair shape directly in Illustrator and fill it with flat colour. Now add Effect > 3-D > Revolve > Plastic Shading. The shiny plastic appearance instantly transforms the flat shape into rounded 3-D.

Final image

An image such as this, where an abstract, iconic cartoon is integrated with a rendered item, could be used to draw attention to a product or service – a new range of sofas, perhaps, or a deluxe departure lounge. The 'realism' of the item draws the focus of the image to it, while the simplicity of the figure allows for the maximum affinity with viewers – the simpler the cartoon, the more people will identify with it.

2 On a new layer, outline a seated figure using the Pen tool. Fill all the sections with flat colours and place this layer above the chair. Create a third, drop shadow layer and place it between the inflatable and the flat figure (Select the Figure layer, choose Effect > Stylize > Drop Shadow, with a low value for the X and Y offsets – the other options are up to you). This lifts the flat figure and adds to the illusion that she is seated.

Tip: When you have mastered the basic functions of the Revolve tool, experiment with diffuse shading and create more ambitious custom colour palettes.

Retro style

Every period in history is reflected in its art, and popular graphic styles speak volumes about the culture and music of an era. Fashion tends to look back at past styles, and new trends often borrow from earlier times to create 'retro' styles, either reproducing colours and patterns associated with specific periods or amalgamating retro influences into a new 'fusion' style.

The computer is a tool that's perfect for such imitations, as program filters and simple techniques can successfully reproduce the cruder appearance of nostalgic ephemera, such as jazz record sleeves, with their coarse halftone colour screens and mis-registration.

Final image

For the final touch, scan some yellow paper, torn at the edges, and place it above the entire image in 'Multiply' mode. Now this battered LP sleeve could easily be stumbled across in a thrift-store. Although worn around the edges, this image still has effortless cool. If you want more realism, use the Brush tool to add highlights to the sunglasses, choosing the uppermost layer. Now all you have to do is choose a band name!

Using retro influences

1 Do a light pencil sketch in the 1960s' graphic style, simplified and stylized, with legs and arms tapering away to small wedge feet and hands. Scan the drawing. Changing the line colour to blue in Photoshop may help you keep track of which lines you have overdrawn in the next stage.

2 Overdraw the sketch in Illustrator with the Pen tool set to 1pt. Expand and drag the lines to add variable weight to them (Object > Expand). The lively character of the lines suits the freeform, musical nature of the cartoon, while the open areas are perfect for large swatches of colour.

3 Import the drawing into Photoshop and select a limited palette of colours appropriate to the period. The muted blue and orange deliberately lack the vivid brightness of contemporary hues. The saxophone is a toned-down grey. Apply these hues as flat colours, then proceed to the next stage.

1950s' advertising imagery

1 Pencil a quick sketch and scan it into Illustrator. Outline the figures using the Pen tool, expanding the lines (Object > Expand) as needed. Stroke the lines with sober, dark versions of the colours you will fill them with: orange for the skin tone, deep blue for the dress and so on before importing into Photoshop to fill the areas of flat colour. You may find it easier to import the black line art into Photoshop, fill the areas of colour and then colour the lines with the Fill tool on the line art layer, using the Lasso tool to isolate sections of the image. Apply tonal brushwork on a layer placed above the flat colour.

2 Outline and colour three rectangles of wallpaper in Illustrator. The wallpapers are formed from bold and simple shapes which can be copied, pasted and rescaled or rotated quickly from a detailed image. Curve the bottom edge of each rectangle, and import the wallpaper image into Photoshop, placing it under your completed figures. Create a soft grey shadow oval with 20% Opacity and position it beneath the feet of the figures.

Final image
The strong blues, turquoises and browns and cheery 'big-headed' cartooning style create a period image that's perfect for illustrating an article on home décor – whether in the 1950s or the present day!

Spot colour head

The distinctive mis-registration of colour layers is a key feature of 1950s' and 1960s' graphics, the result of a limitation in the offset lithographic printing presses of the time. Replicating this imperfection grants retro-style images authenticity.

Out of register ▲
The head is drawn directly in Illustrator and the line expanded at various points. The flat colour is applied deliberately to misalign with the outline edges.

Applied halftone filter ▲
Still in Illustrator, the drawing is extended to include the body, limbs and giant toothbrush, all set against a plain yellow circle with an outline stroked in red. In Photoshop, a Colour Halftone filter is applied on a new layer (Filter > Pixelate > Colour Halftone), then partially erased to leave a dotted effect around the edges.

4 On a new layer, apply separate gradients to areas of the hair, scarf, shirt and trousers. Apply Filter > Sketch > Halftone Pattern to the gradients to convert the gradient pattern into dots. On a further layer, airbrush in black shadows and add Noise (Filter > Noise > Add Noise) for texture.

5 To get the retro effect of pinstripe wallpaper, create a square on a new background layer and fill it with orange. Now draw a single blue stripe on a layer above and duplicate it across the width of the orange square. For a brighter, more modern image, simply change the wallpaper colours.

Integrated characters

Cartoons can be elaborate and still remain focused. A beautifully researched and executed setting elevates a simple frame to the level of high art. In the history of animated films many of the artists responsible for their richly detailed backgrounds were successful painters in their own right. In the pre-digital days, painstaking hours were spent fleshing out dense foliage – a task that can now be achieved in a fraction of the time using computer shortcuts.

When attempting a jungle scene, nowadays you do not need to paint every vein of every leaf to offer the impression of density. Working in layers on Photoshop or Illustrator allows you to simulate depth, building up areas of detail that recede into a distant haze of soft silhouettes. Learning to pare down detail as the layers recede and work from strong colours at the fore to washed out colours at the back is the key to success.

Final image

Every element of the background works in unison to direct attention towards the main character. Framed by the simple greens of the foliage, the jungle man is shunted to the fore of the image by the resultant negative space. The lineless silhouettes of trees suggest depth without overlapping with the figure, while the yellow background gradient behind his torso is another subtle cue that draws the eye's attention.

Using background setting

1 Sketch the jungle man in pencil, resting on a tree trunk and gripping a vine, with a curious snake dropping into the scene. Block in areas of the jungle, but don't go into great detail at this point – leaving the intricate line work for the inking stage adds more spontaneity and life to the final drawing.

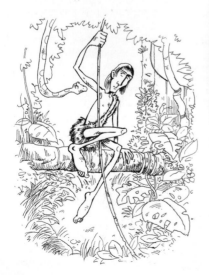

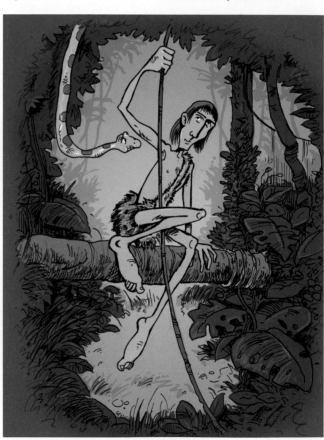

2 Ink over the drawing in dip pen and black Indian ink, filling in all the details of the frame of dense undergrowth. Add shading to the main elements – the figure, snake and tree trunk – with sparser tonal marking elsewhere. Leave the canopy and upper background as a simple keyline. Leave the black-and-white picture to dry, erase your pencil marks and scan the finished drawing into Photoshop.

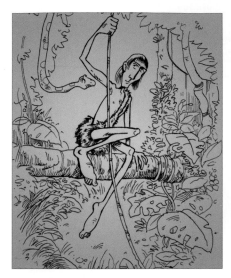

4 On a new layer, strongly tint the snake, man, log and clothing. Keep the colours simple and light, and add only the minimum of shading. Colour the foliage in the fore- and middle ground with a flat, overall green. Add sketchy shadows and highlights with the Brush tool, complementing the detail of your inked drawing with thin lines of soft colour. Finally, on a further background layer above the gradient, brush in the tree silhouettes, using a soft, medium-sized brush. Tint these in a lighter green so they fade into the background.

3 On a layer beneath the line art, apply an intense, gradated radial light seeping through the canopy: make this simply as a circular gradient, bleeding from yellow to green with the Gradient tool.

Fully painted depth of field

1 Draw a cute and comical monkey using a dip pen and black Indian ink. Apply extra pressure to the pen nib around the simian's head and body, increasing the line's width and character.

3 Import the background image into Photoshop and apply a Gaussian Blur (Filter > Blur > Gaussian Blur) to the foliage to suggest distance. Import the monkey and branch into a layer above the background and tint both in flat colours on a separate layer, adding a second shading tone to the fur. Allow the dark green at the feet to show through.

Tip: As a rule of thumb, the more dense the illustration, the simpler the colouring needs to be. It is the definition of the line work that will 'carry' more of the image.

2 The range of brush tools in the Painter application is ideal for the impressionistic background. Use acrylic brushes to lay down soft, opaque strokes that can be smudged using the Blending tool. Keep softening the marks until all the hard edges have disappeared. Add some fine detail to suggest grass stalks in a thinner brush.

Final image

Surrounded by solid black lines, the monkey pops out of the image, as if photographed with a shallow depth of field. In contrast to the flat, sharp colours of the monkey the soft foliage recedes, adding a range of hues and shapes without overwhelming the subject of the cartoon.

Cartoon symbols

In the graphics world symbols are often used as a means of communication. Easy-to-read images can present all kinds of messages: they are often connected to specific products or appear as brand logos, or are used to give directions or instructions in public places or on a website.

Creating a pared-down, instantly readable, recognizable symbol is a skilled undertaking and thinking economically is no small task. The target for the cartoonist is to reduce an image to its essence and produce a result with as little visual fuss as possible. Producing symbols using a computer graphic package is ideal because of the naturally clean look of a digitally generated image.

Creating a graphic logo

1 Make pencil sketches of your ideas for the mechanic character. Maintain an unfussy line which will be suitable for redrawing in Illustrator. Scan the sketch and open it in Illustrator. Trace around the outline using the Pen tool and expanding some line widths.

2 Import the image into Photoshop and select a simple mono-chromatic palette – white, pale blue and darker blue. A monotone logo still has a tightly designed power. On a new layer beneath the line art layer, fill the different shapes in your image with flat colour. Create small spots for the cheeks using a pale blue fill in two circular selections.

3 Make the cartoon look more like a logo by dropping in a circular background. Draw this using the Ellipse tool, holding the Shift key down to constrain the proportions so that the height and width of your selection remain the same. Place this layer behind your line and colour layers, so that the figure is projected to the forefront. Apply an 8pt white stroke around the character. As seen in the final image, shadows can make a lot of difference to the perceived depth of your symbol. Here, Layer effects (Layer > Layer style > Bevel and emboss) have been applied to the background circle.

Final image
This logo for a company of mechanics is the perfect fusion of clarity and personality. The limited colour palette focuses the attention on the form rather than the rendering and the comically enlarged spanner and overalls leave the customer in no doubt of the services offered, while the pared-down cartoon face adds friendly reassurance. The logo would be equally at home above a garage, on headed notepaper or as an embroidered badge.

Anthropomorphized objects

1 Sketch your final idea, firming up pencil lines to check their graphic strength. Scan and import the drawing into Illustrator. Trace over the sketch using the Pen tool. Experiment with line widths and sizes using the Expand tool (Object > Expand).

Final image
This symbol is perfect for an anti-littering or recycling bin awareness campaign, or for boroughs creating literature on littering for schools.

2 In our first colour interpretation, the lines vary between thick and thin to add character. The colours are filled with flat yellow and green, with highlights running vertically down the front edge of the bin and on the cheek dimples for added interest. To help the bin show up more against the white background, and to tie it together as a logo, a yellow ellipse with Opacity reduced to 30% is placed behind the bin on a new layer.

3 This alternative version of the same image reduces the detail and complexity in order to make it read more cleanly. A uniform 3pt line runs around the whole of the figure, the background elements have been entirely stripped out and the two colours are completely flat, with no highlights. This makes it perfect for rendering on a bin as cut-out areas of colour formed from a soft plastic such as EVA. Evaluate the success of your various versions.

Design variations

To guarantee the most effective results, consider several options, even if you're happy with your first attempt.

Reversing out ▲
Try reversing out the images by converting the black line to white. Does this render the image more effective?

Glow effect ▲
This striking glow effect is applied in Photoshop using Layer > Layer style > Inner glow/Outer glow.

Simple logo

1 Draw the cup and saucer shapes in Illustrator with the Pen tool. Create the aroma swirl using the Spiral tool. Add a grey tint to fill.

Final image
A clear logo is essential to promoting a product with success. This simple coffee cup sends a message that is universal in its appeal.

2 Re-colour the grey silhouette cup and aroma spiral in black and transfer the image into Photoshop. Draw a picture box with rounded corners on a new background layer. Select and apply a medium-blue colour fill from the colour palette. Create a final layer with the Gradient tool set to circular. Apply a warm orange colour and place this at the front.

3 Experiment with filters, effects, line strokes and fill colours to explore different results. The original drawing does not change throughout this process but the results can profoundly alter the look of the symbol. Here, the cup is enhanced with coloured horizontal bands. A Glow layer (Layer > Layer style > Inner glow/Outer glow) is enhanced by the black background.

Enhancing the stroke ▲
Illustrator can be used to enhance specific details of an image, such as this spiral of coffee steam as a 4pt yellow stroke.

Texture, depth and perspective

Slithering, scuttling or crawling creatures enjoy much more favourable press in the land of cartoons than they do in real life. The horror and revulsion with which they are usually met tends to evaporate when they are personified as wide-eyed, good-humoured and lovable – no matter how many their legs or how sticky their thorax.

The irresistibility of bugs as cartoon characters is compounded by the fact that they make fascinating and rewarding subjects for the artist. Coming as they

do in a plenitude of sizes, shapes, textures and colours, they give plenty of opportunity to explore and exploit the range of tools and effects in Illustrator and Photoshop to the full. Perhaps the best thing is that, given the immense number of species and variations, you should never run out of inspiration for new bug-eyed, bug-ugly characters.

Final image

A handful of out-of-the-box textures and filter effects combine to create a varied and engaging snail with only a small amount of effort. The colourful bubble-wrap texture on the body creates a slimy and exotic feel, while the swirl of colours on the shell at once complements and stands apart from the line work, like a pop-art painting mounted on the creature's back.

Applying colour and texture

1 Create an Illustrator line drawing of a snail with strong, rounded shapes to give plenty of character. Expand the Illustrator shapes (Object > Expand) at points along the line to bring it to life. Add humanistic features, such as expressive eyes to the tips of the feeler stalk, or a mouth with a knowing grin.

2 Import the drawing into Photoshop, create a duplicate layer and clear the original. Draw a simple square on a new layer and fill it with a flat, yellow-ochre colour. Add broad, brushy strokes of various colours on top, using a special-effects brush from the Brush palette. Don't be conservative about your colour choices – keep them complementary, but don't feel constrained by realism.

3 For the shell pattern, apply the Twirl filter to the shell colour layer (Filter > Distort > Twirl) and size the spiral. Remove excess pattern by selecting the relevant areas with the Magic Wand tool on the line art layer, then changing back to the colour layer and pressing delete. Apply a 'bubble-wrap' pattern from the Styles palette to the snail's body, then select the front of its belly and apply streaks of black and yellow, before blurring them with Filter > Blur > Motion Blur. To create the reflection, flatten, duplicate and flip the image, then apply Filter > Distort > Ripple and some Motion Blur.

Rendering and perspective

1 Consider the shapes and overall structure of the spider and draw it using a dip pen and black Indian ink. Scan and import into Photoshop.

2 Select the whole outline apart from the eyes using the Magic Wand or Lasso tool and apply a gradient blend of light- to mid-brown across the width or length by drawing the gradient line in the appropriate direction. Pan in closer using the Zoom tool and tidy up any stray colour around the outer line using the Eraser tool or Magic-Wand-and-delete method.

3 To give the torso a realistic sense of depth, tint the markings in various shades of brown, yellow-ochre and a range of dark reds. On a new layer select the filled areas to Fill, then apply Filter > Render > Lighting effects to adjust the intensity, texture and shine of the arachnid markings.

4 Construct the tiled floor on a new layer. Create a single grey square and go to Layer > Layer style > Bevel and emboss. Now right click on the layer and choose Convert to Smart Object. Duplicate the layer to make the tile into a square of 12 tiles, and merge the tile layers into a single object. Now put the object into Perspective (Edit > Transform > Perspective). Finally, create the spider shadow by duplicating the creature on to a new layer, darkening the colours to black using Image > Adjustments > Levels. Distort the shadow using the Shift key and Transform, then apply the blur filter. Reduce the shadow's Opacity to 70%.

Final image

Bristling with tiny hairs and stalking across the bathroom floor towards the bath, there's no question this cartoony spider would get an arachnophobe's back up, even if he is waving hello with his palpi. The bulging, crossed eyes, however, soften the blow and make this alien insect relatable!

Textured soil

As with all cartoon creations, environment is the key to 'selling' your characters and making them believable. Here, we'll integrate an earthworm with a realistic patch of soil.

1 Create a coloured outline drawing in Illustrator, expanding the line in certain areas. Import it into Photoshop and apply soft airbrush modelling to the body segments. Tint each segment on one layer, then create another layer above it and add the white highlights.

2 To form the textured earth square, paint a few blobs of brown on to a rectangle and apply the Craquelure filter (Filter > Texture > Craquelure). Put the rectangle of earth into Perspective using the Edit > Transform > Perspective command. Apply the earthworm shadow to the soil using a soft brush on a new layer in Multiply mode underneath the worm's colour layer. Add the movement strokes using a suitably soft brush on the white highlight layer.

Final image

The detailed rendering on the worm's body, and its well-integrated nature with the background, results in a compelling 3-D image. The manner in which the perspective is framed also makes the worm look as if it has burrowed into the page.

Composite images

Digital methods offer artists the opportunity to create images which can look good enough to eat. Whether created for use in product development, advertising, food magazine articles or as commodities within a graphic novel, these realistic foodstuffs trick the eye and tempt the stomach. The high degree of realism is achieved through the use of layers, filters and 3-D tools, combining separately rendered 'ingredients' in a deliciously digital mimicry of real-world cooking.

Creating a realistic image with filters

1 For the first part of this image, draw a circle in Photoshop and fill it with a three-part gradient of yellow, white and light brown (Gradient tool). Select a soft brush, and use it to add a few touches of a darker brown around the edge to simulate a burnt crust. Apply the Craquelure filter (Filter > Texture > Craquelure) to the whole to express the cooked dough.

2 Create the base of tomato sauce on a new layer as a circle of rich red with deliberately rough edges. Select a darker red hue, and add a thickly scribbled edge to the whole disc using a solid brush. Apply the Plastic Wrap filter (Filter > Artistic > Plastic Wrap) to the central part of the circle so that the tomato appears to glisten. This may look unfinished but will be covered up by the next layer.

3 Add the yellow cheese layer above the tomato layer as a slightly smaller circle of pale yellow. Keep the edges loose and fussy, extending the odd tendril out over the tomato layer. Apply dabs of mid-yellow across the cheese surface and use the Liquefy filter to swirl it like melted cheese. Add a slight 3-D effect to elevate the topping, using Layer > Layer Style > Bevel and Emboss.

4 Create a salami slice, then duplicate it and arrange 18 images on the surface. For a more natural look, overlap cheese on to the slices using the Clone tool. Apply small brush dabs of brown and green over the surface to represent a sprinkle of herbs and seasoning. Work these tiny, short strokes randomly over the whole of the pizza. Now flatten the image and correct the perspective using the Transform tool.

5 Use the Selection tool (Lasso or Polygonal) to cut a wedge shape out of the pizza and move it to a new layer above the rest. Use a light yellow brush to add strings of cheese, adding shadows in mid-yellow, and using the Smudge tool to smear and blend. Place the whole pizza on a black background to make it stand out and add a few wisps of steam using a soft, white brush. To take the image further, why not recreate various toppings, illustrate a pizza knife lifting up the slice or composite the pizza image into the box art of an Italian food brand of your creation?

Final image

Utterly tempting, this image is a great example of how simple shapes and colours can produce professional results when coupled with a selection of filters. This pizza is made entirely of manipulated circles, layered atop one another, but judicious application of filters and brushes renders it almost photorealistic.

Combining 2-D and 3-D elements

1 Construct the cone in Illustrator and apply the 3-D filter (Effect > 3-D > Revolve) using the settings shown in the screengrab below. To map the image of stars onto the object, click the 'Map Art' button and apply the settings shown at the right. You can map any image you like on to a 3-D object, but it must be stored in the Symbols palette in the document you are working on – you can add a layer or group to the Symbols palette just by dragging it in: it will then be selectable from the drop-down menu in the 'Map Art' option.

2 Import the cone into Photoshop. Draw a single French fry, duplicating and rotating it using Edit > Transform and the Rotate function. Spot the fries with tiny strokes of white to indicate salt and apply Filter > Render > Lighting effects to selected areas to add realism. Select areas of the cone with the Ellipse tool where fries are overlapping it, then go to Image > Adjustments > Invert and delete.

Final image

The specialist 3-D tools of the Illustrator program are perfect for artificial design elements such as this carton, while Photoshop excels at the organic elements of this illustration. Combining the two lends your images variety, novelty and – appropriately – flavour. Try duplicating the same process to different effect – why not start by rendering a tub of popcorn?

Layering ingredients

Preparing food often involves building up ingredients in layers. The snacks illustrated here demonstrate clear parallels with digital layers and filters that can be used to mimic texture. Why not take a cue from fast food and create your illustrations in a modular way?

Hamburger layers ▼
The three hamburger images show how easily Illustrator layers can be stacked, duplicated and rearranged. This method is an effective way to mass-produce simple images and reuse portions of a drawing without them looking stale. The examples would make great additions to a new menu or website.

Layered lolly ▲
The ice is sketched in Photoshop using the Pen tool and filled with a yellow/red gradient. The stick is made in the same way and placed above it. The stick part inside the lolly is selected, moved to a layer above and set to 'Multiply'. Filter > Distort > Ripple is applied to distort the view slightly, and a few gradient-blended, liquid drops are added.

Between fantasy and reality

This subject matter is as old as the fairy folk themselves. Goblins, trolls, leprechauns, pixies, imps and fairies good and evil all play the central role in tales and myths where morality needs to be explained. They inhabit the magical side of cartooning where, like the best superheroes, they can interact with any situation – real or imaginary. Employing Illustrator and Photoshop together provides the ideal vehicle for bringing together the fantastic and the realistic in a believable, yet make-believe fashion.

Merging cartoons with photos

1 Make a pencil sketch of your fairy's pose. You will also need a digital photograph for the backdrop, which may influence your figure's interaction with her environment. When you are happy with your composition, scan the sketch into Illustrator and draw over the outline using the Pen tool, stroking the line in blue and expanding the line on the sweeping curves.

3 Tint the crown yellow, the lips red and the neck and skirt ruffs mauve. Now add the 'magic glow' all around the fairy's outline: select the whole outline using the black arrow Selection tool and add a feather of 10 pixels, with a soft 10 pixel brush, in a creamy yellow. This effect will be more visible against the background.

2 Import the Illustrator outline into Photoshop and choose a range of blue hues using the picker from the Colour palettes. When making your selection, consider contrasting the weights of tones. For example, a mid-blue, flat tint for the hair is best teamed with a much paler hue for the face, but one that is within the same range, such as warm blues.

Final image

This fusion of the digital photograph and simple cartoon typifies the world of fairies – at once overlapping and apart from our own. The white glow around the fairy figure keeps the real world at bay and draws our attention to the fact that she doesn't belong – as if her winter-blue skin and wings weren't big enough clues! The outlandish purple sky and ripple effect in the water further blur the definitions of 'our' world and 'hers', while the trees mirrored in the water only add to the unsettling, otherworldly, but strangely soothing effect.

Sharpening the focus

The fairy character and little devils here exemplify the irresistible temptation of chocolate cake.

Wicked fairy ▶
An ink drawing is scanned and taken into Photoshop and combined with an imported digital picture, which is cut out using the Selection tool and placed below the line layer. The figures are selected and tinted in flat colours and a separate layer is made for the 300-pixel soft airbrush background.

4 To create the background, select and duplicate your digital photo of a tree (Image > Duplicate). Flip the image (Image > Rotate Canvas > Flip Horizontal). Bring them together on a Photoshop document large enough to fit both versions side by side. Drag the flipped photo on to the first image, which will import it as a new layer. Line up the two images accordingly. Alter the overall colour to blue (Image > Adjustments > Hue/Saturation).

5 Create the ripples in the still lake using the Ripple filter (Filter > Distort > Ocean Ripple). Now position the fairy over the background, where she conveniently hides the join in the middle of the two photographs. Her glow, previously invisible on the white background, will finally come to life – add a reflection of it in the water. Lastly, tint the sky lilac using Image > Adjustments > Hue/Saturation.

Humorous contrasts

1 Make a clear pencil outline sketch of the leprechaun (note the contrast of the bulky body and tiny feet). Scan and import the outline into Illustrator. Carefully trace over it with the Pen tool, expanding the line where appropriate to thicken it (Object > Expand). When you are satisfied with the drawing, import the image into Photoshop.

2 Note the limited colour range here. The green of the skin is close to brown, with the red outline, beard and wings deliberately selected to complement it. The red spots on the toadstools mirror the beard and tie the picture together.

3 Add tone overall by selecting areas for darker tinting using a soft brush. Then add Filter > Texture > Grain. Finally, tint an elliptical background shape.

Final image
This version of the popular, male, Irish equivalent of fairies known as a leprechaun is a simply hued mix of jollity, luck and goodwill. The heavyset figure with tiny wings brings to mind the myth about the aero-dynamics of bumblebees!

Legendary lighting

Ancient myths, such as the Greek legend of the Minotaur, offer perfect material for creating the cartoon or comic strip equivalent of a Hollywood blockbuster. As with all good movies, the mindset of a director is needed to facilitate the cartoon and find the high point of the narrative so that an audience is exposed to the full potential of the drama. With cartoons, this is achieved not only through the cropping and composition of images, but also through the use of a range of dynamic and dramatic lighting effects, such as fire, lasers and torches. Computer technology offers the digital cartoonist the chance to unleash high-impact effects on an audience by applying a selective range of simple tools and filters.

Colour and spot lighting

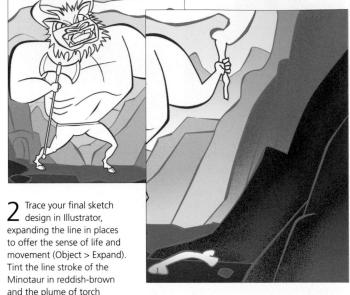

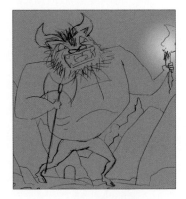

1 Give careful consideration to the way of presenting the character and situation to best achieve the effect you are aiming for. Looking at other cartoonists who specialize in your chosen area, and adopting some of their styling, may help. 'Thumbnailing' the illustration – experimenting with bold compositions in frames the size of postage stamps – may help kick-start the process by forcing you to think about shape and framing rather than fine detail. Sketch your final outline carefully in pencil. Scan the image into Photoshop, and apply a simple gradient overlay to give yourself an idea of where the central light source will fall.

2 Trace your final sketch design in Illustrator, expanding the line in places to offer the sense of life and movement (Object > Expand). Tint the line stroke of the Minotaur in reddish-brown and the plume of torch smoke in pale blue. Tint the larger rock masses in flat colours taken from the same tonal range.

3 The mood of the cartoon is dependent on the subtleties of tone used on the rock strata. Take the image into Photoshop and apply these darker gradations within selected areas on a new layer, using low-Opacity brushes set to Dissolve. Place this layer above the flat colours so that the colour still shows through.

4 Next, paint the Minotaur in flat colours so that he stands out from the rocks. Add detailed modelling to the figure, isolating areas to colour with gradients using the Quick Mask tool on your selections in the Photoshop Layer palette. When you have shaded your Minotaur to your satisfaction, apply a radial gradient (at right) to the whole image (on a new 'Multiply' layer, set to 60% Opacity), adjusting the gradient with the levels slider (Image > Adjustment > Levels) to increase the glow effect of the torch without making it overly distracting.

5 Give the scene an eerie light with a gradated overlay of blue and brown in 'Hardlight' mode applied across the image. This will intensify and darken shadows at one end of the scale and highlights at the other. Check over the image and tweak colour imbalances. Finish the image by brushing in additional flames on the torch and the reflections in the Minotaur's eyes.

Final image
This image is a masterclass on creating mood and drama. Blues and browns tightly grip the picture, drawing the eye to the red flame, its fiery reflection in the Minotaur's arm. The creature is framed by the gulley, pushed to the foreground by the cool blues of the receding trench, while dark gradients push in from all sides.

Torchlight and laserlight

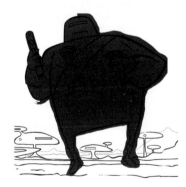

1 This pastiche of a 'Judge Dredd'-style character begins as a careful Illustrator line sketch, including the background setting, which is then imported into Photoshop. Using Quick Masks to isolate the figure, apply a blue-and-red gradient overlay to it, leaving the background untouched. Erase any excess colour from around the edges of the figure.

2 Colour the background scenery in the same assortment of gradients and flat colours, giving the cartoon an overall dark and gritty mood. The key feature of the picture is the laser gun blast, so use the Lasso tool to roughly select the area intended for it. Fill the area with a pink-and-white gradient.

3 Add a thin, sharp line up the centre of the gradient with a small, soft brush, holding down the Shift key to ensure it is straight. Use Filter > Render > Lens Flare to model the intense light. Repeat for the torch, with a blue gradient. Add red and blue highlights to the figure on a new layer. Add the stars with a 100-pixel brush set to Dissolve, with a Flow of 20%.

Final image
This image uses a time-honoured cinematic trick of using torchlight and/or laserlight to provide lighting and focus, in addition to giving a grittier, more ominous feel to the cartoon.

Aerial perspective

The illusion of using colour to represent pictorial depth is known as aerial perspective – which should not be confused with aerial viewpoint, or the bird's-eye view! For centuries, painters have explored the relationship that exists between colour and distance. In nature, the scattering effect of atmospheric particles results in distant objects appearing bluer and washed out. Art, however, gives you licence to use any colours you wish. As a general rule, stronger, more primary coloured shapes grab immediate attention and are perfect for foreground elements, while paler pastel hues recede into the background, furthering the illusion of depth.

Photoshop is a great program to use for the creation of a cartoon with a receding background. As well as the extensive choice of colour palettes, numerous filters can be used to soften shapes, reduce focus by blurring or alter textures to suit.

Final image

The colours may be emotive rather than realistic, but the eye has no trouble reading the distance in this image. The base and forefront of the picture are anchored with full-black shadows and heavy lines, while line weights diminish to nothingness towards the rear – the farthest objects lack keylines, becoming vague shapes in the autumnal sky. The complexity of the textured pattern on the man's coat brings him to the fore, as the eye slows down to decode the zigzags.

Using colour to create depth

1 Make a simple outline pencil sketch that contains all the basic information for the illustration. Try to keep the shapes simple and bold. Scan this image into Photoshop.

Tip: When inking over your pencils, don't try to replicate every nuance of the original sketch. Aim to capture the same freshness of line that was in your sketch – draw inspiration from that, rather than being a slave to your pencilled blueprint.

2 Duplicate this background layer and set it to 'Multiply' before deleting the original background. Create a layer for colour beneath the line art layer and roughly block in the various colours, using the Brush tool at 100% Opacity and Hardness. Reduce the Opacity of the pencil line layer to 50% using the slider. Now draw around the line in black, tracing it with a fine brushstroke, making sure your line is loosely and freely stroked for a more painterly effect.

3 With the line work complete apply a fill pattern (Edit > Fill > Use > Pattern) to the coat. Make a simple arrangement of diagonal lines to create the basic 'herringbone' pattern. Tidy any pattern overlaps that stray outside the coat outline with the Eraser tool. A Gaussian Blur filter (Filter > Blur > Gaussian Blur) on the buildings in the background distorts the pixel pattern to create a different, yet subtle texture. Sections of the background are erased with the History brush to ensure that the foreground remains in focus. As a final, tonal adjustment, you may wish to use a selection of gradients applied on layers above the whole image (as on the previous spread) to tie the colours together. Experiment with layer options – 'Multiply' and 'Hardlight', particularly – in order to give a subtle boost to the colours.

Changing the scene

The same subject can be moved through the seasons by changing colours or filters. Simply slide the Hue/Saturation controls: Objects > Adjustments > Hue/Saturation. Isolate the figure with a Lasso tool/Quick Mask selection, or reinstate his colours with a History brush.

Diminishing with distance

1 Create a single robot figure in Illustrator and tint it in Photoshop. Duplicate the figure and then scale each duplication using the Scaling tool.

> **Tip:** Try this particular distance technique with other subjects. A mountainous landscape offers stunning pictorial depths, with trees and peaks receding into the background, becoming paler and more blurred as they diminish.

2 Reduce the scale of each robot, altering the colour too. Shift the hue range further towards the recessive blue/mauve palette. Also adjust the colour Saturation (Object > Adjustments > Hue/Saturation).

Final image
This robotic assembly line demonstrates the ease with which aerial perspective can be put into practice, and also underlines the effectiveness of the digital domain at mass-producing characters. With a copy of Photoshop and a representative character, you can produce an army of thousands in minutes. Just remember, for non-robotic characters, try and introduce quirks or imperfections to differentiate your cast of thousands.

3 Select the three robots behind the foreground figure, one by one. Apply Filter > Blur to the first and increase the level of blurring to the second and third. This technique is an effective way of increasing the illusion of receding depths.

Pet portraits

Digital painting and rendering software offer excellent tools for creating pet caricatures – with their wide range of naturalistic media options, you will find it easy to capture the intricate details of furs and hairs – whether building up textures in layers of digital paint or utilizing bold colours and repeating patterns for a more abstract effect. The digital domain also offers an endlessly reworkable way to build drawings from brief colour sketches into fully rendered pieces of art.

Pets make great subjects for the cartoonist, offering a host of endearing, quasi-human traits that can be exaggerated or massaged into an amusing or characterful illustration – just think how many successful syndicated cartoons feature household pets as their stars! Enlarged noses, muzzles or ears can expose an animal's inner character, while large, emotive eyes anchor the drawing and make it relatable for human readers. Body shape too is an important indicator of cartoon

personality – a rotund pet dog reads as contented and friendly, while a skinny, stalking cat comes across as aloof or even suspicious.

Experiment and draw inspiration from family pets or animal photos in magazines, attempting to capture the nuances of their personality in a cartoon form. Work from very quick pencil sketches, elongating, squashing and exaggerating key features, before embellishing and adding detail in Photoshop and Painter, as below.

Curious dog caricature

Final image

Several effects increase the effectiveness of this image of a dog on the prowl. The exaggerated muzzle and ears – both overlapping the edges of the frame – draw attention to the canine's senses of smell and hearing, while the cocked ear directs the eye to what has caught the dog's attention – the cat, rendered shadowy, abstract and symbolic atop the wall. The dog's head replicates the shape of a dog's favourite toy – a bone. In terms of rendering, a series of fine lines in harsh highlight and deep shadow reproduce the fur without having to paint every fine hair. Finally, the carefully rendered eyes give us a 'human' point of entry into an animal portrait.

1 Make a quick pencil sketch. Scan it into Photoshop and make a light colour sketch on a new Multiply layer, using highlights and shadows of a single dominant colour to 'spot' the main areas of light and dark. Consider how the main elements of the picture interrelate – the moonlight along the top of the dog and the wall, the dog's black nose echoing the position and colour of the black cat and the shadows under the muzzle.

2 Flatten your image and import the layer into Painter, which has a much wider spread of naturalistic tools and filters, the better to replicate the organic elements of the dog's hair. Start to build up the texture of the fur and the wet nose using a fine brush in a dark pastel or charcoal material. Use the Blending tools to massage the colour into the basic blue of your image, leaving your lines sharper the darker the colour gets.

3 Start to work in the other colours and compositional elements – paint in the base coat for the eyes and collar, and begin to block out the bushes and the back wall. Don't be afraid to go overboard on the smudging and blending of colours at this point – you want to create a variety in texture and tone within a limited palette, and will be tightening up each portion of the illustration at the final stage. Pay close attention to the shading around the eyes and mouth, and to the expressive eyebrows, which will need to stand out against both the mid-tones of the fur and the highlights.

4 More colours are added to vary the palette: deep blue-greens for the suburban hedges and a dark brown for the brickwork. The composition has also been tightened – where previously the moon was a crescent shining from the top left, it is now a full circle spotlighting the cat. The full moon echoes the white circles of the dog's eyes, drawing the viewer's attention to the cat. The image is imported back into Photoshop for some final fine brushwork on the eyes and nose. The foliage leaves are created from a custom brush set to blue/ green, and a brick texture added as a pattern fill completes the picture.

Sinister cat caricature

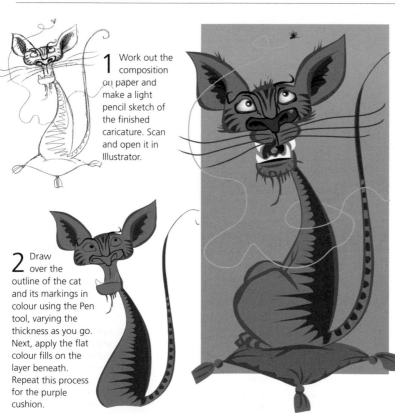

1 Work out the composition on paper and make a light pencil sketch of the finished caricature. Scan and open it in Illustrator.

2 Draw over the outline of the cat and its markings in colour using the Pen tool, varying the thickness as you go. Next, apply the flat colour fills on the layer beneath. Repeat this process for the purple cushion.

3 Fill in the eyes with a radial gradient of orange to white and add the black coils of whiskers. Add overlapping tufts of deep orange to the outer line to lend variety to the fur. On a new layer, create a gradated rectangle background, bleeding from orange to mauve. Finally, colour the fly in black and delineate the flight trail in a pale blue colour, using the Freehand Pen tool.

Final image
The elongated, top-heavy shape of this sinister cat provokes much amusement. The picture is anchored by background colours that reflect the cat and its environment, while the trail of the fly draws the image up and across the picture to its focal point. A simple image such as this would make a perfect Flash animation – simply moving the fly around the image with the cat's eyes following its course would be very effective.

Digital fashions

A cartoon character's clothing is another element of your illustration that can expose their hidden traits or offer the audience clues to their personality – they can also offer readers a surprise: think of a multimillionaire in faded jeans and a charity shop T-shirt, for instance, or a homeless superhero who always wears the same immaculate suit. Clothing can indicate humour – clothes that cling too tight or hang too loose – or denote a particular time period or social setting, and can be an excellent shortcut to mood or place.

The use of layers and masks in Photoshop allows you to effortlessly swap mixed media scans in and out of line art creations, adding authentic patterns and logos to your pen-and-ink characters. Furthermore, digital pattern fills can quickly replicate many fabric styles, from pinstripe to plaid, taffeta to tartan.

Using clothing to tell a story

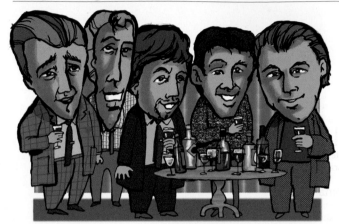

Final image
This image of an after-work drinks party would work well as the opening spread of a men's lifestyle article, whether on fashion or alcohol habits! The suit and shirt patterns are easily applied, but add interest and texture, supporting the claims of the caricatured heads that each man is an individual.

2 Set the layer to 'Multiply', and add further characters to the group, each separately drawn and scanned in.

3 Select areas of each character on a colour layer and tint them with flat colours. Add shading to the heads using a soft brush.

1 Begin by drawing a single character in roughly hewn pen-and-ink lines – exaggerate and elongate any pertinent characteristics. Leave plenty of open space on the clothing, as this is where you will apply the pattern. Scan the illustration into Photoshop.

4 Select the individual items of clothing using the Magic Wand tool, and add a variety of textures to the flat clothing on a layer above the colour art. Use scanned imagery of fabrics, or create a Fill Pattern that replicates stripes, checks or wool. Set the pattern layer to multiply, and adjust the Opacity until you are happy with the percentage of flat colour showing through.

5 The table is a scanned pen-and-ink line drawing. Place this above the figures and colour with flat and shaded hues. Use sharp white highlights to pick out the bottles. Apply a wood texture to the table in the same way as the fabrics in step 4. To create the floor, add a single swatch of a neutral colour on a new background layer. The wallpaper is a similar swatch, with lines of orange drawn with the Brush tool, holding down Shift to ensure straight lines.

Fashion photographer

1 Use a dip pen and ink to make a loose, quirky drawing of a stereotypical fashion photographer. Scan and import it into Photoshop.

Final image
This cartoon shows fashion's power to shock, surprise and delight – the neutral grey beige of the background, coupled with the soft primary colours of the character's clothes, are no match for the vivid pink print. The addition of a camera captures the eye and ties the image thematically with the photographer.

2 Begin to colour the image by selecting different areas on separate layers. Fill the dress area with the optical chequerboard pattern (Edit > Fill > Use > Pattern > Custom Pattern). Colourize this in a red selected from the colour picker on the desktop. Apply different shades of flat colour to all the other areas.

3 Scan a piece of pink fur fabric and import it into Photoshop. Place it on a layer that sits above the patterned dress. This juxtaposition of vibrant colour against the pattern of the dress causes it to stand out against the flat background, making it the focal point.

Integrating patterns

While adding patterns to a character is a quick and easy process, the resulting image, if left unmodified, can often look flat and unrealistic. However, it is easy enough to distort and alter such combinations to create blended images that are more convincing.

Blending images ▼
Place your T-shirt logo on a new layer above your line art, distorting it to fit your character's physique (Free Transform tools or Filter > Distort > Ripple). Next, scan a piece of fabric for the texture – the weave is more important as colour can be adjusted in Hue/Saturation. Add the texture on a new layer above the logo, and change the layer mode to Overlay or Multiply to blend the two together. Erase any excess using the Eraser tool or Magic Wand/delete method. Adjust the Opacity of the texture layer until you are happy with the effect.

Fashion girls ▲
For quick results, create a single fashion model figure and repeat her several times. It is then an easy process to select and change the colour, pattern or texture of the dress. Use this method for making quick comparisions, and to build a fabrics library for future reference.

Simple animation

Many simple Internet animations are created using Flash and it is ideal for anybody new to animation. It is designed to work in conjunction with vector and paint programs and they share common features, such as building images in layers. The different elements can either be created directly in Flash or in Illustrator or Photoshop and then imported.

Although the animation is still very simple, it is easy to lose track with so many layers of moving parts, so the following projects have been broken down into easy-to-follow stages. There are three main ways in which to animate your illustrations: 'Motion Tweening', where Flash creates frames in between two keyframes that make an object movie; 'Shape Tweening', where Flash creates frames that cause one shape to morph into another; and 'Guided Motion Tweening', whereby a character or element moves along a set path. The following pages outline these methods in more detail.

Final animation

These sets of images comprise a very simple animation using two moving elements and a fixed background. However, it effectively demonstrates creating movement using keyframes, and some basic ways in which existing shapes – or Symbols, as they are called once converted to animatable components – can be moved, reshaped and made transparent.

Converting shapes to animated objects

Tip: The most common keyboard shortcuts in Flash are as follows:
F8: convert shape into Symbol
F5: insert new frame
F6: insert new keyframe
Enter: play movie
Ctrl + B: 'Break Apart' – if you have created an image with clearly defined parts, for example, a word, this function will break it apart into its component units – in this case, the letters. These can then be animated individually.

2 Our animation is of a spaceship taking off, a power beam extending underneath it. To create it, you will need to make a number of 'keyframes' at the key points of action. Flash will interpolate the animation between your keyframes. Click at frame 30 and press F5 to create 30 empty frames. To insert a new keyframe within those frames, click a point on the timeline and press F6, or right click and select 'Insert Keyframe'.

3 Place the saucer on the ground at the bottom left of the frame, as shown, and hide the beam on the layer directly behind it. Now, add a new keyframe at frame 11 on the timeline. On this keyframe, select the saucer and move it directly up and into the middle of the picture. Extend the beam all the way down to the ground using the Transform tool. Select frames 1–11, click the Tween drop-down menu from the Properties toolbar and choose 'Motion'. This will create a smooth animation of the saucer rising into the sky, with the beam extending below it. Don't extend the slider bar of the beam past frame 11 when adding new frames – this will make it vanish at that point.

1 Create the spacecraft, beam and background in Illustrator, and import them into Flash as separate layers. Set the background as the background image, filling the whole of your frame. Change the spacecraft and beam into Symbols by pressing F8, or right-clicking and selecting 'Convert to Symbol'. Symbols are the moving parts in a Flash animation. Leave the background as it is.

4 Create a new keyframe at frame 30, and move the saucer to the top right-hand side of the frame. Change the Alpha percentage of the saucer to 0% in the Colour Effect drop-down menu (Modify > Instance) – this will cause it to disappear by the time it reaches this frame. Press the Enter key on the timeline to preview your animation.

Motion tweening

3 Use the Transform tools to rotate the ear on frame 30. Now select frames 1–30 by clicking and dragging the mouse across them on the timeline, and click Tween > Motion. This will create a smooth motion between frames 0 and 30.

1 Create a simple image of a friendly dog in Flash or import the image from Illustrator, with the right-hand ear brought in as a separate layer. The higher the frame rate, the more convincing the quality of animation. To adjust the frame rate of the project, go to the document settings. Around 12 frames per second will achieve the best result.

2 Select the ear and make it into a Symbol (right click on the object and select 'Convert to Symbol', naming it 'Ear'.) On the timeline, create a new keyframe at frame 30 by right clicking on the timeline and selecting 'Insert Keyframe'. This creates a new frame with both the dog and the ear in the same position as they are at frame 0.

Final animation

This shows a very simple animation: a movement to a dog's ear. The ear is on a separate layer to the head and is made into a symbol. The ear is shown moving in two screengrabs: one shows the red 'onion skinning' outlines, the other the final effect. As well as movement, Flash allows you turn one shape into another – in this example a green square into a mauve circle. Make further variations on the theme of the moving dog ear and morphing shapes and increase your ambition each time.

Shape tweening

1 Morphing one coloured shape into another can be achieved easily, as follows. Draw a green square with the Shape tool, but don't convert it into a Symbol, as you can only 'shape tween' between vector shapes. Place the square at the left-hand side of the frame. Using the F5 key and the timeline, create 30 frames of animation. Click at frame 30, and create a keyframe using F6.

2 On this keyframe, select the green square and delete it. Draw a mauve circle using the Shape tool, again not converting it to a Symbol. Place it at the right-hand side of the frame. Now, select the frames on the timeline, click on the Tween drop-down menu in the Properties bar and select 'Shape'. Press Enter to see the square turn into a circle. You can loop this as a repetitive movement by selecting Control > Loop Playback.

Tip: Turning on 'onion skinning' by clicking the second button from the left in the timeline bar allows you to view previous frames in your sequence as 'ghosted' after-images on your current frame. This is useful for fine-tuning animations with the frame-by-frame method.

Advanced motion tweening and guided motion tweening

2 The screengrab on the right shows the library where every part of the dinosaur is named and saved as a Symbol to its own layer. The library can hold up to 16,000 symbols! Each Symbol should be saved as a Movie Clip (below), which is the top option in the dialogue box that appears when you select 'Convert to Symbol'. Motion tweening is used here in the same way that it is used on the previous spreads: to make the dinosaur walk, open its mouth and move its tail. However, whereas previously you were moving a single object from point to point using keyframes, you can now control several discrete objects, moving and scaling each one independently.

1 Create the component body parts. Either do this in Illustrator and import them as separate layers, or make them in Flash using the Shape tool. Save each piece of the body as a separate Symbol, which can then be moved and animated independently.

Final animation

This is a slightly more complex animation made up of eight moving elements, or Symbols. The background, being a fixed, flat image, can be created in one of two ways – as a photo, or in the same cut-out method as the dinosaur. While the dinosaur moves and opens its mouth like a pre-school picture book character come to life, an outsize prehistoric bee buzzes across the animation on a guided path.

Tip: Tracking progress is important, and you will need to stop and check how everything is coming together. When using Flash in particular, your timeline will not always offer a 'realtime' preview of your animation or interactive functions, and movie clips cannot be played unless in an exportable format. While you can create a final 'publish' of your Flash project, it's easier to publish a preview, which renders faster and opens in your Macromedia Flash project window. Simply go to File > Publish Preview, or press F12 on your keyboard (PC or Mac).

3 Here, the dinosaur is fully assembled 'on stage' in Flash, on an empty background. The screengrab on the right shows the empty timeline and layers before any animation or keyframes have been assigned, while the one underneath it, shows the slider bars and keyframes afterwards. Keyframes can be created for each individual component part, or you can move several components on a single keyframe. Learning to 'micro-manage' your animation in this way will give you the greatest control – and results.

4 To create a background for the dinosaur (a non-moving, non-Symbol part), you can either create a flat background in Illustrator or Flash in the same style as your character, or import a digital photograph, as shown on the left. This stage can be added at any point, as it will not interfere with your animation.

5 The bee is the final element, here constructed in Illustrator, imported into Flash and saved as a Symbol. To make the bee move along a pre-determined path, do the following. Click the 'Create Guide' icon at the bottom of the layers menu (it's a blue cross and blue dot with a red dotted line joining them). Draw a wiggly path for the bee to follow on this layer. Click back to the bee's Symbol layer, select the Arrow tool and press the 'Snap to Objects' button in the Options area of the toolbox. Snap the bee to the guideline by moving it to the start of the line. Place the centre of the bee on the line (the centre will show as +). A black circle appears when the bee is snapped to the motion guide. Create a new keyframe at the end of the animation and snap the Symbol to the end of the line. Click the timeline and select Tween > Motion. The bee will now follow the guided path from beginning to end. Press Enter to see your completed animation.

Glossary

Animation The process by which an image is made to move in realtime. Flash and I-movie are two popular programs used to create simple animation.

Anthropomorphism Taking objects or creatures and offering them human characteristics or mannerisms.

Artboard Card or heavyweight paper, smooth or surfaced, used for drawing and tinting cartoons.

Background The farthest picture plane in a 2-D image where the illusion of depth is achieved using colour, mark or tone.

Balloons (speech) White oval shapes with a short, directional arrow pointing to the mouth of a cartoon character, containing the conversational speech. Thought balloons are a variation projecting thoughts.

Bezier curve A digital line that is a mathematically defined curve linking two points, drawn in a computer program.

Bitmap A graphic image or character of text comprising a number of black, white or coloured dots or 'pixels', which together form the image within a pictorial grid.

Body language The body expressing a variety of moods and expressions via posture, movement and positioning of limbs.

Brush tools Computer program palette tools that convert the function of mouse and its cursor into a number of digital mark-makers, emulating the styles of actual paint brushes.

Caption A small block or panel of text running along the top or bottom of a cartoon to title it, or set the scene, ready for the dialogue between characters.

Caricature Exaggerating, distorting or twisting the physical attributes of characters to create humour.

Cartoon A humorous or satirical style of drawing developed in a gag, strip, animation or comic-book format.

Cartridge paper Machine-made paper with a slightly matt surface, which responds well to most wet and dry media.

CMYK Cyan, Magenta, Yellow and Black. The percentages of those inks create all colours in the four-colour print processes.

Collage Forming a picture by physically gluing found materials on to a flat surface such as paper.

Colour – flat; limited; print Flat colour is opaque without tonal variation. Limited colour is when a few colours are deliberately used to enhance a mood or effect. Print colour is CMYK – all colours for reproduction are derived from these four saturated colours.

Comic (book) A magazine format that expands the strip cartoon into epic narratives – static films, almost.

Composition The organization of elements containing tone, colour and form within a picture.

Contour Line defining shape or form in drawing. It is the depiction of solid objects using lines but no shading.

Cross-hatching Pen stroke lines, which cross each other in repeated, angled patterns for the purpose of building tone in a linear drawing.

Deformation The distortion and stress offered to a cartoon character to show a specific movement or mood to the viewer.

Digital Data as numerical figures and codes that provide the basis for computing. Anything computer-created.

Dip pen Also known as a nib pen. A pressure-sensitive drawing and writing tool with a handle or holder, and a changeable nib, which is dipped frequently into drawing ink.

Distortion Stretching, squashing or altering a cartoon image significantly to add drama or exaggeration to it, in order to present the message more effectively or quickly.

Drawing tablet (graphic) A computer hardware input device that allows you to draw or write with greater control using a pen-like stylus on to a rectangular plastic tablet.

Dyes Chemical or natural mineral pigment-based liquid stainers that have strong, vibrant colours and easy dilutant properties. An alternative to coloured inks or watercolour paints .

Feathering Marks made with a brush and ink or watercolour, or a pen, which optically blend with the white space between strokes to form the tone.

Fineliner pen Disposable, mechanical pen with a fine metal nib in various sizes, and ideal for drawing controlled lines. Available in waterproof and non-waterproof inks.

Flash A vector-based program like Illustrator and Freehand but for the creation of simple animations.

Focus Main area of visual interest in a picture, drawing the eye of the viewer.

Foreground The nearest picture plane in a 2-D image where the illusion of least depth is achieved using specific colour, mark or tone, and enlarged scale of objects.

Foreshortening The effect of perspective in a single object or figure, in which a form appears considerably altered from its normal proportions as it recedes from the artist's viewpoint.

Frame An image that is part of a sequence of images forming part of a comic strip or moving animation.

Freehand Vector-based drawing program, which uses mathematical plotting to draw in an accurate, linear way.

Gag A witty and simple idea, often presented as a joke, which is simply illustrated in cartoon form.

Graphic novel Genre of cartoon book pitched somewhere between a novel and a comic.

Halftone Any process by which illustrations are converted into reproducible formats using lines and/or dots.

Highlight Emphatic patches of light offering extreme contrast within a picture, usually located on a relatively smooth surface.

Illustrator Like Freehand, a vector-based drawing program that uses mathematical plotting to draw in an accurate, linear way.

Ink The medium used with a dip pen or brush, allowing fluid marks to be made. May be diluted for greater fluidity.

Layout paper A lightweight paper with a level of transparency to allow an image underneath to be traced over.

Lettering Drawn characters which make up the text for dialogue and captions for cartoons.

Light and shade The contrast and balance of tonal and black-and-white values within a cartoon or artwork.

Line Any black mark made with an appropriate mark-maker that is solid and contains no tone.

Line and wash Black line with additional watercolour, ink or dye washes. Very popular technique for spontaneous cartoons.

Materials Any medium used for creating images.

Media The collective term for materials used to create artwork, and also for the newspaper, magazine and TV industries.

Midground The middle picture plane in a 2-D image, sandwiched between the foreground and background.

Mixed-media A collaborative use of various materials for creating an image, such as pen line, watercolour and fabric.

Montage Composing an image from miscellaneous drawn, photographic and/or found elements.

Movement Use of materials and drawing styles to create the illusion of an object changing from one position to another.

Narrative The sequence of events told as a story to link the events. Narratives have a beginning and a conclusion.

Opaque Dense. Not transmitting light. Opaque colour does not allow colour to be transmitted through layers.

Outline The external line that defines an object or character.

Painter A bitmap-based paint program allowing the cartoonist to reproduce many different techniques and styles with digital media imitating manual media.

Palette A shallow tray of plastic or porcelain with wells that are used for mixing paints. A selection of colours that can be chosen with an appropriate tool in a graphic computer program.

Path (clipping) Any vector-created line that is constructed as a result of two or more points being placed. A clipping path enables any object to be digitally cut out from its background, as you might do manually with scissors.

Pattern A repeated arrangement of decorative motifs providing a background or rendering for an object or clothing.

Perspective Representing a 3-D object on a 2-D surface requires the use of perspective. Linear perspective makes objects seem smaller as they get farther away and this is measured and drawn using a geometric system of converging lines.

Photoshop A complex bitmap-based image manipulation program with a vast repertoire of techniques and applications available to create, paint and alter images.

Pixel The dot on a computer display. Resolution (image quality) is measured by the number of horizontal dots against the number of vertical scan lines.

Realism Term given to any artistic methodology which seeks to reproduce in exact detail, observed life.

Reference Source material used by the cartoonist at the early stages of planning and during the various stages of creation.

Rendering To cover any surface with paint or collaged material. The action of drawing or painting.

Roughs First, rapid sketches, often in pencil, to get an initial idea on to paper for further development.

Scale Scale is the relative size of an image in relation to another. Scaling is where the sizes of images are resized by reduction or enlargement.

Scanner External computer hardware that converts artwork or transparencies into a digital format so that it can be manipulated by computer image-software.

Shading The method by which objects are made to appear 3-D within a 2-D picture. The simplest practice is to vary the pressure exerted on the pencil or other mark-maker to vary the density of the ensuing marks.

Shadow The visual interpretation of a dark area of a picture cast by strong light falling in front of a character or object.

Sketch Initial spontaneous or quick drawing that is not the final presentation artwork but a stage on the way to it.

Speed lines The bold, streaming lines that are drawn trailing any figure who needs to be represented as moving.

Stereotype A recognized trait or convention – usually in a person – that has become fixed through being widely held.

Stippling Shading an area by means of tiny black dots which are drawn closer together and with greater density to make an area tonally darker.

Strip Any story told through a series or sequence of cartoon images. Commonly published in newspapers and magazines.

Technical pens Mechanical pens with specific nib sizes to help artists make controlled lines of exact widths. *See* **Fineliner pen**

Theme Any chief subject for a singular cartoon or strip, around which centre all other stories, gags or plots.

Thumbnail sketch A small, simple sketch used to explore an aspect of composition, such as tone or colour variation.

Tints Term for colour which is lightened with additional white. In a mixture of colours, the tint is the dominant colour.

Tonal contrast The differentiation between lightness and darkness of colour or grey, black or white tone in a picture.

Transparent Allowing light to pass through a medium or be filtered by it.

Vector A computer image made up of plotted points on a curve (Bezier), and created by drawing programs that use Postscript language – for example, Adobe Illustrator.

Viewpoint The physical or attitudinal position or angle chosen to illustrate a scene or cartoon characters. By changing the position, a number of compositions can be considered.

Washes Diluted watercolours, inks or dyes applied thinly to the paper or support to create a translucent coloured film. A gradated wash is progressively paler or darker.

Watercolour Coloured pigment, which when diluted allows wet colour to flow freely across the paper surface using a soft brush to cover large areas with colour.

Weighting (graphic) The harmonious balancing of separate areas of a composition.

Working drawing An alternative to the thumbnail sketch or rough. A developmental drawing vital to the ongoing process of visual problem-solving.

Index

Acknowledgements

The publisher would like to thank the following for kindly supplying photos for this book: Alamy 6*b*, *tl*, 7*bl* and *br*; Dell Inc. 159*tl*; Canon UK Ltd 159*tr*; Epson (UK) Ltd 159*tm* and *ml*; Getty Images 6*tr*; Perris, Andrew 4*t*, 12*mbr*, *mbl*, *br*, *bl*, 16*br*, 24*tl*, *tml*, *bl*, 25*tl*, *tm* and *tr*; Picture-desk 7*tr*; Practical Pictures 16*tl* and 24*tr*; Wacom Europe GmbH 159*mr*.

All other artworks by Ivan Hissey

A big thank you to Jane for her enthusiasm and support, and to Curtis for his stamina and constant cheerfulness. *Ivan Hissey*

Thanks to all who encouraged and supported the making of this book. Firstly to Ivan Hissey who provided outstandingly versatile artwork with true professionalism, making my challenge as author so much easier and very enjoyable. Thanks to Susanne, my wife and manager, for encouraging me throughout and keeping it all on track. To my children, Tilly and Noah, for their enthusiasm and wonderment as the project unfolded – with special thanks to Noah for trying out many of the cartoon exercises! Thanks are also due to all at Bridgewater Books and Anness Publishing, especially to editors, Polita and Hazel, for toiling so hard with me to guide this product into completion. *Curtis Tappenden*